The Florida History and Culture Series
USF Libraries' Florida Studies Center

USF
UNIVERSITY OF
SOUTH FLORIDA

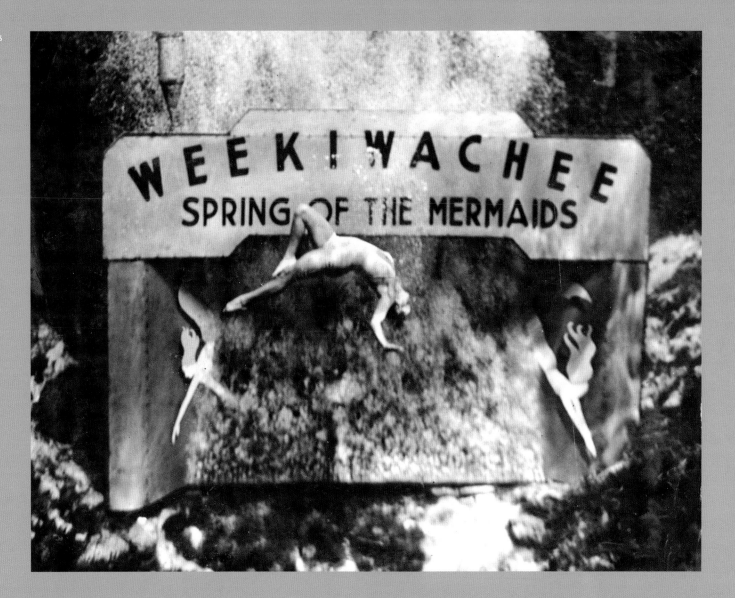

University Press of Florida

Florida A&M University, Tallahassee
Florida Atlantic University, Boca Raton
Florida Gulf Coast University, Ft. Myers
Florida International University, Miami
Florida State University, Tallahassee
University of Central Florida, Orlando
University of Florida, Gainesville
University of North Florida, Jacksonville
University of South Florida, Tampa
University of West Florida, Pensacola

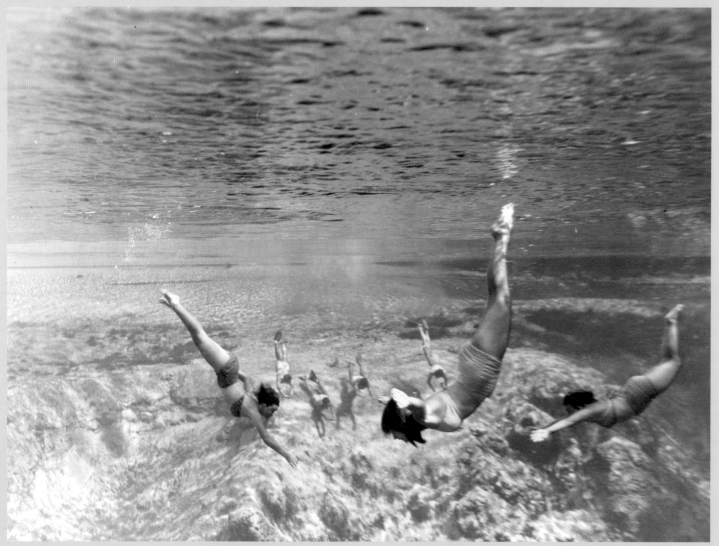

University Press of Florida
Gainesville · Tallahassee · Tampa · Boca Raton · Pensacola · Orlando · Miami · Jacksonville · Ft. Myers

Weeki Wachee

city of

mermaids

A History of One of Florida's Oldest Roadside Attractions

Text by Lu Vickers / Story research and photograph compilation by Sara Dionne

Foreword by Gary R. Mormino and Raymond Arsenault

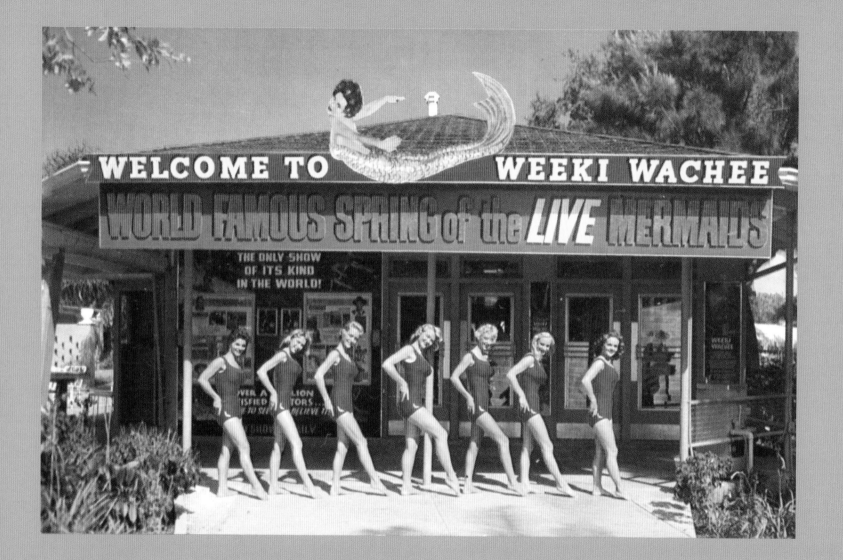

Published in cooperation with USF Libraries' Florida Studies Center

11 10 09 08 07 06 6 5 4 3 2 1

Library of Congress Cataloging-in-Publication Data
Vickers, Lu.
Weeki Wachee, city of mermaids : a history of one of Florida's oldest roadside attractions /
text by Lu Vickers ; story research and photograph compilation by Sara Dionne ; foreword by
Gary R. Mormino and Raymond Arsenault.
p. cm. — (The Florida history and culture series)
Includes bibliographical references and index.
ISBN-13: 978-0-8130-3041-8 (alk. paper)
 1. Amusement parks—Florida—Weeki Wachee—History. 2. Mermaids—Florida—
Weeki Wachee—History. 3. Weeki Wachee (Fla.)—History. 4. Hernando County (Fla.)—
History. I. Dionne, Sara. II. Title.
GV1853.3.F62V53 2007
791.06′80975971—dc22
2006028472

The University Press of Florida is the scholarly publishing agency for the State University
System of Florida, comprising Florida A&M University, Florida Atlantic University, Florida Gulf
Coast University, Florida International University, Florida State University, University of Central
Florida, University of Florida, University of North Florida, University of South Florida, and
University of West Florida.

University Press of Florida
15 Northwest 15th Street
Gainesville, FL 32611-2079
http://www.upf.com

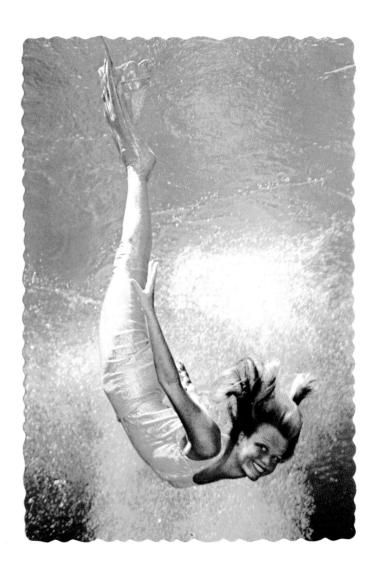

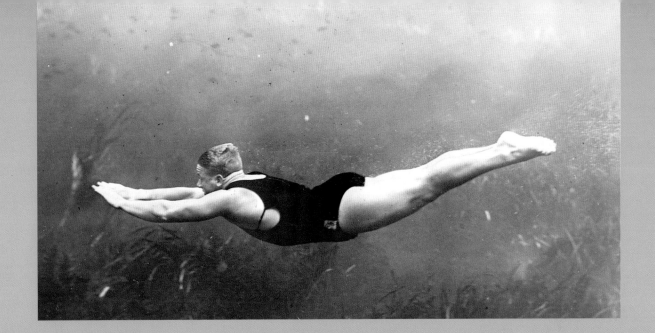

For the one and only Newt Perry, Florida's Human Fish, the man who brought mermaids and movies to the Sunshine State

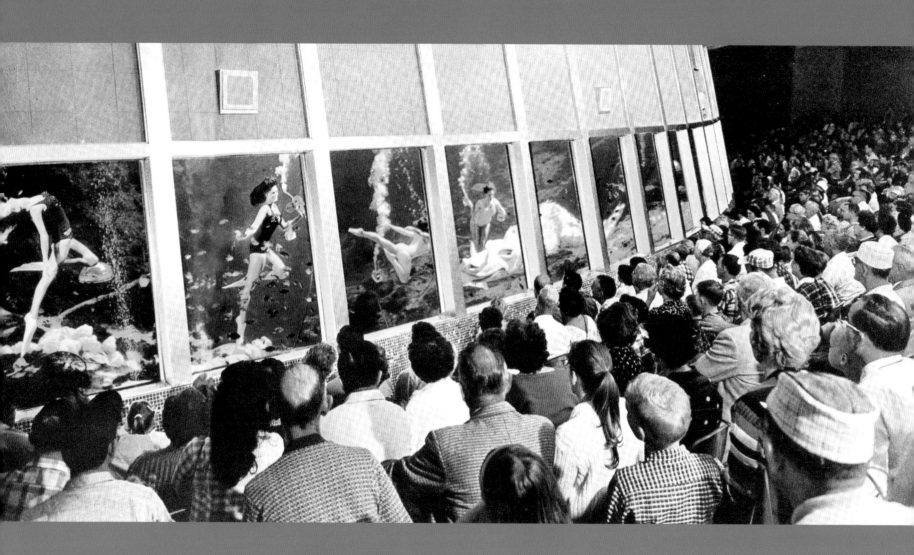

Contents

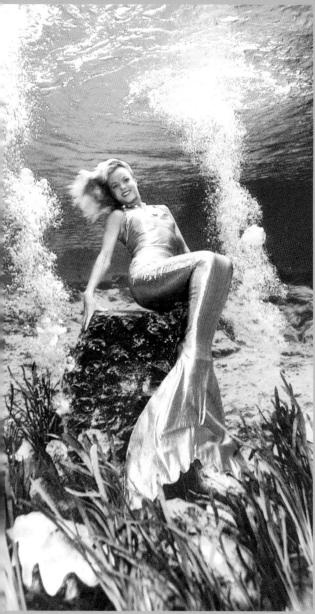
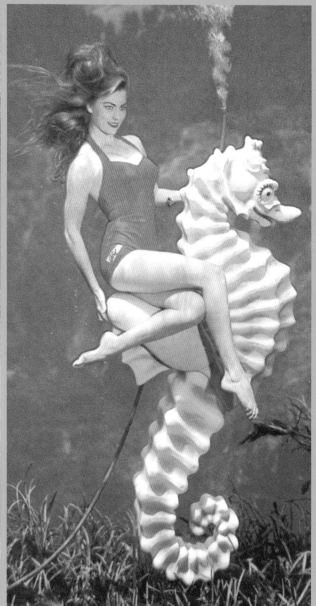

Foreword

Weeki Wachee, City of Mermaids: A History of One of Florida's Oldest Roadside Attractions is part of a series devoted to the study of Florida history and culture. During the past half century, the burgeoning growth and increased national and international visibility of Florida have sparked a great deal of popular interest in the state's past, present, and future. As the favorite destination of hordes of tourists and as the new home for millions of retirees, immigrants, and transplants, modern Florida has become a demographic, political, and cultural bellwether.

A state of vast distances and tumultuous change, Florida needs more citizens who care about the welfare of this special place and its people. We hope this series helps newcomers and old-timers appreciate and understand Florida. The University Press of Florida established the Florida History and Culture Series in an effort to provide an accessible and attractive format for the publication of works related to the Sunshine State.

As coeditors of the series, we are deeply committed to the creation of an eclectic but carefully crafted set of books that will provide the field of Florida studies with a fresh focus, and encourage Florida researchers and writers to consider the broader implications and context of their work. The series includes monographs, memoirs, anthologies, and travelogues. And, while the series features books of historical interest, we encourage authors researching Florida's environment, politics,

and popular or material culture to submit their manuscripts as well. We want each book to retain a distinct personality and voice, but at the same time we hope to foster a sense of community and collaboration among Florida scholars.

In *Weeki Wachee, City of Mermaids*, Lu Vickers and Sara Dionne take readers for an exhilarating journey to one of Florida's most beloved tourist attractions. The book Vickers has written is a pure joy to read, a nostalgic and thoughtful examination of a very special place and the extraordinary people who flocked to the magical waters of Weeki Wachee. Dionne's arrangement of photographs provides an entertaining visual documentation of both the place and the people who swam there.

Nature endowed Florida with an abundance of natural springs; few are grander than Weeki Wachee, located in present-day Hernando County. Vickers describes the odd assortment of creatures and characters that first inhabited the area. Giant sloths and mastodons stalked the land, their bones later discovered by divers. Nineteenth-century pioneers and naturalists found a dreamscape; the watery paradise remained isolated and unsettled until late in the twentieth century. As late as 1950, Hernando County boasted a population of only 6,700 residents.

If Newt Perry hadn't already existed, he would have had to be invented. His life was a dress rehearsal for the development of Weeki Wachee. A champion swimmer, a movie stunt

man, and a trainer of World War II frogmen, Perry's life prepared him for the opening of Weeki Wachee Spring on October 12, 1947. Sadly, Perry was a better promoter and swimmer than businessman, and he never reaped the rewards that his successors enjoyed. Perry would have appreciated the ingenuity of his biographers in unearthing a variety of primary materials that document the man Grantland Rice called "the Human Fish."

Of all of Perry's grandiose and picayune ideas, nothing had more legs—and tails—than his underwater stage for Weeki Wachee mermaids. From the beginning, Weeki Wachee Spring has been synonymous with mermaids. A cavalcade of celebrities from Esther Williams to Elvis Presley to Don Knotts navigated U.S. 19 to be photographed with the mermaids.

Alas, mermaids and roadside attractions were becoming endangered species in modern Florida. Beginning in the 1970s, developers, too, discovered the magic of the once pristine springs and hinterland. Spring Hill, a massive Mackle Brothers' development, became a Hernando County resident. Algae blooms and traffic jams followed. But more threatening than pollution runoff was the changing tourist and corporate landscape. Weeki Wachee became a commodity, as the American Broadcasting Company sold the park to Florida Leisure Attractions, which then sold it to Florida Leisure Acquisition Corporation. Nearly half a million tourists trekked to Weeki Wachee in the late 1970s. But nothing—neither new owners nor old mermaids—could compete against the leviathan Walt Disney World. Weeki Wachee's charm faded in the 1980s and 1990s as tourists sped to Orlando. The fate of Weeki Wachee is uncertain, but readers will be grateful for the precious memories and photographs preserved by Lu Vickers and Sara Dionne in their loving history of this special place and people.

Gary Mormino and Raymond Arsenault
Series Coeditors

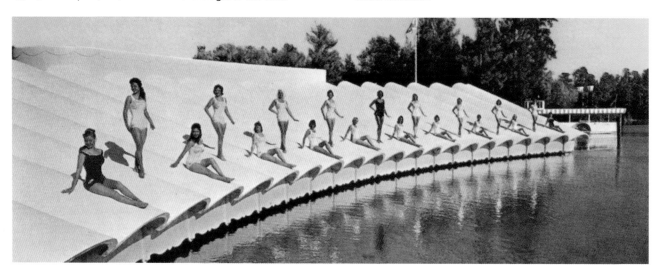

Preface and Acknowledgments

The story of how I came to write a history of Weeki Wachee began about thirty-five years ago on a summer day in Florida. I duked it out with my brothers and sister, kicked and elbowed my way to a window seat in the back of my father's Ford Fairlane. Once we got going, I leaned head and shoulders into the hot wind like a dog, watching trees stream past in a green blur. After an hour or so, a faded billboard appeared in the distance. As we zipped by, I read the pale-blue letters: Weeki Wachee Spring, the City of Mermaids. The big blonde mermaid sprawled lazily across the top of the sign wasn't perfect, but in that split second, she swam deep into the darkness behind my eyes. She had a fishtail. She could breathe underwater. I begged my parents to take me to Weeki Wachee so I could be a mermaid, but they never did.

Their destination of choice was closer to home: Panama City Beach, home of the Miracle Strip Amusement Park. The City of Mermaids I could only swim to as I held my breath and dove beneath the rolling green surface of the Gulf of Mexico. Half-glimpsed, that billboard mermaid had burned into the velvety blackness of my imagination.

I never forgot her. When I grew up and left home, I lived so close to Weeki Wachee I could've driven over on any given day, but I didn't. I liked having that sun-bleached image in my head, and I wasn't sure what effect the actual mermaids might have on her. By the year 2000, though, I was well under way on a novel about a mermaid and I had to go to Weeki Wachee to do some research. As luck would have it, the day I arrived, the former mermaids were performing *Tails of Yesteryear*. After the show I posed for a photograph with mermaid Mary Darlington Fletcher and her brother, merman Ed Darlington. Both of them were "originals," meaning they swam in Weeki Wachee's first show back in 1947. Both of them wore deep-blue tails. And between them, they kicked that faded billboard mermaid right out of my head. I've never looked back. I told Mary I'd like to write an article about her and the former mermaids, and she told me to come down in a couple of weeks when they'd be performing again. "When you pull into the parking lot," Mary said, "look for Ed's Winnebago. It'll be off to the side. Some of the mermaids will meet there."

Bev Sutton, Dottie Meares, Billy Fuller, and Dawn Douglas were just a few of the mermaids I met that day at Ed's Winnebago. They fed me boiled peanuts and took me into the Mermaid Lounge and into the "hole room." Mary and Ed not only shared their stories, they also took me for a swim in the spring, Mary telling me as I hesitated before the icy-cold water, "When opportunity knocks, you gotta open the door." I plunged in.

I wrote my article, and *Doubletake*, a documentary magazine, accepted it and then promptly folded. Not even a benefit concert by Bruce Springsteen could bring the magazine back. The editor sent me the galleys, and I tossed them into a drawer, thinking, so much for that.

But the mermaids were about to surface again, this time with help from the *Creature of the Black Lagoon*. I ran into a mermaid at the Creaturefest at Wakulla Springs in the fall of 2003, and she introduced me to Sara Dionne, who was working on a documentary about Weeki Wachee. After discussing our mutual interest in Weeki Wachee, we decided a book was in order. And so here we are.

Of course, a special thanks goes to Mary Darlington Fletcher and Ed Darlington, who got me interested in the story of the real mermaids in the first place. Mary also introduced me to Penny Smith Vrooman, who told me stories about how her father, Walton Hall Smith, dove into Weeki Wachee before he helped it become the world-famous Spring of Live Mermaids. The book would not have been possible without the help of Delee Perry, who provided me with an amazing number of resources: newspaper clippings, letters, photographs, and stories. She made her remarkable father, Newt Perry, Weeki Wachee's cofounder, come alive. Nancy Tribble Benda patiently shared her scrapbook and stories with me, then answered more questions as I wrote. Both Nancy and Ricou Browning gave me a fish-eye's view of Newt's days at Wakulla, as well as his early days at Weeki Wachee. Dot Fitzgerald Smith, Ginger Stanley Hallowell, Dianne Wyatt McDonald, Marilyn Reed Webb, Fran Dwight Gioe and Mary Dwight Rose, Dawn Douglas, Allen Scott, and Bruce Mozert, underwater photographer extraordinaire, also shared their scrapbooks and photographs. Thank you. I could not have written the book without the help of Bonnie Georgiadis, who worked at Weeki Wachee for thirty-seven years. Not only did she share several scrapbooks, complete with newspaper articles, she also let me interview her twice and then pester her for a whole year with questions. She midwifed this book

into being. She introduced me to Marilyn Nagle Cloutier, then she and Genie Westmoreland Young tracked down Martha Delaine (and Martha tracked down Gussie Washington, and Gussie tracked down Joe Ann Bennett, adding a whole new dimension to the book and proving that what the mermaids say about Weeki Wachee is true: We are family). Thanks also to Ron Weiss, who opened the Wakulla Springs Archive to me, and to Jason Vickery, who went through box after box of dusty papers with me, looking for info about Newt Perry. Thanks to John Athanason, marketing director of Weeki Wachee, who provided me with behind-the-scenes access to the current mermaids. A great big thanks goes to Meredith Morris-Babb for enthusiastically accepting my proposal for the book, and to John Byram for patiently guiding me through the review process. He deserves a medal for bringing this book to press. Thanks also to designer Larry Leshan and project editor Susan Albury for all of their hard work. I'd also like to thank my friends Sue Gambill, Jennifer Cherrier, and Pamela Ball for reading drafts of the manuscript. Jennifer and Pam read the draft dozens of times, and Pam suggested the present structure of the book. Both of them saved me from myself on numerous occasions. A special thanks is also due to the people who reviewed the book: Dr. Amy Mitchell-Cook and Dr. Tracy Revels. Tracy read the book twice and offered valuable suggestions on content and structure. Her lovely book on Wakulla Springs, *Watery Eden*, actually piqued my interest in Newt Perry a decade ago when it was still in dissertation form, and it was an inspiration in many other ways. The librarians at the Florida Archives, FSU, and the University of Florida were also helpful. The Florida newspaper collection at the University of Florida proved to be invaluable. Thanks also to Rita Dickey of TCC; she located hard-to-find books and

newspaper microfilms. Angie Davis of the *St. Petersburg Times* also researched and copied articles for me. Adam Watson of the Florida State Archives supplied photos. Laura Peterson, Michael and Mary Jo Peltier, and Herb and Bette Cherrier provided much needed moral support and child care. The Veranda Club listened to me talk about all things mermaid: Meri, Mike, Larry, Donmetrie, and Shauna. The late Jerry Stern also had a hand in shaping this book. Last but not least, I want to thank my family, who lived without me for practically one whole summer and then nearly every weekend for over a year: Jennifer, Jordan, Samuel, and Elias (who believes in the Weeki Wachee mermaids, zippers or not).

Lu Vickers, April 2006

First and foremost, I would like to thank Bonnie Georgiadis, who allowed me to spend countless hours with her and her photo albums as well as helping me identify and locate mermaids.

Many photos I have used would have been lost forever if it were not for Bonnie and Genie Westmoreland Young's efforts years ago that saved them from the dumpster. The same can be said for Allen Scott's collection, from which I have also drawn.

I deeply appreciate Lu Vickers for agreeing to write this book. Her enthusiasm and her own in-depth research have taken the text far beyond my initial vision. I would also like to thank Lu's family for their support of her during this time.

Thank you to the University Press of Florida's Meredith Morris-Babb for accepting Lu's proposal and to John Byram for his comments and suggestions that gave this book a lot of integrity.

It's an honor to have worked with Sparky Schumacher; his prolific contribution is the greatest source of Weeki Wachee's photographic history. The legacy of Ted Lagerberg's compelling work also moves me to document it. I have utmost respect for Bruce Mozert, the "grandfather of underwater photography," who well into his eighties continues his work today. Andrew Brusso's work continues to gain momentum, and he is closer to becoming a modern-day equivalent.

Holly Hall and Dolly Heltsley have helped me immensely with the fund-raising that fuels my Weeki Wachee projects. I am also grateful to Dawn Douglas, Ed Darlington, Mary Darlington Fletcher, Richard Fletcher, Susan Sweeney, and Gina Stremplewski for their help with these efforts.

Another steadfast supporter is Dan Wester of the Tallahassee Film Society, who continuously promotes my Florida projects.

I'm grateful to Dianne Wyatt McDonald and Thea Jorgenson Whitehead for keeping such detailed scrapbooks and archives.

Being a fashion designer, I was thrilled to meet Jo Ann Hausen and go through her wonderful photo collection from her years spent working as Weeki Wachee's costume designer.

I cherish my friendship with Crystal Robson, who shares a common interest in fashion with me and is the owner of the largest swimwear shop in Florida.

I can always rely on Judy Ginty Cholomitis for her spare room in her pink condo, which is my home away from home when I'm in Florida.

I'm grateful to Gerry Hatcher Dougherty, who also provided a wonderful place to stay, and to Dot Fitzgerald Smith and Vicki Smith for their warm hospitality.

I truly treasure the Reed family—Bob, Marilyn, and Barbara—and thank them for their contributions.

Jack Mahon, whose love of Weeki Wachee led to an abundant collection that was gathered from his time there and even after he left. His daughter, Cathy Mahon Havens, kept it all safe and was generous enough to share it with me.

I would also like to thank all the other mermaids and former staff who opened their hearts and their scrapbooks to help me accomplish this endeavor: Naomi Ruth Roll, Ginger Stanley Hallowell, Nancy Tribble Benda, Penny Smith Vrooman, Lydia Dodson, Mary Rose, Frances Gioe, Dorothy Stanley, Patsie Boyett, Mary Sue Clay, Shinko Wheeler, Jana Cofer, Yvonne Chorvat, Tina Fischer, Anna Cooke, Martha Lambert, Betty Graves, Beverly Orchard, Miriam White Patterson, Sue Saxon, Jennalee Hadley, Anne Tappey, Cheryl Rhoads, Vera Benson Huckaby, Terry Ryan Hamlet, Marti Nosti-Monaldi, Susan Backlinie, Ricou Browning, Susie Pennoyer, Melody Harding Hope, Melinda Harding Flinn, Beth Thomas, Beverly Bender, Doreen Durendetto, Linda Sand Zucco, Debby Poore Kaufman, Sharon Cihak Elliot, Marvin Kimbrough, and Tonia Lynn Waldron. To any of you I may have forgotten, please forgive my oversight.

Delee Perry was a great contributor, and I will never tire of listening to her stories about her father.

Additional contributors were Becky Boyett Gonzalez, Charlotte Boyett, Lauren Dodson, Adam Watson, Roy Winkleman, David Rice, Merilyn Burke, Alexa Favata, Rex Nelson, Juan Cabana, Bambi Cambridge, Julie Atlas Muz, Ron Kolwak, Janaina Tschäpe, Larry Poos, and Kelly Engler.

Florida has an abundance of other historical gems of tourist attractions, and I'd like to thank the directors of them who have allowed use of their material: Steve Specht at Silver Springs, Sandy Cook at Wakulla Springs, Alyson Gernert at Cypress Gardens, as well as Ron Coley in San Marcos, Texas, on behalf of Aquarena.

It's been a pleasure associating with fellow Weeki Wachee fans Larry Warren and Phillip Giles, who have shared from their collections.

Of my project support crew, Audrey Sacco is my "consigliere," on whom I endlessly rely for her intellect and council. Autumn Tarleton, Frederick Olsen Jr., and Laurence Kingston have greatly assisted in the documenting process.

The legal staff at the Volunteer Lawyers for the Arts, both in New York and Florida, deserves a mention for their care in providing insight into copyright law and the publishing world.

My husband, Dino Dionne, has allowed me to sustain my efforts with his understanding of the deep interest I have for Weeki Wachee's history.

A special mention must go to my friends and family, who have encouraged and supported me in life: Duane Dionne, Tracy Fish, Denny Fish, Kristin Farr, Meagan Chapman, Andrew Cleary, Susie Christie, and Charmayne Anderson.

Last, thanks to all the Loreleis, Undines, and Aquamarines out there who continue to inspire my endeavors.

Sara Dionne,
April 2006

Florida

A Watery Dreamscape

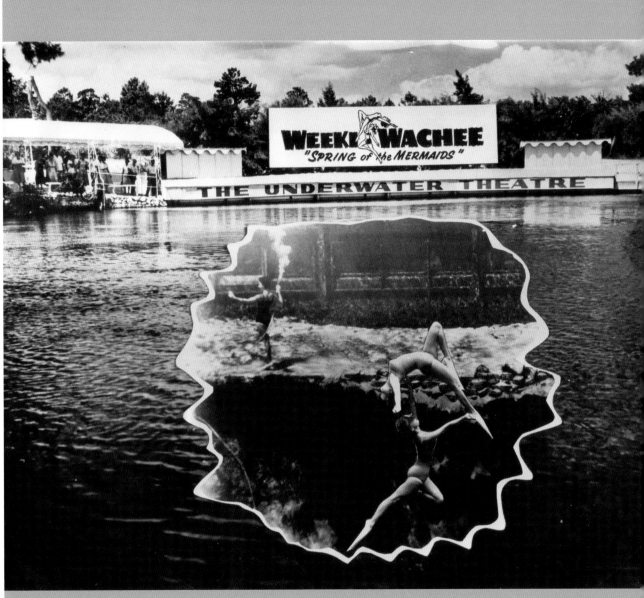

Original theater with a canvas awning, ca. 1949. Courtesy of Patsie Hadley Boyett.

Life in the Sunshine State was destined to be surreal from the very beginning. Thirty-seven million years before two water-crazed entrepreneurs landed at Weeki Wachee–a spring forty miles north of Tampa Bay—sunk a glassed-in theater underwater, and converted the locals into mermaids, the entire peninsula of Florida was an underwater theater, its sea bottom crowded with a strange menagerie of "snake-like whales, dugongs, sea-biscuits, and urchins."[1] As Florida rose out of the sea, the skeletons of those creatures, combined with crushed shells and coral, transformed the seabed into limestone, the porous rock that's responsible for the formation of Weeki Wachee and the other six hundred-odd springs that shimmer against the Florida landscape like plate glass windows.

Nowhere is the Sunshine State's dreamlike quality more evident than in those green and blue springs. They bubble to the surface from underground rivers, forming pools so clear and so deep that boaters suffer vertigo, feeling as if they were suspended high in the air. For centuries people have been gazing into these otherworldly springs, through water glasses or wooden buckets with glass bottoms, through glass-bottomed canoes, through the portholes of scenic submarine boats. In these springs, nothing is as it seems. Water becomes air, boaters become aeronauts, and turtles fly. From Ponce de León's Fountain of Youth to Silver Springs' underwater Bridal Chamber and Wakulla's pole-vaulting catfish and submarine bee tree, people have looked into Florida springs and found enchantment. Even today, in the twenty-first century, no fewer than four springs claim to be the Fountain of Youth. But that's okay, because this is Florida, where myths die hard or don't die at all.

If there is a quintessential Florida Spring, it has to be Weeki Wachee, at once a primordial pool and kitschy tourist attraction. This shimmering spring of blue light has attracted flightless cranes, mastodons, ancient Indians, Spanish conquistadors, and glass-bottomed boat hucksters. And those are just the run-of-the-mill visitors, typical for Florida. Weeki Wachee upped the ante for surrealism in the late 1940s, when those two water-crazed entrepreneurs who descended on the spring decided the local flora and fauna weren't exotic enough for the kind of roadside attraction they had in mind. There would be no pole-vaulting catfish or underwater bridal chambers for them. Instead of transforming reality into fantasy the way their predecessors had, they decided to transform fantasy into reality. The result was a startling collision of kitsch and nature.

If you look into the water at Weeki Wachee these days, you will see the results of that collision: live mermaids eating bananas and drinking soda, their hair billowing around their heads like strands of silk, proof that life in the Sunshine State is *still* surreal and probably always will be. The mermaids have been performing their underwater magic at Weeki Wachee Spring, one of Florida's oldest and wackiest roadside attractions, since October 12, 1947. On that fall day, a small crowd attended the grand opening of the Underwater Theater, a small rectangular building sunk into the edge of the spring. They pushed through a turnstile, climbed down some steps, and entered what looked like a boxcar with windows. They took their seats on benches and peered out through the glass into the spring, where, as one reporter put it: "nature, aided and abetted by some shapely cuties in bathing suits, puts on the show. . . . The water's

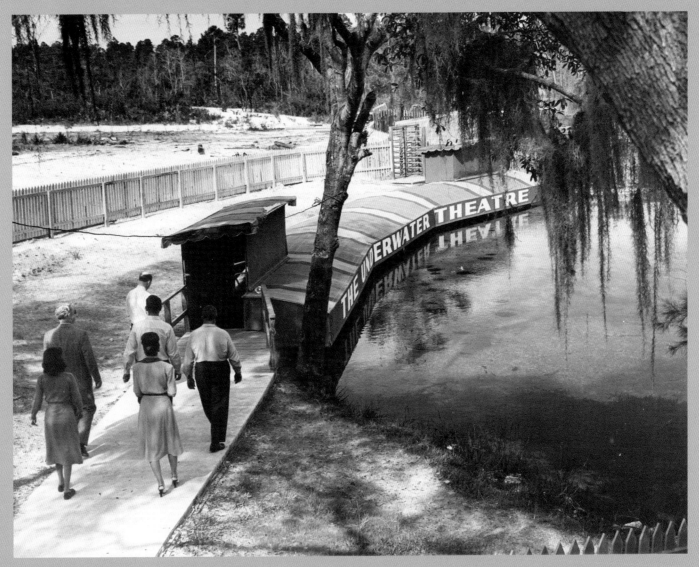

Newt Perry, Walton Hall Smith, and company entering the theater, 1947. By Modern Photographers, New Port Richey, Fla. Photo by Ted and Vi Lagerberg. Courtesy of Delee Perry.

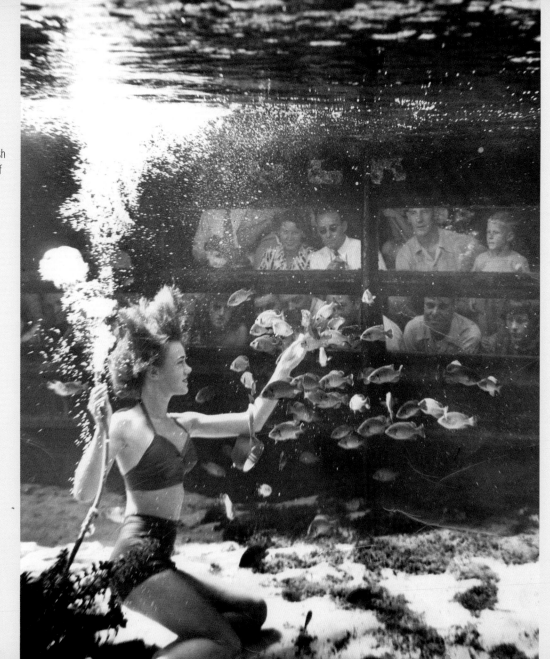

Mary Darlington Fletcher feeds the fish for the audience, ca. 1948. Courtesy of Lu Vickers.

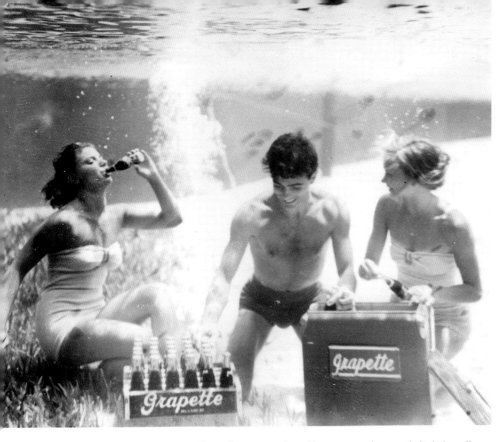

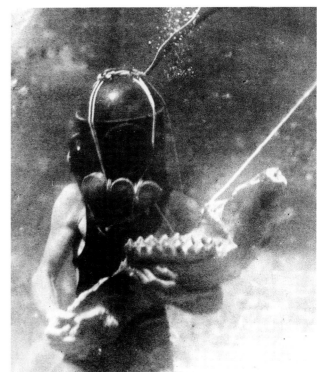

Diver holding a mastodon jawbone. Courtesy of the Florida State Archives.

Left to right: Nancy Tribble Benda, Dick Woolery, and Eleanor Nichols guzzle Grapette underwater, 1949. Modern Photographers, New Port Richey, Fla. Photo by Ted and Vi Lagerberg. Courtesy of Nancy Tribble Berda.

surface above your head becomes a low and slightly sullen sky. . . . The fish-filled cavern below from which the water boils becomes a mountain viewed through the granddaddy of telescopes. It's right in your lap."[2]

In this topsy-turvy world where water became sky and a cavern became a mountain, local teenagers became mermaids and mermen, even though they weren't wearing fishtails. They sucked breaths of air from hoses and dove fifteen or twenty feet down into the spring where, in perfect silence and surrounded by schools of bluegill fish and turtles, they performed ballet, posing and dancing underwater in groups of two or three. With the "Human Elevator," they demonstrated buoyancy, using their breath to make their slender bodies rise and sink in the water. They ate bananas, letting the peels float away to be snagged by turtles hovering overhead. And they guzzled Grapette without burping, then fed pellets of bread they'd tucked into their swimsuits to the fish.

By the 1960s, when Elvis arrived at the spring in his Cadillac, Weeki Wachee had gone from being a curiosity in the middle of nowhere to becoming one of the most popular tourist attractions in the country. The mermaids traded in their swimsuits for elaborate costumes and hid their air hoses in giant flowers. They changed costumes in an airlock disguised as an enormous queen conch shell, and they rested inside clamshells and rode through the water on dragons and seahorses. Esther Williams and Howard Hughes popped in for visits, as did countless other stars, beauty queens, and dignitaries.

The Weeki Wachee mermaids have weathered Disney World, hurricanes, rising gas prices, shortened attention spans, and heightened expectations. And the spring has hung in there too, weathering development brought to its very edge with a four-lane highway, development that has meant toxic runoff from malls, overfertilized lawns, and numerous golf courses.

Both the mermaids and the spring are showing their age, or rather the age they live in. The mermaids perform for dwindling, although adoring audiences, and the spring is emptying of bluegills and Suwannee cooters and filling with brown algae. Still, people gaze with astonishment through the windows of the theater at both, wondering how the mermaids breathe underwater, wondering if that water is really just air, if those turtles are flying. Some things never change. The story of how Weeki Wachee came to be the Spring of Mermaids is, in many ways, the story of Florida and all of its springs.

Hernando County: From Mastodons to Mermaids

Just like real estate developers these days, Florida's earliest natives, including mammoths and mastodons, were attracted to Florida's springs. When Weeki Wachee's current theater was being constructed in 1959, operations manager Bob Reed found the rib bone of a mastodon at the bottom of the spring. Reed's daughter Marilyn, who swam as a mermaid in the 1960s, said the rib bone was tested at the University of Florida and sent on to the Smithsonian. Not surprisingly, given the mermaids' fondness for the fruit, she said the bone "looked like a big petrified banana."[3]

Then in 1969, a worker clearing an area near the river for the orchid garden uncovered some bones and pottery. The Florida State Museum was contacted, and in the summer of 1970, a crew from the University of Florida unearthed the largest collection of Spanish artifacts found in North America at that time, as well as a grouping of aboriginal burial mounds.[4] Mermaids Bonnie Georgiadis and Genie Westmoreland Young found the dig irresistible. "Genie and I would swim a show, then not even warm up in the shower; we'd walk straight from the water to the diggings and help them brush dirt with trowels and paint brushes," said Bonnie. "Then at the next show time we'd walk back to the water and dive in to wash off all the sand. They found an ulna with rounded shell beads from wrist almost to elbow. Every bundle burial was topped by a conch shell. There were glass chevron beads and silver beads so small they fell through the strainer so they had to switch to a smaller grade wire.... [Working at that dig] was one of the highlights of my life."[5]

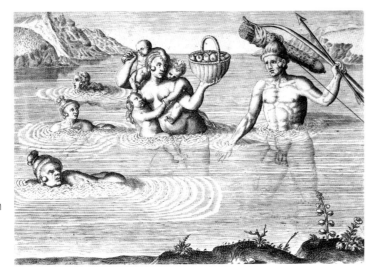

and West Florida (1791) as a crib sheet for writing poems about springs, alligators, and wild palms.[9]

In a more recent book on Florida springs, underwater photographer Doug Stamm imagined Bartram's reaction to the mermaids:

> [He] would surely envy an audience that watches mermaids underwater in the blue glow of Weeki Wachee Spring. In fascination, they see in a way Bartram never could the color and vibrancy of these places. There is a sense of wonder here that bridges the gap of centuries.[10]

Yet Florida's water did more than inspire wonder. After creeping along the shores of the St. Johns River to get a closer look at some anhingas, the naturalist John Audubon finally waded in: "I cooled my over-heated body," he wrote, "and left behind on the shores myriads of hungry sandflies, gnats, mosquitoes, and ticks, that had annoyed me for hours!"[11] Audubon wasn't the only person to find relief in the springs. Health-minded tourists flocked to Florida's sulfur springs hoping to heal "ailments ranging from kidney problems to rheumatism."[12]

A writer from Palatka, in an opinion piece published in the 1854 Floridian and Journal, noted that besides being "medicinally beneficent to the invalid and the valetudinarian," Florida's springs were also interesting to the "geologist, philosopher, and chemist . . . and commercially useful to the agriculturist and merchant." The "Wickawatcha," he noted, along with other Florida springs, also possessed a sense of mystery because they flowed from underground rivers. He envisioned a Florida that "[rested] on one vast network of

The bones and other remains the mermaids helped the archaeologists excavate were determined to be those of the Timucua,[6] Florida's first people, an ancient Indian tribe who considered the water a "liquid God." The Timucuans weren't alone in their worship of the springs; Florida's Seminoles believed the water could transport one to the "land of souls."[7]

Florida's springs could also transport one to the land of dreamy dreams. After observing the fish in Six Mile Spring on the St. Johns River, the naturalist William Bartram described the effects of the magnification caused by the depth of the spring: "You imagine the picture to be within a few inches of your eyes, and that you may, without the least difficulty . . . put your finger upon the crocodile's eye."[8] Romantic poets from Wordsworth to Coleridge used Bartram's book Travels through North and South Carolina, Georgia, East

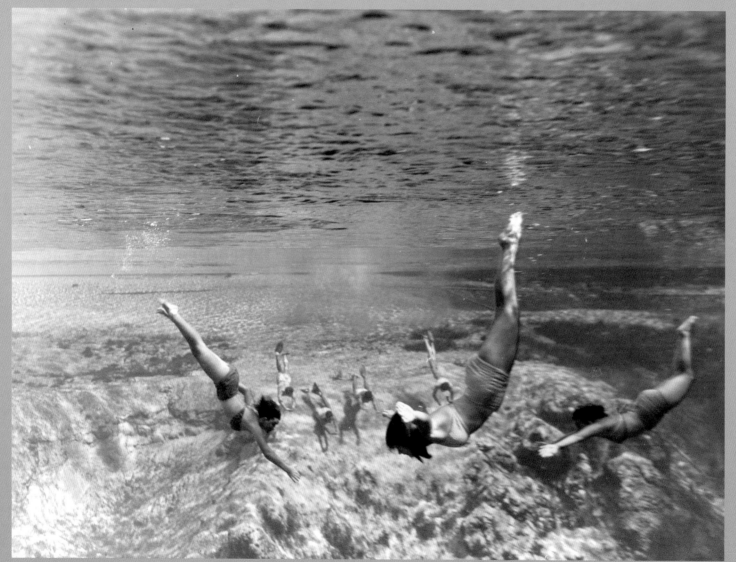

Mermaids dive into the spring, 1947. Modern Photographers, New Port Richey, Fla. Photo by Ted and Vi Lagerberg. Courtesy of Bob Reed.

Alligators at the St. Augustine Alligator-Ostrich Farm. Courtesy of the Florida State Archives.

irregular arches of stupendous magnitude, through which innumerable rivers, creeks, and mineral waters, in silent darkness perpetually flow." He urged the Florida Legislature to fund a study of these underground rivers, even though he conceded that the findings might clash with Louis Agassiz's theory that "Florida was built by the coral worm and other marine animaculae."[13]

Whether or not Florida was built by "minute marine architects" or simply balanced on giant arches, one thing was clear. The springs that resulted from its unique geology dazzled people from the Timucua to Ponce de León to environmentalist Marjorie Stoneman Douglas, who called them "liquid bowls of light." Generations of tourists have tried to describe the giddy effects of floating over the crystal-clear springs, the feelings of "being suspended between two atmospheres," "suspended in air," of losing one's "hold on the

earth." Stoneman Douglas's simplicity aside, a lot of writers have positively strained the language to describe the springs:

> The moss-covered stones, jutting irregularly from four to more than a hundred feet below, where they centre around a fathomless depth; the flexible roots and grasses all bathed in rainbow hues; the numerous fish, eels and even alligators, sporting in their element, reflecting the prismatic coloring, together with the gentle dreamy gliding over the depths of aqueous transparency, and its kaleidoscopic changes, accompanied by the music of the many throated songsters, make it a fairy scene, in which for a time we lose all sense of the earth.[14]

Even the most practical of writers was seduced into fantasy by the springs. In 1889, echoing Ponce de León's impression that Florida wasn't what it appeared to be (he initially thought it was an island), a reporter for the *New York Times* wrote that "Jacksonville and St. Augustine are only stopping places to the *real* Florida. . . . Southward is where all the attractions lie: there the oranges grow, the alligators live, the springs flow, the rivers rise." Inspired by a visit to Silver Springs, the writer speculated Jules Verne style about the possibilities engendered by Florida's unusual geology:

> What would the Florida boomer say, for instance, to the discovery of an immense navigable water course under the state . . . the water stocked with overgrown eyeless manatees and alligators bigger than whales, and a chance to go from Jacksonville to Tampa by the subterranean steam boat route. . . . The opening may be there and if they can only find it, you can trust to Florida to work it for all its worth.[15]

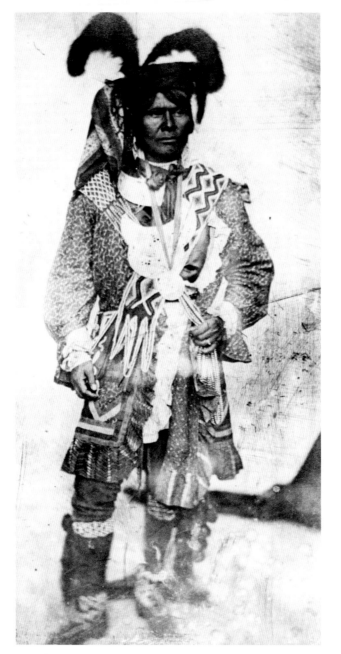

Holata Micco, or "Billy Bowlegs," ca. 1850s. Courtesy of the Florida State Archives.

Unfortunately, to work its allure for all it was worth, Florida boomers found it necessary to do their best to empty the state of Native Americans in order to attract white settlers. Land in what would become known as Hernando County, home to Weeki Wachee Spring, as the Seminoles named it, was paid out to veterans of the Second Seminole War, which had ended in 1842. But it was the Armed Occupation Act that really brought settlers to the area. The act encouraged homesteaders to move onto Seminole land with an eye toward pushing the Seminoles out. The Seminoles didn't sit idly by; they attacked the settlers so frequently that the settlers came to view the deadly assaults as just another hazard of living in Florida. Still, by 1843, enough people had settled in the area to call it a county. Officials chose to name the county after Hernando de Soto, who'd explored the area in the 1500s, even though the Seminoles had gotten there first.[16]

The Third (and last) Seminole War began in 1855, when Holata Micco, or "Billy Bowlegs," chief of the last few Seminoles living in South Florida, was provoked into battle by a group of army surveyors who trespassed onto his banana plantation and chopped the plants down.[17] After over two years of skirmishes, the Billy Bowlegs' War worked its way up to what was then the southern tip of Hernando County. The war ended in 1858, when over a hundred Seminoles, including Billy Bowlegs, surrendered to the United States Army and were sent out to the Oklahoma Indian Reservation, thus opening the door for even more settlement in the area. The remaining Seminoles fled into the Everglades.[18] By the late 1930s, one writer observed that "Seminole names are more numerous and widespread in Florida than are living mem-

Award-winning photo of Gerry Hatcher Dougherty feeding fish, ca. 1948. By permission of Weeki Wachee. Photo by J. R. Yagel.

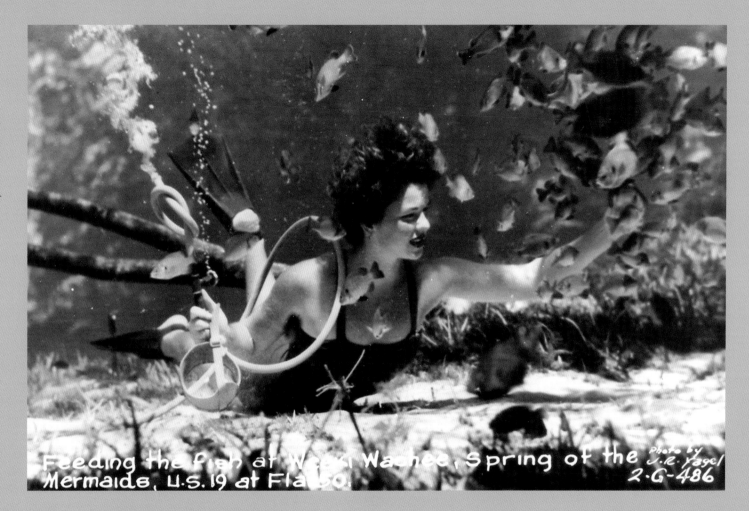

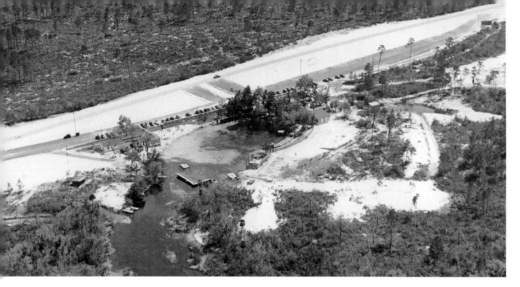

Highway 19 in front of Weeki Wachee, ca. 1948. Modern Photographers, New Port Richey, Fla. Photo by Ted Lagerberg. Courtesy of Penny Smith Vrooman.

bers of the race."[19] One of those names was "Weekiwachee," from the Seminole's Muskogee language: "wekiwa" (spring) and "chee" (little).

Throughout the Civil War, growth in Hernando County stagnated as questions regarding slavery and secession were dealt with nationally. Yet between 1860 and 1890, Florida nearly doubled its population.[20] The state might have missed out on establishing an underwater steamboat route, but it quickly figured out how to capitalize on its watery allure, with beach resorts over in Jacksonville and steamboats chugging up the Ocklawaha and Silver rivers. Many of the newcomers had been seduced by descriptions they read in tourist guides like George Barbour's *Florida for Tourists, Invalids and Settlers*, which extolled the virtues of Hernando County:

> three groceries, two or three saloons, and about thirty dwellings, nearly all small cottages . . . in location and soil

it is the gem of South Florida; and if a railroad should ever reach here . . . it will probably become, in time, the center of a thickly settled prosperous region.[21]

The family of Ella Wilder Metcalf bought Weeki Wachee Spring and the surrounding five hundred acres for $5,000 in 1883.[22] In *Camping and Cruising in Florida*, published a year after the purchase, Dr. James Henshall describes a jaunt he made to "Weekawachee" from Bayport. He noted that there was a "store and a dwelling" at the edge of the spring, as well as a large schooner "which had been built and was being rigged at this place." But the real attraction was the landscape he spied beneath the surface of the spring:

> This "White Mountain Spring" as it is called . . . is fifty feet in depth, and so clear that one's boat seems like Mahomet's coffin, suspended in mid-air. . . . The smallest object can be clearly defined at the bottom of pure white sand. It is said that with a heavy cannon-shot the largest rent has been sounded to a depth of ninety feet. At the bottom of the spring . . . are growing curious water plants, whose small elliptic leaves exhibit tints of red, purple and blue, which are reflected through the water with a strange and pleasing effect.[23]

However, despite both Barbour's and Henshall's plugs for Hernando County's natural beauty, there were few takers. In 1910, Brooksville—the county seat and the town closest to Weeki Wachee—tried a different approach in a pamphlet designed to attract newcomers. Contrary to Audubon's assertion that Florida was rife with insects, the pamphlet bragged that not only was the area spared from "fogs,

Aerial photo of Weeki Wachee on Highway 19, ca. 1947. Modern Photographers, New Port Richey, Fla. Photo by Ted Lagerberg. Courtesy of Penny Smith Vrooman.

cyclones, tornadoes, hurricanes, or earthquakes," it was also insect-free.

> To more than half of the inhabitants of the county the mosquito bars or screens against insects are unknown, because not needed. Ants or other insects as pests are not to be found among these hills.[24]

Whether that statement was true or not, the Florida land boom finally made it to the west coast of Florida, arriving in Hernando County in the mid-1920s with the construction of Brooksville's first hotel, the Tangerine. Meanwhile, in nearby Citrus County, the Florida Club of Chicago established the Florida West Coast Development Company and invested $3 million to develop the area surrounding Homosassa into a world-class resort.[25] A 1926 advertisement touts Homosassa as "Florida's west coast Metropolis," noting that all it and the rest of Florida's west coast needed was "TRANSPORTATION. Without transportation there could be no Chicago, no New York, no Homosassa." The transportation the ad refers to was the newly proposed Highway 19, the "State Gulf Coast Motor Highway . . . Concrete and Wide."[26] Caught up in the excitement promised by the developers, the local press proclaimed in a headline: "Homosassa Destined to Be among Great Developments of Nation When Complete."[27] Before the year was out, the company had begun construction on the Hotel Homosassa as well as a 4,500-seat theater, a casino, and several apartments.[28]

Situated just a few miles south of this metropolis-in-the-making, Weeki Wachee Spring didn't escape the notice of real estate speculators. In 1925, a group of men formed the Glenarden Company and purchased the property from the Metcalf family. They proposed to develop the area surrounding Weeki Wachee along the lines of Homosassa by building a hotel, a golf course, a country club, and a large hunting preserve.[29] Rex Beach of New York, a famous novelist and former Floridian, was one of the men who bought into the project. Speaking with a reporter from the *Tampa Sunday Tribune*, Beach noted that "Every writer has compared this rush to Florida with the gold rushes and the oil booms," adding that the Florida boom wasn't as risky as those others.[30]

He took advantage of a trip to Weeki Wachee to gather material for his novel *The Mating Call*.[31] Even though it is unnamed in the book, Weeki Wachee Spring figures prominently in the novel. At the heart of the book is a clash over the spring between a Florida farmer and politicians from Gulf City. The farmer wants to keep the spring for his wife. (She loves it so much that he calls her Undine, which is really just another word for a Weeki Wachee mermaid.) The politicians say they want to buy his spring to supply their city with clean water. The real reason they want the spring, however, is so they can use the water as a selling point to make more money on real estate.

Beach might have used St. Petersburg as a model for the fictional Gulf City. One of his business partners in the Weeki Wachee deal was Frank Pulver, the former "millionaire bachelor mayor" of St. Petersburg. Known for wearing snow-white suits and for once parading down New York City's Broadway with a bevy of Florida's "bathing beauties" in an attempt to publicize the state, Pulver was not new to controversy. Accused of graft and bootlegging, he had been recalled as mayor in 1924. Still, he must have felt he

Doyle Lee leaps from the rope swing at Weeki Wachee, ca. 1944. By permission of Mary Sue Wernicke Clay. Photo by Ruth Wernicke.

had political capital because he attempted to persuade city officials to purchase Weeki Wachee Spring as a water source. They declined.[32]

Despite Beach's contention that the Florida land boom wasn't as risky as the gold rush, the Glenarden Company's plans to develop Weeki Wachee were brought to an abrupt halt with the collapse of the stock market in 1929.[33] The stock market crash didn't stop the swimmers from coming to the spring as they always had, though. After the Glenarden Company's failure, developing Weeki Wachee into a moneymaker didn't cross too many people's minds. The City of St. Petersburg finally did buy the spring in 1940, thinking to use it as a source of water, but those plans were never

realized. There was always the occasional glass-bottomed boat operator, but for the most part, over the next twenty years, the spring belonged to the locals.

In the 1930s and 1940s, people who dove into the ice-cold water at Weekiwachee—the name was one big word back then—on a hot-as-hell summer day got a skin-bracing shock that was just as sensual and spiritual as it had been to their predecessors.

"Weeki Wachee was always there," said Dot Fitzgerald Smith, one of the original mermaids, who grew up in nearby Aripeka. The daughter of a Tarpon Springs sponge fisherman, she learned to swim when she was two or three by jumping off the back end of her father's sponge boat.[34]

Bordering an arid sinkhole known as the Devil's Punch Bowl, and filled with what one reporter called "weird submarine plant life,"[35] Weeki Wachee Spring was the locals' beloved swimming hole, the deep blue fountain of their youth. And their laundromat. "Back then," Dot said, referring to her mother's day, "the ladies didn't have running water in Aripeka, so they'd go up to Weeki Wachee and do their laundry up there. They had an old swing in one of the big trees; I think the tree's still there. My mother used to swing off of it when she was a young girl, and I used to jump off it too, not knowing I'd someday make my living up there."[36]

Mary Darlington Fletcher, who, like Dot, had no idea she would become a mermaid, swung off the same tree as Dot and her mother when she was a kid. She remembers the post-conquistador, pre-mermaid days when her dad would hitch a trailer to his truck and haul the family from Elfers up to Weeki Wachee to picnic and swim. "We'd get some monkey to climb the tree, to get the rope swing going, and

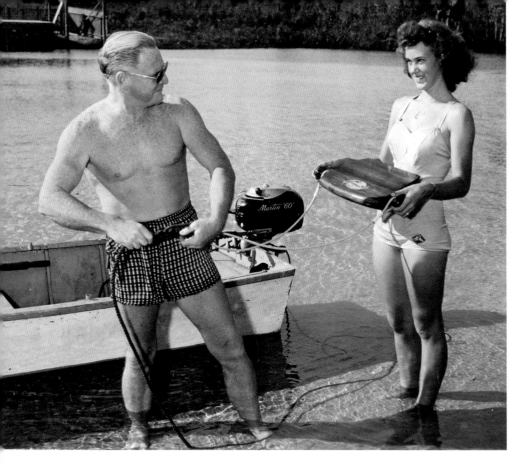

Walton Hall Smith and Mary Darlington Fletcher, 1947. Courtesy of the Florida State Archives.

and when we got through we loaded up to go home and milk the cows and feed the chickens."[37]

About the same time Dot and Mary were swinging off that rope into the spring, the Depression-era Works Progress Administration got the idea to employ thousands of unemployed writers to create the American Guide Series, a collection of travel guides for each of the forty-eight states. The Federal Writers' Project *Guide to the Southernmost State* begins with some frightening "General Information" about arsenic and pecans, and snakes and tics, and ends with the following admonition: Watch out for livestock.

The route to Weeki Wachee Spring from North Florida hasn't changed much since it was described in 1939:

> From red clay hills covered with oaks and magnolias, this route descends into a region of flatwoods and runs straight as an arrow for many miles, passing numerous turpentine and sawmill settlements. . . . Green citrus groves, cypress hammocks, and scattered clumps of cabbage palms relieve the somber vista of cut-over pine land and scrub palmetto. Little of this sparsely settled territory is under fence, and free range cattle are a constant menace to motorists.[38]

Along much of the road, the pungent smell of pine sap floats in the air. The free-range cattle are no longer a problem, but in the early morning, a driver may have to dodge the buzzards that have taken their place, landing in the middle of the road like winged cats to peck at scraps of roadkill.

Perry, the biggest city on the way to Weeki Wachee, looks like a diorama of forties Florida, when the typical summer

somebody over here on the bank would grab it, and that's what we'd hold on to," Mary said. "We'd swing out there and drop, and the next guy better grab that rope, otherwise it'd be 'there goes the monkey again.' Then we'd get tired of that, and we'd float down the river. The bank was so beautiful with white sand. We'd get up at the top and roll all the way down and hit that water. We'd have our picnic there,

Penny Smith Vrooman feeding fish, 1947. Modern Photographers, New Port Richey, Fla. Photo by Ted and Vi Lagerberg. Courtesy of Penny Smith Vrooman.

Leg being compared to a cypress knee at Tom Gaskins's Cypress Knee Museum, Palmdale, Fla., 1954. Courtesy of the Florida State Archives.

like giant insect antennae. A green neon sign on top of the shop evokes a simpler time: *Take a kid fishing*.

Near the outer city limits, a dilapidated blue sign stands at the edge of the road on an overgrown lot, its posts twined with coils of dark-green kudzu. The Mickey Motel. One wonders if the Mickey was Mickey Mouse, but the irony would be too rich. Disney World, with its fool's gold of perfection, lured Florida's tourists off Highway 19 onto the Florida Turnpike, snuffing the life out of such funky west coast attractions as Gatorama and the Cypress Knee Museum.

At Crystal River, the yellow signs warning of bear crossings disappear and manatee imagery takes over in the form of sculptures and signs: there's Manatee Lanes, Manatee Office Supply, Manatee Plumbing. This close to Weeki Wachee, Spring of the Live Mermaids, the traveler wonders if it's true that explorers from Christopher Columbus to Henry Hudson mistook manatees for mermaids. There just might be a connection; Weeki Wachee is just a few miles down the road from Crystal River and Homosassa, the self-proclaimed "Manatee Capital of the World."

In the WPA days, Weeki Wachee Spring bubbled out of the earth in a sparsely settled area "matted with palmetto thickets . . . and stretches of second-growth pines." The guide noted that "Weekiwachee Springs . . . is the fifth largest in Florida," and that the water boils so furiously it's nearly impossible to anchor a boat. There's mention of a "log clubhouse" as well as a small business involved in gathering "underwater growth . . . and [shipping it out to aquaria]." For possible diversions, the writer suggests "bathing, fishing and glass bottom boats."[40]

tourist arrived on its west coast. The vintage architecture of the Stardust Hotel and the Skylark Motel—two of the hundreds of "tourist courts" that sprang up on the Gulf coast during the boom—serves as a reminder that Highway 19 was once better known as the Gulf Coast Highway, the two-lane road that was supposed to funnel tourists to Florida's west coast.[39] Then there's the Williams Bait shop, with scads of varnished bamboo fishing poles splayed against the wall

These days, the glass-bottomed boats, scrub pines, and palmettos are gone, and the spring is fronted by the aptly named Commercial Way, a four-lane highway littered with strip malls and punctuated by retail outlets. It's hard to believe a natural spring could be in that unnatural spot. But there it is, right past the blur of traffic over asphalt. Weeki Wachee Spring bubbles out of the earth as it always has; its surface is a shimmering pool of blue light.

The Spring of the Live Mermaids

Penny Smith Vrooman, daughter of Walton Hall Smith, president of the company that eventually brought the mermaids to Weeki Wachee, remembers the first time her father took her to the spring. "It was a beautiful speck of water," she said. "We stopped the car and got out, and there was nothing but wild boars running around. Then we saw that a man was living on the property. There were no buildings, just these wild boars and this old hobo."

Her father, Hall Smith, was a businessman and writer from Kansas City, Missouri, but mostly he was an adventurer. He'd lived in Africa, then Hollywood, hobnobbing with the likes of John Huston and Walter Pidgeon. He and his wife, Martha Belle, spent their honeymoon partying in Cuba with Ernest and Pauline Hemingway. Smith, too, was a writer, penning screenplays, novels, and short stories. In 1939, collaborating with a doctor, he wrote a best-seller titled *Liquor, Servant of Man*. The book is something of a cult classic along the lines of the film *Reefer Madness*. Smith also established the Syfo beverage company and then invented siphon-shaped seltzer bottles. A former commander in the

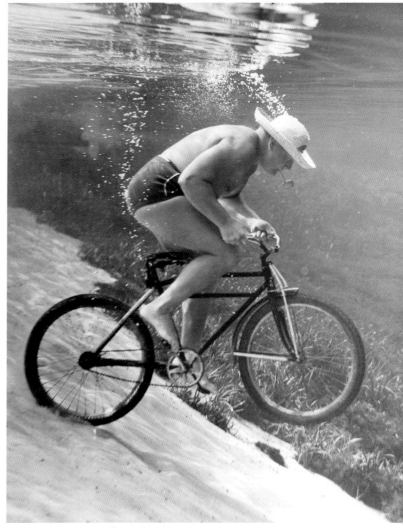

Newt Perry does a bike stunt for Grantland Rice, ca. 1938. Courtesy of Delee Perry.

navy, he taught submariners underwater escape techniques at Pearl Harbor. Penny said her father was also a swimming fool who dreamed of building an underwater world in a Florida spring. "Even though we lived in Kansas City, he used to go down to Florida in the '30s and '40s and swim in all the famous springs. He swam at Silver Springs and at Wakulla Springs."[41]

In 1935, Ed Carmichael, who'd purchased Silver Springs in 1906 and begun developing it into a full-blown tourist attraction, informed Smith about a couple of undeveloped springs on the west coast. Carmichael, whose full name was Christopher Columbus Carmichael,[42] told Smith the springs were called "Chest-o-whiskey, and Weekly Washing, or something like that." Like the explorers who set sail after the original Columbus, Smith, too, set out to find the springs, only to discover that they didn't exist—at least not with those names. It turns out that Chest-o-Whiskey was actually Chassahowitzka Spring, a small spring just north of Weeki Wachee. Smith finally found Weeki Wachee Spring down a washboard sand road. When he surveyed the property, he found not only the wild boars and the hobo but the remains of a building erected in 1892, as well as the charred bits of a dance pavilion built much later.[43]

Penny said that when her father saw the spring, he said, "Wow, this is the most beautiful one I've seen." Like countless visitors before him, he was amazed by the clarity and depth of the water. "You could always drop a coin in it and see it fall a hundred feet down," said Penny.[44]

Like Smith, Newt Perry had been dreaming for years of finding a spring like Weeki Wachee, a place where he could sink a theater and put on underwater shows. Perry was an amalgam of the Spanish conquistadors, naturalists, and glass-bottomed boat hucksters who'd come before him. He'd worked at both Silver Springs and Wakulla. No stranger to underwater shenanigans, he'd already starred in hundreds of newsreels filmed by Grantland Rice and Pathe Newsreel. He'd eaten bananas underwater. He'd set a world record for free diving 185 feet into Wakulla Spring. He'd trained navy frogmen. He'd wrestled alligators and anacondas underwater with his sidekick from Silver Springs, Ross Allen. The famous sportswriter Grantland Rice dubbed Perry "The Human Fish" and made a movie about him. Perry was more at home underwater than on land.

Perry and Hall Smith met in the late 1930s and discussed developing Weeki Wachee, but their plans were disrupted by World War II. However, they kept in touch with each other via letters while Perry was busy providing amphibious training to troops at Wakulla and Smith was training submariners at Pearl Harbor.[45] In June 1946, everything came together. The war had ended, and the Gulf Coast Highway now stretched into Hernando County right past Weeki Wachee. Smith told the *Kansas City Star* that after he got out of the navy, "My own business (Syfo) back in Kansas City had insufficient sugar and plenty of other troubles and I decided . . . to follow up on the Weeki Wachee deal." He rounded up a number of investors and got in touch with Newt Perry, who promptly headed to Weeki Wachee to see the spring for himself.[46] "When he saw it, he just fell in love with it," said Newt's daughter, Delee Perry.[47]

It's easy to understand why people felt so strongly about the water—besides serving as entertainment and laundry room, it's a brew worthy of Marie Laveaux, the voodoo

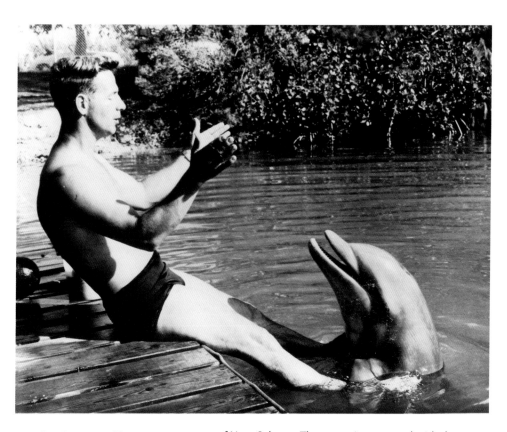

Ricou Browning and Flipper, ca. 1964.
By permission of Ricou Browning.

screenplay for *Flipper*, which was later developed into the television series; he doubled for the Creature in the 1950s horror flick *Creature from the Black Lagoon;* and he served as underwater director for *Thunderball*, a James Bond film, winning an Academy Award for second unit director. He was also president of Ivan Tors Studio, the company that produced television classics such as *Gentle Ben* and *Seahunt*. But he was a teenager when he met Newt Perry at Wakulla Springs in North Florida. Perry had been the manager of the lodge since 1941. Eager to drum up business, he routinely drove a truck into Tallahassee, filled it full of kids, and drove them down to Wakulla Springs to go swimming. "We became lifeguards," said Ricou, "my brother, myself, and a few of our buddies, and for a number of years I [worked] at Wakulla under Newt Perry."

Ricou, who credits Perry for his entrée into the film business, said: "Right after I got out of high school, I got a call from Newt. He said, 'I'm going to develop a spring down on the west coast of Florida; would you like to join me in doing it?' and I said, 'sure.' So we went down there, and here was this spring; it looked like just a puddle on the side of the road; there was no development, nothing. And so as soon as we got there, we both put on our face masks and jumped in the water and couldn't believe the beauty of the spring. With one exception. It was full of junk people had thrown down there: old automobiles and bed frames, mattresses, bedsprings, you name it."[48]

At this point, despite the bedsprings and mattresses, Weeki Wachee Spring was still held by the City of St. Petersburg as an untapped source of water. But in June 1946, Smith, Perry, and the investors made a proposal the City

queen of New Orleans. The water is seasoned with the trunks of petrified trees, the fossils of mastodons, relics of the ancient Indians, the blood of Spanish conquistadors, and soapsuds of the locals. And, surprisingly, in 1946, when Newt Perry and Ricou Browning, Perry's scout, dove deep into the spring at Weeki Wachee, they found something else they didn't expect.

Ricou Browning went on to achieve stardom in his own right; among other accomplishments, he penned the

Mermaids on a dock with Newt Perry, ca. 1949. By permission of Florida State Archives. Courtesy of Dot Fitzgerald Smith.

of St. Petersburg couldn't refuse. They wanted to lease the springs for thirty years and begin development right away, investing $100,000 immediately, with plans to invest an additional $500,000 over the next few years.[49]

Known as the St. Petersburg Springs Corporation, the group planned to model the spring's development after Silver Springs in Ocala—although they promised a few extra amenities because of Weeki Wachee's unique qualities. Hal Messenger, chief negotiator for the corporation, noted that the water in Weeki Wachee remained clear as air even after heavy summer rains, and Smith, who'd spent six months crisscrossing the state on a tour of all its springs and subterranean rivers, said, "I have seen them all, but nothing to compare with Weekiwachee."[50]

As one newspaper reported, the men promised to construct a large boat that would serve as a "commodious, finely-appointed 'submarine photo lounge' equipped with quartz glass ports . . . so visitors could view the underwater marvels." The group would also create a white sand beach, build cabanas and playgrounds, launch a jungle cruise, and last but not least, feature "spectacular underwater ballets" each night, complete with dazzling light effects.[51] Another newspaper reported that "special lighting will also be installed" so that the nighttime visitor could drift over the spring and down the river to view "glittering spectacles of submarine plant life and colorful underwater displays."[52] In a speech to the Hernando County Kiwanis Club, Weeki Wachee Spring's construction supervisor Mabry Milleau said that Ross Allen of Silver Springs promised to build "one of the biggest reptile and animal exhibits in the nation" at Weeki Wachee. Carried away with his own hyperbole, he

mentioned that Allen had secured over 750 alligators, as well as some tropical birds he'd caught in South America. He didn't say whether all 750 alligators would be coming to the spring or not.

Then, in a rare moment of understatement, Milleau announced that Newt Perry had been contacted and was going to "be in charge of the bath house . . . and underwater swimming."[53] That summer, after scoping out the spring with Ricou Browning and finding all those bedsprings and motors, Perry went back to Wakulla and left Ricou at Weeki Wachee. "I spent the rest of the month cleaning out the springs," Ricou said. "I would dive down with an air hose and a rope and hook things to it, and the construction guys would pull it up with the crane. I didn't have a proper air hose; we used one the painters had, and I could smell the paint coming out, so I put pieces of cloth over the end of the air hose to filter it. When I came up, I'd see paint on the other side and wonder why it didn't kill me."[54]

At the end of March 1947, bulldozers arrived at Weeki Wachee and began clearing the land "in anticipation of its development into one of the foremost tourist attractions of Florida."[55] Shortly after construction had commenced, fifteen-year-old Mary Darlington Fletcher and her older brother, Ed Darlington, drove to Weeki Wachee from Elfers as usual to go swimming, only to find that Newt Perry had gotten there first. "He'd put 'do not enter' ropes around the spring," Mary said, eyebrows raised high, describing what Perry had done. "That's what he'd done. 'Do Not Enter.' And we arrived to go swimming." When Mary found Newt and asked him what he was up to, he told her he was putting in a theater to showcase underwater ballet. Since he was in

Marjorie Hite and Diane Fry measure Bonita Colson's hair. By permission of Photographic Concepts, New Port Richey, Fla. Photo by Sparky Schumacher. Courtesy of Allen Scott.

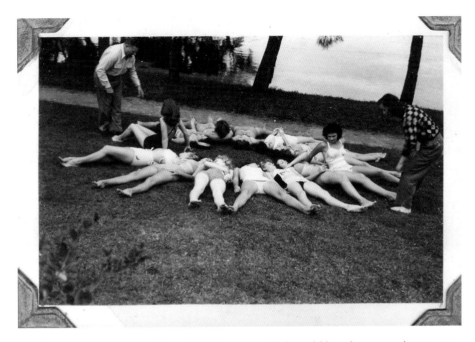

Newt Perry gives instruction to the Aqua Belles, 1947. By permission of Dianne Wyatt McDonald.

the market for mermaids, he told her she was welcome to audition on the following Saturday for a part. Mary, along with Ed and a few of their friends, showed up. "Perry said, 'Now line up, we're going to give you this test,'" said Mary. "So we lined up on the bank. Our test was to swim across the spring and back without drowning, and if we made it, and we all did, we were all mermaids all of a sudden."[56]

Clearly, Perry knew a mermaid when he saw one; all he had to do was sit and wait by the spring for them to show up—they were the beautiful girls with spring water in their blood. As his daughter, Delee, said: "You know a man can only be so graceful under water—he's not like a female who is very graceful underwater. Even though my dad did do

some of the performing, the majority of people wanted to see women."[57]

Penny Smith Vrooman said her father was of the same mind. He wanted to create an underwater show with beautiful girls. "He wasn't really a businessman," she said. "He was creative." His one concession to the business side of Weeki, she said, was that "he did want the girls to have long hair, because underwater it doesn't look wet—it looks beautiful, flowing."[58]

In a reversal of the traditional mermaid story, in which the mermaids sing the sailors into the sea, Perry was the one doing the luring; the spring itself was his song. He collected what mermaids he could at Weeki Wachee, then went in search of more. His next stop was St. Petersburg, where the Aqua Belles, a synchronized swimming troupe, performed water ballets at fancy resorts and hotels. Their coach, George Symonds, told an interviewer he wouldn't be surprised to find a "Johnny Weissmuller or an Esther Williams" among his swimmers.[59] Dianne Wyatt McDonald was an Aqua Belle in 1947. The seventy-two-year-old grandmother, who still lives in St. Petersburg, remembers Perry inviting the swim troupe to come over and perform at Weeki Wachee. In her scrapbook she has a small black-and-white photograph of the Aqua Belles in practice, lying in the grass, their bodies configured in a star shape. Newt Perry stands off to the side, looking on, grinning broadly. "When we originally came up here, he wanted us to put on our ballet show on top of the water," she said. "It was good for the tourists walking around, but it wasn't good for the [tourists in the] underwater theater, so we went back home to St. Petersburg and started drawing all kinds of pictures. This

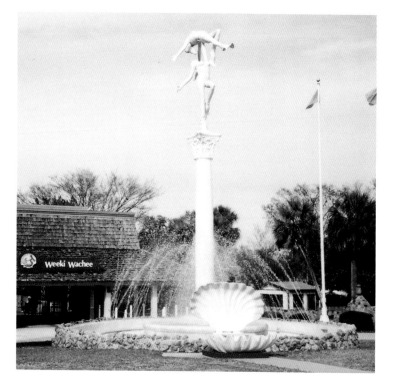

one girl and I would sit for hours trying to draw poses—figuring out what we could do for movement underwater. We really did a lot of hard work."[60]

Dianne said one of the poses they drew was the adagio, which quickly became the trademark of Weeki Wachee. A statue of two mermaids performing the pose graces the front of Weeki Wachee today. Dianne's friend, Judy Ginty Cholomitis, seventy, another Aqua Belle who Newt recruited to swim, drove over to Weeki Wachee with Dianne on the weekends. In between shows, the girls would practice their

moves on the beach. "When they'd get enough people for a show, we'd dive down thirty to thirty-five feet. When we were down on the bottom, it was sometimes scary because it was so cold, but we had a great time," said Judy.[61]

Perry was definitely leaning more toward the Esther Williams types than the Johnny Weissmullers, but Ed Darlington was one of the few lucky guys who made it into Weeki Wachee as a performer. The way he tells it, he got the job as a merman because he had a car. "When I was in the ninth grade, I built a Model A with parts that were left over around the farm. I'd work on it all week, and I could make two trips on the weekend to Weeki Wachee. That's how the girls got there. Since I was there anyway, they gave me the training."[62]

The trainers were Ricou Browning, Perry himself, and a couple of girls he'd trained back at Wakulla—Nancy Tribble Benda, who was a senior at Leon High School, and Theresa (Sis) Meyers, who'd swum in the Tarpon Club at Florida State University. Like Ricou Browning, both women had met Newt at Wakulla, and both had climbed into the back of his truck on those early Saturday mornings for rides to the springs, where he taught them to breathe underwater using the air hose he'd developed.

"Newt always started each training session with a lecture," said Nancy, who moved down to Brooksville in 1946. "He drilled us in the basics of safe diving; we knew the pounds of increased pressure at each depth; we knew the difference between diving with surface air and with compressed air."[63] Perry had sunk an airlock twenty-five feet into the spring where the mermaids could get fresh air without using the air hose or going to the surface. He demonstrated

Newt Perry next to the airlock he built 25 feet underwater, ca. 1948. Courtesy of Penny Smith Vrooman.

Marian Tolar, Newt Perry with turtle, and Gerry Hatcher Dougherty, 1949. Courtesy of Penny Smith Vrooman.

graphically what would happen if they didn't follow the rules about regulating internal and external pressures when they ascended after breathing in compressed air. "He would fill a balloon from the air stage at 25 feet below the surface, release it at that depth and have us see the explosion at the surface," said Nancy. Still, in spite of the dangers of performing some twenty-odd feet underwater, Perry wanted his mermaids to at least appear relaxed, as if they were performing on land.[64]

To accomplish this, he would take two or three trainees into the water with him at a time and show them how to take in the air, sink below the surface, then count as they breathed out and rose through the water. "He explained that with lungs filled you rise fairly rapidly, and when you have a balance between depth and air intake you remained stable in the water—with more air you rise, with less you drop," Nancy said. "[Learning] this skill became the elevator part of the Weeki show."[65]

Gerry Hatcher Dougherty was about twelve years old when Newt hired her to be part of the water show. She was one of the youngest mermaids to ever perform at Weeki Wachee. She got fifty cents a day to ride the Greyhound bus back and forth to work. She remembered preparing for those early shows: "When they first started out [we performed] on top of the water because they were building the theater, and people would go out there and watch us swim around, and that was it. We were just getting the shows started. Newt Perry was the one who trained us. I vividly remember him going down, telling us what to do. It was fascinating to watch him swim; he was like a torpedo going through the water, swimming backwards."[66]

"It was a very clean job," said Dot Fitzgerald Smith. "You were in the water all day; you never had to take a bath. The first thing we had to do was swim up and down the river using a little flutter board to strengthen our legs to get us ready to do the underwater ballet and the deep dive and to get our hips curvy. And then we had to learn to breathe underwater. We used to have this old barrel we'd put on top of our heads, playing around, learning to breathe."[67]

Perry also taught the girls how to move their bodies underwater comfortably, no matter what position they found themselves in, Nancy said. "Feet up, feet down, lying on our backs, lying on our sides. He taught us how to do an alligator roll with no apparent movement of the body. We spent hours taking a face mask off and putting it back on while underwater, then exhaling to empty the mask of water when returning it to our face."[68] Once they accomplished the basics of performing in deep water, Nancy, Sis Meyers, and Ricou spent the summer helping Perry train the mermaids to eat and drink underwater and to breathe using the air hose and airlock Perry had developed back in Wakulla. "Relax, relax, relax became the byword, and [performing underwater] became second nature to all of us," said Nancy; "[performing underwater] became the wonderful floating/flying feeling we all love."[69]

Once the construction of the cottages at the spring was complete, Penny Smith Vrooman and her mother, Martha Belle Smith, spent summers in Florida with her father. Penny moved down to Weeki Wachee full time during her freshman year of high school. She was about fourteen years old. "Those mermaids took me on like a little sister," she said. "I was a wild thing running around. It wasn't like it is now; it

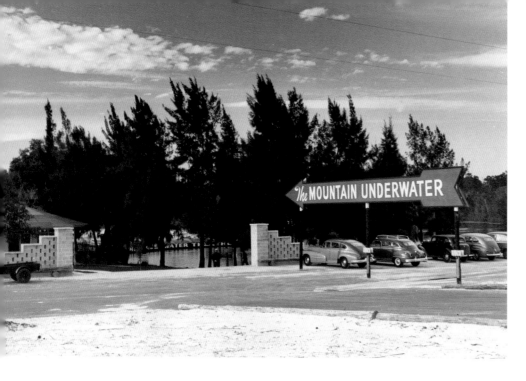

Above: The Mountain Underwater, ca. 1947. Modern Photographers, New Port Richey, Fla. Photo by Ted and Vi Lagerberg. Courtesy of Penny Smith Vrooman.

Right: Mickey Perry working at the gift shop, ca. 1947. Modern Photographers, New Port Richey, Fla. Photo by Ted and Vi Lagerberg.

was almost primitive. I remember there was a sandy road back to the spring and two houses; one was Daddy's, and right behind his he had a little house built for me, and that's where I lived. A mermaid lived with me; she was older; she was like a sister. I was in a lot of shows. I had taken a lot of ballet. They wanted voluptuous mermaid-looking people, and here I come, a little teeny tiny thing. Most of them wore falsies, but that was just part of the deal."[70]

Mermaids and falsies in place, the idea of having a boat serve as the submarine photo lounge had been ditched, and the construction of the underwater theater was well under way. A photo in one of the local papers shows the theater right before it was finished. About as wide as a train car, the structure featured narrow windows that were boarded up temporarily. The canvas awning that would serve as a roof had yet to be stretched across the metal framework. If you look closely at the photograph, you can see sandbags piled on the bottom of the theater to hold the whole thing down in the water.[71]

A short clipping in the *Brooksville Sun* announced the forthcoming opening of Weeki Wachee, "Hernando County's only resort, a second Silver Springs."[72] The theater itself got top billing in an ad that appeared in the *St. Petersburg Independent* on October 11, 1947:

Announcing
PREMIER OPENING
THE
UNDERWATER THEATER
SUNDAY OCT. 12th
9 a.m. to 6 p.m.
Weekewachee Springs on U. S. Route 19[73]

No mention of the mermaids. Early on, Mabry Milleau, Weeki Wachee's construction supervisor, had commented on the "frightening" beauty of the spring. He said that the company was so impressed with the "mountainous view" created by the spring that they decided to name the development "Weekiwachee, Mountain Under the Water."[74] Carrying out that theme, in a memo titled "The Mountain Underwater: Newly Discovered Phenomenon Located Half-way between Tallahassee and Fort Myers," Newt Perry wrote:

> "The Mountain Underwater" is our main feature here at Weekiwachee Springs. . . . From the "Underwater Theater" you will also see hundreds of fish, turtles and best of all a bevy of beautiful girls who will enact an Underwater Ballet.[75]

Ironically, given the negative impact Disney would later have on the "newly discovered phenomenon" known as Weeki Wachee, the following headline appeared in the *St. Petersburg Independent*, just eight days before Weeki Wachee opened: "Disney Celebrates: Mickey Mouse Now 20 Years Old."[76]

Weeki Wachee's grand opening on October 12, 1947, was sparsely attended. Mary Darlington Fletcher said that first

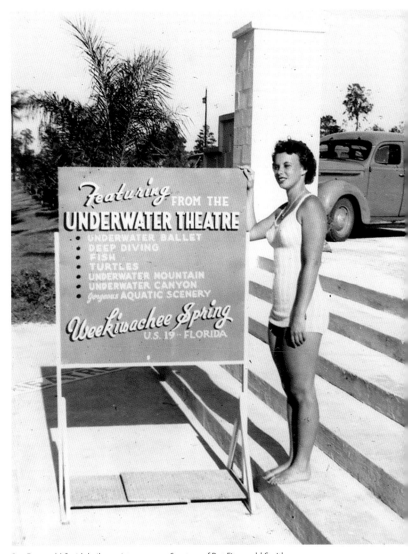

Dot Fitzgerald Smith hails tourists, ca. 1947. Courtesy of Dot Fitzgerald Smith.

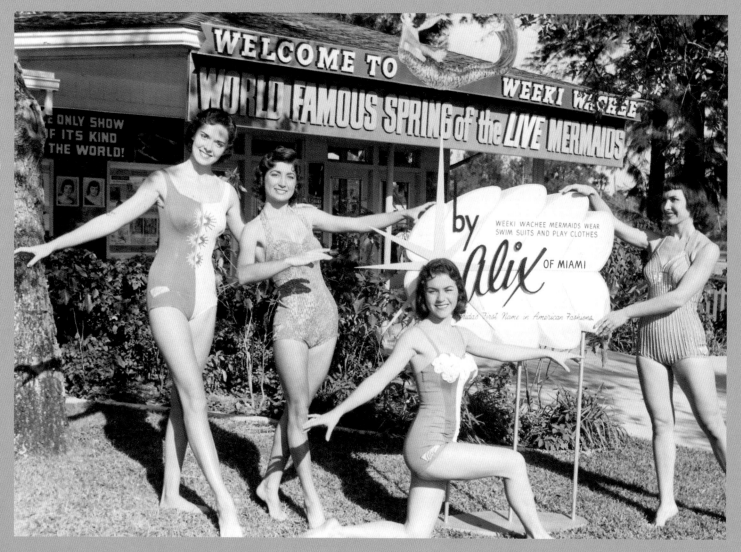

Alix Swimsuit promotion (*left to right*), Joan Gately, Nancy Harkness, Vicki Vergara Smith, and Bonnie Georgiadis, ca. 1957. By permission of Weeki Wachee. Courtesy of Bonnie Georgiadis.

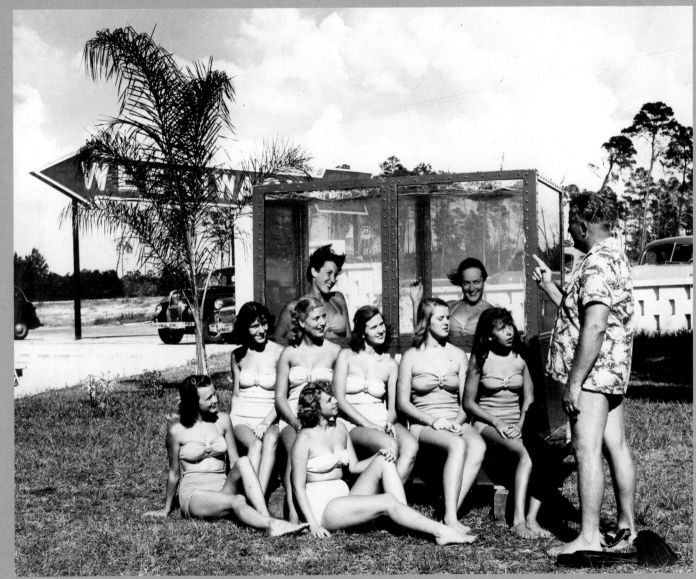

Newt Perry with the mermaids and a demonstration tank, ca. 1947. Courtesy of Dot Fitzgerald Smith.

audience sat on boards straddling orange crates. Newt Perry sold tickets, took the ticket stubs, announced the show, and when it was over, thanked people for attending and asked them if they'd like to buy some souvenirs. His wife at the time, Mickey Perry, ran "Perry's Gift Shop," selling everything from mermaid knickknacks to Florida oranges.

"In those early months he trimmed the hedges and planted flowers," said Delee. "The girls that first worked for them got paid in hot dogs and hamburgers, and they felt like that was enough. They said one of the hardest jobs was keeping the algae off the windows. Then the children would touch the windows inside the theater, and they would have to clean those as well."[77]

"We got no pay," said Dianne Wyatt McDonald. "We received bathing suits; we got our meals and a lot of publicity. And when you're seventeen to eighteen years old, that publicity was better than any pay you could get, believe me," she said.[78]

Before swimsuit manufacturers like Catalina, Jantzen, and Alix of Miami caught on that sponsoring the mermaids' swimsuits was a good idea, management at Weeki Wachee didn't initially give the girls swimsuits. The bikini had only been invented one year before Weeki Wachee opened. Mary Darlington Fletcher remembered seeing a beautiful gold lamé bathing suit in a store one day. "I couldn't afford to buy it," she said, "and my daddy said, 'Why don't you just go make it?' So I went to the store and bought a yard and a half of material and went home and made it. I thought that thing was the cat's meow. I went up to Weeki Wachee, jumped in the water and it stretched out. Needless to say, I wore it only that one time."[79]

She probably didn't have to worry about too many tourists seeing her in her sagging swimsuit. In 1947, despite the early promise of the Gulf Coast Highway, few cars traveled past Weeki Wachee, and of course they didn't have air-conditioning so people drove down the road with their windows open. "If we heard a car coming, we'd get on the loudspeaker and say, 'The underwater mermaid show will start in fifteen minutes,' and that would give them time to park and come in," said Dot Fitzgerald Smith. "And if they didn't park, we'd hang up the loudspeaker and go back to washing windows. I've done the show for two people. In between shows we had to work the bathhouses because they had swimmers there. As we got more people, we had bumper stickers we'd tie on to the bumpers. You've seen the signs on those big trucks that say "Wide Load"? That was the size of those stickers, Weekiwachee was such a long word."[80] In fact, Ricou Browning said Weekiwachee was such a long word that Newt Perry and company eventually decided to break it into two words so they could fit it onto signs more easily.

Weeki Wachee wasn't without competitors. Although no one ever attempted to build an "immense navigable water course under the state" as that one writer had suggested back in 1889, developers had done the next best thing, taking advantage of the springs themselves. "Florida will soon become known as the "Underwater State," a reporter prophesied a week after Weeki Wachee opened. "The reason is a rash of underwater theaters now being planned in the state." Homosassa, right up the road, hadn't turned into the metropolis envisioned in the 1920s, and its new owner, Elmo Reed, was now selling an attraction on the river as

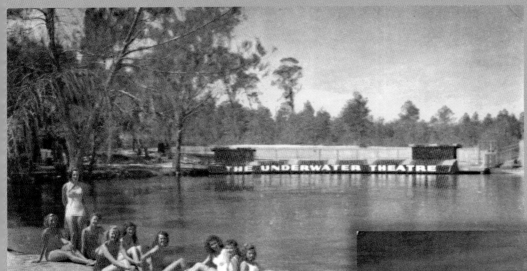

WEEKIWACHEE SPRINGS, FLORIDA
ON U. S. 19

Above: The Aqua Belles were photographed for Weeki Wachee's first color postcard, 1947. Modern Photographers, New Port Richey, Fla. Photo by Ted Lagerberg. Courtesy of Diane Wyatt McDonald.

Right: Aqua Belles Dianne Wyatt McDonald and Mary Dwight Rose flank Patsie Hadley Boyett in one of the first color postcards at Weeki Wachee, 1947. Modern Photographers, New Port Richey, Fla. Photo by Ted Lagerberg. Courtesy of Diane Wyatt McDonald.

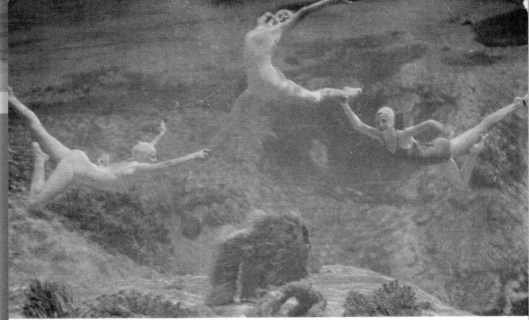

WEEKIWACHEE SPRINGS, FLORIDA
ON U. S. 19

From Kodachrome

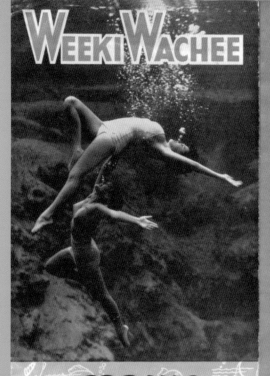

Nancy Tribble Benda and Sis Meyers grace the cover of an early brochure, ca. 1947. By permission of Weeki Wachee.

WEEKIWACHEE

SPRING
OF THE
MERMAIDS
ON
U.S. 19
FLORIDA'S MAIN
GULF COAST HIGHWAY

In all the world there is nothing else like
WEEKIWACHEE!

You'll see World Champion Swimmers, Deep Divers and Underwater Ballet Performers at Weekiwachee!

Incredibly Beautiful! It's difficult to believe your own eyes at the SPRING OF THE MERMAIDS

Featuring THE WORLD'S ONLY UNDERWATER THEATRE

★ THE MOUNTAIN UNDERWATER

★ FISH AND TURTLES

★ EXOTIC MARINE LIFE

★ BEAUTIFUL CRYSTAL-CLEAR WATER— LIKE AIR!

★ YEAR-ROUND SWIMMING IN WATER ALWAYS 74°

★ BEAUTIFUL MODERN MERMAIDS IN UNDERWATER BALLET SWIMMING

★ SENSATIONAL DEEP DIVING

★ NEWEST TECHNIQUES IN DEEP SEA DIVING

Open All Year

BRING YOUR CAMERA!

This Modern Mermaid poses for you before windows of the Underwater Theatre

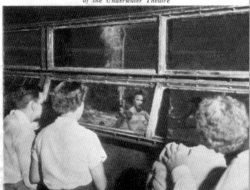

Brochure from Rainbow Springs.

Nature's Giant Fishbowl; tourists could walk into a sunken chamber and gaze out the windows at the fish. Rainbow Springs featured photo submarines where viewers could look out through portholes and watch a girl carve a turkey underwater, or see a witch fly by on a broom. According to the reporter, Rainbow Springs was planning to build an underwater theater as well. And, he suggested, "never to be left out of a new idea," Silver Springs, in the tourist business since the mid-1800s, might also get into the underwater theater business.[81] Nonetheless, Smith predicted that within a few years, Weeki Wachee would surpass the world-renowned Silver Springs in fame and would seduce hundreds of thousands of tourists to drive to the west coast.[82]

The key to that seduction would be the mermaids.

Weeki Wachee didn't take long to give the mermaids top billing. The Aqua Belles were featured in the first two colored postcards made at the spring, one of which was made into a poster-sized placard that Judy Ginty Cholomitis said "was in every bus station and bar from Miami all the way up to Tallahassee."[83] Perry also used one of the promotional shots Nancy made with Sis Myers on a brochure to advertise Weeki Wachee, selling it this time as "The Spring of the Mermaids." *In all the world there is nothing else like Weeki Wachee,* Perry wrote. *Incredibly Beautiful! It's difficult to believe your own eyes at the SPRING OF THE MERMAIDS. Bring your camera! NO ONE HAS BEEN DISAPPOINTED.*[84]

He also put a big sign out front to lure the passersby on in: Weekiwachee, Spring of the Live Mermaids. When enough tourists gathered for a show, Perry would round them up next to the theater, and a photographer would snap a shot of the group, complete with the mermaids

Mermaids and mermen performing early show (*left to right*), Dick Woolery, Shirley Browning Woolery, Dot Fitzgerald Smith, and Bud Boyett, ca. 1948. Courtesy of Dot Fitzgerald Smith.

Mermaids munch on watermelon, ca. 1948. Courtesy of Penny Smith Vrooman.

who would be performing that day. The tourists could buy the photos as souvenirs after the show. After being photographed, patrons entered the theater and settled down to watch the show, peering through the windows at the spring. "Even without the graceful slow-motion swirls of the swimmers," the *St. Petersburg Independent* reported, "the panorama is dreamlike and unreal. White sand appears as snow on a windy mountainside and the scattered aquatic vegetation like wind-stunted shrubs."[85]

The girls fed the turtles, ducks, and fish. "Before we started down," said Dot Fitzgerald Smith, "we'd get some bread, make little bread doughs, and wrap it in wax paper and stick it under our bathing suits. And we'd float on our backs and feed the ducks as we'd go."[86]

To perform ballet in those early shows, you needed eyes in the back of your head, said Dot, because you didn't have music to keep a beat with. "You had to keep up with that girl and that girl and that girl. You soon learned to pick who you wanted to swim with." A central part of the show was drinking and eating underwater. Dot described a typical Weeki Wachee show in which the girls did their best to act like snacking underwater was perfectly natural:

> Back then we had mermen too, so either two girls or a girl and a boy did the show. There was a limb by the theater, and we're tired so we sit down, and then we'd see a banana, so we'd decide to eat the banana. Then we'd look around and see a bottle opener hanging on a branch; we'd look a little farther, and we'd find a Grapette, and we'd take a drink 'cause we were thirsty. We did all that—our burps and all—and then we'd go over by the theater. We'd still

have our flippers and face masks on, but when we got in front of the theater, we'd take our face masks off. Then we'd feed the fish, and then one of us would do the deep dive. That was my favorite thing. I loved the deep dive. The hole there is 117 feet deep. They had a limb wedged in there that we could wrap our feet around to hold onto. Then I'd tug on my hose, and they'd pull the hose away. And I would do a couple of ballet moves on my way up. The whole show would go on for about thirty or forty minutes.[87]

In the late 1940s and early 1950s, watching girls perform underwater for thirty or forty minutes seemingly without breathing was as exciting and surreal as watching Neil Armstrong step onto the moon in the 1960s. People just didn't spend that much time underwater. The aqualung wasn't even introduced in the States until 1948, and it was 1959 before the first scuba diving certification was offered at the YMCA.[88] And just as some people had a hard time believing Armstrong stepped on the moon even though they could see it on their television screens, people had a hard time believing the performances at Weeki Wachee were taking place sixteen feet underwater, even though they could see the girls floating behind the glass. As Dot said, "The water was so clear, you didn't hardly know it was water."[89]

"One time this woman was sitting right in the front row," said Nancy Tribble Benda, "and of course the ducks and fish were there, and this turtle just happened to float through the scene, and this woman just let out this squeal and said, 'Look at that, look at that. I didn't know turtles could fly.' I guess there are some people who aren't swimmers that just couldn't comprehend what they were looking at."[90]

Others thought the whole scene was rigged—that the girls were held in place by wires. One promotional photo created quite a stir when it went out over the Associated Press newswires. In the photo, Mary Darlington Fletcher and Bunny Eppele sit on swings while Vina Rathfield pushes them. Editors of northern newspapers refused to believe the girls were swinging fifteen feet underwater. After a back-and-forth argument over the veracity of the photo, one editor finally conceded that the girl doing the pushing didn't have her feet on the ground and that he could see air bubbles floating over their heads. A New York editor ended the argument with the observation that "Water in Florida just isn't as muddy as it is in Lake Erie."[91]

Audiences watched as the swimmers entertained them with underwater shenanigans Perry had finessed over the years: dancing around a maypole, swinging on a swing set, cutting a watermelon they had to weigh down to keep it from floating away. "We even had an underwater hot dog stand," said Ed Darlington. "I still remember seeing my friend, the late Ned Stevens, propping his elbow on the counter, watching the young girls go by and letting his pot boil over. We were just kids swimming at Weeki Wachee," he said. "We would come up and do everything, clean restrooms, cook . . . anything there was to do, we did. We ate bananas," he said. "We didn't eat them all back then, so we're still eating them today."[92]

Luckily, the locals accepted Newt Perry's offering of bananas and everlasting life as mermaids in exchange for their beloved spring, otherwise he might have suffered the same fate as Ponce de León, who sailed onto the Florida shore and proclaimed the land a feast of flowers. Like Newt,

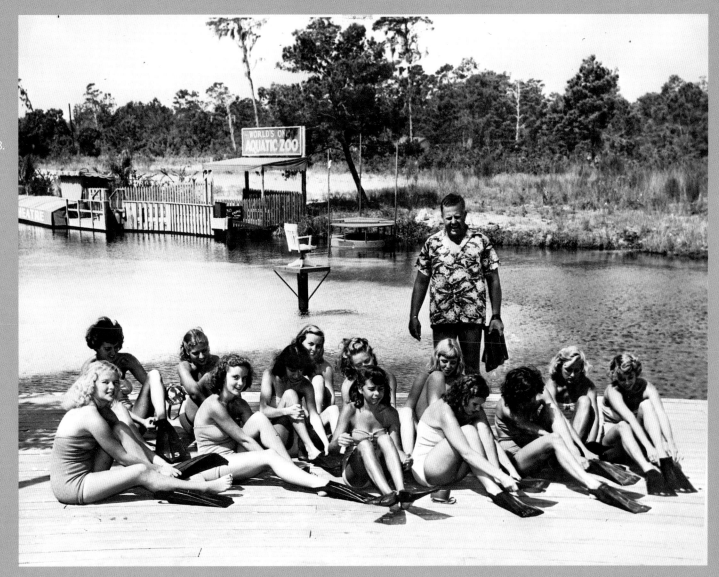

Newt Perry and his river full of mermaids, ca. 1948. Courtesy of Florida State Archives.

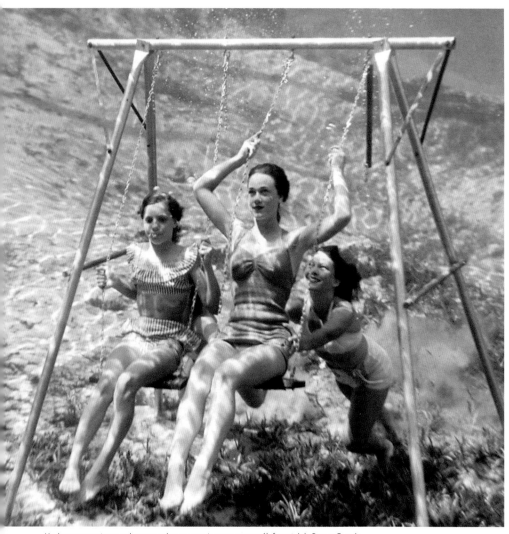

Underwater swing set that caused argument in newspapers (*left to right*), Bunny Eppele,
Mary Darlington Fletcher, and Vina Rathfield, ca. 1947. Courtesy of Mary Dwight Rose.

de León was sure that the springs of Pascua de Florida possessed some mighty mojo. He went looking for his own Fountain of Youth and ended up mortally wounded with a poison arrow.

If he'd lived, he might have made it to Weeki Wachee like Hernando de Soto did. Hundreds of years before Newt Perry stocked Weeki Wachee with mermaids, de Soto's men had heard the river was full of mermaids and had climbed the tall cypress trees lining the banks of the river to look for them. Spotting what were probably manatees, they got excited and fell, and pieces of their beards were snatched off in the branches of the trees. These became Spanish moss.

At least that's what the captain of the *Princess Wondrous*, Weeki Wachee's tour boat, tells the tourists between shows these days as they drift down the clear green river gawking at the wood storks and great blue herons.

The Human Fish

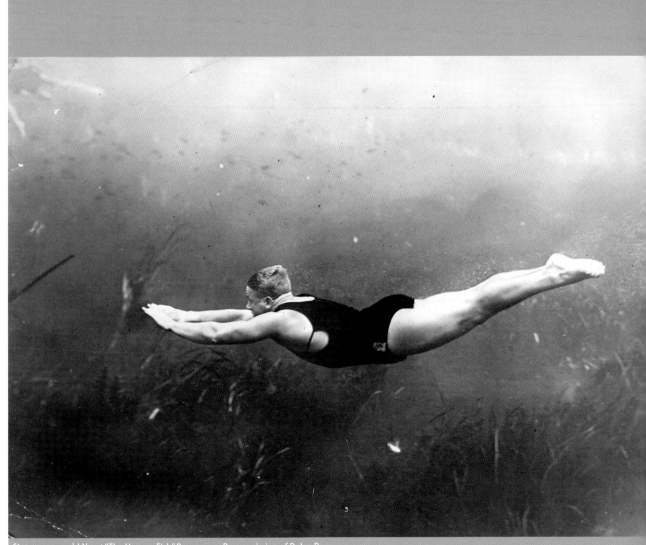

Sixteen-year-old Newt "The Human Fish" Perry, 1924. By permission of Delee Perry.

Newt Perry first dove into his watery Florida Dream at Silver Springs, the "Shrine of the Water Gods" in Ocala. Originally known as *Ocali*, the area around the main spring was a subprovince of the Timucua's "Kingdom of the Sun," where they'd lived undisturbed, worshiping sun and water thousands of years before red-headed, one-eyed Pánfilo Narváez arrived in 1528 looking for gold. Unimpressed with his greed, the Timucua sent Narváez on a goose chase north to Apalache *where the gold really was* to get rid of him. When Hernando de Soto showed up eleven years later, he was so focused on finding "gold and silver and many pearls" that he completely overlooked the area's crown jewel: the magnificent Silver Spring. Disappointed, he too headed north to Apalache.[1]

So the conquistadors came and went and missed the point, but writer Daniel Brinton got it. Upon visiting Silver Springs in 1856, the army surgeon–turned-ethnologist wrote that seeing the spring up close is a "spectacle that once seen can never be forgotten." But, he added, "Far more strangely beautiful than the scenery around is that beneath—the subaqueous landscape."[2] It was this subaqueous landscape that Phillip Morrell sought to gaze at, as well. In the late 1800s, the red-headed Silver Springs resident invented the glass-bottomed boat. Taking his inspiration from watching older boys press pieces of glass against the surface of the spring for a good look below, he cut a hole into his rowboat, wedged a piece of glass into it, sealed it with caulk, and pushed off into the spring. Before long he was in business.[3] People loved the sensation of floating over Silver Springs, over water "so clear that one could hardly tell where it ended and the air began."[4] The glass-bottomed boat transformed the way people looked at springs; they could now look into them and not just at their mirrorlike surfaces.

It was the three Henrys, however—Flagler, Plant, and Ford—who transformed the vision of Florida from what the naturalist John Audubon called a "wild and desolate part of the world"[5] to what Flagler and Plant called the "American Riviera." Flagler and Plant extended rail lines into the state and built fancy hotels that catered to the "fruit growers," not the "tourists," like Flagler's Hotel Ponce de Leon and its annex, Hotel Alcazar in St. Augustine.[6] But it was Henry Ford's invention of the Model T, and the subsequent flurry of road building that funneled the masses into Florida. Unable to afford expensive hotels and restaurants, these folks "[knew] the art of getting the most out of a dollar": they slept in their cars and ate their meals out of tin cans, earning them the name *tin-can tourists*.[7]

Popular hits such as Bert Moss's "Florida Calls to You," Al Jolson's "Florida Moon," and Irving Berlin's 1925 "Florida by the Sea" also sang the praises of the Sunshine State, as did land developers, newspapers, and magazines. Railroad companies frequently engaged writers to publish travel guides spelling out Florida's charms. One of the most famous of these was written by Georgia poet Sidney Lanier with the all-inclusive title: *Florida: Its Scenery, Climate, and History. With an Account of Charleston, Savannah, Augusta, and Aiken; a Chapter for Consumptives; Various Papers on Fruit-culture; and a Complete Hand-book and Guide*. One sheet-music advertisement for the Florida Central and Peninsular Railroad took a similar approach; it reads more like a real estate ad than one for rail service. Listing practically every stop on its

Silver Springs glass-bottomed boat post-card. By permission of Silver Springs.

680-mile route, the ad touts Florida as being "suited to the FARMER, the FRUIT GROWER, the VINEYARDIST, the BUSINESSMAN, the RETIRED MAN, the INVALID, the STUDENT, the LOVER of the PICTURESQUE." A traveler could visit the "tobacco plantations, vineyards and pear orchards in the fertile rolling region of the hill country of Middle Florida" or simply head to "the romantic Silver Springs and weird Wakulla."[8]

Florida had something for everyone. If you wanted to see alligators and ostriches, you could head over to the St. Augustine Alligator-Ostrich Farm. If you wanted to see one man's homage to unrequited love, you could head to Homestead, where Edward Leedskalnin, a Latvian immigrant, carved a castle out of heartbreak and 1,100 tons of coral. If you wanted to meditate to the sounds of a carillon, you need only go to Lake Wales, where Frederick Law Olmstead designed and built Bok Tower for his friend Edward Bok.

By 1925, over a half million people were trekking to Florida each year to see the alligator wrestlers and monkeys and to buy a couple of "Magic Acres," as one real estate developer dubbed his lots.[9] Along with them came Newt Perry. He was born in Georgia on January 6, 1908, and that's where he learned to do what he did best: swim. His daughter, Delee, who still operates the Ocala swim school Perry founded back in the 1950s, said her father learned to swim out of sheer will. "When he was about eight years old he would walk by this pond going back and forth to school, and he'd see the boys swimming, but he was too embarrassed to go out there and try. One day he went by and the boys weren't there, and he went out there and started imitating their movements, and pretty soon he became good enough, and he ventured out deeper and deeper."[10]

In 1917 or 1918, Perry's father, who was a conductor on the Seaboard Coastline Railroad, decided to move the family to Florida. It took them five days to make the drive in one of Ford's old Model Ts. Sometimes they'd get stuck in the sand and have to get out and gather branches and limbs to shove up under the car to free it. "At night they would stop at a farmhouse and ask, 'Do you mind if we camp out?'" Delee said. "Sometimes the farmers would let them sleep in the barn, and sometimes they'd let them sleep in the house. They had to carry a lot of water and their own gas because there weren't a lot of gas stations. When they got to Payne's Prairie outside of Gainesville, which was a huge lake at the time, they had to put their car on a barge, and the men actually pulled the barge across the lake."[11]

The Perrys moved to Tampa first, and they lived so close to the beach that Newt, who was ten at the time, could walk down to the Gulf and practice swimming. The lifeguards would watch him swim and suggest ways he could improve his stroke. The man newspapers would later describe as "barrel-chested" and "husky" was larger than life even as a boy. "When he was about thirteen (he was the oldest of five with four younger sisters)," said Delee, "he decided to drop out of school to go to work because the family was really struggling financially. He got a job digging ditches, and one day the foreman said, 'I need you to come in early,' and my dad said, 'I'll have to ask my mom,' and the foreman said, 'Son, how old are you?' and my dad said, 'I'm thirteen,' and the foreman said, 'You can't work here; we've got child labor laws.' The man thought my dad was eighteen years old."[12]

Florida-themed sheet music, ca. 1934. Courtesy of the University of South Florida.

By "Streamliner" Thru Tropical Florida

Train postcard, 1930. Courtesy of Lu Vickers.

In 1922, the Perrys decided to move to Ocala so Mr. Perry could see the family more often. He built their house one block away from the railroad tracks. Whenever the train got within a couple of blocks from the house, he'd blow the whistle to alert his wife that he was near, then slow the train down so she could bring him food or talk to him if she needed to. By this time, Perry was fourteen years old. Silver Springs was six miles away down a dirt road. As often as he could, he'd walk down to the spring to go swimming. One day, one of the owners of the spring, W. M. "Shorty" Davidson, watched Perry swim for a while. Impressed by the young man's ability, he asked him if he would teach his wife to swim, and Perry said yes, beginning his lifelong career of teaching people to swim.

Davidson hired Perry to be a lifeguard at Silver Springs. When he wasn't lifeguarding, he was promoting Silver Springs. He took cardboard bumper stickers that read "Go See Silver Springs" and hired boys to go out to the parking lot and tie them onto the bumpers of cars with twine. He paid them a penny per automobile. While working summers at Silver Springs, Perry decided to finish his high school education. When he found that Ocala High had no swim team, he got permission to form one, then served as both coach and swimmer. Under his direction, the team ended up ranking third in the state. Somehow he also managed to earn a spot on the all-state football team.

After graduating in 1929, he invited Ross Allen, whom he'd befriended at a swim meet, to come up to Ocala to live. Once Allen got to Silver Springs, he became the resident taxidermist and formed the Ross Allen Snake Club, where he taught young boys the finer details about reptiles. The Snake Club would eventually become the internationally known Ross Allen Reptile Institute, the place where Allen would handle poisonous snakes and milk them in front of oohing and aahing tourists. But there was a serious side to the operation as well—the venom he collected was used in scientific research.[13]

Still, no matter how serious their other pursuits, Perry and Allen always managed to have fun. A 1931 newspaper article describes a "jaunt" Perry made up the Ocklawaha River with his close friend the snake handler to find alligators to stock Allen's pens. They caught seventeen alligators, including one that Allen had to dive into the water to re-

Ross Allen teaching nature study at Silver Springs, ca. 1930s. Photo by Verne Williams. By permission of Silver Springs. Courtesy of Delee Perry.

trieve, prompting the paper to pronounce the two men the "champion alligator hunters of Marion County."[14] Somehow, while catching alligators and lifeguarding at Silver Springs in the summers, Newt Perry managed to get through college. Mr. Kellogg of Kellogg Cereal fame awarded him a football scholarship to a university in Battle Creek, Michigan, but after one winter, Perry decided he didn't like walking in waist-deep snow and moved back to Florida.

In 1931, the University of Florida awarded him a football scholarship, but Perry ended up injuring his knee. He was about to drop out when the Athletic Department decided to award him its first swimming scholarship. While at UF he lettered in swimming, diving, and wrestling. After graduating he taught school and coached at a local high school, then served as a principal at Belleview Junior High, where he also operated Newton Perry's Nature Class, hauling truckloads of boys to the woods, where they studied everything from beetles to hog-nosed snakes, along with fish. In true Newt Perry fashion, he conducted some of his classes deep below the surface of the spring.[15]

All throughout this period, as he continued to work at Silver Springs lifeguarding and setting up diving exhibitions and marathon swims in the Silver River, Perry lived a parallel life underwater, bartending, racing, and eating bananas. He wasn't unlike the spring itself. His surface life was impressive, but his "subaqueous" life was even more so. As one writer said, he "has spent almost as much of his life in the water as on dry land." By the time Perry would arrive at Weeki Wachee, he would have swum four hundred miles underwater, earning the title "Mr. Underwater."[16]

Mr. Underwater Goes Hollywood

Both Perry and Allen proved themselves to be indispensable to Silver Springs through the years. And Perry—with help from Ross Allen, W. M. Davidson, Ed Carmichael, W. C. Ray, Bruce Mozert, and the spring—would also prove to be indispensable in bringing the film industry to full bloom in Florida. Ocala was no stranger to movie makers. In 1916, the silent film *The Seven Swans* had been filmed at the headwaters of the spring, and then in 1926, *Old Home Week* was filmed in the area around Ocala. W. C. Fields and Louise Brooks came to town two years later to shoot scenes for *The Old Army Game*.[17]

In 1924, amazed by the clarity of the water, a Paramount newsman built a tank and attached it to a float; he then shot the first underwater film to be made at Silver Springs: a short reel of Shorty Davidson eating a banana underwater.[18] Shorty Davidson's underwater consumption of that banana was a fortuitous moment. Newt Perry must have been in attendance—for twenty-three years later, eating bananas underwater would become one of the trademark acts of the Weeki Wachee mermaids. A year or so after Davidson's debut, Perry himself got to demonstrate his own underwater banana-eating skills. Grantland Rice was vacationing in the area and visited Silver Springs. He saw Perry swimming and asked him if he could swim underwater. Perry told him that not only could he swim underwater, he could also "eat bananas and drink a soda underwater and do some fancy swimming." Impressed, Grantland Rice sent for his cameraman. Perry set up a picnic scene underwater with a table and some food.[19]

"They didn't even have a way for the cameraman to get underwater, so they took a bucket and popped the bottom out and put a piece of glass in, [and sealed it] watertight," said Delee. "Then they held the camera down into the water to get a picture of Daddy. My dad was underwater doing all his different stunts, and when he came up everyone was cheering and yelling and clapping. He didn't understand why everyone was cheering until one of the cameramen said, 'Well, you've just set a new World's Record for holding your breath underwater.' They'd forgotten to tell my dad he could come up and take a breath of air and they would stop the cameras. He was trying to do the whole thing with one breath of air."[20]

With that scene, Newt Perry's film career as an underwater performer was launched. And so was his creative impulse. Perry's desire to set scenes underwater was the mother of invention. Delee said: "As Grantland Rice did more and more underwater work, they had to come up with a way for the cameraman to be underwater and stay dry, and they came up with this thing called a 'hole in the water.' It's just a cylinder with porthole, and the cameraman could sit down inside it." Ropes were attached to the outside, and a person on shore would pull the contraption around so the cameraman could get his shots.[21] Apparently news photographers got in on the action as well; a photograph of Newt Perry sitting at a table underwater appeared in the *Atlanta Constitution*'s Gravure Pictorial section in 1928. But no one loved Perry's underwater antics more than Grantland Rice. In 1928, he cast Perry as "champion turtle catcher" along with Johnny Weissmuller, the Olympic swimmer who would later be known as Tarzan. Perry caught fifty turtles in

Ross Allen and Marlon Perkins being filmed for *Mutual of Omaha's Wild Kingdom* at Silver Springs, ca. 1960s. By permission of Mozert Studios, Ocala, Fla. Photo by Bruce Mozert.

under an hour.[22] According to Shorty Davidson, that two-reel talkie "really put [Silver Springs] on the movie map of the world." By 1931, practically every movie company in the United States had been to the springs, drawn, as Davidson said, "by the remarkable clarity of our water."[23]

Using water as a medium to stage scenes transformed them from ordinary to extraordinary, or, as Daniel Brinton put it, "when the sunbeams fall full upon the water," the result is an "optical delusion."[24] The glass eye of the camera took the place of the glass-bottomed boat, and people took the place once reserved for fish. "When they showed [the films] in the theater," Delee Perry said, "people didn't believe there could be water that clear and people that could swim underwater that good, and they said, 'There's no way. You've got wind blowing the girls' hair up.'"[25] The filmmakers knew they were on to something. After the turtle-catching film, other shorts quickly followed: Rice made *Splashing Through*, and *Water Jamboree*, which featured Ross Allen "making a fire dive and wrestling an alligator." MGM and Johnny Weissmuller returned to Silver Springs in 1932 to film scenes for *Tarzan Returns*.[26] In 1933, Fox made a short film called *Silver Springs* that featured Perry and his sister Eileen in an underwater magic-carpet ride. It was recognized as the best short film of the year. Altogether, Perry and his sidekicks starred in about a hundred short films doing everything from eating turkey to playing trombones to riding bicycles and smoking cigarettes, all underwater. Ross Allen made over sixty-five newsreels himself—his specialties were "catching animals, fishing, canoeing, swimming and wrestling alligators."[27] But Perry was the one who really captured Rice's heart. In 1939,

Chasing turtles (*left to right*), Buster O'Steen, Johnny Weissmuller, Newt Perry, and friend, ca. 1930s. By permission of Delee Perry. Photo by Bruce Mozert.

the filmmaker paid homage to Perry with a film titled none other than *The Human Fish*.[28]

Silver Springs' reputation as a unique spot to make films was furthered by newspapers and magazines, which frequently ran stills from the short movies. *Hold Your Breath*, which featured Perry and his sister Eileen in an underwater track meet, made it into the *Washington, D.C., Sunday Star*.[29] In April 1937, *Underwater Romance*—complete with bar, bartender, and four-piece band—was featured in a full-page spread in *Life* magazine. "It was made a few months ago," the article stated, "and has since mystified many movie-

Eileen Perry Waddington, ca. 1920s. Courtesy of Delee Perry.

Band plays for *Underwater Romance*, ca. 1937. Courtesy of Delee Perry. Photo by Bruce Mozert.

Underwater track meet, 1939. Courtesy of Delee Perry. Photo by Bruce Mozert.

Underwater Romance, 1937. Courtesy of Delee Perry. Photo by Bruce Mozert.

goers. Some can't understand how the movie could be made underwater. Others just don't believe that it was made underwater. But the film is no fake." Set in the "Silver Fizz Night Club" with Newt Perry as martini maker, the film was touted as best short of the year in 1937.[30]

In addition to the clear water, another selling point for the film industry—particularly for MGM, which made the Tarzan films—was that the woods around Silver Springs were full of monkeys. In the late 1930s, a man named Colonel Tooey had released some monkeys on an island at Devil's Elbow, five miles downriver from the spring, hoping to liven up his Jungle Cruise. He thought if he kept the trees pruned and fed the monkeys well, they'd stick around. They didn't. They swam off into the woods and reproduced. "By the time the Tarzan movies came," said Delee, "the monkeys were in the woods and everything was set for Tarzan."[31]

Everything but the underwater cameras. Bruce Mozert, a photographer who came to Florida on assignment for the New York–based magazine *PIC*, went to the Florida Chamber of Commerce in St. Augustine. He was asked to go over to Silver Springs, where *Tarzan* was being filmed, to take some publicity photos. When he arrived on the set, he found that they didn't have any underwater cameras he could use. All they had was a barrel with a plate of glass inserted in the bottom, and there was only room for one cameraman to crawl inside it and shoot, and he was already in it. So Mozert asked Silver Springs' manager Wilton Martin if he could use the shop. Martin asked him what he planned

Bruce Mozert teaches class (*left to right*), Ginger Stanley Hallowell, Bill Ray, and Frank Denbleyker. By permission of Mozert Studios, Ocala, Fla. Photo by Bruce Mozert.

to do. "I want to build a housing," Mozert said, "and [Martin] says, 'What's that?' and I said, 'an underwater housing. . . . I'm going to put my camera in it, and he said, 'Build it so the camera won't get wet.'"

By that evening, Mozert had built his first underwater camera by boxing his Rolleiflex in airtight sheet metal and fitting a rubber inner tube over the top for his arm. The resulting photographs were so good that MGM took the film back to Hollywood, made huge prints from the negatives, hand-colored them, and put them on movie marquees across the country.

The talented Mozert filmed his way though the alphabet, working as a cameraman for ABC, NBC, CBS, and MGM. At eighty-six, he still makes underwater photos and movies in his studio in Ocala. He remembers the first time he met Newt Perry: "It was unbelievable. He was standing with his feet up in the air and he had his two hands down on the platform. Martin, the publicity director, introduced me to him, and with his feet in the air, he kept one hand on the platform and shook my hand with the other one."

Shaking hands while doing a handstand was one thing, but Perry really impressed Mozert when he dove underwater one evening. "Newt had a set of lungs on him," Mozert said. "I'll tell you a true story. Carl Ray and myself and a colored guy went out in a glass-bottomed boat. Newt dove down in the cave. You know, he had the world's record for holding his breath. Well, he goes in there, and he held his breath for five minutes. Can you imagine? Five minutes he was back in that cave. And Mr. Ray said, 'What are we gonna do, what are we gonna do? He must've got caught up and

drowned in there.' Here he comes five minutes later—Newt Perry—swimming to the surface. He had a heck of a chest on him. I thought he never would die because he was so healthy."[32]

By 1942, MGM had filmed six Tarzan movies at Silver Springs, and Newt Perry and Ross Allen had both doubled for Johnny Weissmuller, diving out of trees and wrestling alligators and anacondas. The three men were close friends. According to Delee Perry, they "were like three peas in a pod. . . . They loved the outdoors and they loved to party." Besides developing close friendships with Allen and Weissmuller through their mutual interests, working as a technical adviser Perry developed close relationships with the movers and shakers in the film industry.[33]

Mozert explained: "Newt was actually the forerunner in underwater photography and directing. He was it. There was nobody else in it, so when Hollywood came, they would hire Newt. When other companies came later to film *The Yearling*, they hired Newt because he knew all the locations; he knew the people; he knew the underwater."[34]

Delee agreed: "They used my Dad not only as Johnny's double, but if they needed natives, Daddy would work with the Negro population. And they were thrilled to make a couple of dollars and have fun at the same time. My dad was a liaison between the movie industry and the community—if they needed extras or lodging, or vehicles or caterers. My dad really set up everything."[35]

He even found doubles for the actors. A 1939 letter from Billy Grady at MGM refers to a double for "Boy" in Tarzan. Grady instructs Newt to have pictures made of the boy "the

Johnny Weissmuller, Johnny Sheffield, and Newt Perry (*left to right*) on the set of *Tarzan Finds a Son,* filmed at Silver Springs, 1938/39. Courtesy of Delee Perry. Photo by Bruce Mozert.

Newt Perry with teenagers at Silver Springs, ca. 1941. Courtesy of Ginger Stanley Hallowell.

minute you select" him, and send them along via airmail. He adds, "When you get the boy you think would be the right one, be sure he does not cut his hair."[36]

By 1941, Newt Perry had not only made a name for himself. Silver Springs was known as the "underwater film capital," and it attracted interest from all over the world, including a small place in North Florida with a big spring named Wakulla. Financier Ed Ball had fallen in love with Wakulla Springs, one of biggest and deepest freshwater springs in Florida, when he came down south in the 1930s to buy up timber for the DuPont interests. He decided to buy the spring, and in 1937 he built a lodge next to it. Then, in 1941, after going through a series of managers who just couldn't make a go of it, Ball, who'd heard of Perry's exploits, gave him a call and asked him if he'd come up to Wakulla and run his resort.

At first Perry wasn't sure—Wakulla Springs was in the middle of nowhere—but in the end, Ball made him an offer he couldn't resist, so Newt loaded up his wife and children and headed to North Florida, following in the footsteps of Pánfilo Narváez and Hernando de Soto. He ended up at Wakulla, which Ball claimed was Ponce de León's Fountain of Youth. Ball wasn't alone in his assertion. However, according to Wakulla County legend, the spring was also the Fountain of his Death. Supposedly, an Indian nailed him in the chest with an arrow, and he collapsed into the water. The story goes that he lost so much blood that the blue waters of the spring darkened into a deep red as he died. Ball, the elflike owner of the spring, claimed he possessed the bloodstained arrow that killed Ponce de León, saying that he kept it in a box up at the Lodge.[37] Of course, the reality is that Ponce de León was shot in the thigh by a Calusa Indian near Charlotte Harbor, and he died in Cuba.

Clearly, like all the other Florida springs, Wakulla did something to people's perception of reality. Besides being so clear and so deep it caused boaters to startle as if they were about to fall, the spring was full of "largemouth bass, shellcrackers, stumpknockers and bream, to the more scarce chain pickerel, ocellated killifish, gizzard shad and giant shrimp—big as lobsters."[38] Before Newt Perry got finished, the spring would be full of Aquamaids, as well as sword-wielding, turkey-eating, prize-fighting, hose-breathing teenagers.

Wakulla

Fit Palace for Neptune

Tarpon Club synchronized swimmers from the Florida State College for Women, ca. 1937. By permission of Wakulla Springs State Park and Lodge. Courtesy of Delee Perry.

Tah-ille-ya-ahan, as Wakulla Springs was originally named by the Timucuan Indians, means "a place where the water flows upward like the rays of heavenly light out of the shadow of the hill." The Spanish called it Guacara; the Seminoles called it Wakala; mapmakers called it Talacatchina, Tagabona, Wachkulla. It was spelled Wachullah, Waculla, Wacolla, Wacully, Wahkula; it was "the river of the crying bird," the "land of mysterious waters."[1]

These days the locals call the whole county "Wilkilya."

Nineteenth-century writers weren't as astute or as concise. No one was more flowery in her description of the spring than Miss Mary Bates, a New York writer who stopped by Wakulla in 1847:

> The magnificent basin was skirted with water lilies, 'Naiad's loveliest wreath' . . . The water was as transparent as air. . . . and lying there in those bright pure depths, there seems caverns formed of pearl and emerald. Fit palace for Neptune . . . or here might be Titan's hut or a Mermaid's grot, or a Naiad's home.[2]

Bates must have been thinking of the future, envisioning the arrival of Florida's own Neptune, Newt Perry. She wasn't alone in her praise of the springs. Even Johnny Weissmuller was inspired. He followed Newt Perry from Silver Springs to Wakulla, where he dove from the tops of trees, wrestled the alligators, and chased the local girls at Bennett's Drug Store up in Tallahassee. He took one look at the deep, blue water and grunted, Tarzan-style, "I like Wakulla Spring very much."[3]

So did Ed Ball.

Ball, who established the St. Joe Paper Company, was Florida's largest landowner and one of the richest men in Florida for nearly fifty years. Like everyone before him, he fell in love with the spring when he arrived in Wakulla County. Wakulla Springs was home to the locals' mayday parties, where huge crowds gathered to picnic and to listen to the stump speeches of politicians. They weren't pleased when Ball bought up nearly four thousand acres on the river, effectively ending an era.[4]

Unfazed by the disapproval of those who'd hunted and fished the area, Ball quickly hired two of Jacksonville's most prominent architects to design and build a lodge in the Mediterranean Revival style, complete with a terra-cotta tile roof, marble floors, and arched entryways. Word got around that he'd hired a painter who'd served under Kaiser Wilhelm of Germany to embellish the pecky cypress ceiling with delicate pastel images of ibis, herons, and egrets, although these days, that story is seen as apocryphal.[5] Although Ball hoped to "[pick] up a few nickels and dimes" at Wakulla, he never had any intention of turning Wakulla into a "honky-tonk," as he told an interviewer in 1974: "Well, my friend Dick Pope [founder of Cypress Gardens] said I was the only person he ever met that was sitting on a fortune and wouldn't do anything with it . . . I wrote him that the Lord had done a pretty good job by it and it suited me as it was."[6]

Still, he wanted to break even on his investment. So he called Perry. After Perry accepted Ball's offer to work as manager of the springs and moved his family up to Wakulla in February 1941, he promptly got down to doing what he did best: creating underwater entertainment. By the end of February, Jack Eaton of Grantland Rice Sportlight had written him explaining that they wanted to make a film on how underwater movies were made, and that they were in-

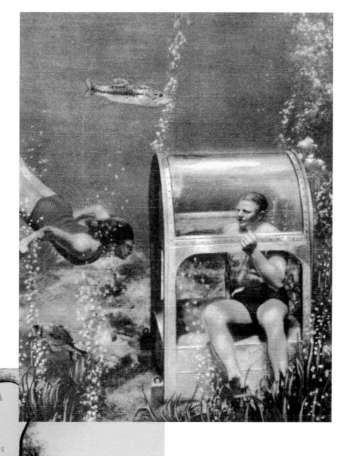

Newt Perry with swimmer and underwater air station at Wakulla Springs, ca. 1940s. By permission of Wakulla Springs State Park and Lodge.

WAKULLA
SPRINGS
AND
Lodge
WAKULLA SPRINGS
FLORIDA

Wakulla Springs Lodge postcard, ca. 1944. By permission of Wakulla Springs State Park and Lodge.

terested in showcasing "the latest style in fin flippers" made by Walton Hall Smith, the man who would go on to develop Weeki Wachee with Newt.

Eaton wrote: "Smith is supposed to be quite an expert at swimming and we plan to use him probably with you at Wakulla with these attachments. . . . Russ [Warren] mentioned the proposed hole in the water that you were building. Is this ready?"[7] In May, Eaton wrote again, requesting that Newt find six girls and boys and one "fat boy, or should I say young man, if there is one available," for an underwater picnic sequence, that will "be made in pretty shallow water with a white sand base where the picnic will be spread. We'll use small turtles for ants getting into mischief and we want the usual gags of eating underwater and drinking out of pop bottles, etc."[8]

Perry posted a cattle call for "fat boys who could swim." The *Tallahassee Daily Democrat* reported that the "Chamber of Commerce was immediately flooded with the fat lads applying for the position."[9] The underwater picnic was just the beginning. Perry also hired a crew of Leon High School students including Jack Yeager, Ernie Daffin, and Ricou and Buddy Browning to act in the underwater films. "We did a lot of shows for Grantland Rice Sportlight," said Ricou. "We did crazy things like towing a Model T Ford underwater and kids having an underwater picnic, prize fights, all kinds of crazy stuff."[10]

Just like he had done back in Silver Springs, Perry came up with lots of novel ideas to spice up the acts, like smoking underwater. Even though he hated smoking, he couldn't resist a good sight gag. To imitate a smoker, a boy would take a slug of milk and pretend to puff on a piece of chalk.

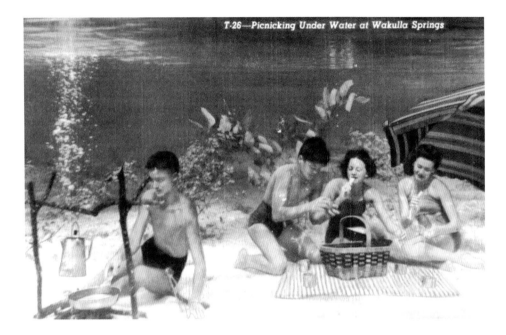

T-26—Picnicking Under Water at Wakulla Springs

Underwater picnic at Wakulla Springs, ca. early 1940s. By permission of Wakulla Springs State Park and Lodge. Courtesy of Lu Vickers.

When he blew the milk out into the water, it looked just like smoke. In another scene, a kid cooks hot dogs in what appears to be a bubbling pot of water; in another, a girl opens a phonograph to play a record, and mullet swim out.

"If you could name something on land, he could duplicate it underwater; it didn't matter if it was eating a watermelon or pouring coffee," Delee Perry said. And antics like pouring coffee into a cup underwater were fascinating to people. "People know that if you pour something into the water it's just going to dissipate, so what they did is put BB pellets into the coffeepot, and the BB pellets were heavy enough that if you viewed them from a distance, they looked like coffee pouring into the cup."[11]

Just one month after Perry arrived at Wakulla, the *Ocala Morning Banner* reported that the Tarzan film slated to be filmed at Silver Springs that summer might well be filmed at Wakulla instead.[12] Two weeks later, MGM Tarzan director Richard Thorpe, Johnny Weissmuller, and a couple of cameramen were met at the Tallahassee airport by Newt Perry. They drove to Wakulla, where Weissmuller caused the local girls to go "all a-twitter." They said, "He's not a bit prissy; he acts human just like us."[13] Weissmuller and crew spent the night at the Wakulla Springs Lodge, and by the next afternoon the story was that when Johnny woke up at the crack of dawn, he didn't ring the bell for service, he "hung his head out in the hall and Tarzanlike in a loud voice demanded, 'My breakfast!'"[14]

That afternoon, after taking a swim with Newt, Weissmuller and entourage headed back up to Tallahassee, where they had dinner with Florida governor Spessard Holland and his wife.[15] The crew had made their decision. They would move their operation to Wakulla and, as usual, rely on Perry to recruit locals to act as doubles and extras. The late Jack Yeager, a Tallahassee insurance agent, and his pal Ernie Daffin, an architect, were Leon High school students when they were tapped to double for Weissmuller and Johnny Sheffield, who played Boy. Yeager told the *Tallahassee Democrat* that the chimps, who "were raunchy as hell" swung wildly through the trees, until their trainer cocked his BB gun and aimed it at them.[16]

Daffin and Yeager also doubled as "primitive savages." In pre–politically correct fashion, the makeup crew "blacked" the boys' bodies, strung bones around their necks, and strapped them into loincloths. "We'd get into a dugout

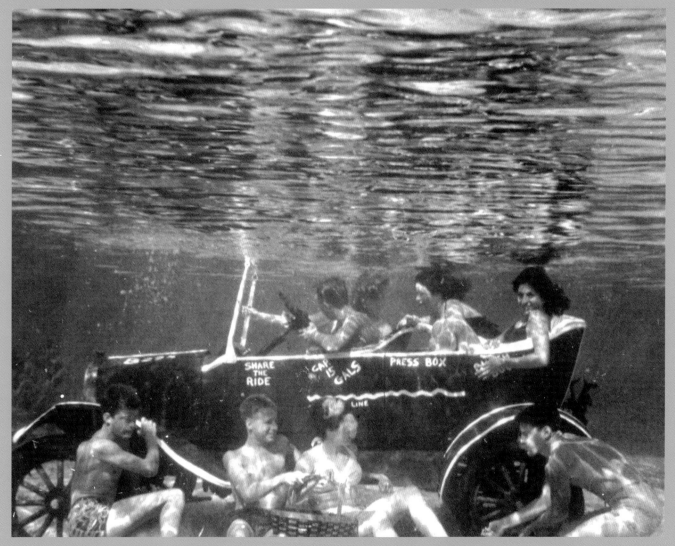

"Sharing the Ride" under-water in a Model T Ford, ca. early 1940s. By permission of Wakulla Springs State Park and Lodge.

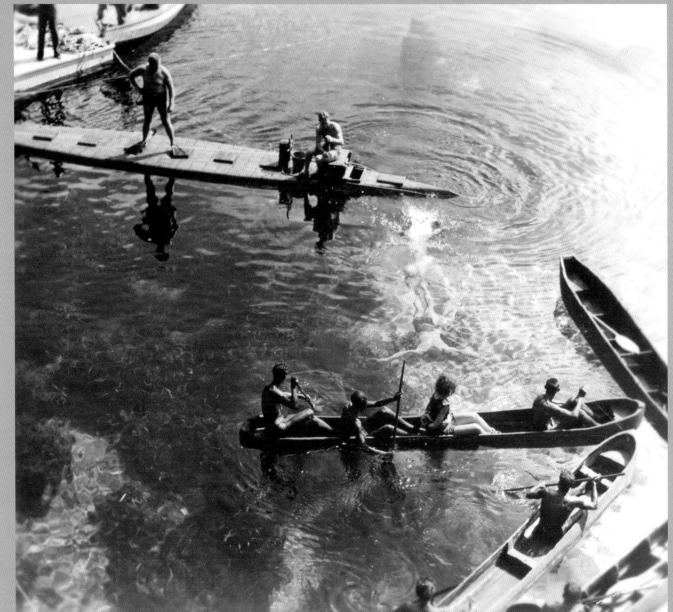

Tarzan's Secret Treasure being filmed at Wakulla Springs, 1941. Courtesy of Delee Perry. Photo by Bruce Mozert.

canoe and paddle along, Yeager said, "and Johnny Weiss-muller would turn the canoe over and kill us in various ways."[17] They weren't the only "natives" the crew hired. Perry also recruited local African Americans to play "savages." In their real lives, one paper reported, these men "hoe the sweet potatoes and peanut crops in Wakulla County where they've lived all their lives."[18]

Perry's duties weren't limited to finding screen doubles. He also hired, as glass-bottomed boat captains, African American men who, as one writer put it, "have been taught a better brand of natural history than that found in far more sophisticated circles." These men rowed their glass-bottomed boats over the spring, pointing out the fossilized mastodon bones, Henry the pole-vaulting fish, and other oddities such as "the submarine forest, nature's flower bowl, 'the Injun bee-tree,' the face on the rock, the Injun stairway and the submarine garden." Whenever a suspicious tourist would wonder out loud whether the face on the rock was real, the boatman would reply, "Use yo' 'magination."[19]

Perry certainly used his. In August 1941, he began work-ing with the Tarpon Club girls from the Florida State College for Women, organizing synchronized swimming shows and diving exhibitions at Wakulla for the huge crowds that he'd begun to attract because of the war. "We had gobs and gobs of servicemen; they showed up at Wakulla, by the thousands," said Ricou. "The place was jam-packed."[20] In addition to supplying homegrown entertainment, Perry was enlisted by the USO to bring in some big names, and he obliged, recruiting stars like Gene Tierney.[21]

When he wasn't organizing synchronized swimming shows and USO events, Perry rented swimsuits to visitors, periodically cleaned off the mastodon bones at the bottom of the spring, erected a fence to keep out the nonpay-ing swimmers,[22] and put signs advertising the lodge in places from the Palace Barber Shop in Tallahassee to City's Service Station in Panacea.[23] He built a "hole in the water" for cameramen to use; he built a floating "Winter Bath House," invented an airlock, built a mechanical alligator that would hold eight or nine teenagers, and developed the air hose—innovations that brought him closer to realizing his dream of opening an underwater theater.[24]

He tried out these innovations on local teens. However, it was in the Tarpon Club, the swim team from the Florida State College for Women, and in his own swim team, the Wakulla Aquamaids, that Perry found prototypes for the Weeki Wachee mermaids: Sis Meyers and Nancy Tribble Benda. "Newt started using a group of us from Leon High," said Nancy. "Most of the work he did with us was in the wintertime because the springs weren't busy and theater people liked to come to Florida in the winter, so that all made sense. He'd come pick us up at about seven on Saturday morning, and we'd all be hauled down to Wakulla Springs. Sometimes he would just be working with us on underwater breathing and how you hold your breath long periods of time. He built what we called the hothouse. It was a little plastic screened house with a chimney built on one of the floats down at Wakulla. He'd take us out there on boats so we didn't get wet, and then we'd go down into the water. The water was comparatively warm. It stayed about 71 or 72, and so we'd go directly from this warm hothouse into the water and stay in the water and then come out the same way we'd gone in."[25]

Newt Perry works with the Tarpon Club, ca. 1941. By permission of Wakulla Springs State Park and Lodge.

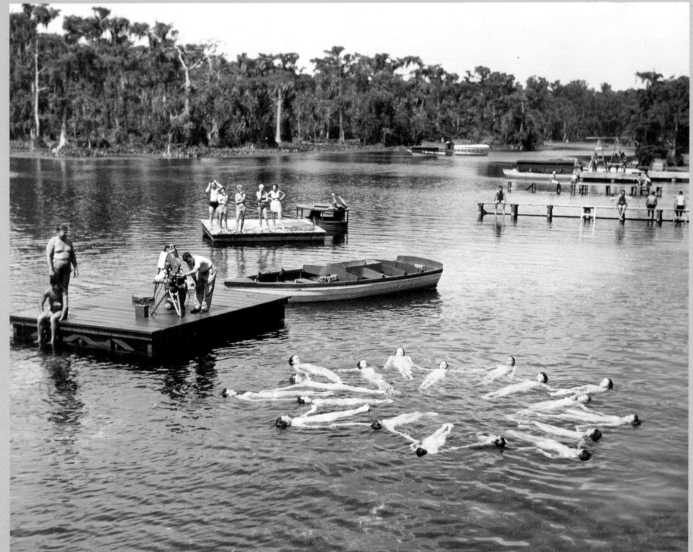

Newt Perry organized shows with synchronized swimmers, ca. 1941. By permission of Wakulla Springs State Park and Lodge.

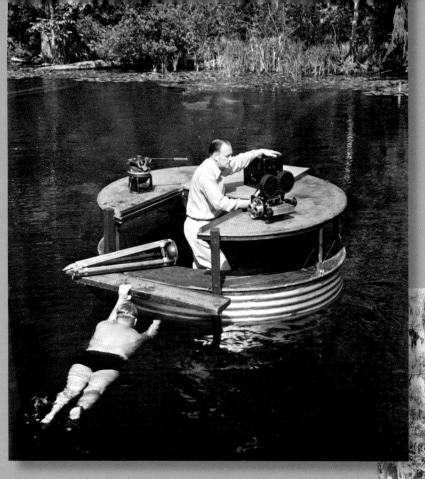

Left: Newt Perry propelling Russ Erving in the "hole in the water," 1941.
By permission of the Florida State Archives.

Below: Newt Perry and local teenagers at bathhouse, ca. 1941.
By permission of Wakulla Springs State Park and Lodge.

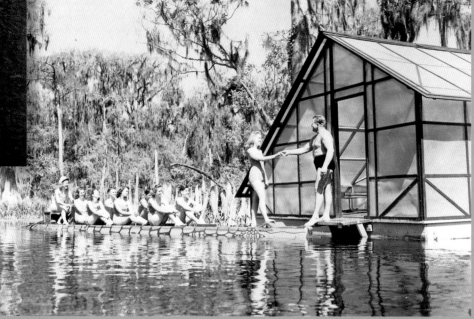

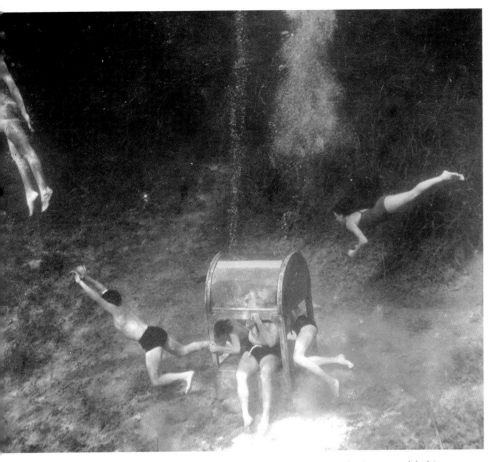

Newt Perry and teenagers swim from airlock, ca. 1944. Courtesy of Delee Perry.

them so they wouldn't float. And you could swim from one to the other. But we had two accidents where people who didn't know how to dive went and breathed and came to the surface without exhaling and ruptured their lungs, so we had to shut those down."[26]

But the idea of the airlock had been born, and it would be utilized again at Weeki Wachee. While at Wakulla, Perry also developed the air hose that would become the life support of the mermaids at Weeki Wachee. According to an interview, Perry said he got the idea for using the hoses when he was standing on a boat with Johnny Weissmuller watching cameramen shoot a scene for one of the Tarzan films. He spotted an air hose dangling in the water and told Weissmuller he'd like to take a shot at breathing through it. Weissmuller couldn't believe it when Perry dove into the spring, took hold of the hose, and sucked a breath of air out of it.[27]

Delee Perry thinks her father got the idea of breathing straight off a hose from the Tarpon Springs sponge divers. "They were already using the metal helmet with the air hose attached to it. And while he had used a helmet himself, he found it too cumbersome. He'd rather just have a face mask on and be able to take a breath from a hose."[28] So hose breathing was born.

But it was not without its glitches. Nancy Tribble Benda described the prototype for the air hose as being a bit of a clunker: "It was literally just an old hose, and the deeper you got, the less the air pressure. You'd have to bite the end of the air hose so the air would build up and you could get a breath when you let it go." Perry's trainees bit the air hose so much they reduced the end of the hose to strings, which

Perry also built underwater airlocks to enable his actors to stay underwater for longer periods. Shaped like street-side mailboxes and placed twenty-four feet below the surface of the water, the "free air stations" weren't for everyone. Ricou Browning remembered them. "He built two or three of these airlocks, pumped air into them, and put weights on

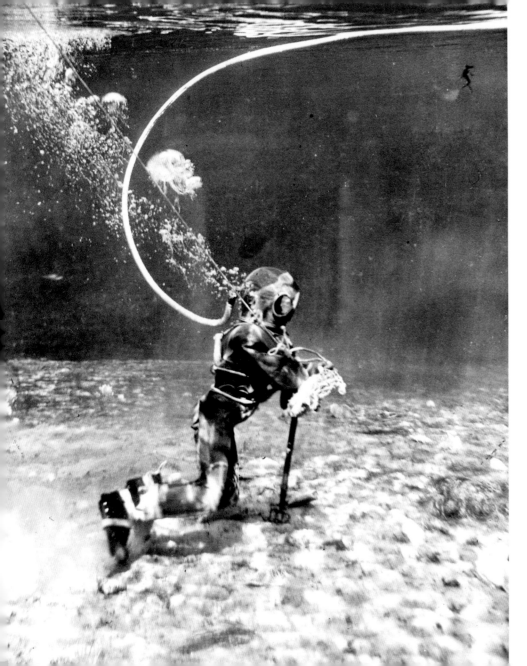

they would end up swallowing. Not something you'd want to think about, said Nancy. "The strings were just awful, and you'd think about everybody swallowing everybody else's [strings], you know, because there was only one air hose."[29]

Strings or no strings, Perry treated his swimmers right, Nancy said. "He would build a roaring fire in the lodge after we'd been swimming all day, and he'd bring us hot home-made vegetable soup and sandwiches from the kitchen, and we'd sit around in front of that fire, and that was wonderful. We had a great time."[30]

Ricou Browning recalls Perry in a similar light. "We'd go down in the wintertime to the springs and ask Newt if we could do some work, and he'd find something. One time he sent us out into the spring to pull eel grass out of the swimming area, and we pulled eel grass all morning and then ran inside the lodge where they had a fire going in that huge fireplace. And my brother and I would warm up for about ten minutes and then get back into the spring again."[31]

In January 1943, a couple of years after World War II broke out, General Omar Bradley and his wife, Mary, arrived at Wakulla Springs. They took a room at the lodge until Bradley could get settled at Camp Gordon Johnston, an Amphibious Training Camp situated at Carrabelle, a small town fifty miles south of Wakulla. Bradley came to hate Camp Gordon Johnston, with its stinging insects and relentless heat. When he wrote in his autobiography that "the man who selected that site should have been court-martialed for stupidity," he sounded a bit like the naturalist John Audubon griping

A sponge diver harvests live sponges off the ocean floor, 1946. Courtesy of the Florida State Archives. Photo by Ham Wright.

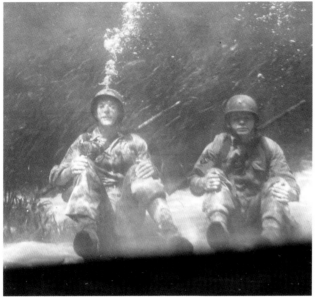

Frogmen train underwater at Wakulla Springs, ca. 1940s. Courtesy of Delee Perry.

kill yourself. He taught them how to put out an oil fire on the surface of the water, and he taught the men how they could dive down about two feet under the water because the bullets would penetrate about 18 inches and then they would ricochet off. He also trained them to use the scuba equipment—the rebreather and the air hose."[35]

Naturally, Grantland Rice Sportlight came to town to film the soldiers diving under oil fires and jumping off towers at the springs. They staged a combat scene involving lots of artillery and a mock Japanese boat that they blew up. Aircraft from Dale Mabry, a nearby airfield, strafed the river.[36] *Amphibious Fighters*, the resulting short film, made it into theaters by July, and in the spring of 1943 it won an Academy Award for short subject.[37]

In his typical showman fashion, Perry couldn't help but flaunt his swimmers to the navy frogmen he was training to be hard-hat divers. "They had strung a cable across the springs from a big cypress tree to the top of the diving tower; then in the middle of the springs they put another cable all the way to the bottom," said Ricou Browning. "They put two stages where these divers in hard hats would go out and get hold of the cable and then go down to the first stage, and then the second stage, and then down to the bottom. But then while they were doing all this, us kids would take the air hose and swim down next to them, and they thought we were out of our minds. There they were in these big rigs, and there we were with just air hoses in our mouths."[38]

The navy divers were so impressed with the teenagers swimming up and down in the water next to them like suckerfish that they almost couldn't believe it. "They came

about the heat and insects after stalking anhingas. And like Audubon, Bradley found relief in a Florida spring. After training all week in Carrabelle, he'd head to Wakulla Springs and spend Sunday with his wife.[32] The men at Camp Gordon Johnston loved Wakulla Springs as well; the *Camp Gordon Johnston Amphibian* hawked it as the "Best G.I. Weekend," noting that it is a "dreamlike place in silver and green Technicolor."[33]

Bradley asked Perry to train navy frogmen at Wakulla, and he obliged, formulating what would become standard training for frogmen.[34] "He taught them how to jump off a tower without injuring themselves," said Delee, "because a ship is about three or four stories high, and if you don't know how to enter the water properly you can basically

out later and talked to us about having almost perfect timing on letting air out before we would come to surface," said Nancy. "None of us were given any kind of timing. It was just Newt working with us over and over again on how you surface after you'd been taking compressed air."[39]

Perry also took time to do a little impressing of his own. With a Camp Gordon Johnston reporter in attendance, he set a world record by free diving 185 feet into the spring. The reporter described his descent: "Streaming bubbles like a fine silvery snow he works his way down gradually from air traps at different levels, breathing through a 300-foot air hose which is operated by a pump on shore." A photo accompanying the article shows a beaming Perry holding aloft the rib bone of a mastodon he'd plucked from the bottom of the spring.[40] When Perry finally made it to Weeki Wachee, he would teach the mermaids to do the deep dive; their plunge into the depths of the spring would be featured as the highlight of the show.

In the spring of 1945, Perry wrote Ball saying he himself had been classified I-A and that he was requesting a deferment. He also noted that business had picked up, that the "red will soon be completely missing" from the springs' financial report.[41] Ed Ball wrote back, saying he was glad that business was picking up, and adding, "I do hope that you don't get drafted into the Army; in fact, I don't know whether you would get by on ordinary rations."[42]

By 1946, Grantland Rice had made over sixty newsreels at Wakulla; one, *Like Father, Like Son*, featured Perry and his son, Newt Jr., along with other leading athletes of the day.[43] MGM had made two Tarzan movies, and dozens of other

film companies had shot sequences at the springs.[44] Harriet Carson, a local radio station personality, celebrated Newt's influence on the springs with the following pronouncement: "Like Benedictine and brandy, moonlight and roses, hot-dogs and baseball—Newt Perry and Wakulla Springs go together."[45]

All during this time, Newt was getting closer to his idea of an underwater theater. All the elements were in place: the airlock, the air hose, the deep dive, and the beautiful girls. In 1947, he had a brainstorm: *Let's have an underwater beauty contest at Wakulla Springs*. He'd already taken the Wakulla Aquamaids to Marineland, where they'd put on an underwater fashion show in the same tank with the sharks. Grantland Rice filmed it. Nancy Tribble Benda and Ricou Browning performed. "We had a good time," said Nancy. "They did move the barracudas out of the tank. But those were the only fish. They left the sharks in, and they put one of the divers in, supposedly to protect Ricou and me, but their dive suits took so much air we finally took the diver out so Ricou and I could use the air hose. Ricou was in a full tux. It was pretty ridiculous as I recall."[46]

Ridiculous or not, the underwater fashion show was such a success that Perry set a date for the underwater beauty contest at Wakulla. In May 1947, girls from all over Florida arrived at Wakulla for the chance to be crowned Miss Underwater of Florida ten feet beneath the surface of the spring. The local newspaper touted the upcoming event as the first of its kind in Florida, and "possibly in the U.S." Cameramen from three different newsreel companies descended on the springs for a chance to film the event from the diving bell.[47]

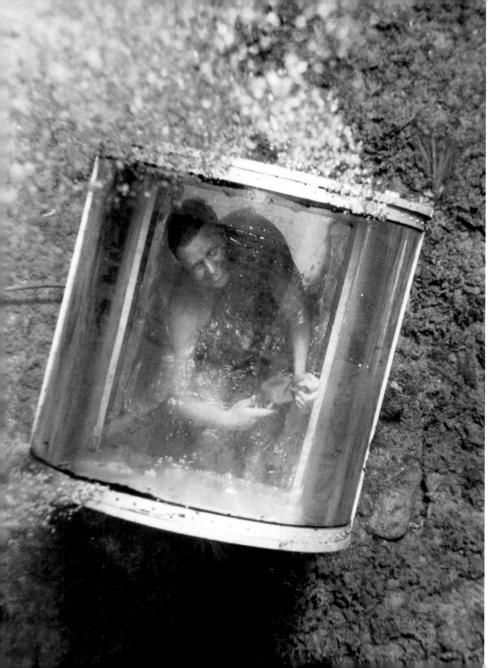

Newt Perry looks up from "Air Filling Station" in 30 feet of water, 1944. Courtesy of Delee Perry.

Nancy entered as Miss Killearn Gardens, but Miss Hazel Day, who entered the contest as Ross Allen's "Miss Swamp Angel" swam away with the crown.[48]

The underwater beauty contest was Newt Perry's swan song at Wakulla. Over the year, he'd been working with Hall Smith in the negotiations for developing Weeki Wachee, which was about 150 miles down the road. In June 1947, when the final touches were being put on the theater, he wrote a letter of resignation to Ed Ball, saying that he was accepting the position of aquatic director for the St. Petersburg Springs Development Company. "The [spring] is called Weekiwachee," he added, "and is located just north of Tarpon Springs on a well traveled highway, U.S. 19. The President of the company is a very good friend of mine from Kansas City." He assured Ball that "we will not be going into competition with Wakulla Springs as we are going to have an underwater Photo Gallery that will seat fifty people and will have aquatic shows. . . . My sincere aim is to promote the West Coast of Florida and to get people to come this route rather than to go down the middle of the state." He closed his letter asking Ball if it would be okay if he came back up to harvest the fruit from the citrus trees he had pruned and fertilized using his own money.[49]

Newt's concerns about the west coast of Florida were prophetic. For nearly sixty years after he left Wakulla to develop Weeki Wachee, the attraction would find itself struggling with the same dilemma: how to draw tourists away from the middle of the state.

4

Transforming
Myth into Kitsch

Bonita Colson reels in Lou Sikes at the St. Petersburg Holiday Inn pool, ca. 1961. By permission of Photographic Concepts, New Port Richey, Fla. Photo by Sparky Schumacher.

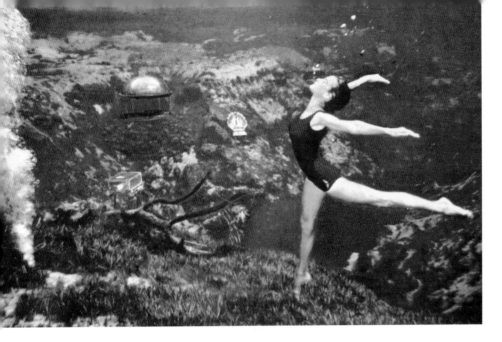

Martha Steen Lambert performs ballet, 1956. By permission of Weeki Wachee. Photo by Ted Lagerberg.

By the 1940s, Florida roadside culture, seaside or not, required weirdness, or at least a couple of monkeys, cockatoos, or ostriches, strange combinations that inspired Joel Achenbach of the *Chicago Sun-Times* to write of the Sunshine State, "Before you go to Florida, you have to decide if you want to see the Authentic Florida, the Fake Florida or the Authentically Fake Florida."[1]

Sometimes it was hard to tell which was which. Cockatoos pedaled miniature bicycles in Vero Beach; Seminole Indians wrestled alligators over in St. Augustine, and monkeys played pianos down in Miami. Weeki Wachee Spring might as well feature mermaids, and the mermaids might as well eat bananas and perform ballet. Banking on thousands of years of mermaid mania, Newt Perry knew that if he stocked

his natural spring with aquababes, the curious crowds would pour in. And he was right. Apparently Achenbach himself was lured into the park by Perry's tantalizing blend of nature and kitsch:

> You will instantly know if you are in the Authentically Fake Florida. For example, you might find yourself in an underground amphitheater staring through a huge glass window at women swimming in a deep freshwater spring, wearing bikini tops and mermaid-fin bottoms, smiling, doing spins and flips, and occasionally sucking on air hoses to stave off drowning.[2]

When Newt Perry taught the mermaids to drink Grapette fifteen feet below the surface of Weeki Wachee Spring, he was just doing what people had done for thousands of years—putting a spin on an age-old myth. Mermaids already had a reputation for their unpredictable shenanigans. As the writer Chelle Koster Walton notes:

> [The mermaid] is beautiful, enticing and seductive. But beware! She is also treacherous, destructive and conniving. [She] is the product of centuries of water deities and creatures—and she has picked up some pretty bad habits through the years. Her character is as formless as the sea foam she will become if she fails (as one legend has it) to earn a soul. . . . Like a becalmed sea, she merely reflects. Reflects the requirements of the various seaside cultures that created her.[3]

Perry was following two simple rules. Wherever there's water, there are mermaids, and those mermaids should reflect the culture that created them. The Japanese had Ningyo, a

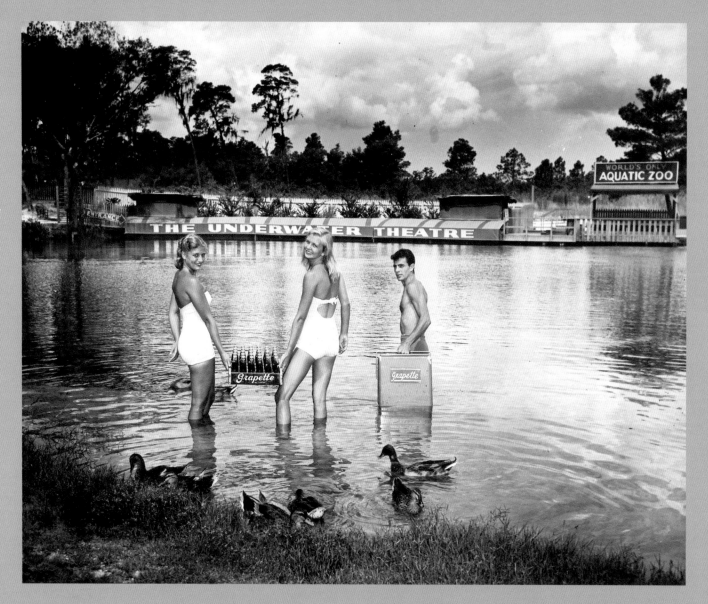

Nancy Tribble Benda, Eleanor Nichols, and Dick Woolery (*left to right*) carry Grapette into the spring, 1949. By permission of Weeki Wachee. Courtesy of Nancy Tribble Benda.

Bonita Colson checks her reflection in the mirror, ca. 1960. By permission of Weeki Wachee. Photo by Sparky Schumacher.

fish-bodied woman with a human head who cried pearls instead of tears; the Polynesians had Vatea, a god who was half human, half porpoise. The Africans created Mami Wata, a river mermaid who overturns canoes. The Shetland Islands had a Sea-Trow; the Germans had Nixe and Lorelei; the Irish had the Selkie. The stoic Russians had Rusalka. Why shouldn't the Florida mermaids drink sodas and eat bananas?

The Greeks and Romans started the whole mer-trend, coming up with all sorts of water gods, including the crowd favorites, Neptune and Poseidon. But the first merman, of sorts, was the sun-god Oannes, who might have been Newt Perry's great-great-great-great-great-grandpa. Draped in the skin of a large fish and wearing a fish-head hat, Oannes waded from the sea each day to teach the Sumerians the finer points of life before sloshing back to the water in the evening. Then there was Atergatis, the first known mermaid, who doubled as a moon goddess in charge of the tides. A typical siren, Atergatis was two-faced. When she was calm, the seas were calm. When she was upset, well, you'd want to head for higher ground to escape the flood.[4]

Mermaids didn't exist only in Greek and Roman mythology. In 77 AD, the Roman naturalist Pliny the Elder described mermaids along with dog-headed men and two-headed snakes in his groundbreaking encyclopedia *Historia Naturalis*:

> And for the meremaids called Nereids, it is no fabulous taile that goeth of them: for looke how painters draw them . . . their bodie is rough and skaled all over, even in those parts wherein they resemble a woman. For such a Meremaid was seene and beheld plainely upon a coast neere to the shore: and the inhabitants dwelling neer, heard it a fare off when it was a dying, to make piteous mone, crying and chattering very heavily.[5]

Pliny's scientific observations held sway well into the Middle Ages,[6] about the time when the Greek and Roman mermaid types lost their status as deities and entered the pop culture of the times. Then they were featured in medieval church art, not because they once were goddesses, but to remind people that mermaids are soulless creatures eager to seduce men in order to steal their souls.[7] But they could be tamed if handled right. In 1403, a Carmelite monk reported that a "wyld woman" broke through a dyke in the Netherlands and was found flapping in the mud by some milkmaids. She was taken in and cleaned up and taught to spin wool even though her hands were webbed. She became a Christian and lived quietly in Haarlem for over a decade.[8]

Most mermaids, though, remained "wyld." They were frequently spotted at sea by explorers who were more often than not disappointed in their looks. On his first trip to the Americas, Christopher Columbus complained that the mermaids he spotted were not as beautiful as he thought they'd be, "for somehow in the face they look like men."[9] John Smith, the English explorer made famous by his relationship with Pocahontas, had better luck with his mermaid. He said that the "upper part of her body perfectly resembled that of a woman, and she was swimming about with all possible grace near the shore." However, he ultimately decided that her looks were "too, too, too." She "had large eyes, rather too

Greek Tritoness, 1st century BC. By permission of the National Archaeological Museum of Greece. Photo by Dr. Valtin von Eistedt.

round, a finely shaped nose (a little too short), well-formed ears, rather too long."[10] Even so, he was on the brink of falling in love with her until the green-haired creature rolled in the waves, revealing her fishy bottom.

Ordinary people came across mermaids as well. In 1830, a group of women chopping seaweed on the beach on the island Benbecula in the Outer Hebrides noticed a tiny mermaid cavorting in the water right off shore. Several days later her body washed ashore. Her upper body was described as "the size of a well-fed child of three or four," but her bottom half was "like a salmon but without scales."[11]

Three years later, a half-dozen Shetland fishermen accidentally caught a mermaid who got tangled in their fishing line off the Isle of Yell. They kept her on their ship for three hours, noting that she had a crest of bristles from head to shoulder that she could move up and down like a fin, but she didn't have gills or scales anywhere on her body. When they tossed her overboard, she dove straight toward the bottom of the sea.[12]

Even though these encounters were often accompanied by detailed descriptions of green hair and breasts and tapered bottom halves resembling fishtails, some scaled and some not, nonbelievers suggest that the most likely source of these mermaid sightings is the dugong, or West Indian manatee, although dolphins, seals, and sea lions have been implicated. The West Indian manatee actually has breasts, and it must surface to breathe. After many days at sea watching water blend into sky, an explorer or fisherman might mistake a half-glimpsed manatee for a mermaid.

Nevertheless, even though these stories have realistic details—the small nose, the crest of bristles, the "piteous

Cover of Ed Zern's *How to Catch a Mermaid*, 1959. By permission of Western Filament, Inc.

mone"—they still come across as fish tales. They have that secondhand quality that reeks of urban myths. Someone needed to get hold of a mermaid—not to convert her to Christianity or teach her how to weave, but to simply show her off. According to Jan Bondeson, author of *The Feejee Mermaid and Other Essays in Natural and Unnatural History*, the person who did this was Samuel Barrett Eades, captain of a merchant vessel owned by Londoner Stephen Ellery. After saving the crew of a sinking Dutch ship, Eades traveled to Batavia, hoping for a reward. There was none. But he did make acquaintance with some Dutch merchants who showed him a dried mermaid they'd purchased from a Japanese fisherman, ignorant of its worth. Eades was so taken with the mermaid that he sold the ship for $6,000 and used the money to buy her.

He traveled to London and set up an exhibition at the Turf Coffeehouse, announcing the arrival of the mermaid with the following ad:

> THE MERMAID!!!—The wonder of the World, the admiration of all ages, the theme of the Philosopher, the Historian, and the Poet. The above surprising natural production may be seen at No. 59, St. James-street, every day, Sundays excepted, from ten in the morning until five in the afternoon. Admittance One Shilling.[13]

For three or four months, the captain's mermaid was a great hit; hundreds of people paid to see her. An article in the *Gentleman's Magazine* declared her to be the real thing. However, scientists revealed the mermaid to be a fraud, half orangutan and half salmon, sewn together with hardly a seam. The secret revealed, the public lost interest; the

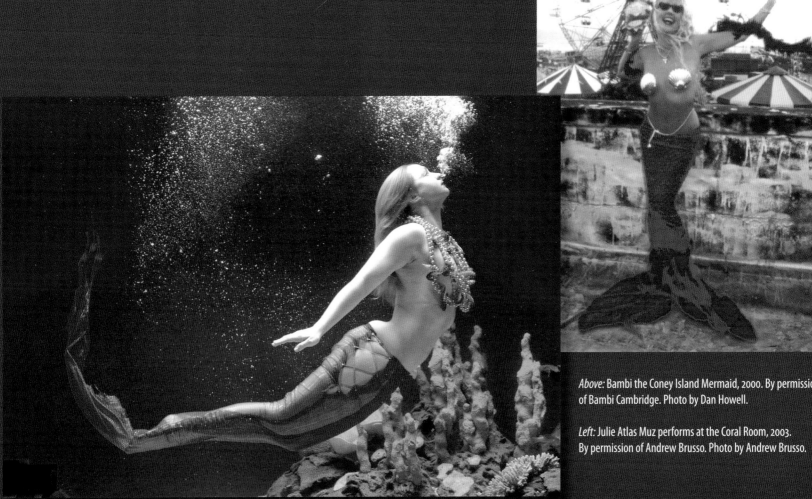

Above: Bambi the Coney Island Mermaid, 2000. By permission of Bambi Cambridge. Photo by Dan Howell.

Left: Julie Atlas Muz performs at the Coral Room, 2003. By permission of Andrew Brusso. Photo by Andrew Brusso.

Juan Cabana's reproduction of the Feejee mermaid, 2004. Photo by Juan Cabana.

Barnum's mermaid had a good run in Philadelphia and then in New York before Dr. Griffin grew tired of performing his act and people grew tired of the mermaid.[15]

The mermaid, having suffered the indignity of being faked with the parts of an orangutan and a salmon, was finally brought to life by none other than the "Perfect Woman," as Annette Kellerman was known. The Australian Kellerman had overcome childhood polio and become a "brilliantly acclaimed aquatic artist" with a body people compared to that of the Venus de Milo.[16]

Her first professional job was performing as a mermaid in a tank at the Melbourne Aquarium, but she gained notoriety for swimming twenty-five miles down the Thames River in London and attempting to cross the Channel three times. She didn't succeed, but she outlasted the men she swam with. Then she went to Paris and swam the Seine, then to Danube, where she swam the Rhine, dodging whirlpools and jagged rocks, all of this at a time, noted an Australian journalist, "when women's liberation hadn't even been heard of."[17]

Running out of rivers and seeking new ways to make money, she moved to Chicago in 1906, where, billed as "The Australian Mermaid," she combined water ballet with stunts like reading a newspaper underwater. Two of the Three Stooges joined her act as "diving girls."[18] By 1907, she was performing lavish water shows at the Hippodrome Theater in New York alongside Charlie Chaplin and ballet star Anna Pavlova. She stunned audiences by making swan dives off the roof and cavorting underwater with the fish for as long as two minutes. A New York theater critic, seduced by her serpentine movements underwater, wrote that her perfor-

Turf Coffeehouse shut down the exhibit, and, after Captain Eades took the mermaid on a brief tour in the country, they both drifted into anonymity.[14]

It wasn't until 1842 that the Feejee mermaid surfaced again, this time in the hands of P. T. Barnum. Well aware of her bad reputation, Barnum took no chances. He had his assistant pretend to be Dr. Griffin, a naturalist, and he invented for him a respectable post at the nonexistent London Lyceum of Natural History. Barnum notified the newspapers of Dr. Griffin's imminent arrival in the States. When the doctor checked into his hotel in Philadelphia with the Feejee mermaid, the papers were there to get the scoop.

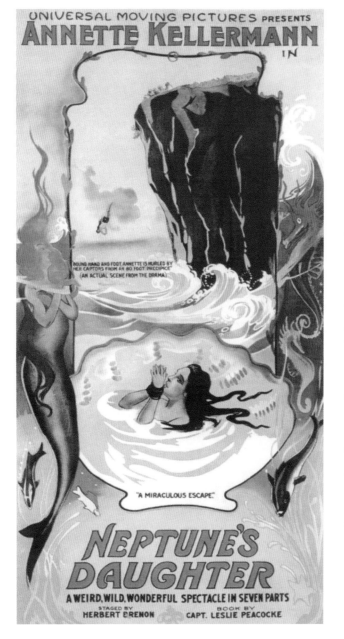

Movie poster from *Neptune's Daughter*, starring Annette Kellerman, 1914.

mance "fills the eyes with flashes of exquisite motion, [and] convinces you that there really were mermaids after all."[19] Mermaid Kellerman wasn't performing for peanuts, either; she earned $5,000 a week, more than any other "working woman" in America at the time.[20]

Before Esther Williams was even born, Kellerman starred in films built around her swimming. In the 1916 silent film *Neptune's Daughter*, she played a mermaid named Annette and performed her own stunts, one of which was to dive off a cliff into the water ninety feet below. In *Daughter of the Gods*, she dove into a pool filled with alligators that transform into swans. Of course, other films also capitalized on her swimming and diving abilities, as well as her good looks: *Diving Venus* and *Queen of the Mermaids*.[21] Still, Annette Kellerman wasn't the first person to perform underwater shows; that distinction belongs to the 1860s vaudeville act Enoch the Fish Man, who submerged himself to play the trombone,[22] and the 1890s freak-show star Blatz, The Human Fish, who ate bananas, tooted on a trombone, and read newspapers underwater.[23] But she was the first person to turn an underwater performance into an act of beauty. Even more important, Kellerman—who liberated women from having to wear "neck-to-knee" swimwear—liberated women to challenge men physically. In 1915, in an interview with *Ladies' Home Journal*, she said that for her swimming was more than just a physical way of achieving self-confidence. In swimming, a woman could achieve equality with or even surpass men. Water transformed women, she told the reporter: "For women, swimming is a time being a fish."[24]

Other women swimmers were quick to follow her lead. In 1923, perhaps inspired by Kellerman, Chicago swimmer

Esther Williams at Weeki Wachee, 1954. Courtesy of Patsie Hadley Boyett.

Kay Curtis started her own water ballet; eleven years later, a troupe of sixty water performers she called the "Modern Mermaids" swam at the World's Fair in Chicago.[25] In 1939, showman Billy Rose launched his Aquacades at the New York World's Fair, starring Olympic swimmers Johnny Weissmuller and Eleanor Holm along with various other aquagals and aquadudes. Rose enthralled audiences with his Broadway-style synchronized swimming shows and high-dive acts, all set amid cascading waterfalls lit by colorful lights.[26]

When the 1940 Olympics were canceled because of World War II, Esther Williams, who'd qualified for three events, was at loose ends. But only until Billy Rose spotted her photo in the paper. He invited the swimmer to be Aquabelle to Johnny Weissmuller's Aquadonis, and the rest is aquahistory. In a repeat of what happened to Kellerman in the silent film era, in 1941 the film industry discovered Williams and soon began cranking out water-based movies like *Bathing Beauty* and *Neptune's Daughter*, with over-the-top musical numbers choreographed by Busby Berkeley, who got his best ideas lounging in a bathtub. One of the most extravagant of these musicals was MGM's *Million Dollar Mermaid*, in which Williams plays Annette Kellerman. The film features a Busby Berkeley spectacular complete with leggy swimmers, colored smoke, flames, and flying trapezes.

Newt Perry arrived at Weeki Wachee at the perfect moment: the collision of Florida springs as roadside attraction with the mermaid as movie star. By 1939, Blue Springs had already changed its name to the catchier Rainbow Springs and launched its submarine photo boats. Tourists could climb aboard and peer out of the portholes at the black

bass as well as the occasional girl swimmer. A swimsuited Betty Grable had glanced over her shoulder at the camera and beyond, winking at the soldiers who would pin her image up in their barracks. Then, in 1946, the bikini was invented, and suddenly two-piece bathing suits were in, thanks to the efforts of Esther Williams and Jayne Mansfield. Also, cameras had been popularized—practically everyone owned one and wanted to snap photographs. Perry capitalized on all three of those developments, enticing tourists with the following words written beneath a photo of four beautiful girls seemingly suspended in midair:

> You can take pictures like this yourself of the sensational underwater performances, featuring the MERMAIDS' BALLET from the UNDERWATER THEATER. BRING YOUR CAMERA![27]

Perry didn't have the firepower of Annette Kellerman or Billy Rose or Busby Berkeley; Weeki Wachee mermaids would not be engulfed in red and orange plumes of smoke when they dove into the water; they would not be wearing gold-sequined bodysuits or feathered headdresses. But they didn't need to. Weeki Wachee wasn't a glorified swimming pool or an aquarium—behind the glass flowed one of the most exquisite natural springs in the world. Emerald-green eel grass grew out of sand that was so white and powdery it looked like fresh-fallen snow. Hundreds of bluegills, catfish, and turtles swam in crystal-clear water past the windows. Perry's mermaids would be what they were: beautiful girls swimming in what Arthur Godfrey later called "one of the Seven Modern Wonders of the World."[28] The girls didn't wear

fishtails, but the audience, transfixed by their apparent ability to breathe underwater, didn't seem to mind. As mermaid Bonnie Georgiadis said, "We had a tail in the house."[29]

The tail she was speaking of belonged to movie actress Ann Blyth, who came to Weeki Wachee just months after it opened to play a real fishtail-wearing mermaid. Universal Studios was no slouch in the tail department, arriving with a $20,000 fishtail in hand to film *Mr. Peabody and the Mermaid*, a comedy about a middle-aged man who catches a mermaid while he's on vacation. Weeki Wachee would not only provide a setting, but several of the mermaids would be asked to double for Ann Blyth, the star.

Then, in 1954, when Esther Williams traveled to Silver Springs to film *Jupiter's Darling*, her last movie at MGM, she was suffering with a perforated eardrum and the studio wouldn't let her perform any underwater shots. Who did they get for her double? None other than a former Weeki Wachee mermaid named Ginger Stanley Hallowell. While she was in Florida, Esther Williams dropped in on the mermaids at Weeki Wachee, where MGM filmed a couple of scenes for *Jupiter's Darling*, including an underwater shot of a Roman soldier chasing yet another Weeki Wachee mermaid doubling as Esther.

So, the mermaid juju that began back in the days when Oannes donned a fish head and waded ashore swam down through the centuries. After a series of twists and turns, monkeys and movies, the mermaid magic ended up in the spring at Weeki Wachee, in the form of a Florida girl doing back-kneed dolphins, slurping sodas, and eating bananas: 1940s Florida's take on an age-old myth.

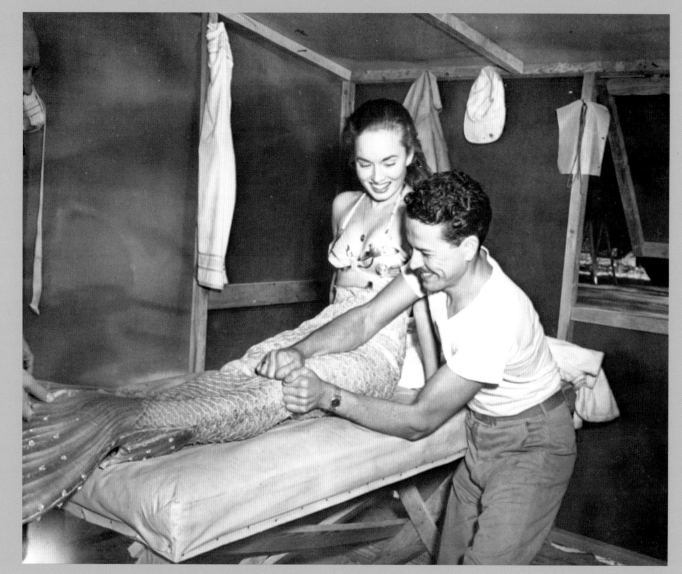

Ann Blyth dons tail with the help of Jack Kevan, 1948. Courtesy of the Florida State Archives.

Florida Senator Dempsey Barron carrying a Weeki Wachee mermaid onto the Senate Floor, 1982. By permission of the Florida State Archives.

The Forties and Fifties

Weeki Wachee's
Glamour Shot

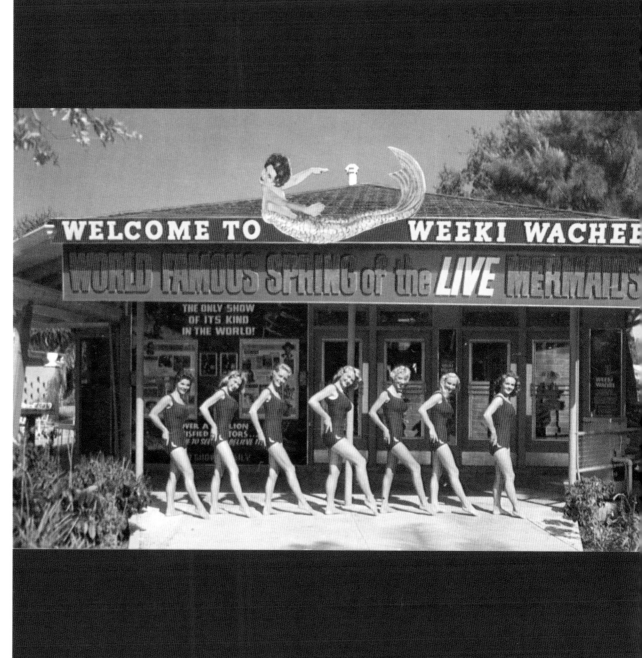

Welcome to Weeki Wachee (*left to right*), Lou Sikes,
Mary Sue Wernicke Clay, Martha Steen Lambert,
Florence Gothberg McNabb, Judy Shockley, Terry Ryan
Hamlet, and Shirley Walls, ca. 1956. By permission of
Weeki Wachee. Photo by Ted Lagerberg.

I can remember when I was very young, I mean like in grade school, and I read some place that your tonsils are modified gills. I can re-member talking to my mother and father at the time and condemn-ing them for having already had my tonsils out because I might have been able to breathe underwater, and that was long before I did any work.

Mermaid Nancy Tribble Benda, September 13, 2005

"Weeki Wachee was just a hole in the water off the highway with a little sign that said Weeki Wachee, Spring of the Mermaids," said Ricou Browning. "We had about fifteen employees, and Newt would ask them to park their cars out front so that the tourists going by would see the cars and park too. His old saying was, 'People go where people know people go.'"[1]

Perry didn't have to depend on the employees to park their cars out front for long.

In 1948, just a few months after the mermaids' first performance, Hollywood arrived to film *Mr. Peabody and the Mermaid*, starring Ann Blyth and William Powell. Searching for a suitable location, Universal-International's producers had watched reel after reel of film featuring underwater footage, and Newt Perry kept bobbing up.[2] They tracked him down at Weeki Wachee before the theater was even finished and wired him asking if he knew of any good loca-tions to make a movie starring a mermaid. "Of course," he said, "Weeki Wachee." He told them to come on down, and as soon as the theater was completed they did, bringing a crew of over sixty people and truckloads of equipment. Over the next couple of weeks, they spent over $40,000

building a mermaid's castle on a raft, then sank the entire thing.[3]

"It was quite a production," said Ed Darlington. "Outside of the spring area the water gets shallow, and they had to dredge that to eighteen feet deep so they could sink the set. And when they got done dredging, that whole area was rough. I'll never forget; Newt Perry put on a real heavy weight belt, took an air hose in his mouth, took a rake, and went down there for three hours and raked that place com-pletely smooth. I was amazed."[4]

Nancy Tribble Benda, who had gone back to Tallahassee to finish high school, got a call from Perry inviting her to come down to Weeki Wachee and try out for the mermaid double's role. "Newt was always using us for things, and I paid no attention to it one way or the other," Nancy said. "I didn't even tell my parents what was going on because I didn't think anything of it. I was at school at Leon, and mother got a call from Hollywood, California, saying, 'Can you be ready to bring your daughter to California next week?' She was the only one more surprised about it than I was."[5]

Nancy flew to Hollywood to be fitted with a mermaid tail. Bud Westmore of the legendary Westmores, a makeup and costume design family, created the tail. (Members of the Westmore family headed practically every makeup department in Hollywood.) The first thing they did when Nancy arrived in California was to plaster her from head to toe so they would have a mold to build a tail on. "They envisioned the mermaid having a vertical tail like a fish, not a horizontal tail like a dolphin or whale, which made it very

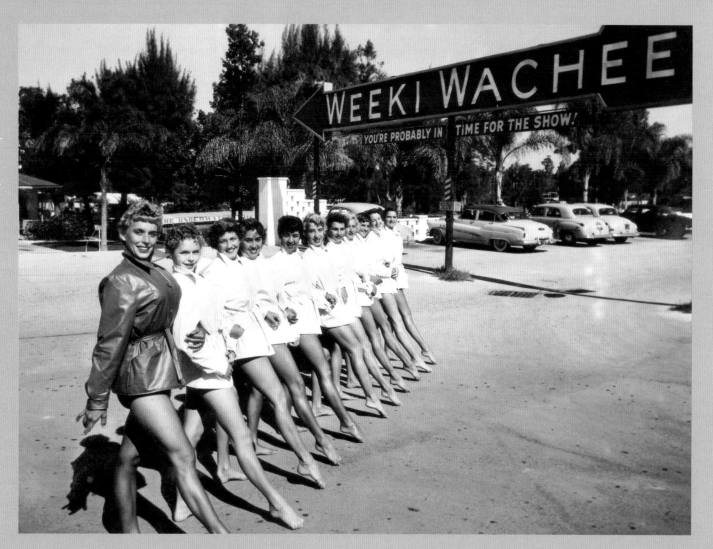

Former mermaid supervisor Patsie Hadley Boyett and company, ca. 1950. Courtesy of Patsie Hadley Boyett.

Mr. Peabody and the Mermaid movie set prior to sinking it into the springs, 1948. Courtesy of the Florida State Archives.

Nancy Tribble Benda with tail, 1948. Courtesy of the Florida State Archives.

difficult to move because you don't move this way," Nancy said.[6]

To fix that problem, they decided to slip a motor into the tail under Nancy's feet, hoping it would flip the tail back and forth. It didn't work. After a couple of more botched tails, they decided to go horizontal. That worked—not bad for twenty grand.

The makeup crew also fitted Nancy with a glittery-gold wig, "jabbing in a hairpin here, driving home a bobby pin there," Nancy wrote in an essay at the studio's school. The wig was so heavy she thought she wouldn't be able to swim with it on, but she managed to. After weeks of test-driving tails and wigs, it was time to head back to Weeki Wachee, where the filming began.[7]

Mary Darlington Fletcher was one of three stand-ins for the mermaid who got squeezed into one of the tails the film crew made. "My mother used to get me up here at 5 o'clock in the morning to be made up," she said. "They had a trailer they used as their stationary office, and they'd make me up. Then when it was daylight, I'd walk over there to where the beach place is now, and they'd put me into this tail. I mean it was heavy rubber; there was no zipper on it. I literally had to be picked up and poured into it, and then they laid me down on the beach, and I waited and waited and waited all day long. I wasn't in the water at that point, just waiting and waiting and waiting, and some days they didn't even shoot me. So they'd get me undressed, and I'd go back home, and my mother would have me back up here at 5 o'clock the next morning."[8]

Nancy remembers the makeup crew pouring her into the tail as well, and putting the squeeze on her, starting

Ann Blyth and Newt Perry behind the scenes of *Mr. Peabody and the Mermaid*, 1948. By permission of Sue Saxon.

weren't attacking the mermaid tails simply because they were so realistic. As it turns out, when the crew began filming, practically every single fish swam out of the spring and down the river. Because film producer Nunnally Johnson felt that "no mermaid would look authentic unless fish were swimming alongside her," he got a special permit from the state to net the fish and haul them back to the spring.[9] But just bringing the fish back wasn't enough to entice them to swim around the mermaid, so the crew "heavily baited" the tails with fish roe, hoping to attract fish. Whether the fish were fooled or not wasn't clear, but the bears certainly fell for the trick.[10]

The crew also had run-ins with razorback hogs. "I came out one morning getting ready to get the wig put on," said Nancy, "and all of the camera guys were up on the picnic table [with their cameras] rolling. A razorback hog had come out of the woods and was chasing something." The film crew had heard that if a razorback hog tried to swim, it would slit its own throat with its big front claws. They were sure they were going to catch the hog swimming across the spring, said Nancy, and they "wasted all this film, but it was fun."[11]

Movie star Ann Blyth spent three months in Florida and about two weeks at Weeki Wachee training with Newt Perry so she could do the close shots the film required.[12] Everyone found her charming. One reporter wrote that "since a mermaid must have a tail and moreover does not engage in conversation, Ann has the difficult task of portraying a woman who cannot talk and whose motions are confined to graceful undulations achieved by a slight bend of the knees."[13]

at her feet and working their way up to press the bubbles out of the foam liner so the tail would sink. Once the crew finished filming for the day, they were faced with another problem, Nancy explained, one the city-bred crew had never experienced before: "They had built tripods to dry the tails off at night, and the bears around Weeki Wachee came in out of the woods and attacked them." However, the bears

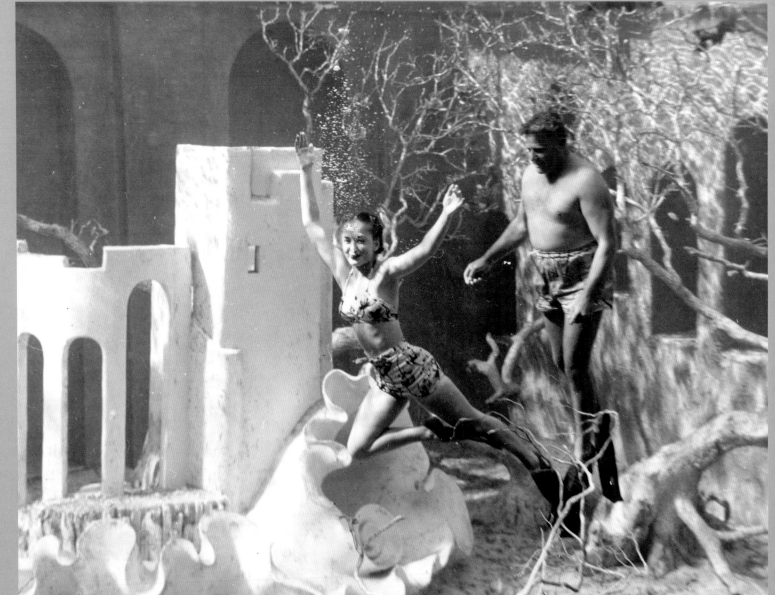

Newt Perry teaching Ann Blyth to swim, 1948. Courtesy of the Florida State Archives.

Since Blyth was confined to her mermaid tail while filming, she had to be carried around Weeki Wachee on a stretcher, Cleopatra-style. Ed Darlington was recruited to tote the star's shoes in case she got a hankering to slip out of the tail. "I carried Ann Blyth's shoes all the way around the spring," Ed remembered. "She was the most gorgeous, attractive young lady you ever saw in your life, but I was so intimidated by her notoriety that I didn't say one word the whole time; I was speechless. I regretted it ever since, but that's what happened."[14]

Ann Blyth admitted that before getting the role as mermaid, she did all her swimming "topside," but she was determined to learn how to perform underwater in the ice-cold spring, and Newt Perry was determined to teach her. She said she spent over eighty hours underwater. "And at this moment, I can safely claim that I am, Esther Williams notwithstanding, the most waterlogged actress in Hollywood," she wrote in an article for *Modern Screen* after the film was finished. "I have learned how to do a Bronx cheer underwater, how to laugh underwater without strangling, how to brush my hair underwater . . . [Perry] taught me all I know about underwater swimming. And at this point, he can have it back."[15]

The crew of *Peabody* got into the spirit of the film, referring to Blyth's stand-in as a "swim-in" and asking the star if she'd like a sardine sandwich for lunch. However, a studio newsletter revealed that not all the food jokes were related to fish. The California-based crew was unaccustomed to southern cuisine. A headline proclaimed "'Mermaid' Location Crew Weary of Grits on Menu." One technician claimed that he went to a Chinese restaurant only to find his chow mein served on a bed of grits. When he pushed them aside, the Chinese waitress asked, "Don't you-all like your grits, honey-chile?" Apparently, the crew wasn't used to southern-flavored accents either.[16]

For Newt Perry, *Mr. Peabody and the Mermaid* was the equivalent of a movie-length advertisement, even better, because it didn't cost him a dime. Publicity was there for the taking. Universal-International Studios even employed a cartoonist to travel with the crew, Nancy said. "One of the cartoons he drew showed all the fish walking around on their fins on the beach at Weeki Wachee breathing through air hoses."[17]

Perry took advantage of Weeki Wachee's day in the sun to recruit new mermaids. A small clipping in the *St. Petersburg Independent* announced that Newt Perry was coming to St. Petersburg to look for "girls who can learn to perform underwater specialties. The girls are wanted for the William Powell picture now being made at the springs. . . . Main requirements Perry states are beauty and long hair that will flow with the current. . . . It won't be necessary for the girls even to know how to swim, as long as they can hold their breath underwater."[18]

Dianne Wyatt McDonald, Judy Ginty Cholomitis, Frances Dwight Gioe, and Mary Dwight Rose were already working weekends at Weeki Wachee, so they signed on with a few other swimmers to perform for Ann Blyth in a special synchronized swimming show. Much to their delight, *Look* magazine sent a photographer down to take photos of them frolicking underwater. They were featured in a two-page spread in the national magazine, pretty heady stuff for teenagers.[19]

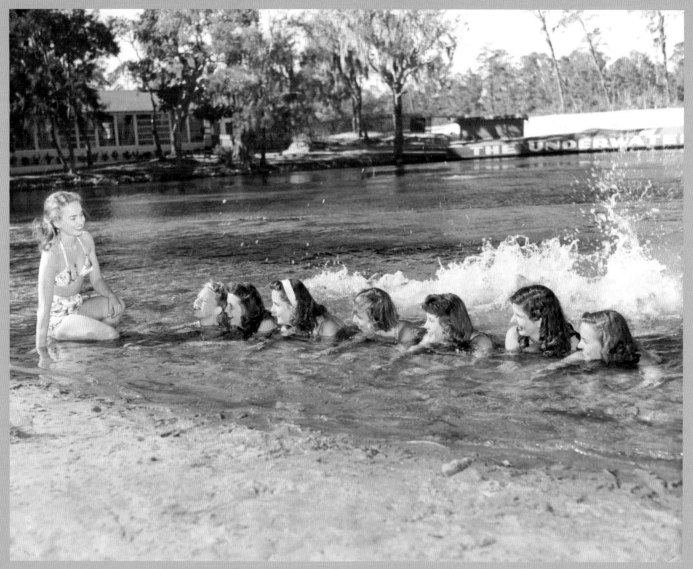

Ann Blyth with Aqua Belles (*left to right*) Patsie Hadley Boyett, Dianne Wyatt McDonald, Frances Dwight Gioe, June Young, Joan Smiley Amick, Darlene Sellers, and Mary Dwight Rose, 1948. Courtesy of Dianne Wyatt McDonald. Photo by Earl Weir.

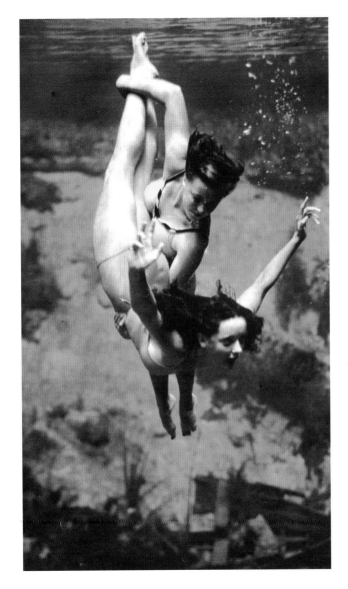

Frances Dwight Gioe and Mary Dwight Rose in *Look* magazine, 1948. By permission of the Library of Congress Archives. Photo by Frank Bauman.

Nancy, Mary Ann Zeigler, and Flo Wilkinson got in on the publicity end of the film as well. To promote the upcoming premiere, Perry decided to haul a six-by-four-foot glass tank to the courthouse in Tampa, where the mermaids would demonstrate their underwater talents for the public. The first day was problematic. Perry hadn't thought out the mermaid details—that once they were in tails they wouldn't have the use of their feet. He had to haul them across the square in his arms and put them into the tank. Then there was a problem with the water.

"They had trouble with the tank," Nancy recalled. "They had filled it with Tampa drinking water, and it was so dirty and cloudy [the crowd] couldn't even see me." Perry tried draining the tank and filling it with water from a private company, but he wasn't satisfied with the results. He rented a tanker truck, drove back to Weeki Wachee, filled the tank with spring water, and hauled it back to the courthouse, where he pumped it into the tank. Success.[20]

In a brief article titled "Amazes Citizenry: Mermaid Splashes in Pool to Herald Movie Debut," a reporter described the exhibition the mermaids would be performing: "[They will be] demonstrating to the public for the first time the newest method of deep water diving, hose breathing, which was discovered and developed by Newton Perry. Performers . . . will demonstrate how easily they can eat fruit, drink a cold drink, smoke and do other unheard of feats below water."[21]

In between demonstrations, Nancy sat in Perry's big old station wagon, still wearing the mermaid tail. "The door was open, and people would come and talk with me," she said. "This one person came and wouldn't speak to me. I've

worked in equity issues for years now, and I've noticed that [when faced with] people with disabilities, the general public often will speak to the caretaker or speak to someone nearby, and that happened to me while I was in the mermaid tail. They would turn to Newt and ask him about me, and Newt would weave a good tale. Finally this woman said, 'But have you searched to see whether there's some sort of surgery that could relieve her of that tail?' Even Newt didn't have an answer."[22]

For the southern premiere of *Mr. Peabody*, the Park Theater in Tampa sponsored a beauty contest to crown "Florida's Mermaid Queen." It would take place the evening after Nancy, Flo, and Mary Anne wowed Tampa's citizenry with their mermaiding skills. Several Tampa businesses donated prizes to be awarded the queen. The Tampa Tire Company donated a "two-strand string of pearls," and, because "even a mermaid can wash her clothes at the Launder-dry without her hands touching the water," Launder-dry donated twenty-five free washes. Not one to miss an opportunity to promote Weeki Wachee or to find a promising new mermaid, Perry sponsored one of the prizes, which was "a week's vacation, all expenses paid at Weeki Wachee Spring, the 'mountain underwater.'"[23]

"One of the girls in the Aqua Belles said, 'Mary, you enter that contest,'" Mary Dwight Rose said. "And I said, 'I've never been in any beauty contest.' Anyway, I put the heels on, and she taught me how to walk, and I went into it and won."[24] That evening, Tampa's Mayor Hixon, dressed in a white suit,

Newt Perry carrying Nancy Tribble Benda to the portable tank, 1948. Courtesy of the Florida State Archives. Photo by Wade Bingham Studios, Tampa, Fla.

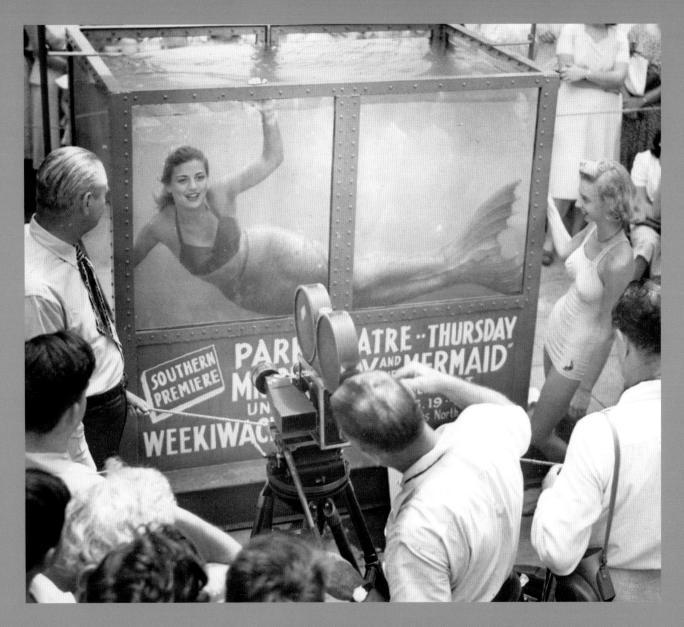

Nancy Tribble Benda (*in tank*) and Mary Ann Zeigler at the Tampa courthouse, 1948. Courtesy of the Florida State Archives.

Al Zaebst (*right*) and Alton Smith taking a smoke break at the Aquatic Zoo, 1948. Courtesy of the Florida State Archives.

crowned Mary queen and placed Neptune's crown on her head. She sat on a chair, wearing one of the *Peabody* tails.[25]

Meanwhile, back at Weeki Wachee, disaster was about to strike. Walton Hall Smith had hired Al Zaebst, one of Perry's old friends from Silver Springs, as promised early on, to open an Aquatic Zoo on the river and stock it with alligators, as well as some decidedly nonaquatic bears, panthers, and baboons. "Al looked like he just stepped out of Africa," said Penny Smith Vrooman. "He was very much the animal man. He and his wife didn't have children; they had monkeys, and the monkeys were like their little children."[26]

Actually, by the time Zaebst arrived at Weeki Wachee, he *had* just stepped out of Africa. For the tenth time. An article in the October 1947 issue of *Florida Wildlife* describes a recent trip he'd made to Africa, where he had caught over six hundred "jungle monkeys, by getting the whole long-tailed tribe lousy drunk on seven-dollar-a-bottle Scotch." He lived with his wife, Irma, in the Irmal, their estate near Silver Springs on a 110-acre spread. According to the writer, "loose monkeys cavort in every tree, an alligator guards the pumphouse and baboons do close order drill through the oleanders."[27]

The "Monkey Tycoon," as the magazine dubbed him, would fit in perfectly at Weeki Wachee. The Weeki Wachee River wound twelve miles to the Gulf through a densely wooded area. Tourists could cruise downriver on the glass-bottomed boat, also named the *Irmal*, after Zaebst and his wife. Sometimes the mermaids would join them between shows, and a photographer would snap a photo to sell to the tourists when they came back. But sometimes the mermaids would skip the cruise. Apparently not having gotten enough of being submerged in water during the shows, they would swim down the river on their breaks, not paying any mind to the gators who lounged on the banks. Nancy said the mermaids usually swam in pairs. She'd planned to go swimming with Hall Smith's wife, Martha Belle, the day *Mr. Peabody* was to premiere at the Park Theater but was slow getting ready. Martha Belle went without her.[28]

Al Zaebst (*right*) has a look at Martha Belle Smith's alligator bite as Walton Hall Smith looks on, 1948. By permission of Penny Smith Vrooman.

"Every day she swam down the river and never worried," said Penny. "She'd seen the alligators, but Al Zaebst and Ross Allen, who'd come over to Weeki Wachee as a consultant, told her alligators wouldn't attack. That day it was raining little droplets on the surface of the water. Mother loved to duck down and swim and look up and see the little diamonds on the surface. And all of a sudden she felt this huge bump against her bottom, and she thought it was one of the men who'd swum down to tease her, but no—it was a 9-foot, 2-inch-long alligator, and its mouth was wide open, and boom boom, it clamped right down on her arm. Mother was so scared. She thought she was going to die, but she hit the alligator with her hand, and it let go." Penny said her mother swam over to the sandy bank of the river and walked all the way back to the spring through the "beautiful

flowers, palmettos, and palm trees." She ended up getting twenty-one stitches. "She told Zaebst and Allen, 'They do come after you after all,'" said Penny. "But they said [the gator attacked] because it was raining, and she had on a white bathing suit."[29]

That afternoon, while lying in a hospital bed, Martha Belle told a reporter that Zaebst promised to bring the gator to her house the next day. Questioned whether or not she wanted the gator dead or alive, she said, "I want his hide."[30]

The incident was also written up in *Florida Wildlife*, under the heading "Alligators DO Attack!" Martha Belle explained what happened: "Pain shot through my arm when his jaws snapped shut. Suddenly he made a terrifying roll but lost his hold. Like a streak of lightning, he darted around me and then turned and started straight at me. I was frantic— I struck at his ugly mouth with my left hand. He grabbed me again and I felt a bone snap in my hand. Then, as if by magic, the 'gator turned and disappeared."[31] Martha Belle told reporters she planned to attend the premiere of *Mr. Peabody* that evening to tell the audience how it felt to get that close to an alligator.

Around ten o'clock that night, after the premiere, Hall Smith and Zaebst went down the river with a gun and shot the alligator.[32] They had the skin tanned. "Mother had this wonderful back room in her house back in Kansas City," said Penny. "Daddy had lived in Africa, and the room was filled with spears and everything. And over the bar was the skin of this alligator. People loved to go to her house because they got to see the alligator."[33]

News of the alligator attack surely couldn't have attracted mermaids to Weeki Wachee, which may explain

why, when Mary Dwight Rose showed up at the spring to enjoy her weeklong vacation as Florida's Mermaid Queen, she found that it was no vacation at all, but a week's worth of training. Undaunted—she had swum at Weeki Wachee weeks earlier, as an Aqua Belle—she went along. "I took the week's training, and then Frannie came up, and she took the training. My guess is Newt needed some swimmers." After the physical training, they had to take a written test. One of the questions had to do with skin diving. "Skin diving to me meant skinny dipping," said Mary, "and I was looking at that test, and I thought, skin diving?"

"And she put down 'swimming without clothes," said Fran.

"I probably did," said Mary.

"She warned me," Fran said, "'Watch out for the question on skin diving—that doesn't mean swimming without your bathing suit.'" Once they passed all the tests, they were bona fide mermaids, delighted to swim for Newt Perry. "He was a wonderful man, said Mary. "He was always smiling, always had a positive attitude; anything could be done. He just had this manner, he was really nice. I was proud to know him—this is the man who started Weeki Wachee."

"We got to meet and work for the Human Fish," said Fran.[34]

Giant Catfish, Eels, and Other Realities of Mermaiding

After Universal packed up and left, and after the alligator had been skinned and tanned, mermaid life at Weeki Wachee got back to normal. During the week while shows were going on, Perry took the tank he'd used for the pre-miere and trucked it around to hotels and resorts. The mermaids who traveled with him would show the crowds how they ate bananas and drank Grapette underwater. He also reprised his underwater fashion show for a Fox Movietone newsreel, *Queen of the Mermaids*. Fran and Mary signed on for that one too. "They put lacquer in our hair," Mary said, "and it was hard as a rock; there was no way those curls were going to move, and it took quite a while to get it out." Not only was their hair lacquered into rock-hard bouffants, they had to wear high-heeled shoes with weights in them, to keep not only the shoes but themselves down. Mary was crowned queen yet again.

Sometimes she and Fran would go to the theaters and one of the newsreels featuring them would flicker across the screen. "I'd hide," said Fran. But she couldn't hide from a photo made of her feeding the fish at Weeki Wachee. It was made into a billboard and added to every fishing license in the state of Florida. She even saw the picture when she went to France.[35]

Not to be outdone by the studios, Newt Perry wrote and directed his own film, the *Underwater Mermaid Ballet Show*, which featured a day at Weeki Wachee: tourists walking into the theater, girls wadding bread into clumps of dough and then feeding the ducks as they swim toward the spring. Nancy Tribble Benda shows up in the *Peabody* tail twirling and twisting mermaid style; the Aqua Belles perform underwater ballet and then swim to the surface, where they do a synchronized swimming act.[36]

By bringing the mermaids to Weeki Wachee and drawing the tourists and the film studios to the spring, the Human Fish had made an indelible mark on Florida. In his column

Tanya Barber White (*left*) and Mary Dwight Rose in the short film *Queen of the Mermaids*, 1948. By permission of Weeki Wachee. Courtesy of Mary Dwight Rose.

110—Weekiwachee Spring
on Florida's Gulf Coast Scenic Highway (U.S.

Frances Dwight Gioe, 1948.
By permission of Modern
Photographers. Photo by
Ted Lagerberg.

"Florida Sports Whirl," the writer Ash Wing featured an article written by Russell Kay, the secretary of the Florida Press Association. In "Weekiwachee's Underwater Ballet," Kay wrote:

> Florida can thank the amazing growth of her tourist business over the years largely to the faith, enterprise and effort of her attraction promoters. . . . without them, millions who now know and love the state, in all probability would have never heard of it. The publicity experience and "know-how" possessed by such men as Dick Pope of Cypress Gardens, Bob Eastman of Marine Studios, Pete Schall of Silver Springs and Newt Perry of Weekiwachee Springs has brought this state more priceless national advertising than it has gained from all other mediums combined.[37]

Then Kay goes on to single out Weeki Wachee, praising Perry for being an "enterprising chap with something different to enter the attraction field. . . . Getting away from the glass-bottom boat or diving bell as a means of presenting the springs, Perry conceived the idea of an actual underwater theater . . . where the humans are caged and the fish are free."[38]

By the time *Peabody* had come and gone and the writers had gotten used to the idea of an underwater theater, the mermaids had settled in at Weeki Wachee. Most of them either lived on the grounds of the spring in cottages or over in Brooksville. Nancy Tribble Benda stayed in Brooksville whenever she came down from Tallahassee to swim at Weeki Wachee. Since there wasn't so much as a mailbox at Weeki Wachee, she and the other mermaids would carry the mail back to Brooksville with them at the end of the day. "We'd entertain ourselves by reading postcards the tourists had written from Weeki Wachee," she said. "Time and time again there would be postcards from these guys that would say, 'This is the one that I took out last night,' or 'Let me tell you about this mermaid.'"[39]

The tourists weren't the only ones capable of mischief. Fran Dwight Gioe remembers pulling down the shades in the mermaid cottage she shared with her sister and playing penny ante poker to pass the time. Perry thought they were just innocents, turning in early. "[He] had the cottage right next to us, and a new mermaid would come in, and he'd say, 'Look at the Dwight sisters; notice how they go to bed early' . . . and she'd say 'huh?'"[40]

To spice up their lives in the middle of nowhere, the mermaids also had what they called the "safety pin club."

Nancy Tribble Benda in Newt Perry's short film, 1948. Modern Photographers. Photo by Ted Lagerberg. Courtesy of Bob Reed.

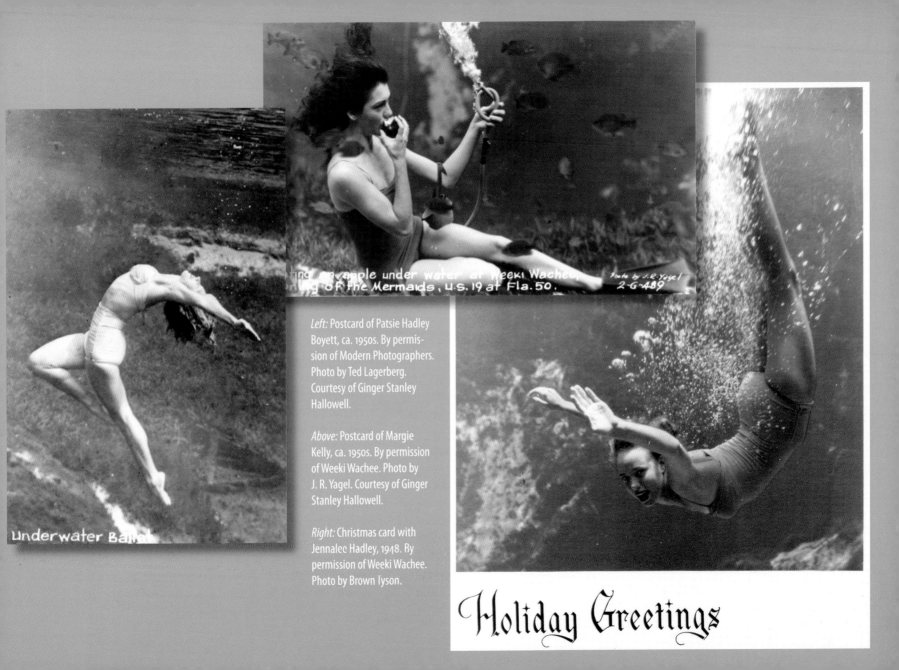

Underwater Ballet

Left: Postcard of Patsie Hadley Boyett, ca. 1950s. By permission of Modern Photographers. Photo by Ted Lagerberg. Courtesy of Ginger Stanley Hallowell.

Above: Postcard of Margie Kelly, ca. 1950s. By permission of Weeki Wachee. Photo by J. R. Yagel. Courtesy of Ginger Stanley Hallowell.

Right: Christmas card with Jennalee Hadley, 1948. By permission of Weeki Wachee. Photo by Brown Iyson.

ing an apple under water at Weeki Wachee, ng of the Mermaids, U.S. 19 at Fla. 50. 2-6-489

Holiday Greetings

Membership in this club didn't come free—the mermaid in question had to endure an embarrassing wardrobe malfunction. "That's when your straps break and your top falls down," said Dot Fitzgerald Smith, "or your bathing suit splits in the back or something. One time they were taking pictures of me for a magazine, and they kept banging on the windows. I knew they were banging, but I couldn't see what was going on, so I put on my face mask to see what was going on and my strap had fallen down." And so she was inducted into the safety pin club.[41]

The mermaids also quickly came up with pranks to play on the already gullible audience—they'd paid money to see mermaids, after all. One trick was to pretend to strip while doing the deep dive. Dot tried that one out on April Fools' Day, not realizing that Newt Perry was announcing the show. "I did the deep dive that day," she said. "I had put on a two-piece bathing suit and then put a one-piece over it, and when I got down [to the hole] I struggled out of that one-piece, and I mean it was a struggle—that current was pushing. I got out of that one-piece and put it on the hose and sent it to the top. Newt Perry didn't think it was funny at all."[42]

Another trick was to exploit the audience's naiveté regarding the mermaids' ability to hold their breath. The deep dive was the defining moment of every show. The sight of the mermaid plunging into the depths of the spring, the air hose being dragged up, sputtering a stream of air bubbles, lent the deep dive a lost-in-space quality complete with danger of mythic proportions. Jacques Cousteau hadn't popularized human ventures into the undersea world yet. People still gazed at Florida's deep springs with as much

wonder as had their nineteenth-century counterparts. The announcer played on the aquaphobia of the audience, often wondering out loud: "Where's the mermaid? Can you hold your breath with her?"

"If you dive everyday, your capacity builds and builds," Fran said. Mary agreed. She told how she and Fran would dive down then "wait and wait and wait and wait" to finally come up. One day, the two got to wondering just how long they could stay underwater. They dove down and let their air hoses go, then took their sweet time drifting back up through the water. When they came into the audience's view, they swam casually back and forth in front of the theater doing ballet. They'd been without air for three minutes.

Mary and Fran didn't realize that Hall Smith was announcing the show. "When we broke the surface," Fran said, "we heard him say, 'Mary and Frances Dwight, would you please report to the underwater theater,' and I thought, 'What did we do this time?' But the people were panicking because without realizing it they were holding their breath along with us. Mr. Smith said, 'Don't do it that long anymore.'"[43]

Even though the mermaids made performing eighteen to twenty-five feet underwater seem effortless, it wasn't. Because of the demanding physical requirements of performing at that depth, Perry was always on the lookout for mermaids. Some of the girls would leave because they developed ear or sinus infections. Others left because they couldn't handle the intense physical pressure of doing the deep dive. Or they couldn't stand the constant shivering from performing in the icy water. The mermaids' temperature would drop one degree for every fifteen minutes they were in the water. Sometimes they came awfully close to

developing hypothermia. If they didn't develop an aversion to the cold, cold water, they'd get married to some boy who'd found them in the middle of nowhere swimming in the Spring of Mermaids.

The sirens might have been luring suitors from all over the west coast, but Newt's concern was luring the sirens to Weeki Wachee. And what better place to find prospective mermaids than at a beauty contest? He'd landed Mary Dwight Rose over in Tampa when she won the Florida Mermaid Queen crown and her free week's "vacation" at Weeki Wachee. He spotted Ginger Stanley Hallowell walking across the stage at a beauty contest in 1949 and approached her with a similar proposition. "He said, 'I'm looking for mermaids, for girls to be swimmers who don't look like swimmers,' whatever that means," said Ginger, "and I said, 'Well, thank you—I think,' and he said, 'There's a training period; you could come over and see a show and see if you might like to do it.'" She ended up going over to Weeki Wachee to see what the shows were all about and found herself amazed. "I'd never seen anything as special or beautiful as all this going on in this gorgeous spring. You're in another world when you're down there in that deep, deep spring. Then it was natural; there were no props. Way across the spring there was an underwater stage with the air curtain. They had embedded two limbs in the spring where the mermaids would sit and eat; other than that there was nothing else. The fish were there; the turtles and alligators, and I thought, 'This is fascinating,' and by the time the show

Ginger Stanley Hallowell in beauty contest, 1949. Courtesy of Ginger Stanley Hallowell. Photo by E. A. Gruber.

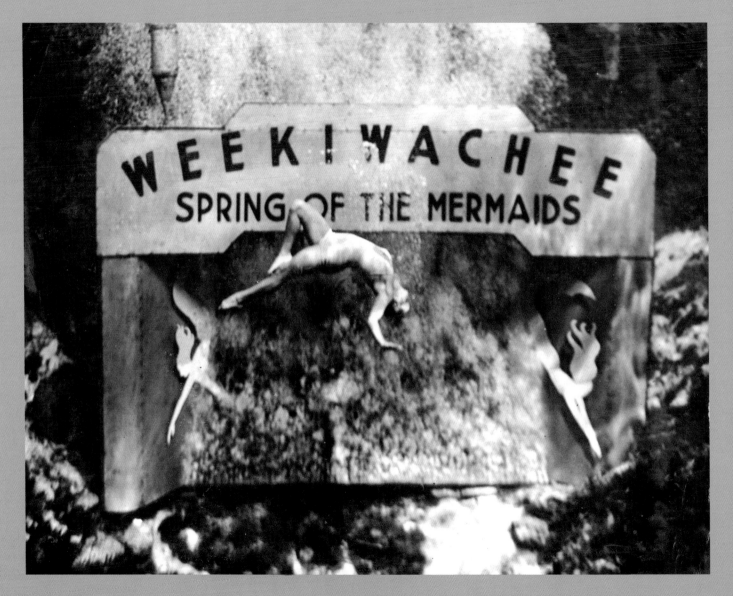

Mermaids perform in front of a bubble curtain, ca. 1949. Modern Photographers, New Port Richey, Fla. Photo by Ted Lagerberg. Courtesy of Dot Fitzgerald Smith.

was over I said 'yes.' And he said they would put me up in the Mermaid Villas, which were right behind the spring. I would have no expense; food and everything would be taken care of, plus a little spending money."[44]

Ginger went through the six weeks of intensive training and ended up doing three shows a day—that meant being underwater for three 45-minute-long shows per day. She and Ricou Browning did Weeki Wachee's first night show, *Aqua Fantasy*, with special light effects. "We wore silver swimsuits and actually painted our bodies silver," she said. "I had a silver swim cap; everything except my face was silver. Ricou sprayed me once I got into my swimsuit, and I thought, 'Is that real paint? How will I ever get it off?' It was terrible, but we did get it off."[45]

For the mermaids there were much scarier things to worry about than paint. Two in particular were the deep hole that formed the mouth of the spring and the creatures that lurked around it. A bar was jammed into the space above the hole and the mermaids would hook their legs around it during their deep dive, waiting for the moment to ascend. Former mermaid Elsie Jean Bell remembered wanting to go a little bit deeper. "I wedged my way down feet-first, and actually it was stupid of me. I'd never do it in a million years again; it scares me when I think about it, but I actually pushed my way down and put my legs into the hole." Later, she said her dad told her she could have gotten sucked in. After her experience with the hole, giant catfish were simply a nuisance. She remembered a huge catfish that lurked in a hole next to the bar. "Sometimes he'd come after you, and you'd whack him on the head with an

Marilyn Reed Webb at the Mermaid Villa, ca. 1950s. By permission of Marilyn Reed Webb.

air hose, and he'd go back into his hole. He was quite comical."[46]

Mary Dwight Rose remembers not one catfish, but many. "I remember going to do the deep dive, and I looked down and saw maybe twenty to twenty-five huge catfish, and I thought, 'I'm not going down there,' so I looked over at the announcer and drew a finger across my throat."[47] The creatures lurking below weren't always catfish. Once there was a water moccasin, another time there was a sea turtle, yet another time, a garfish. Gerry Hatcher Dougherty remembered eels. "There was this huge, huge eel down in there. He was back in this cave, and at first you didn't see him, and then you looked, and there was this big monstrous eel. He just disappeared like he appeared."[48]

Newt Perry was about to do the same disappearing act. Despite the crush of publicity he'd managed to bring to Weeki Wachee over the first three years: the newsreels, the features in *Life* and *Look*, the numerous newspaper articles and publicity shots, with its one-dollar admission, the attraction was not pulling in enough profit to satisfy the stockholders. Delee Perry said they thought too much money was going out, not enough coming in. Perry wrote a letter to Bob Gilham, one of the main investors:

Dear Bob,

This letter is going to be very difficult to write, but I feel that I should and I do hope you will read it carefully for what I say comes from the bottom of my heart and whatever I have done here at Weekiwachee has been done with the sole aim and purpose of making Weekiwachee a success. To say that my heart is crushed is putting it very mild.[49]

The letter suggests that although Weeki Wachee might have been an underwater fairy world to visitors, running it was another story altogether, one that wasn't profitable for Perry either. He noted that when he left Weeki Wachee, "I will have nothing but debts and thank goodness some very close friends." In his letter, he asks that he be allowed to "handle the publicity and distribution of folders in the Tampa and St. Petersburg area for the sum of $200 per month. That is enough for Dot and me to just live on." He wanted to put on glass-tank shows, secure and train mermaids, and continue to get free swimsuits for them. He wanted to give Weeki Wachee Spring $10,000 in service for the next few years in an attempt to appease the stockholders, whom he felt he had let down. "Weekiwachee has got to be . . . kept in the eye of the public," he wrote, "or else it will dry up on the vine just like Wakulla Springs and others who have failed to take every advantage of promotion and publicity."[50]

Brokenhearted but undefeated, Perry headed back to Ocala, became principal of a local high school, opened his own swim school, and began developing his own traveling tank show. A letter from Grantland Rice provided both consolation and encouragement:

When I selected you as "The Human Fish" and proclaimed you the best all-around swimmer in America I did not realize that you would go so far with the many unusual and novel stunts that you have perfected and presented to the public on film and in person. We consider you the Father of Underwater Swimming in its highly developed form and we hope that it will be our pleasure to continue to make Grantland Rice Sportlight Films on the new underwater

AQUARENA
San Marcos, Texas

Aquarena postcard. By permission of Texas State University, San Marcos, Texas. Photo by Bill Kobert.

routines that you are constantly working up. My staff and I wish you every success with your new Underwater Aquatic Theater show.[51]

In 1952, Perry traveled to San Marcos, Texas, to supervise the development of Aquarena Springs, an attraction located at the headspring of the San Marcos River. Texan A. B. Rogers had bought the spring back in the 1920s and built a hotel and a golf course. After a trip to Weeki Wachee, he decided he wanted to add glass-bottomed boats and mermaids too.[52] Of course he called Perry. An article in *Popular Mechanics* described the theater. Instead of being underwater like the one back at Weeki Wachee, it was situated above water, and then lowered forty-two inches below the surface

for each show. The shows featured diving ducks, fish-feeding "aquamaids," and a clown named "Glurpette."[53]

By 1953, Perry returned to Ocala, where he continued teaching swimming and working with his traveling underwater tank. In February, he and his third wife, Dot, a champion swimmer and diver in her own right, presented a show called "Breakfast with the Neptunes" featuring a complete underwater Crosley kitchen at the Florida State Fair in Tampa. Besides including a stove with glowing burners and a refrigerator with a lighted interior, the show also featured some of Perry's old standbys—the boys and girls would drink Cokes and eat bananas underwater.[54]

Perry's partner, Walton Hall Smith, left Weeki Wachee in 1952, said his daughter, Penny. He wanted to write an addendum to his book on liquor and maybe head back to Hollywood and get back into screenwriting. He died just a few years later.[55]

Swimming to Fame

Perry and Smith weren't the only people to leave Weeki Wachee after a few years. Several of their mermaid protégés shot out of Weeki Wachee like torpedoes. Mary and Fran got a call from Cypress Garden's impresario Dick Pope in 1953. "He said, 'I got a pool in the shape of Florida,'" said Mary. "'Can you come up here and teach our girls how to do synchronized swimming so they can open the pool officially? We'll teach you to water ski, and you can be in the movie *Easy to Love* starring Esther Williams.' We were scared to death. We had to walk past Van Johnson and say 'Good morning, Mr. Floyd,' and we never got it right—it was either

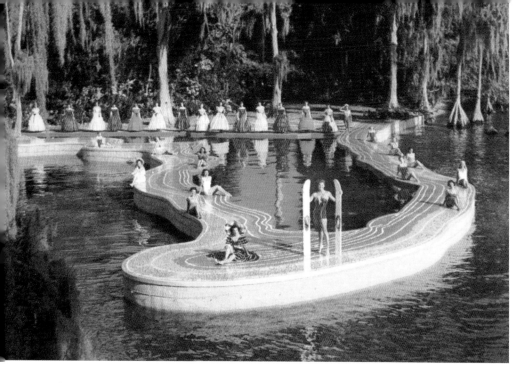

Esther Williams at the Cypress Gardens pool built in 1952 for the MGM production of *Easy to Love*. By permission of Cypress Gardens.

Lloyd or Freud or Floyd. The third time, we stopped him and said, 'Are you Mr. Lloyd or Mr. Floyd?'"[56]

After they did their stint at Cypress Gardens, they joined the International Water Follies and began traveling all over the world. Fran ended up at the Moulin Rouge in Paris, where she won rave reviews for her performance in the giant aquarium. "I did a whole underwater show by myself," she said. "I got the best review. There were other attractions in the show, variety attractions, we called them, and so we're all sitting out there after opening night waiting for the newspaper, and then whose picture was on the front page? Mine. The other performers said 'America' when they saw it,

and I said, 'Oh, when you're American you know how to do things.'" She ended up leaving because there was a huge strike, and she had her children with her. The owner of the Moulin Rouge called her after she left and said: "When are you coming back? You could've been here for fifteen years."

"I'm not coming back," she said. Fran may not swim in the tank at the Moulin Rouge anymore, but her days as a performer aren't over. These days she works at a retirement center, where she teaches synchronized swimming to people aged sixty to eighty. They perform an annual water show. Mary became a U.S. national champion in synchronized swimming and went on to develop her own national champions as coach of the Loreleis Synchronized Swim Team in Orlando. She helped synchronized swimming become recognized as an Olympic sport and currently serves as director of the sport for Florida's Sunshine State Games. Along with her late husband, Eddie Rose, "the World's Greatest Water Comedian," Mary was inducted into the International Swimming Hall of Fame.[57]

Ginger Stanley Hallowell and Ricou Browning would achieve a different sort of fame. In 1953, Silver Springs finally lured Ginger away from Weeki Wachee, featuring her as Silver Springs' very own "It" girl. She'd been going up there to swim on her days off, doing the occasional photo shoot with Bruce Mozert. Now she would be working at Silver Springs full time as a staff member of the public relations department who not only swam but modeled underwater and on land for film directors and photographers.

While at Silver Springs, she reconnected with Ross Allen, who encouraged her to go to New York, to seek bigger gigs. She landed one after the other. She doubled for Julie Adams

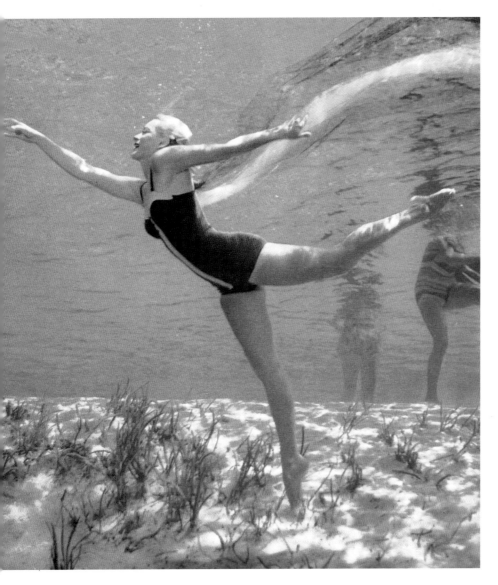

in *Creature from the Black Lagoon*, filmed at Wakulla Springs in 1953 with her former fellow merman Ricou Browning serving as the Creature's double. In 1954, she doubled for Esther Williams in *Jupiter's Darling*; later that year, she reprised her role in *Revenge of the Creature*. Not one to sit around in a dry room, she traveled to New York City in 1955 and splashed into CBS Studios, where Barbara Walters had gotten a big idea: Put Ginger in a tank where she will be the underwater weathergirl on the *Morning Show*. For two weeks Ginger woke at 4:15 a.m. to prepare for her 7 a.m. appearance in the studio, where she climbed into a giant aquarium adorned with a map of the United States. With a "special underwater crayon," she marked weather conditions on the map while chatting with Dick Van Dyke. "We kept it very simple," she said. "If it was snowing in the Rockies, I'd draw a snowflake over the Rockies."

While employed at Silver Springs, she appeared on *I've Got a Secret*, *What's My Line?*, and the *Garry Moore Show*, where she squeezed into a tank and ate a carrot on national television while Garry Moore stood by and joked, "She's spent more time underwater than most fish I know." She stayed at Silver Springs until her marriage in 1956. She's been modeling ever since—she even had her own television show in Orlando, *Browsing with Ginger*. These days she makes occasional appearances at film festivals featuring 1950s horror flicks, like the Creature series, which has become a cult classic.[58] Sometimes Ricou Browning can be enticed to show up as well, and they sign autographs on

Ginger Stanley Hallowell as Silver Springs "It" girl, 1955. By permission of Mozert Studios, Ocala, Fla. Photo by Bruce Mozert. Courtesy of Ginger Stanley Hallowell.

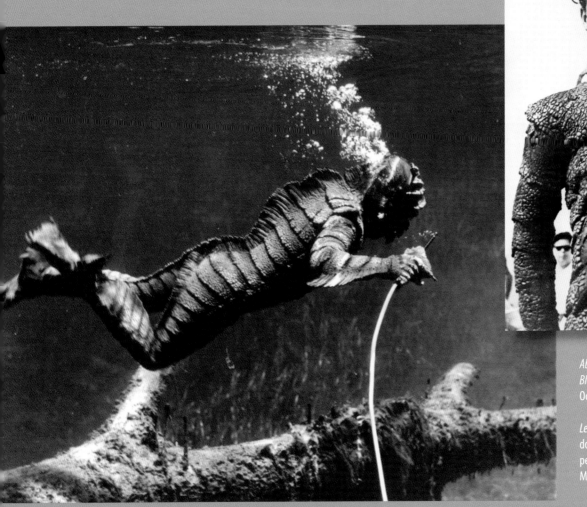

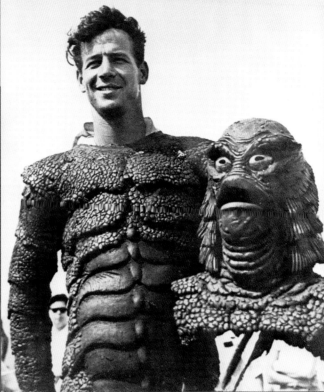

Above: Ricou Browning in costume for *Creature from the Black Lagoon*, 1954. By permission of Mozert Studios, Ocala, Fla. Photo by Bruce Mozert.

Left: Creature from the Black Lagoon underwater stunt double Ricou Browning uses the air hose at work, 1953. By permission of Mozert Studios, Ocala, Fla. Photo by Bruce Mozert.

black-and-white photos of Ricou dressed as the Creature carrying Ginger away. Both Ricou Browning and Ginger give credit to Newt Perry for launching them in their watery film careers. Ricou recalled being a student at Florida State University when he got a phone call from Newt Perry asking him to pick up a producer who was scouting locations at Wakulla for a film. Perry was in Miami and couldn't get home in time.

"There was a cameraman and the director," said Ricou, "and the cameraman wanted to film some shots underwater after he saw the spring from a glass-bottomed boat. He asked me if I'd swim in front of the camera so he could get some perspective on the size of logs and fish and grass in relationship to a human being, and I said 'Okay.' And they went down the river and shot the river. They loved the river because it's so beautiful, being an Amazon-type–looking place. They left. And that was the end of it." Ricou called Newt and told him the shoot had gone well. "About two weeks later I got a call from Jack Arnold, who was the director, and he said, 'Hey, we like the way you swim; how would you like to be the Creature? And I said, 'Creature of what?' And he said, 'We're doing a film about an underwater monster, the Creature, and we like the way you swim, and we want to know if you want to do it,' and I said, 'Why not?' And that started it."[59] It's remarkable, but not surprising, that Ricou Browning and the mermaids were able to parlay their stints as underwater performers into full-blown careers. After all, Annette Kellerman had done the same thing back in the 1920s, as had Esther Williams in the 1940s and 1950s. What's surprising is that they did it from the middle of nowhere.

Hernando County wasn't exactly hopping with career opportunities, especially for women. A girl either had to get married, leave Hernando County to go to college, or become a mermaid. For African American women, the possibilities were even more limited. Eighty-year-old Martha Delaine remembers the early days in Hernando County before Weeki Wachee became the Spring of Live Mermaids. "We went through some hard times back in the thirties," she said. "We couldn't go around like we do now. You couldn't go into the drugstore; and if you had to go in, you'd have to get what you wanted and go back out. Those were tough days."[60]

In 1952, Martha and her sister-in-law Gussie Washington both got jobs at Weeki Wachee. They'd never been to the spring before. Both women said the local African Americans swam and fished in Hernando County's Horse Lake. Gussie Washington got a job as cook in the Patio Restaurant. Getting to the spring from Brooksville was an adventure in itself: "One or two of us had cars, and we'd have nine or ten people riding in a car. We'd be stacked three high in the back, sitting in one another's laps. Frances Coburn had a car; she was a waitress. The employees were paying for a ride, and they put it in a pool and saved up enough to buy a station wagon and later a Volkswagen bus. We'd meet uptown under the pecan tree. We'd have to find a way to get there, and that's where they'd pick us up and let us out. The mermaids didn't ride the bus; it was the waitresses and the maids."[61]

Martha worked in the gift shop. "I worked all the way around," she said. "I'd sell and keep stock up. Everyone was nice to me. Two other [African American] girls worked with

me, Clyde Logan and Nora Lee Haygood. I loved working there; it was a good job."[62]

Gussie, seventy-five, who has traveled to Europe and all over the United States since she left Weeki Wachee in the 1970s, claims she found the secret to getting along in less than agreeable circumstances. "A lot of times I'm with someone who doesn't even speak English, and I help them and they help me." She found the same camaraderie at Weeki Wachee. "I miss it all. A lot of the mermaids I miss, because everybody was like one family. Everybody worked together and helped one another. If the mermaids or the waitresses or anybody got to where they needed help, they helped each other."[63]

Even though Weeki Wachee's employees helped each other out personally, in the 1950s, Jim Crow still ruled the South. Weeki Wachee Spring, the business, was no exception. "Back in '52 we couldn't go in the dining room and eat," said Martha. "We carried our lunch, and later on they had a building down there where the employees could go at lunchtime and sit in there and eat their dinner. If you wanted anything from the restaurant, you had to go to the back door."[64]

Every Christmas, Gussie said, management at Weeki Wachee threw a party at the restaurant for all the employees. She and the other African American workers had to stay in the kitchen. But that all changed when Charlie McNabb took over as restaurant manager. Just like in Newt Perry's film, the tourists were flocking in to Weeki Wachee by then, even though the spring was still practically in the middle of nowhere. "When the restaurant opened up, people would be lined up for two miles, from north and south,"

said Gussie. "They would be waiting to get in to the restaurant and to the theater to see the mermaid show."[65]

Charlie McNabb was married to Flo Gothberg McNabb, a mermaid trainer. Her parents, the Gothbergs, were two of the tourists who came to Weeki Wachee in the 1950s for a visit. Mr. Gothberg took one look at the lines of cars outside of Weeki Wachee and saw an opportunity: he would build a "Mermaid Motel."

"My grandfather was a successful air-conditioning contractor who lived in Birmingham, Alabama, and he and my grandmother had been looking to relocate," said David McNabb, Flo and Charlie's son. "They saw the boom coming in Florida. They wanted to buy in early and be there in advance. Highway 19 had just been built." Since Florida was in the midst of the postwar tourist boom and tourists traveled mostly by car, the Gothbergs built a motor court, something David said was "scandalous" at the time. "It was hard to convince people that it was family-oriented," he said.[66] The neon mermaid on the sign probably didn't help matters. After the Gothbergs built the motel, their son-in-law Charlie left his job as restaurant manager over in Silver Springs and took over as manager of the Patio Restaurant. That was good news for the African American workers who'd been relegated to the kitchen during the Christmas parties.

"When Charlie McNabb took over in '53 or '54," said Gussie, "he came to us and told us that we didn't have to stay in the kitchen during the parties. That we were somebody. He said, 'Come in to the party.'" Although they were allowed to join the mermaids and other employees at the annual Christmas party, they still had to observe the Jim Crow laws when they went into the theater. Gussie and

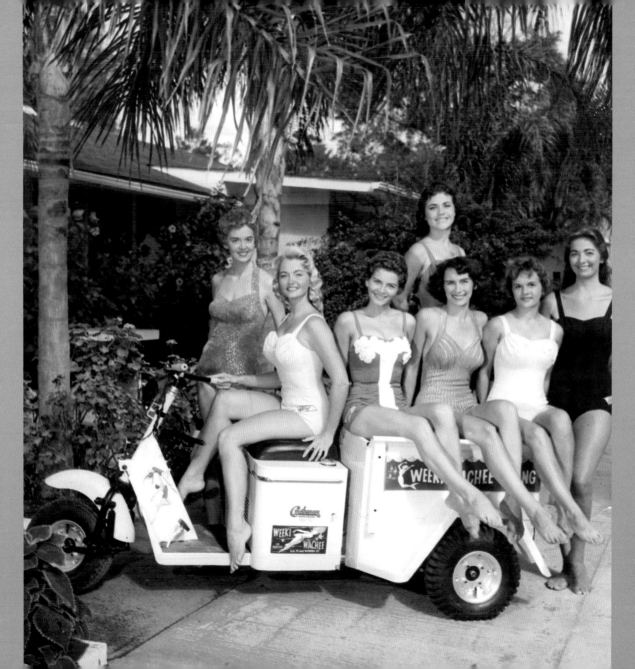

Left to right: Joan Gately (*standing*), Florence Gothberg McNabb (*seated*), Lou Sikes, Bonnie Georgiadis, Vicki Vergara Smith (*standing*), Shirley Walls, and Jeanette McDonald, ca. 1953. By permission of Weeki Wachee. Courtesy of Bonnie Georgiadis.

Mermaid Motel, ca. 1950s. Modern Photographers, New Port Richey, Fla. Photo by Ted Lagerberg. Courtesy of Florida Archives.

Martha and the rest of the African American men and women who worked at Weeki Wachee may well have been the only people of color to have seen those early shows. "When they had the theater, we could go, but we always had to sit in the back," said Gussie. "If we weren't doing anything and wanted to go, they'd allow us to go see the show, or go see the Birds of Prey, or go down the river on the boat. The first time I saw an alligator mating, it was down the river. [Later] they had the museum with all types of butterflies and insects. I went there too; we could go to anything they had for free."[67]

When she wasn't watching the shows on her breaks, Martha said she could look out the windows of the gift shop and watch the mermaids practice their routines on the grass. "When I started," Martha said, "Bonnie [Georgiadis] and Genie [Westmoreland Young] were there. They were the best swimmers, and they put on the best shows."[68]

The "Bonnie" Martha referred to is Bonnie Georgiadis, one person who really took mermaiding to heart. She gave Weeki Wachee Spring thirty-seven years of her life. "I went to school in Tarpon Springs," she said, "and my sister's classmates were among the originals: Mary Darlington, Mary Anne Zeigler, Barbara Clark. They worked up there for nothing, or maybe they got gas money. Since they were going to school, most of them were working on weekends. We went up and watched the show, and when I saw it, that was it. I had to be that; I had to do that. And then I told my Aunt Margie I was going to do it, and she said, 'You could never do that.' That settled it. I started in 1953, my junior year of high school. I drove thirty miles up, thirty miles back—sixty miles a day for thirty-seven years." To top it off, she even gave birth to a mermaid. Her daughter, Sue, slipped into a fishtail in 1973 and swam for three years.[69]

Bonnie went from doing the deep dive to hobnobbing with celebrities like Marty Milner and Arthur Godfrey to being the choreographer, to being the head of the spring's bird department. She got to observe the goings on at Weeki Wachee from a fish's-eye view. She was on hand in 1954 when Esther Williams came to Weeki Wachee to shoot a scene for *Jupiter's Darling*, a film set in Rome. "They built a tower over what is now Buccaneer Bay, with a ramp," said Bonnie. "They had a horse go up the ramp. Ricou's sister, Shirley Woolery,

Preparing for *Jupiter's Darling* horse stunt on ramp at Weeki Wachee, 1953. Courtesy of Marilyn Reed Webb.

sat on the horse's back, and the platform ramp tilted down, and the horse jumped into the water. Shirley was kicked by the horse when she separated from him. Esther posed for a few pictures beside the water. but she didn't go underwater; she had a problem with her eardrum."[70]

The horse and Shirley Woolery weren't the only ones who had trouble during the filming of this movie. Ricou Browning doubled as one of the Roman soldiers who chased mermaid Mary Kleinkopf down into the deep hole in one scene. She made the descent on one breath of air. "She was an extremely low breather who always turned the pressure on her air hose way down," said Bonnie. "Because of the unions, they wouldn't let one of us be in the hole to hand her the air hose when she got there, and one of the Hollywood people handed her a hose that was on full blast, and she couldn't get a breath, and she passed out and had to be carried up. They laid her in the grass, and she came to and was all right."[71]

In the 1950s, Esther Williams was the Queen Mother of swimming. Some of the mermaids secretly dreamed of being discovered at Weeki Wachee, of becoming a star like Williams. Ginger Stanley Hallowell got as close to being Esther Williams as humanly possible when she doubled for her over at Silver Springs. "I was made up to look like her," Ginger recalled, "and people were stopping me all the time thinking I was Esther Williams, saying 'Would you sign this?' Well, I would sign, but I wouldn't sign her name, and they'd look at it and say, 'Who is Ginger Stanley?' and I'd say, 'I'm her swimming double,' but they thought they had Esther's signature until they read my name."[72]

Besides meeting her own future husband at the shoot,

Ginger met Esther Williams's husband at the time, Ben Gage. He arrived at Silver Springs to throw Esther a birthday party and invited everyone, including the extras. "He said, 'You're the best swimming double Esther Williams has ever had.'" said Ginger. "I took that as a wonderful compliment."[73]

Having Esther Williams drop by for a visit more or less sealed Weeki Wachee's fate as one of The Places to Go. Howard Hughes visited in 1955. It's likely he'd been over at Silver Springs, where he'd just presented the world's first underwater premiere featuring his newest film. Aptly titled *Underwater*, the film was a skin-diving adventure with the voluptuous Jane Russell in the starring role. Audience members wore aqualungs and swimsuits, and they actually waded into the spring, where they sat amidst the turtles in an underwater amphitheater. The benches had to be anchored down. None other than Newt Perry and his wife, Dot, were on hand, Dot as an "usherwet" and Newt as escort and bodyguard for the starlet Jayne Mansfield, who was "discovered" at the event.[74] Bill Ray, whose father, W. C. Ray, helped develop Silver Springs, told a reporter that when Mansfield "put on a swimsuit and walked out on to the beach . . . the men couldn't help but notice her appeal."[75] Delee said her mother wasn't very happy about Newt's job as bodyguard to the starlet.

Apparently not having gotten enough *Underwater* entertainment, Hughes dropped in on Weeki Wachee for his very own mermaid show. Mermaid Ruthann Skinner was asked to perform for him. "I swam a show and went over the top and asked him to come and swim with me," she said.[76] Apparently he declined. Maybe he was unsure about the water quality. He shouldn't have been.

Ginger Stanley Hallowell (*right*) doubles for Esther Williams at Silver Springs, 1953. By permission of Mozert Studios, Ocala, Fla. Photo by Bruce Mozert. Courtesy of Ginger Stanley Hallowell.

Ruthann Skinner Manuel, ca. 1953. Modern Photographers, New Port Richey, Fla. Photo by Ted Lagerberg.

NBC arrived at Weeki Wachee in 1955 with over two hundred people to film a segment for Dave Garroway's *Wide Wide World* at Weeki Wachee. It was to be the "first live, underwater show, ever to be televised."[77] However, once the film crew got to the spring, they discovered that the water was so clear, the underwater scenes didn't look like they were underwater. It was a replay of a centuries-old observation about the springs; that the water is as clear as air, a repeat of the debate between newspaper editors back in '47 over the underwater swing-set scene, except this time NBC wasn't going to depend on the viewers to see a few bubbles. Like the crew of *Mr. Peabody* had done years earlier, they hired wardens from the Florida Freshwater Fish and Game Commission to go out and scoop up a couple of thousand fish to dump into the spring to make sure there was no mistaking that the shots were underwater.[78] The only problem was that the fish wouldn't cooperate, swimming everywhere except in front of the cameras. "You're a fish," Bonnie Georgiadis explained. "You're scooped up with all your other buddy fish, and you're dumped into a place you've never been before. Where's the first place you're gonna go—are you going to swim over to those mermaids and start eating bread? No, you're gonna hide."[79]

"Well," said Genie Westmoreland Young, former mermaid supervisor, referring to the problem the clear water presented, "that was Hollywood for you—bring in the fish." To make sure it was clear that they were indeed filming underwater, she joked that the mermaids "had to practice saying 'glub glub' every once in a while."[80]

Ruthann Skinner Manuel swam that day. "They wanted me to do the deep dive, and they wanted me to do it over the boil where the spring comes out because I could do a 100-foot dive from the surface on a breath of air and go down. Then they said, 'We'd like her to take her mask off and do it,' and I wouldn't be able to see where I was going or anything. I said, 'That's impossible; I just don't want to do that.'"

But when Patsie Hadley Boyette, the mermaid supervisor, said, "Okay, we'll get someone else," Ruthann buckled down. "I said, 'Fine, I'll do it!' So I went up to the top, and I took a deep breath, and I took my mask off, and I swam. I think I did it ten times. My cue was 'cue the fish,' and every time they'd cue the fish I'd swim down to the deep hole."[81] Before Ruthann did the deep dive, the camera panned the spring. A trio of hula dancers swayed and swiveled in one shot, while in another a couple of mermaids sat on a tree limb eating. Dave Garroway did the voice-over: "This is guaranteed to be the first time on television you've seen a girl eat a banana underwater."[82] A sailor swam by, and the camera moved over the eel grass to a corner of the spring where Bonnie had just begun an "Apache Dance" with Patsie Boyette's husband, Bud, who announced shows when he wasn't swimming.

"It was very exciting because I was quite new, and I'd never done a television show before," said Bonnie. "The Apache Dance was one breath long; that's how long your part lasted. I had on this split skirt and beads and high heels. Bud would reach out and grab my wrist, and I would twirl in, and he would envelop me in his arms and I would twirl out and do a knee-back dolphin up into his arms again, and we kissed, and that was the end, then BREAK for

Bonnie Georgiadis, left, and Donna South perform underwater hula dance, ca. 1960s. Courtesy of Bonnie Georgiadis.

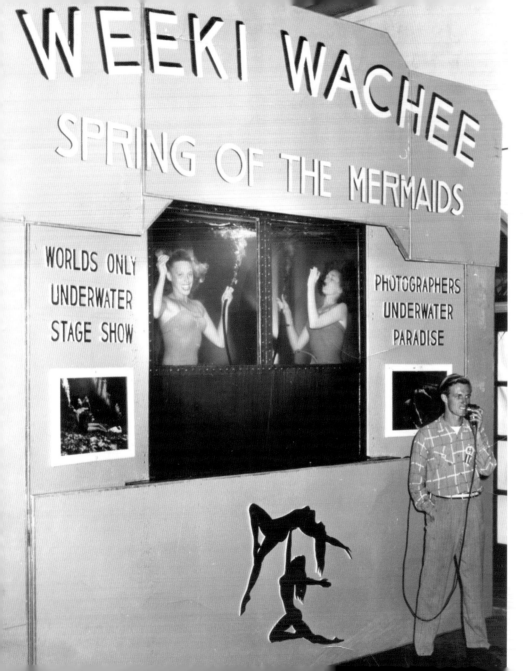

Silver Springs postcard. By permission of Silver Springs.

air. At the time my husband was up in Gary, Indiana, working in the steel mills, and he saw me on television and came home. That was part of my intent."[83]

The mermaids also had brushes with fame away from the cameras. Elsie Jean Bell remembers meeting crooner Eddy Arnold in the late 1950s. "He was secretary of the Nashville Vols baseball team, and they took their spring training in Brooksville. At the time I had my son; he was about three, four months old, and I had just gone back to swimming, and I was living with three other mermaids, Nell, Tammy, and Judy. And Judy was crazy—a typical blonde. She came home one evening and said, 'Hey, guess who's down at Mom Tracy's—that was a local juke joint in Brooksville—and we said, 'Who?' and she said, 'Eddy Arnold' and Sam, the

Patsie Hadley Boyett performs in traveling tank while husband, Bud Boyett, announces, ca. 1950s. Courtesy of Patsie Hadley Boyett.

guy who rented the house to us, said 'Well, Judy, call Mom Tracy up and ask to speak to him and ask him out. I'll let you use my new Cadillac to go pick him up.' So Judy goes to the telephone, calls Mom Tracy's, and he gets on the phone, and she says, 'We're having a party; we're all mermaids out here. You wanna come?' And he says, 'Sure,' and she says, 'I got a black Cadillac convertible,' and so she went down to Tracy's, and about thirty minutes later she comes back with Eddy Arnold, his publicity manager, Herschel Greer, and about six of the ball players. I called Mary Sue, and we got up some girls to come down. Sam had a guitar there, and Eddy sang songs to us. He came out to the spring and picked me up nearly every day he was here for two months. He gave us free concerts every night, and we'd cook supper. He loved fried chicken."[84]

Weeki Wachee wasn't just attractive to crooners like Eddy Arnold. James May, an internationally known British insect collector, decided to set up shop at Weeki Wachee in 1955, bringing along twenty thousand of his most prized specimens. His "Tropical Museum," featured insects from around the world such as the tropical lantern fly, complete with red headlight and green taillight, and the morpho butterfly from the Amazon, whose brilliant blue wings could be seen flashing in sunlight from half a mile away. Then there was the nine-inch-long, quarter-pound Hercules beetle from the West Indies that, incredibly, despite its weight, was clocked flying though the air at forty miles per hour.[85]

The highlight of the show had to be the gigantic fake rhinoceros beetle perched up on the grounds in front of the

Mary Sue Wernicke Clay sits atop May's giant beetle, ca. 1955. Modern Photographers, New Port Richey, Fla. Photo by Ted Lagerberg. Courtesy of Bonnie Georgiadis.

Shirley Walls, Bonnie Georgiadis, Joan Gately, and Terry Ryan Hamlet (*left to right*) in front of May's Museum of the Tropics, ca. 1955. Modern Photographers, New Port Richey, Fla. Photo by Ted Lagerberg.

museum. Beetle-brown and shiny, at about ten feet tall and twenty feet long, it looked like something out of a science fiction novel set in Florida's future, when outsized sculptures of monkeys, dinosaurs, and alligators would be commonplace sights alongside roadways.

Clearly, Newt Perry and Walton Hall Smith had left Weeki Wachee just a bit too soon. With all the attention Weeki Wachee was getting from Hollywood and New York, it was just a matter of time before Florida State Theaters Inc., whose parent company was none other than the American Broadcasting Company/Paramount Theaters, would arrive check in hand and gussie the place up for the 1960s.

Ironically, in 1954, Leonard Goldenson, CEO of ABC/Paramount, struck a deal with a couple of brothers named Walt and Roy Disney. Disney lore has it that Walt got the idea to create Disneyland in California after visiting an amusement park and noticing how grungy the whole affair was. He wanted to create a super-clean park where the patrons would feel like guests.[86] He sent his brother Roy on a mission, touring the country and looking over various tourist spots, and he ended up in Winter Haven, where the Swami of the Swamp, Dick Pope, had opened Cypress Gardens in 1935. The story goes that Pope noticed a man standing near the gate counting people as they went in.

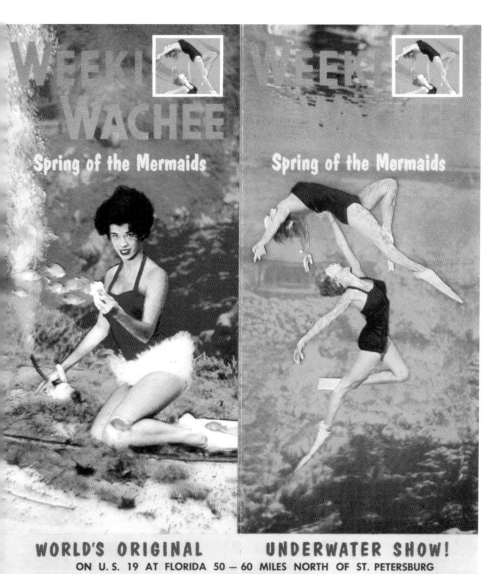

WEEKI WACHEE

Spring of the Mermaids

Spring of the Mermaids

WORLD'S ORIGINAL UNDERWATER SHOW!
ON U. S. 19 AT FLORIDA 50 — 60 MILES NORTH OF ST. PETERSBURG

Luggage sticker from Cypress Gardens. By permission of Cypress Gardens.

Pope walked over and introduced himself. The man was Roy Disney.

Apparently Disney wasted no time calling his brother to tell him what he'd found. "Walt," he began, "I'm down here with a guy named Dick Pope back in the woods of Central Florida, and all he has is some flowers and girls and he's drawing 2,500 to 4,000 people a day!"[87]

The idea of constructing Disneyland was launched, and ABC/Paramount struck a deal with the brothers, agreeing to loan them the money to build Disneyland for a share of the profits. So it wasn't a stretch for ABC, which was just finding its way in the burgeoning television market, to pick up Weeki Wachee five years later. Who knows? Maybe Goldenson took one look at that giant rhinoceros beetle and those lovely mermaids and thought Weeki Wachee had the makings of a Disneyland with its giant teacups and flying elephants.

Anne Tappey Tomlin graces cover of a 1950s brochure. By permission of Weeki Wachee.

6

The Sixties

From Elvis to Don Knotts

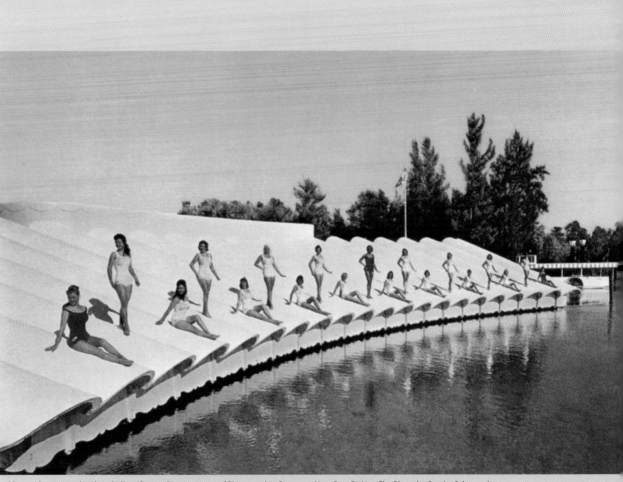

Mermaids pose on the clamshell roof, 1960. By permission of Photographic Concepts, New Port Richey, Fla. Photo by Sparky Schumacher.

On a hot summer day in 1961, a long white Cadillac convertible pulled into the parking lot at Weeki Wachee. The door opened, Elvis Presley stepped out, and a thousand girls sighed. He was there to see the mermaids, and he dressed for the occasion, wearing a natty black suit and a white tie even though the air was hot enough to melt tar. He was filming *Follow That Dream* over in Crystal River, where he played Toby Kwimper, a young man who homesteads a piece of Florida paradise with his makeshift family, much to the chagrin of government officials. They couldn't quite get past Toby's Converse All Stars, his blue jeans, or his guitar.[1]

The *St. Petersburg Times* sent cub reporter Lynn Chako, a high school senior, over to Weeki Wachee to cover the King's arrival. "Elvis Presley Kissed Her Four (Sigh) Times" read the headline. Chako described spending time with Elvis as being similar to "taking a friendly walk with a forest fire." Outside the theater, a crowd of about four thousand adoring fans stood on tiptoe to get a better look. A chain-link fence had been erected to keep overly enthusiastic girls from storming the King. Young women had driven down from New York City, from Kansas. Pinky Clough, the Tri-City Suncoast Fiesta Queen, showed up in her swimsuit to get her kiss and an autograph from Elvis.[2]

Mermaid Marilyn Reed Webb was there that day as well. She snapped photos of Elvis as he stood in the parking lot surrounded by fans. "I think every girl in the state of Florida came to see him. Thousands," she said. "He spoke to every one he could, shook hands, let them take his picture. That was at the beginning of his career. He was just a pleasure to be around. I got to kiss him on the cheek. And I got an autographed record album that my sister swears I gave her. But

I don't believe it."[3] Her father, Bob Reed, Weeki's operations manager, was there as well. He remembered Elvis being as nice and polite as he could be. "He kissed every girl on the beach," Reed told one reporter.[4]

Once inside the theater, Elvis walked down the aisle to the window. Two mermaids bobbed in the spring holding a life-sized black-and-white cutout of Elvis. Another mermaid swam close to the window, holding a placard that read "Elvis Presley's Underwater Fan Club." According to one report, he "was genuinely awed" by the mermaids.[5] He went to the mermaid lounge after the show. Naomi McClary, who swam at Weeki Wachee for that one magical year, said that Elvis was nervous about meeting the mermaids. "We were all in the lounge area of the villa and Elvis was escorted in with his hands up in front of him. When he realized that we were not going to attack him, he sat down between Bonita and me. He held my hand and I thought he was going to rub my knuckle off, he was so nervous. He had attended the show and was amazed at our talent and lung capacity for holding our breath. We were amazed that Elvis, the King of Rock and Roll, was so humble and genuinely nice to us."[6]

Elvis didn't limit his attentions to the mermaids. Martha Delaine, who worked in the gift shop, also got a chance to meet him. "[Meeting Elvis] was something great for me because I'd never seen any movie stars," she said. "I got a card of his, a postcard with a picture of a gold Cadillac."[7] After wowing the crowd, Elvis cruised down the river. Taken with the beauty of the scene, he asked spring manager Jack Mahon why he "hadn't built this near Madison Square Garden where there's a lot of people?" Apparently, he thought the spring's water was piped in.[8]

Sandy Lawliun and Florence Gothberg McNabb flank a cutout of Elvis Presley, 1961. By permission of Photographic Concepts, New Port Richey, Fla. Photo by Sparky Schumacher.

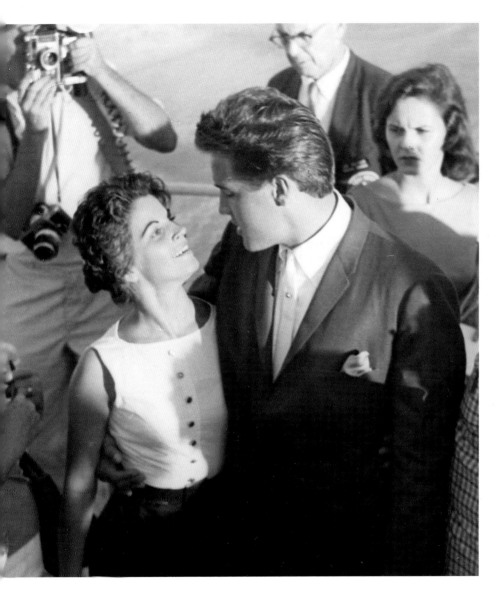

Confused or not, Elvis had a point. Weeki Wachee was still in the middle of nowhere. In spite of its location, though, by the time Elvis drove over from Crystal River, the park wasn't suffering from a lack of tourists. The mermaids were performing up to nine shows a day during peak seasons to full houses. After the American Broadcasting Company bought the attraction in 1959, they hired Miami architect Robert Collins to design and build a new theater that would seat five hundred people, one of the many improvements in a five-year program that manager Joe Seltzer said would "make Weeki Wachee one of the foremost tourist attractions in the United States."[9]

ABC executives headed to New York in search of a choreographer for their newly planned show only to be told that the best choreographer in the business was living just seventy-five miles away from Weeki Wachee in Sarasota.[10] She was Lauretta Jefferson, better known as "Jeff" to her friends. Lauretta Jefferson might have been a novice when it came to working with mermaids, but she wasn't a novice where choreography was concerned. She'd begun her career in dance as a Radio City Music Hall Rockette and precision-kicked her way to Broadway choruses, where she was tapped to help the director. She ended up in San Francisco as choreographer for the world-famous Billy Rose Aquacade. Then, after setting out on her own for a while, she was hired by the Ringling Brothers Circus to "arrange the dance patterns" for their "spectaculars."[11] And arrange them she did. For the "Dance of the Seven Veils," she, along

Lou Sikes looks adoringly up at Elvis Presley, 1961. By permission of Photographic Concepts, New Port Richey, Fla. Photo by Sparky Schumacher.

Interior view of
Weeki Wachee's
million-dollar
theater, 1960.
By permission of
Weeki Wachee.

with Robert Ringling, evoked the "Ziegfield heyday," as one reviewer noted, with its "Rockette style chorus in checker-board velvets of orange, yellow, purple, red and green with ostrich plumage fore and aft." Sometimes her dancers were elephants.[12]

She finally decided to retire and moved to Sarasota. Her retirement lasted one year. Then she became mermaid supervisor at Weeki Wachee. The first thing she did was double the number of mermaids from ten to twenty. The *Sarasota Herald Tribune* reported that she chose the new "girls" on the basis of "sinkability, coordination and attractiveness and an ability to relax."

"Some of the heaviest objects on land shoot right to the surface when you try to submerge them," Jefferson said. "With the girls, it's hard to tell. Some sink easily."[13]

Then, of course, there was the fish factor to contend with. The mermaids had to be calm enough not to panic when a fish decided to nibble them. Jefferson was impressed with one mermaid from up north who smoothly performed her role in a show with a garfish staring her right in the face. When she surfaced, the rest of the mermaids commented on her unflappability. "What?" she said. "If I had known it was a garfish, I'd have fainted. I thought it was an alligator."[14]

While Jefferson trained the new mermaids, the construction of the theater was getting under way. In one of the biggest "highway moving jobs ever undertaken in Florida," the construction crew hauled enormous prefabricated steel sections, along with the windows, each of which was six feet high and two-and-a-half inches thick, from a plant in

Bartow. The 75-mile trip took four days. At Weeki Wachee the sections were welded to steel frames and sunk into the spring. Divers welded and bolted the window frames together underwater.[15] Plumes of smoke rose out of the water like fog from all of the welding.

The construction crew had to move the old theater to make way for the new. "They took out the enormous weights that were holding the old theater down." said Bonnie Georgiadis. "Then they floated it over to the south bank of the spring and put bricks on top of it, stacks and stacks of bricks."[16]

In the meantime, management brought in a glass-bottomed boat from Silver Springs, and the mermaids performed underneath it. Bonnie described the difficulties of performing under that docked glass-bottomed boat. "We had to hold our air hoses away from the bottom of the boat because the bubbles bursting on the glass would obliterate us. We'd stick our heads out from underneath the glass part and take a breath. We would eat and drink; we'd do the mermaid crawl sideways, back and forth across each other, and we'd pose for pictures. The announcer was a mermaid, and at the end of her announcement she would dive into the springs and swim across to the Mermaid Villa."[17]

The finished theater, "built like a battleship inasmuch as it would float if not anchored," according to a Weeki Wachee "Fact Sheet," was beautiful.[18] To complement the mermaid theme, the concrete roof was cast in waves like a clamshell, and inside the theater, beneath the gigantic windows, a tile setter had created a classic 1960s mosaic with a school of pink, green, and blue, cubist-inspired fish. Five hundred

Lauretta Jefferson instructs Marilyn Reed Webb, Bonnie Georgiadis, and Vicki Vergara Smith at the ballet barre, ca. 1960. By permission of Weeki Wachee. Courtesy of Bonnie Georgiadis.

Construction of theater, 1959. Courtesy of Bob Reed.

guests could be seated in air-conditioned comfort in plush seats with armrests, "duplicating . . . the finest on Broadway."[19]

However, Broadway actors probably never had to worry about how they would get onto the stage. Before ABC rebuilt the theater, the mermaids would either dive off the top of the theater or swim into the staging area from across the spring. Someone got the idea to construct a sixty-foot-long tube that snaked from the theater into the spring. The mermaids would drop into the tube, then magically appear in the spring. Some mermaids, having gotten used to diving

directly into the spring, found the tube daunting. They had to take a deep breath, drop into the black hole, then swim sixty feet through the dark, claustrophobic tube grasping for the air hoses as they went.

The innovation that created the most changes for the mermaids, though, was the introduction of an underwater sound system. "[Before ABC] we had a two-person show, occasionally three," said Bonnie. "It was more of a demonstration, because we couldn't hear music underwater. We'd do an arabesque, a knee-back dolphin, then a swan. If you thought of some new routine all by yourself, you did it.

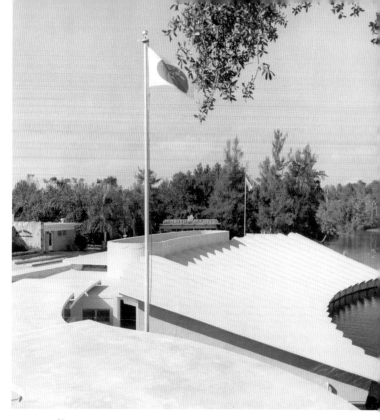

Construction of theater, 1959.
Courtesy of Bob Reed.

Then we could hear, and that changed everything. They had visions of a chorus line of thirty girls. Of course, it never got that far, but it was part of the dream."[20]

Jefferson worked with electronic engineers to fine-tune the underwater sound system so she could communicate with the mermaids. They found that men's voices were too low to carry into the spring—the announcers would have to be women. Once the kinks in the sound system were worked out, Jefferson put the mermaids through the paces underwater, teaching them to perform acrobatics and ballet

to music.[21] "She was the one who gave the original girls a basic understanding of ballet that they used throughout the years," said Bonnie. "She would've been the fountain-head of that."[22] The water was so clear that in photographs taken of their practices the mermaids look as though they are pirouetting through space.

On October 14, 1960, Farris Bryant, Florida's Democratic nominee for governor, flew to Weeki Wachee, where he presided over ribbon-cutting ceremonies at the new theater. As the cameras whirred, Bryant snipped his ribbon while a

Thea Whitehead Jorgenson directs from the control booth as Suzi Spencer looks on, ca. 1960s. By permission of Weeki Wachee.

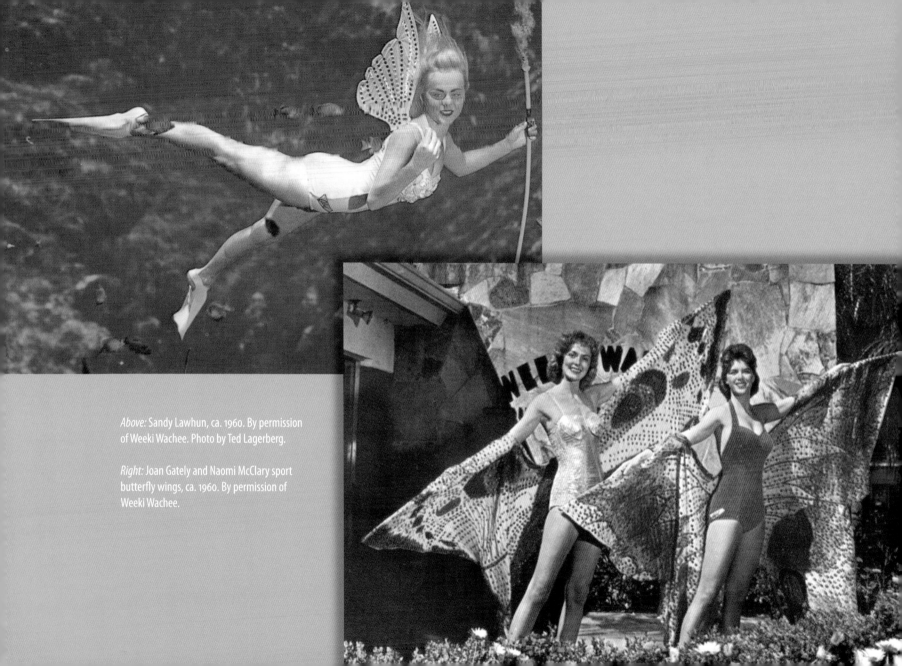

Above: Sandy Lawhun, ca. 1960. By permission of Weeki Wachee. Photo by Ted Lagerberg.

Right: Joan Gately and Naomi McClary sport butterfly wings, ca. 1960. By permission of Weeki Wachee.

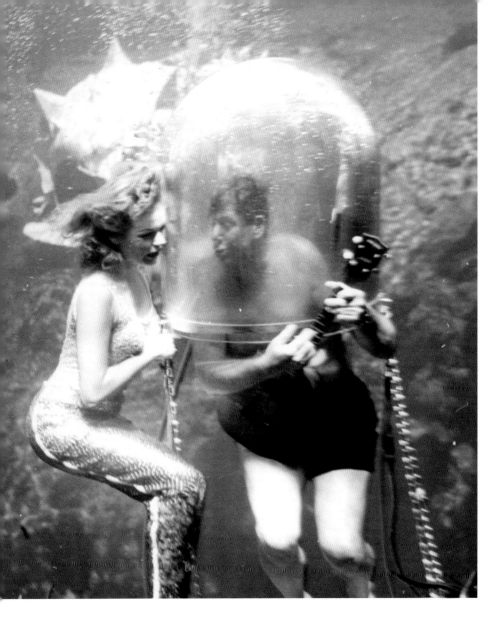

mermaid dressed in a yellow swimsuit and butterfly wings hovered in the water just on the other side of the glass and cut her own ribbon. The theater opened to the public a couple of weeks later.[23]

For what would be her first and last show at Weeki Wachee, Jefferson revisited Newt Perry's territory, as well as her own circus past, adding a comedy routine worthy of a Grantland Rice Sportlight newsreel. Max Weldy, who had worked for the Folies Bergère in Paris and for the Ringling Brothers, designed the costumes, and Skip Cumber, who also worked for the Ringling Brothers, designed the props. In a review of the show, a reporter noted, "The [Underwater Circus] show now includes the Butterfly Ballet, the Strong Man Act, the Underwater Tightrope Act, the Spangled Tails, and the famous Living Mermaids." In the Butterfly Ballet, mermaids dressed as yellow butterflies hovered over giant flowers, secretly inhaling air from hidden tubes. The new show also debuted Weeki Wachee's first motorized prop: Wiley Willie, a giant dragon that would pull the mermaid back and forth in front of the theater.[24]

Not long after the new theater opened, Arthur Godfrey was inspired to don a swimsuit and dive into the spring toting his ukulele for a live television special called "Gurgle along with Godfrey." He ducked under an airlock Bob Reed had built just for him, strummed his ukulele, and sang "Minnie the Mermaid" to Bob's daughter, mermaid Marilyn Reed Webb. "He was there for several days," said Marilyn, "and he even took all of us up in his DC 4 airplane and flew

Arthur Godfrey serenades Marilyn Reed Webb in "Gurgle along with Godfrey," 1961. Courtesy of Marilyn Reed Webb.

1960s brochure. By permission of Weeki Wachee.

Florida's WEEKI WACHEE

Spring of live mermaids

ARTHUR GODFREY says "Weeki Wachee is one of the Seven Modern Wonders of the World!"

North of Tampa, St. Petersburg

Florida's underwater grand canyon

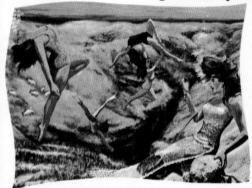

World famous LIVE mermaid show!
Completely new show every year!

Over 10 Million Visitors Agree it's the WORLD'S GREATEST UNDERWATER SHOW!

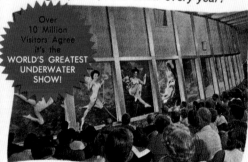

THE LIVELY, LOVELY MERMAIDS perform against an awesome backdrop of underwater caverns and mountains while you sit 16 feet below the surface of this crystal clear spring!

Unbelievable Excitement and Thrills!

WEEKI WACHEE
U. S. 19 and FLA. 50
Weeki Wachee, Florida

BOB HOPE says, "The live Mermaids are the greatest at Weeki Wachee."

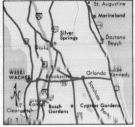

America's Greatest Underwater Spectacle

An unforgettable experience. Your trip to Florida is not complete without seeing this beautiful and unique attraction. Shows daily from 9 to 5, rain or sun.

TED MACK says, "This is the finest underwater talent in the world."

Catalina swim suits and play clothes are exclusively worn by the Weeki Wachee Mermaids!

Adventure Cruise

Enjoy the Congo Belle Adventure Cruise . . . See the river described by Sports Illustrated Magazine as "the most beautiful, primitive, untouched river in Florida!" See native animals and the natural beauty of Florida!

See Wildlife

Seminole Indian Chief, Billy Osceola says, "This river trip reminds me of the old times."

Wilderness Trail

Climb aboard the Wilderness Train and head for the wilds of Weeki Wachee. Now see the real Florida in its primitive, untouched beauty.

WE RECOMMEND THESE FLORIDA ATTRACTIONS ASSOCIATION MEMBERS:

Belim's Cars & Music of Yesterday	Jungle Larry's Safari	Monkey Jungle
Busch Gardens	Lightner Exposition	Oldest Store Museum
Circus Hall of Fame	Lion Country Exhibit	Parrott Jungle
Early American Museum, Inc.	MGM's Bounty Exhibit	Potter's Int'l. Hall of Fame
Edison Winter Home	Marineland of Florida	Rainbow Springs
Everglades Wonder Gardens	Masterpiece Gardens	St. Augustine Alligator Farm
Florida Cypress Gardens	McKee Jungle Gardens	Sarasota Jungle Gardens
Florida's Silver Springs	Miami Seaquarium	Six Gun Territory
Florida's Sunken Gardens	Miami Serpentarium	Stephen Foster Memorial
Homosassa Springs	Miami Wax Museum	Tiki Gardens, Inc.
International Deer Ranch		Weeki Wachee

Florida's Two Great Natural Wonders . . . *Weeki Wachee and Silver Springs*

BE SURE TO PLAN A FULL DAY AT WEEKI WACHEE . . . SEE EVERYTHING FOR THE HIGHLIGHT OF YOUR FLORIDA VACATION

us over the Kenilworth Hotel in Miami that he owned. I got to sit in the cockpit with him." Godfrey was so taken with the mermaids that after he left, he stayed in touch, sending Christmas cards and letters, champagne and perfume.[25]

ABC was able to draw lots of celebrities besides Elvis to Weeki Wachee—one of the brochures produced during the ABC years includes blurbs not only from Arthur Godfrey but from Bob Hope, who wrote, "The live mermaids are the greatest at Weeki Wachee." Scientist Wernher von Braun said, "Your show is like our last rocket; it is out of this world." And always quick with a pun, mystery novelist Mickey Spillane said, "No mystery why it is Florida's greatest attraction."[26]

The mermaids benefited from ABC's Hollywood connections as well. Like a lot of the other mermaids, Bonnie had her moments of television fame with ABC affiliates. In those pre–reality television days, being on television meant something. Thirty percent of American households didn't even own a television, but when they did, they frequently tuned in to watch *What's My Line? I've Got a Secret*, and *Missing Links*. The mermaids were a shoo-in to get on these shows, and not just because of ABC. How many people could say they were mermaids?[27]

Meanwhile, the management of Weeki Wachee continued executing the five-year plan they'd begun in 1960 to "make Weeki Wachee one of the foremost tourist attractions in the United States." They hired Jack Mahon as publicity director, and they hired the nationally known naturalist John Hamlet, who'd cowritten *Birds of Prey of the World*.

John Hamlet at his Indian outpost, ca. 1960s. By permission of Weeki Wachee. Courtesy of Barbara Smith Wynns.

His job was to restore landmarks they said were hundreds of years old: "the Trader's Landing, the Indian Camp and the Indian sailing canoe, which was discovered in the river by the Brooksville Explorer scouts."[28] The staff at Weeki Wachee sank the canoe again, so tourists could see it when they took the glass-bottomed boat downriver. When he wasn't restoring landmarks, Hamlet inventoried the wide variety of native plants on the lands surrounding the spring, plants that could, as a New York Times reporter noted, "keep a person alive indefinitely if he could not make it to a hot-dog stand on the highway." The writer was thoroughly impressed when Hamlet made a lunch menu using plants and animals found at Weeki Wachee:

> staghorn sumac lemonade, a flower salad made of violets, red buds and grape shoots, and for the main course, a stew containing squirrel, rabbit, gopher, turkey, golden club root, yellow pond lily roots, arrowhead roots and yucca flower buds, seasoned with bay leaves and Colt's foot salt. For dessert there was rolled Spanish bayonet pod sweetmeats with yaupon holly leaf tea.[29]

Building a new theater, launching a new show, and sorting out Weeki Wachee's flora and fauna was just the beginning for ABC. The company also rehired Miami architect Robert Collins, who'd designed the new theater, to carry out their vision: they wanted to surround Weeki Wachee with stone mermaids. Together, they commissioned Ed Lach, a concrete manufacturer who specialized in creating decorative architectural items, to do the job. Lach hired sculptor Gene Eley of St. Petersburg to create the statues. After three months of trying to design a mermaid au naturel (using

swimsuited Nancy Harkness as a model) that wouldn't upset station-wagon loads of families, Eley got it right. The mold was made, and a dozen topless mermaids were cast—at a cost of $4,500.[30]

Unlike their stone counterparts, the Weeki Wachee mermaids did not go topless. But they were issued falsies. "Everybody lost their falsies at one time or another," said Bonnie, "and they'd go drifting up in view of the audience, and you'd go 'Oh' and dash up and snatch 'em back." If that wasn't bad enough, there was the embarrassment of being caught squeezing the water out of the things after a show. "The first thing you'd do when you got up in the hot room was lean over the drains and squeeze your falsies while you're still wearing them," said Bonnie, "and sometimes guys would be in there, and they would watch all that water pouring out and say 'oh.'"[31]

Not only did the real mermaids not go topless, they did not wear fishtails. The arrival of the stone mermaids was the first time since Mr. Peabody was made in 1948 that mermaids with fishtails graced Weeki Wachee.

But the mermaids would not be tailless for much longer.

Stories in the Spring: Off-Off-Off Broadway

Despite Lauretta Jefferson's innovations, she wasn't able to satisfy ABC with a second show, and they let her go after about a year and a half. They hired Jack and Marilyn Nagle to take over. The Nagles had started as a dance team, then moved to Miami and began producing musical comedy shows. Marilyn Nagle Cloutier had grown up in Louisville, Kentucky, where she'd taken dance lessons, and learned

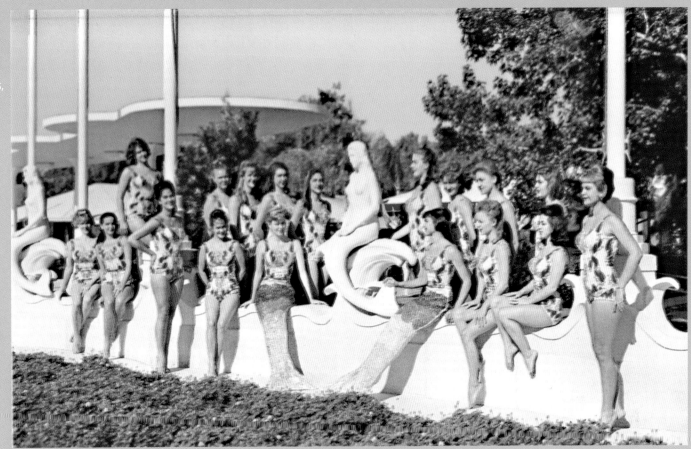

Mermaids with statues, 1966. By permission of Weeki Wachee.

to swim in a quarry that had been turned into a swimming club. "Of course I went there every day," she said, "and trained as a swimmer, mainly on the back stroke. When I was twelve, my parents, my coach, and my dancing teacher all got together and said: "You've got to choose. What do you want to do? Do you want to be a swimmer or dancer? You can't do both." So I decided at that point that dancing would have a longer life and be more profitable than swimming. Although in those days there was the Billy Rose show, the Aquacade, I chose dance. But I had always been a strong swimmer, and that was what brought me into Weeki Wachee."[32]

She and her then-husband Jack produced Broadway musicals at the Deauville Hotel in Miami for seven to eight years. "We were off-off-off Broadway, but we were an equity company. We did night club shows; we worked for Lou Walters, who was Barbara Walters's father. He was the producer of all the Latin Quarter shows. So we did the choreography and production for the hotels in Miami. The manager of the Olympia Theater in Miami knew we were doing these shows, and he was also connected in some way with Weeki Wachee, and he knew that I had a swimming background. He thought it would be a good tie-up."[33]

The Nagles moved up to Weeki Wachee, staying there over the summer to work on routines. "When we went to Weeki Wachee," said Marilyn, "I started to give the girls basic dance forms, which they already had to a great extent, but we would work out routines on the land rather than in the water so that they could get what I felt was the proper look when they were in the water. And then they would get in the water, and we'd work it through. Having the sound booth was great because I could talk to them while they were in the water. We had to do trial and error, and if something didn't work, we'd change it, and that's where Bonnie [Georgiadis] and Genie [Westmoreland Young] were helpful; they could try things out; they knew what they were doing a lot more than I did. They were very receptive to most anything."[34]

"[Marilyn and Jack] were professionals working with professionals before they got to us," Bonnie said, laughing. "They worked with dancers on stage, and then they came up here and, well, a lot of the girls had just come out of the woods. A lot of the girls who'd come out of the woods could be really good, and then there's the other kind. Jack would get mad if we weren't perfect."[35]

Captain Carol Parrish also remembered the Nagles as being a lot more demanding than Lauretta Jefferson. She mermaided at Weeki Wachee from 1963 to 1965 and then again from 1983 until 1989, when she began piloting the *Princess Wondrous* riverboat. "The Nagles were very, very strict; you never knew when they'd show up," she said. "They'd watch a show and critique it and let you know exactly what they expected of the show and what they expected of their performers. They were perfectionists."[36]

Besides insisting on perfection, the Nagles introduced several changes to the shows at Weeki Wachee. "The biggest difference [between performing on land and in the water]," said Marilyn, "was that you had to breathe at some point. So we had to incorporate into the routines a time to go and take a breath. One of the first things we did there was to have flowers with air hoses attached to them; the pistil of the flower would actually be an air hose. We did that

Terry Ryan Hamlet, Cheryl Rhoads Wood, and Bonnie Georgiadis (*front row*) rehearsing for *The Mermaids and the Pirates*, ca. 1962. Courtesy of Bonnie Georgiadis.

routine to 'Yellow Bird.' The girls would do a couple of pieces of choreography and then go down to the flowers and take some air."[37]

Bonnie remembered using a fiberglass conch shell with a little tiny air tank in it. "We'd push off the bottom of the spring, rise up, put the conch shell to our lips and . . ."[38] Genie added, "Pray for air."[39]

"That little tiny tank had three breaths in it at the most," said Bonnie, "so you'd go up; the music would be 'dududududu,' and you'd pretend to blow this thing, and then you'd do a back dolphin with one arm, and come back up and take a breath, and then you'd have to do something else, and then something else. The third breath generally wasn't there, and then you'd dash down to the air chamber so you could take a breath."[40]

Not only were the tanks small, but they were difficult to use. "Now on that trip around in the dolphin," said Genie, "when you took that breath you counted on, sometimes you got all air, sometimes you got air and water mixed so you're trying to separate the two with a cough. Then when you go backward and your face mask leaks, you get water up your nose, and you get one of those ice cream headaches, and you cry, 'I'm not gonna do this anymore.'"[41]

In spite of the fact that the audience could see the mermaids suspended underwater, their bodies arched into poses like back dolphins, some people had a hard time believing their eyes. They couldn't understand how the mermaids could perform a 45-minute show underwater

Genie Westmoreland Young with a *Mermaids on the Moon* prop, 1969–70. By permission of Weeki Wachee. Photo by Sparky Schumacher. Courtesy of Bonnie Georgiadis.

Artwork from a 1960s brochure.
By permission of Weeki Wachee.

without surfacing. "One lady had the whole thing figured out," said Bonnie. "She said, 'There are at least three breaths inside that face mask.' She didn't realize you'd suck your eyes out of your head if you tried to inhale while wearing a mask. People would be adamant about the show not being real. They'd think the theater windows were aquariums with little fish in them and that we were suspended out there on strings and there were big fans blowing our hair. It'd be much easier just to put a show on underwater. The people who appreciated our shows the most were the divers because they knew how difficult it was, and they couldn't believe we could do it without weights."[42]

After their success with "Yellow Bird," Marilyn said she and Jack wanted to "do more than just have number, number, number like a dancing school recital. We wanted to have a show that was a story. So we started producing story shows, and one of the first was *Alice in Waterland*. The

girl who was playing Alice would dive off the roof of the theater into the spring and fall into the stage area; then she would meet all of the characters from *Alice in Waterland*, like Tweedle Dum and Tweedle Dee."[43]

The rehearsals for the new show were labor-intensive. At the time, Marilyn said, twenty-five mermaids were on the underwater staff, but only five could be used in each show. "Each one of those girls had to learn each part, so if we had five parts and twenty-five girls, we'd have to go through a hundred and some-odd rehearsals," she said. "A girl had to do every part; she couldn't just be Alice every time, she had to be Alice, and she had to be Tweedle Dum or Tweedle Dee. They had to double, so to speak."[44]

Ironically, reporter Thomas Rawlins, writing about the upcoming premiere of *Alice in Waterland*, opened his article with this line: "Even Walt Disney didn't have troubles like these." He wasn't referring to the difficulties of training

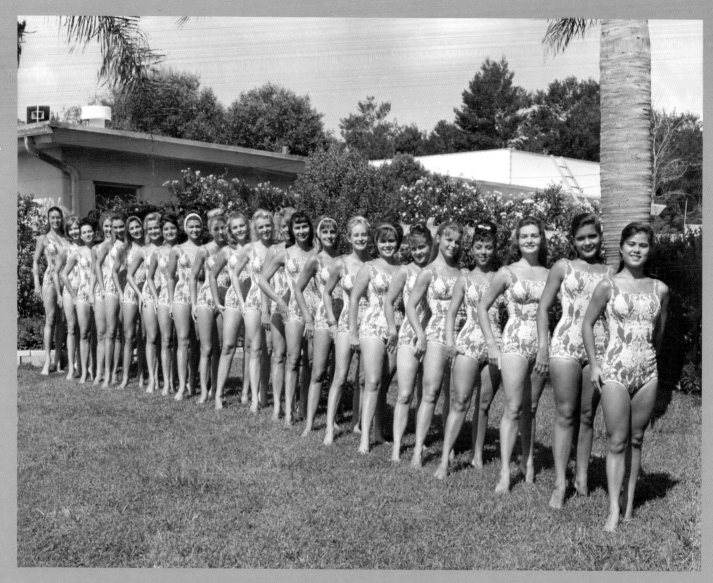

Twenty-five mermaids for five roles, ca. 1960s. By permission of Photographic Concepts, New Port Richey, Fla. Photo by Sparky Schumacher. Courtesy of Bonnie Georgiadis.

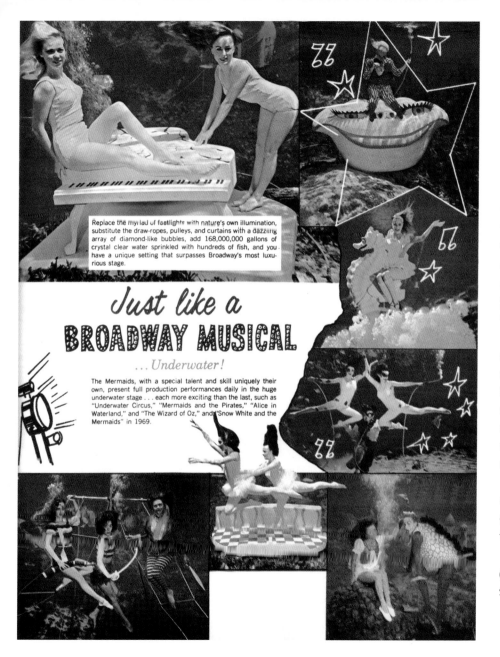

Replace the myriad of footlights with nature's own illumination, substitute the draw-ropes, pulleys, and curtains with a dazzling array of diamond-like bubbles, add 168,000,000 gallons of crystal clear water sprinkled with hundreds of fish, and you have a unique setting that surpasses Broadway's most luxurious stage.

Just like a
BROADWAY MUSICAL
...Underwater!

The Mermaids, with a special talent and skill uniquely their own, present full production performances daily in the huge underwater stage . . . each more exciting than the last, such as "Underwater Circus," "Mermaids and the Pirates," "Alice in Waterland," and "The Wizard of Oz," and "Snow White and the Mermaids" in 1969.

twenty-five mermaids to do five separate parts but to the difficulties of creating costumes on land for use underwater. Colors and fabrics didn't always translate. Reds would dull to brown; grass hula skirts would float upward like seaweed. Also, changing costumes underwater while hanging onto the air hoses required the mermaids to possess the agility and nerves of a Houdini.[45]

For *Alice in Waterland*, Skip Cumber made a giant mad hatter head for one of the mermaids to wear, and he built a throne for Alice. Genie was Tweedle Dee. "We had stomachs with tanks in them," she said, "and those were big enough to get you through the routines. The stomachs were made of fiberglass and shaped like a big vest. There was a little pocket inside the stomach where the tank fit in, and then you'd pull the regulator out and breathe off of it through the arm hole or something like that."[46]

The show also featured two giant caterpillars that rose out of the spring on a lift. "We would be in the caterpillar sticking out from our waist up and talking to Alice," said Bonnie. "Then you'd become a butterfly and squirm and wiggle and come out of the caterpillar. We had these rubber wings, and we'd sing, 'We're butterflies.' Dragging those wings around was bad; you'd be kicking and not going anywhere."[47]

Allen Scott, who worked as an underwater maintenance man from 1966 to 1970, said the prop makers would start generating ideas about props a year before they needed them. "Whenever they needed something done they didn't

Captain Carol Parrish riding a seahorse from program brochure, ca. 1960s. By permission of Weeki Wachee. Courtesy of Bonnie Georgiadis.

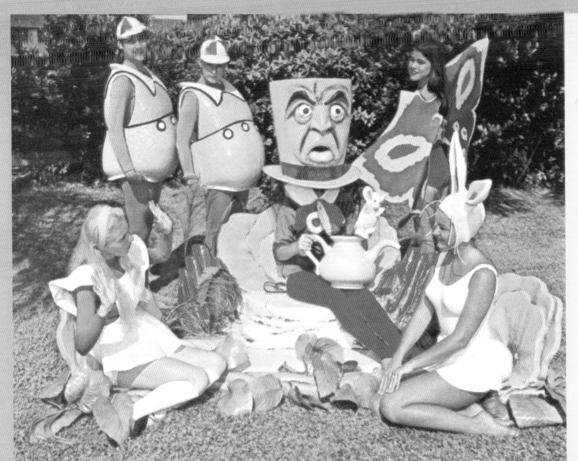

Alice in Waterland post-card (*left to right*), Genie Westmoreland Young, Terry Ryan Hamlet, De De Palmer, Rita McKenna, Tammy Gyarmathy, and Diane Fry, 1964. Florida Natural Color, Inc., Miami, Fla. Photo by Sparky Schumacher.

WEEKI WACHEE *Presents* **"ALICE IN WATER- LAND"**

Underwater boys Bill Moran and Allen Scott, 1971. By permission of Weeki Wachee. Courtesy of Allen Scott.

spare expenses. The props were made in Sarasota or Venice; they were constructed out of electrical conduit welded together and covered with a fiberglass skin, with an out-coating of fiberglass in whatever color they wanted it to be. No matter how much you scrubbed them, they maintained the color. Some of those props survive today," Allen added. "Bubbles the Seahorse was used in *Alice in Waterland* in about '64, and it's still being used. It's been patched and repatched and coated and painted over to match the original."[48]

One of the Nagles' next shows was called *The Mermaid and the Pirates,* which featured a sunken treasure ship and huge oyster shells that rose from the bottom of the spring on hydraulic lifts. They were designed by Skip Cumber and seemed to have been inspired by Botticelli's *The Birth of Venus.* The shells opened to reveal mermaids lounging inside. "They were used during a 'Me and My Shadow' routine," said Bonnie. "Being inside was like getting in a trunk and closing the lid. But you could push up on the shell and open it. It wasn't bad; after all, you had your air hose with you."[49]

The Nagles also instituted a night show to entertain the tourists, who, once they got to Weeki Wachee, had nowhere else to go. "The girls weren't particularly anxious to go into the spring at night," Marilyn said. "It's scary enough to go into the spring without it being pitch-black. This is where Bob Reed and Skip came in. They set up banks of lights underwater so we could light different areas of the spring individually, and you could flash them on and off. We used 'Rites of Spring,' but we called it 'Lights of Spring.' I don't think

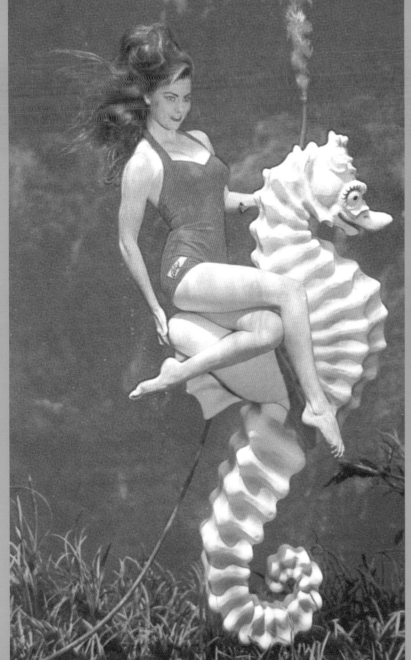

Above: Mermaids pose with a collection of props, ca. 1960s.
By permission of Weeki Wachee.

Left: Bonita Colson rides "Bubbles" the seahorse, ca. 1960s.
By permission of Weeki Wachee. Photo by Ted Lagerberg.

The Mermaids and the Pirates (*left to right*), Suzi Spencer, Linda Salgado, Genie Westmoreland Young, and Bonnie Georgiadis, 1962. Florida Natural Color, Inc., Miami, Fla. Photo by Sparky Schumacher.

many people got that; how many people know Stravinsky? There are cues in that music, and if you listen, you can hear them. And what we did was flash the lights in the spring. It was mostly just lighting up parts of the spring, like *Dancing Waters*. Bubbles would go up from one place and then another. And we'd light them up. It wasn't too successful."[50]

The Nagles did have success with another innovation they introduced. Up until their arrival, the mermaids had never performed wearing tails; they had always worn swimsuits or ballet leotards with tutus. Not surprisingly, one of the first pieces the Nagles created was a tail the mermaids could wear even while doing the deep dive. Up until then, with the exception of the $20,000 *Peabody* tail, the tails were either too buoyant or too unwieldy to swim in.

"I knew about flippers and the way a body could move in the water," said Marilyn. "That was one of the reasons they hired us—I knew something about weights and balances in the water and how you could move in water and what effects you could get with things. The tail worked well. With the proper movement—the fish movement or the ripple movement—the tail worked well with flippers and also looked nice. They could slip into it in the underwater dressing room or down in the deep hole. They could put it on or take it off depending on what they were doing."[51]

Genie Westmoreland Young said the first tail the Nagles created had zippers on each side and a bib that went around the mermaids' necks to hold it on. Later, they dropped the bib and fitted the tails around the mermaids' waists. "The base of the material was a canvassy cloth, and then they hand-stitched in some metallic green and blue sequins all over it," said Genie. "They would last about a month. They were extremely expensive."[52]

The novelty of the tail-wearing Weeki Wachee mermaids must've caught the eye of Stirling Silliphant, a writer for *Route 66*, the classic television show that followed a couple of guys as they tooled down Route 66 in their Corvette,

stopping here and there to have adventures with the locals. In 1963, Marty Milner and crew arrived at Weeki Wachee to film an episode called "The Cruelest Sea of All." Tod and Linc get jobs at Weeki Wachee, where the locals just happen to be mermaids. A strange girl shows up in the water claiming to be "from the sea," and Tod falls for her even though he suspects she's just trying to get attention to jumpstart a movie career. Diane Baker starred as the mermaid, and Genie doubled for her in the underwater scenes. "The costume they fixed for Diane Baker was a two-piece suit," said Genie, "and they put some plastic foliage and flowers and stuff all over it so it looked like she was wearing the jungle."[53]

Genie wore the same costume. "It had to be sewn on and then I had to stay in it all day till the end of the shooting," she said. "When they do things like that, there's a lot of dead space when you're in the water not doing anything, waiting for the sun to come out from behind the clouds or something. We were freezing normally doing three shows a day with a space in between to warm up. I about died being in the water that long."

Besides nearly developing hypothermia, Genie said there were other difficulties with the role. "They wanted the girl playing Lisa to swim underwater in mermaid fashion, but they didn't want me to wear fins or a mermaid tail—just that flowery bikini with the plastic grass stuff, so I didn't feel too comfortable doing a mermaid crawl in that without fins. I couldn't really go anywhere in that costume."[54]

But she did.

Marty Milner did his own underwater work for the show. Bonnie remembered him as being very gentlemanly. "He

Shirley Walls, ca. 1961. Florida Natural Color, Inc., Miami, Fla.
Photo by Sparky Schumacher.

Mermaids Bonnie Georgiadis (*left*) and Nancy Fisher cut up behind the scenes,, ca. 1960s. Courtesy of Bonnie Georgiadis.

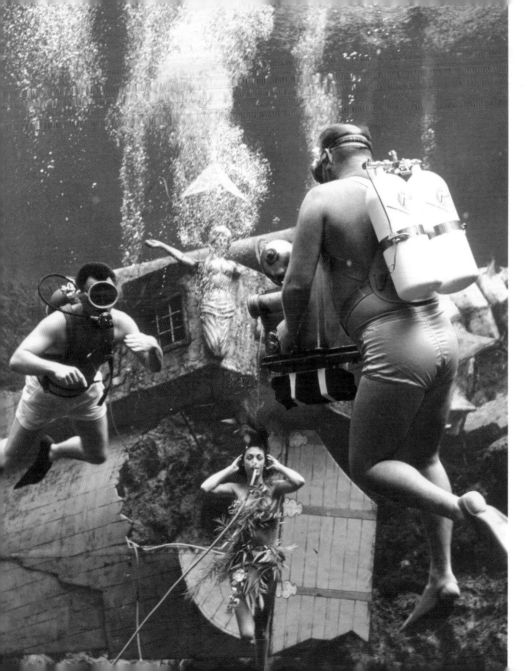

was very happily married," she said, "His father in law was a jeweler out in California, and he sent Marty a gold mermaid with a pearl, and he gave it to me."[55]

Television stars weren't the only ones showing up at Weeki Wachee. In January 1964, a year after Genie did the deep dive in her *Route 66* jungle suit, Warner Brothers showed up. Apparently forgetting that Howard Hughes had staged one ten years earlier at Silver Springs, the studio announced it would stage the World's First Underwater Premiere featuring *The Incredible Mr. Limpet*, the story of a man who wishes he were a fish and then gets his wish when he falls into the water at Coney Island. Actually, they could have billed it as the first underwater premiere where the audience stayed dry. Some of the audience members at Hughes's premiere had actually donned aqualungs and waded into the spring, where they watched the film underwater.

"It was exciting," said Bonnie. "We put on a special show for all the stars. They had a screen underwater, and the projector was in the theater. If a fish swam in between them, it would block out the screen. I wasn't in the theater during the premiere because I was going to be in the water immediately following it. I drove an underwater dolphin; one of the mermaids was sitting on it waving at everyone. I had my picture taken blowing a kiss to Don Knotts. He was in the theater; I was in the water." She laughs, suggesting that Don Knotts wasn't her first choice for a smooch, "but when you're cold, and isolated all the time . . ."[56]

Genie Westmoreland Young in *Route 66*, 1963. By permission of Weeki Wachee. Courtesy of Brabara Smith Wynns.

The premiere of *The Incredible Mr. Limpet* viewed underwater at Weeki Wachee, 1964. By permission of Weeki Wachee.

The day of the premiere, a convoy of Greyhound buses filled with all the stars and their hangers-on drove up to the entrance of Weeki Wachee, where they were met by "mermaids in mufti," a row of about fifteen mermaids dressed identically in orange cover-ups made by Alix of Miami.[57] Ever the mermaid enthusiast, Arthur Godfrey also showed up to watch the film.[58]

The real boon for the mermaids during the premiere wasn't hobnobbing with the stars—by the mid-1960s, stars were old hat—it was the free food. Mermaids think of two things and two things only after performing a show: getting warm and eating. Once the film started, Genie and a few other mermaids headed over to the restaurant for a free supper because they were starving.

However, all that star-making movie machinery rubbed off on the mermaids anyway. Sitting at a picnic table outside of Weeki Wachee, Bonnie and Genie reminisced about the good old days when the mermaids filmed their own movies. "We borrowed John Hamlet's sixteen-millimeter camera, and his wife, Terry, was our cameraman," said Bonnie. "If it was her day off, I'd take a shot at it. We wrote [the films] and produced them and directed them and edited them. We made two. The first one was called 'The Sound of Mucus,' and it was set to the tune of 'Blue Danube.' Whenever the music went da dadadaduhh, we'd have an insert, like blowing our noses, and then for the next dadadadaduhhh, we'd tap our heads to get the water out of our ears."[59] As Bonnie talked, both she and Genie tipped their heads to the side and gave their ears a little tap. Some habits die hard.

"We had to do sound effects a lot," said Genie. "Do you

The kiss Bonnie spoke of was immortalized in a short film made at the time to document the star-studded event "ninety miles from nowhere," as the announcer said in *Weekend at Weeki Wachee*. Still, nowhere or not, the underwater premiere was a first, or at least a second. The day before the actual premiere, over 250 newspeople showed up. Chartered airplanes arrived with celebrities who were then treated to fishing trips and cruises down the Weeki Wachee River on the *Conga Belle* before being subjected to interview after interview from reporters from as far away as New York.

Arthur Godfrey lunches with the mermaids at the Patio Restaurant, 1961. By permission of Weeki Wachee. Courtesy of Barbara Smith Wynns.

know that if you drop water in a bucket it doesn't sound like water dripping in a bucket?"[60]

Bonnie explained, "We had to flush a toilet to get the right effect."[61]

The "Sound of Mucus" was like *Laugh-In*, said Bonnie, with lots of little episodes. "One of the funniest parts of it was when a girl wearing a mermaid tail was sitting on the bow of an old wooden boat with an outboard motor, and one of the girls was driving, and they drove right up on

the beach where Buccaneer Bay is now, and she fell off the boat. We put that in twice." They also did their own takeoff on *Route 66* about a year after the cast left, although they changed the name of the episode from "The Cruelest Sea of All" to the "Creep from the Deep." They changed the star's name from Lisa to Liza.[62] Genie added, "Ours starred three different Lizas because people kept quitting."[63] And then they had to change male leads, Bonnie said, "because he got an ego problem—he always wanted to comb his hair.

Whatever little scenes they had in *Route 66* we did takeoffs. They bought the mermaid a pair of high-heeled shoes, and she couldn't walk in them, and she ended up having to be carried piggyback. But of course our character carried the guy piggyback."[64]

"In our show," Genie said, "there was way too much footage of her trying to walk in those high-heeled shoes."[65]

"You had to be in-house to think it was funny," said Donnie. They tried to make the films as "in-house" as possible, writing scripts that included parts for everyone from maintenance to public relations.[66] Their films also included commercials. In one, the mermaids drank cans of water labeled "Weeki Wachee" and got drunk. In real life, those cans of water were sold in the gift shop. Genie said she still has one. "I used to send it by the case to my husband's twin brother in Viet Nam because they didn't want to drink the water there. The guys in his platoon would say, 'Tell your sister-in-law to send us some more.' "[67]

Weeki Wachee Makes Its Mark on the Map

Bonnie still has the films the mermaids wrote and directed; for years she showed them at all the mermaid reunions, which started in 1960 and got bigger and bigger each year. Newt Perry showed up for the 1965 reunion. Even though he had left nearly fifteen years earlier, he was still very much a part of the spring. Jack Mahon wrote him occasionally to see if he could send some potential mermaids to Weeki Wachee.[68] Despite the glamour and excitement of being a Weeki Wachee mermaid, or perhaps as a result of it (men were known to dive into the spring to get close to the mer-

maids), the turnover rate of mermaids was high—due to "matrimony and motherhood." But there were always more mermaid wannabes. Weeki Wachee attracted young women from all over the country; brochures boasted that mermaids hailed from Florida, Michigan, Indiana, Maryland, Illinois, Virginia, New York, Massachusetts, Canada, Washington, D.C., New Jersey, Ohio, Minnesota, and Alaska.[69]

"We had girls from every state in the Union just about, as well as from Japan and Germany," said Bonnie. "[Being a mermaid] would rub off on their friends—before you knew it three or four girls would come." The popularity of the job brought some problems, said Bonnie. "We had to try out people in the water, and after the second time I had to jump in after somebody because they were drowning, I decided to start asking them, 'Can you swim? What made you think you could do this if you couldn't swim?' And they would say, 'I thought something magical would happen.'"[70]

They might have been deceived by the wizardry of the underwater maintenance team headed up by Bob Reed. "Bob Reed was the man who took care of everything—like the manager of an apartment building or like the stage manager of a Broadway show," said Marilyn Nagle Cloutier. "He saw to it that everything got done; the scenery was placed in the water properly; he handled anything to do with the spring itself and the show props and scenery, keeping the motor running on the air, and on the dragon, things like that. He was the man who was in charge of all that, and Skip Cumber was his right-hand man. Skip was in the water, but Bob was the on-land man."[71]

When the props arrived at Weeki Wachee, the underwater boys, as the mermaids called the divers, would plunge

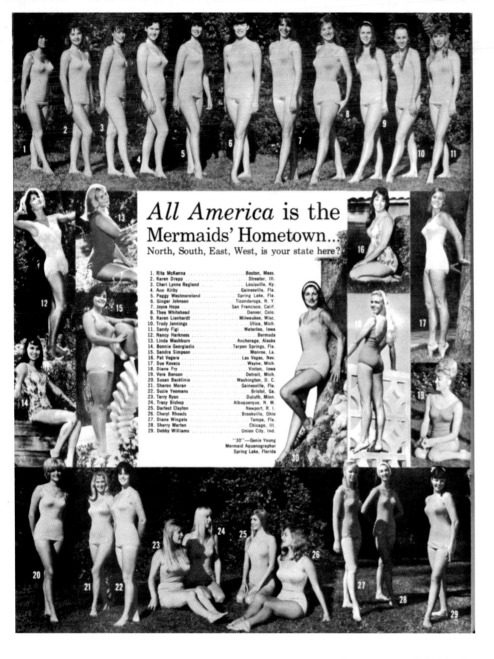

All America is the Mermaids' Hometown...

North, South, East, West, is your state here?

1. Rita McKenna Boston, Mass.
2. Karen Drapp Streator, Ill.
3. Cheri Lynne Ragland Louisville, Ky.
4. Ann Kirby Gainesville, Fla.
5. Peggy Westmoreland Spring Lake, Fla.
6. Ginger Johnson Ticonderoga, N. Y.
7. Joyce Hope San Francisco, Calif.
8. Thea Whitehead Denver, Colo.
9. Karen Lienhardt Milwaukee, Wisc.
10. Trudy Jennings Utica, Mich.
11. Sandy Figi Waterloo, Iowa
12. Nancy Harkness Bermuda
13. Linda Mashburn Anchorage, Alaska
14. Bonnie Georgiadis Tarpon Springs, Fla.
15. Sandra Simpson Monroe, La.
16. Pat Vegara Las Vegas, Nev.
17. Sue Kovacs Wayne, Mich.
18. Diane Fry Vinton, Iowa
19. Vera Benson Detroit, Mich.
20. Susan Backlinie Washington, D. C.
21. Sharon Moran Gainesville, Fla.
22. Suzie Yeomans Bristol, Ga.
23. Terry Ryan Duluth, Minn.
24. Tracy Bishop Albuquerque, N. M.
25. Darlest Clayton Newport, R. I.
26. Cheryl Rhoads Brookville, Ohio
27. Diane Wingate Tampa, Fla.
28. Sherry Marten Chicago, Ill.
29. Debby Williams Union City, Ind.

"30"—Genie Young
Mermaid Aquanagrapher
Spring Lake, Florida

into the spring, set the props up, and make sure they worked properly and realistically. "In one show we had a witch's cauldron, and we had to rig up a fast-acting valve to shoot out an immense amount of air on cue," said Allen Scott. "The girl worked the valve with her flipper. She would take a little squeeze bottle filled with Pet milk and food coloring, and she'd squeeze that into the cauldron, and after two or three colors were squeezed in, she'd hit the air valve with her flipper and a big burst of air would come up, and all the different colors would mix together and boil up out of the cauldron. The audience was amazed."

Besides supplying underwater magic, the underwater boys "helped the girls before the shows, put the hoses in the proper places, wound them up, repaired the mouth pieces and the valves, and kept the air compressors running," said Allen. "When they had a show that required dive bottles, we had to fill the bottles, sometimes four and five times a day. We had a wheelbarrow contraption, and we'd run our bottles up to the compressor station and get them back in time for the show. They drank Grapette underwater at the beginning up until RC Cola came in and took over that franchise, and we'd take a case at a time and put it on our shoulders and walk it down the underwater stage, so all during the day the girls would be able to grab a bottle or two out of that case and open it. The big showmanship part was they had a giant bottle opener," said Allen. "It was like an old Florida souvenir with 'Florida' stamped on it. It was about a foot long, and they'd pop the top off the bottle and drink the soda underwater, which required a special talent."

A nationwide mermaid family, ca. 1960s. By permission of Weeki Wachee.

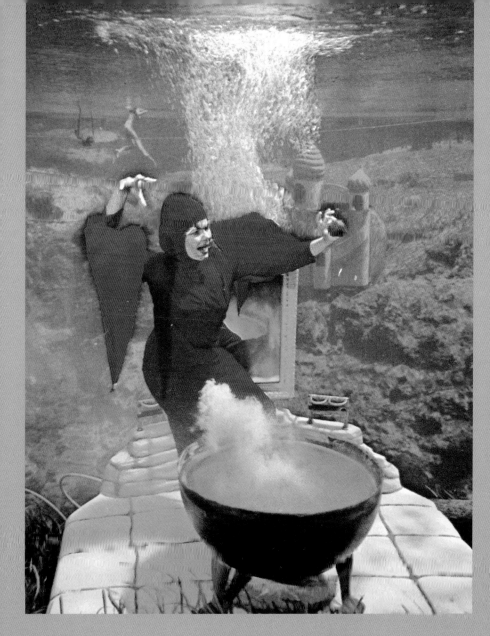

Above: Bob Reed, ca. 1960s. Courtesy of Marilyn Reed Webb. Photo by Bay Photography.

Left: Linda Pagumbi in the pool in Snow White, 1968–69. By permission of Weeki Wachee. Photo by Sparky Schumacher. Courtesy of Lu Vickers.

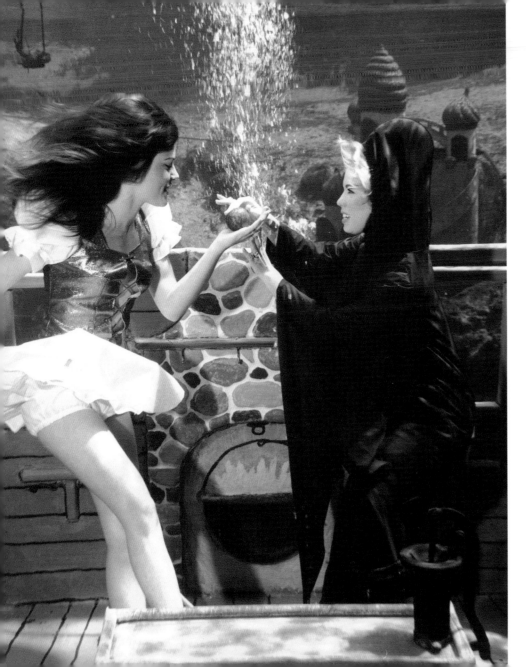

The underwater boys also provided the mermaids with a stash of bananas. The mermaids ate so many the underwater boys tried to find an efficient way to keep them in stock. "We'd go up to the restaurant in the morning and get a box of bananas and bring them down to the shed outside the tube room," said Allen. "Every time there was a show, the girls would take a couple of bananas into the spring; they'd stick them in their suit or their tail and take them down to the underwater stage and eat them during the show. Of course the turtles would get all the leftovers. The big problem was the raccoons. They'd come down after we left at night, and whatever bananas were left they'd peel them and eat them and make a mess. So we built a box out of heavy-duty chicken wire—it was like a parrot cage, but square —and we put the bananas in the box and hung it on chains attached to the ceiling in the shed by the tube room. But the raccoons would still hang on the cage with one foot and pick pieces out of the bananas with their other foot and ruin them. You couldn't use them in a show after the coons got done with them. We decided the best thing was just to get fresh bananas every morning."[72]

Fresh bananas or not, after thirteen years of slugging sodas and eating underwater, Bonnie Georgiadis decided to retire in 1966. She said she was "just getting too cold."[73] Her retirement only lasted a few months before the management called her back to take the place of Genie, who was on maternity leave, and to help put together the latest show. She did such a good job that the management at Weeki

Yvonne Chorvat and Diane Wingate perform in *Snow White*, 1968–69. By permission of Photographic Concepts, New Port Richey, Fla. Photo by Sparky Schumacher. Courtesy of Barbara Smith Wynns.

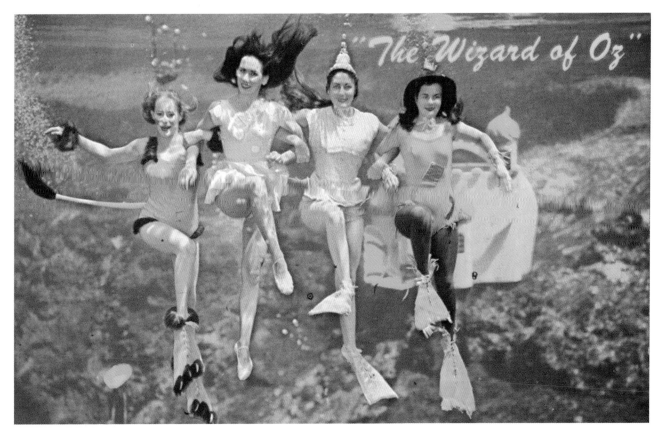

The Wizard of Oz performers (left to right), Terry Ryan Hamlet, Bonnie Georgiadis, Genie Westmoreland Young, and Shirley Walls. By permission of Weeki Wachee.

decided to hire her to be the choreographer. By then the Nagles had gone; Sea World had hired them to do a show in San Diego, and Weeki Wachee wasn't willing to share them.[74]

"I said, 'Sure, why not? I'll give it a shot,'" said Bonnie. "I think I did pretty good. I did *Mermaids on the Moon, Snow White, Peter Pan, The Perils of Pearls,* and *Wizard of Oz.* We would alternate every year; we'd do a fairy tale, and then

we'd do a revue; we'd take music that sounded great and put it all together and call it *The Best of Everything.*"[75]

The same year Bonnie came back, ABC petitioned the State of Florida to grant Weeki Wachee a charter and incorporate it as a town so the name could appear on maps. They feared that the building of Interstate 75 would siphon motorists off Highway 19 and blind them to the charms of Weeki Wachee. The only change that came with the name

Weeki Wachee city limit, 1966. By permission of Photographic Concepts, New Port Richey, Fla. Photo by Sparky Schumacher. Courtesy of Bonnie Georgiadis.

change," Bonnie said, "was that Jack Mahon became mayor. Up until then he was head of public relations. And we had to have our pictures taken on the side of the road. We were popular then."[76]

They were so popular that they had two photographers on staff constantly churning out photos of the mermaids. "They were always trying to think of things that would hit the wire service," said Genie.[77]

"Our photographers were Claude Long and Sparky Schumacher," said Bonnie. "They developed their pictures here. The mermaids, as much as they grumbled about it, would sit and paste the little captions to the pictures, and

they were mailed to newspapers all over the country. We'd think up ideas and make costumes, and they'd shoot it. If you look at a calendar, every week has something, Ragweed Week, George Washington's birthday. Somebody would dress up like George Washington underwater."[78]

Sparky Schumacher was head photographer at Weeki Wachee from 1961 to 1976. "I eventually became gift shop manager, merchandise manager as well as photographer," he said.[79]

No event went unnoticed at Weeki Wachee. Safe Driving Week. National Hot Dog Week. For the weenie promotion, two mermaids clutched a giant hot dog underwater, with

Sparky Schumacher photographs Miss Universe, Norma Nolan, 1962. By permission of Sparky Schumacher.

shooting color underwater was quite difficult. "The water is like a big green filter," Sparky said. "It throws off the reds, and then the glass is several inches thick, and that adds even more green. We had to add a magenta filter."

For several years running, the reigning Miss Universe would stop in at Weeki Wachee to swim with the mermaids and have her picture taken posing next to the spring with the *Princess Wondrous* statue or sitting on a bench wearing a tail. Besides those gigs that landed in his lap, like the arrival of the latest Miss Universe, Sparky was always on the lookout for ways to promote Weeki Wachee. He hit on the idea of heading to the baseball spring training camps in St. Petersburg and Tampa, where the St. Louis Cardinals, the Pirates, and the Yankees practiced. "We'd take three or four mermaids and go down to some of the ball parks and get the mermaids involved with the players and take pictures of them."

In one photo, a grinning Mickey Mantle cradles a mermaid in his arms. Surprisingly, in spite of the beauty and allure of the mermaids, not all the players were interested in these fishy photo ops. "They were hesitant to pose with the girls," said Sparky, "because their wives would see the pictures in the paper and say, 'Uh huh, you're down there having fun, aren't you?'"

The New York Yankees manager, Casey Stengel, was so undone by the mermaids that he left the field. "He didn't want to pose with the mermaids at all," said Sparky, "so he went and sat in the dugout, and I said, 'Oh, we gotta get some pics of him.' So I told a couple of the girls, 'Just go over there and start talking,' and pretty soon he relaxed and was having a big time." In the resulting photograph, Stengel sits

mystified looks on their faces, as if to say, "How are we going to eat that?" When astronaut John Glenn traveled into space, two mermaids posed underwater holding a placard that read "Good luck, Lt. Col. John Glenn, Jr., The Mermaids."

Sparky made most of his photographs from inside the theater. "Underwater is always difficult," he said. "We shot most of them through the windows, mainly because it was easy to communicate through the speakers. Someone in the control booth would say, 'We're ready—hit it.' You could give the mermaids instructions."

A lot of the shots were made in black and white because

Genie Westmoreland Young and Terry Ryan Hamlet pose for National Hot Dog Week promotional photo. By permission of Photographic Concepts, New Port Richey, Fla. Photo by Sparky Schumacher.

with arms and legs crossed, a Mona Lisa smile on his lips, mermaids perched on either side of him.[80]

Besides making funny photos to send to every newspaper east of the Mississippi, ABC executives also peppered the Interstate with bright new billboards and stuffed the racks in hotel lobbies with brochures featuring come-hither mermaids. They hired Burton McNeely and Hack Swain to make short films, like *Beauty in the Deep* and *The Care and Feeding of a Mermaid*, which featured the mermaids eating bananas underwater and doing the deep dive. The films played in all the theaters ABC owned across the state.

"There was one," Genie said, "where Vera Benson Huckaby showed up out front on a Greyhound bus and took a nap on a bench and dreamed she was a mermaid. I was in that one; it was totally embarrassing, it was so corny—right up there with *Frogs*. I'm the one who enticed her into the water and showed her how to swim."[81]

Actually, the short film has the makings of a cheesy cult classic. Vera sits on a bench next to a statue of the *Princess Wondrous* and falls asleep. Then the scene goes blurry, and when focus is restored we see Genie waist deep in water, beckoning Vera to join her in the spring. Through the wonders of double exposure, we see Vera sleeping, while her alter ego stands up and walks into the spring, where she is shown how to breathe off the air hose, eat a banana, and do a front-knee dolphin. Then the screen goes blurry again, and Vera wakes on the bench and shakes her head at the dream. But wait. There's a banana peel lying in the grass—proof positive that she was indeed, a mermaid—at least a Weeki Wachee mermaid!

The film wasn't as far-fetched as it seems. "I grew up in Detroit, and we lived right on the Detroit River," said Vera, "and of course we swam all the time. My dad called all of the girls 'mermaids.' When he retired, he came to Florida looking for a place for us to live. He came through Brooksville and saw Weeki Wachee and said: 'Whoa, this is it. This where I'm coming; my girls will be mermaids.' And that's the reason we moved to Brooksville; it had good water."

Vera, who met her husband, Bill, while working at the spring—he was an underwater boy—said the water had a powerful attraction for her whole family. Not only did she become a mermaid, but so did her sister, Helene, and later, her daughter Catherine.[82]

But the managers weren't just going to depend on the water to draw people into the park. Besides serving as advertisements to lure tourists into Weeki Wachee, the short films also lured young women to Weeki Wachee to be mermaids. Identical twins Holly Hall and Dolly Heltsley were starstruck when they saw the mermaids doing back dolphins across the screen at a theater in downtown Orlando. "When we were little everybody used to go to the Beacham Theater," said Holly. "And at the time, ABC theaters owned Weeki Wachee, so in between the movies and the cartoons they would have little advertisements, and it was always Silver Springs and Weeki Wachee because they owned both of them, and they would show the mermaids performing water ballet. We took ballet lessons for sixteen years, and we just automatically thought, how pretty; we want to go there . . . but we never did. Not until we graduated."[83]

The twins were already celebrities in their hometown of Orlando, having been photographed by the newspaper practically from birth. They were fawned over by famous

folk like Lawrence Welk. A photograph of the twins sitting on Santa's lap when they were three years old made it into papers all over the world. These days they are just as popular. They own Holly and Dolly's, a sports bar in Casselberry, just outside of Orlando.

"We graduated in 1967, and we had both enrolled at Florida State University," said Dolly. "I never found out exactly what happened, but my daddy only had enough money for one of us to go so, we both said, 'You know what, we're not gonna go without each other.' We'd just turned seventeen, so we said, 'What the heck, we'll wait a year and see what happens, and maybe we'll have the money by then.' So one day we said, 'Let's just drive over to Weeki Wachee and see what it looks like.' We started talking to all the girls there, and they said, 'We need people,' so we put on bathing suits, tried out that day, and made it."[84]

They were the first twins hired at Weeki Wachee. They moved into a cottage on the grounds at Weeki Wachee and bought their first car, a pale-pink Mustang with black interior. Shortly after becoming mermaids, they were featured in *American Girl* magazine, as well as in a short film the company made of the two in their mermaid villa eating snacks and drawing pictures of Snoopy. They also made a commercial for Windex, swimming back and forth in front of the glass windows of the theater, while a voice-over said, "Get a better look at your neighbors."

The Windex crew came up from Miami, Holly said, and they hadn't decided on which mermaids to use. "Then they saw me and Dolly and wanted us to be in it. There were no bathing suits and mermaid tails to fit us. You can't see the safety pins, but we were safety-pinned into the suits."[85]

Mermaids and Water Safety

What the twins remember most about their mermaid experience besides their brushes with fame, though, is a near-tragedy that took place at the springs after they'd left for the day. "We were on our way back to Orlando, and an ambulance came screaming by," said Dolly. "A couple of the girls had gone into an airlock, and the air hadn't been changed in there, so they breathed in poisonous gases, and it took them about one minute to pass out."[86]

It was 1969. Susan Sweeney Hopkins and Karen Dutcher were acting the roles of Grumpy and Doc in *Snow White*, roles the mermaids usually cut up in, ad-libbing moves like pretending to be asleep underwater. "It was nobody's fault," said Susan. "We had underwater stages where we would go to change our costumes, and they were out of sight of the audience. They were like little boxes underwater. The water was up to our hips and the rest was an airlock where we could stand and breathe and rest between shows or change costumes. We hadn't used this [airlock] all summer long," Susan said. "We just sat on top of it and waved to the tourists as they walked by until it was time to get back into the water. On this particular afternoon, all I remember is going back into the water to finish the show, and just like in the movies I woke up later in the hospital with my mom and dad leaning over me, and it was like, 'Whoa, what happened?'"[87]

What happened, she found out later, was that the airline to the airlock had been clogged or turned off, and a noxious gas had formed inside the airspace. When she and Karen breathed the gas, they immediately passed out.

Seeing double in *Mermaids on the Moon*, Holly Harris Hall and Dolly Harris Heltsley, 1969–70. By permission of Photographic Concepts, New Port Richey, Fla. Photo by Sparky Schumacher. Courtesy of Holly Harris Hall and Dolly Harris Heltsley.

Dottie McCullough Stanley was in charge that day. She remembers that Karen no longer swam at Weeki, but she'd asked if she could swim in the show. "There are a lot of times that some of the ex-mermaids would come back and swim, but I had told her no, that she could not do it . . . and I was down in the theater, down in the control booth, and I was getting ready to start the show. And when she came in the water, that's when I noticed that she was swimming."[88]

Dottie watched the mermaids dive down into the unused airlock, then went ahead and started the tape for the show. "I turned to do something else," she said, "and then when I went back to the tape I noticed that they were not breathing, you know; they were lying down on the bottom of the spring, and I said something to Doug Hopkins, the underwater boy. So he took off, and he jumped in, and he got one of the girls and brought her up."[89]

"If it hadn't been a Saturday, Doug wouldn't have been there," said Susan. "The only reason he was there was because we still did Saturday night shows, and he was there waiting to set up the props."[90] Lola Howard, another mermaid who was performing in the show, also noticed that something was wrong. She swam over to Karen and brought her to the surface. Allen Scott helped pull them from the water.

"They weren't ready for it," said Susan of the accident. "There were no blankets to cover us with; they covered us with towels from the gift shop. They didn't know where the resuscitator was, and when they found it, they didn't know

Susan Sweeney Hopkins in a Daylight Savings publicity photo, 1973. By permission of Photographic Concepts, New Port Richey, Fla. Photo by Sparky Schumacher. Courtesy of Barbara Smith Wynns.

how to work it, and when they figured out how it worked, it didn't work. So they were just ill-prepared. No one there was trained in lifesaving; nobody at that time was certified as a diver. After the accident, everyone got certified, and they got the equipment and trained people. I don't think they thought anything like that would happen."[91]

Karen was hospitalized for a couple of days; Susan was out for almost a week.

"They put Karen and me in the same room," said Susan. "Everybody called in sick the next day — it was one of only two days we didn't have a show the whole seven years I was there—once was because of a hurricane, once was because of the accident." Once Susan recovered, she began dating Doug, the underwater boy who pulled her from the spring, and they eventually got married.[92]

A few months after the near-drowning, the International Laborers Union and the American Guild of Variety Artists visited Weeki Wachee, and the mermaids voted to join the union to seek better working conditions, including better pay. They negotiated a new contract for several months, and, unable to come to terms, the mermaids and about 120 other employees went on strike in July 1970.[93] Holly and Dolly remember the tension involved in walking the picket line.

"Dolly and I didn't really want to, but we felt compelled to because it was like all the girls standing together," said Holly, "and so the union wanted to send me and Dolly up to New York City because at the time ABC owned Weeki

Dottie McCullough Stanley poses for a publicity photo, 1970. By permission of Weeki Wachee. Courtesy of Barbara Smith Wynns

Yvonne Chorvat goes on strike, 1970.
Courtesy of Yvonne Chorvat.

Wachee, and that's where the headquarters were," Susan went along. They wore their red bikinis and marched on the sidewalk in front of the ABC offices. "We walked up and down on one of the busiest streets in New York City in our little bikinis, and we met Dick Cavett, who came downstairs," said Holly. "All the guys with their brown bag lunches came out and watched us picket."[94]

When Susan and the twins went back to Weeki Wachee, they joined the picket line on Highway 19. "There was no real hostility between the ones that stayed and the ones that walked out," said Susan, "at least not between the mermaids. We understood the ones that needed to stay; it was for financial reasons."[95]

But it was still a difficult time for the twins. "Dolly and I didn't see an end to the strike," said Holly. "We wanted to swim. I said to Dolly one day, 'This isn't working.' And we left. We felt too bad about the whole thing. But a lot of the girls went back after they settled the strike."[96]

Believing that the show must go on no matter what, Bonnie Georgiadis came up with the idea for *Mermaids on the Moon* during the summer of 1969, the summer the mermaids almost drowned and the summer the astronauts landed on the moon. She used the music from *Barbarella*, the 1968 futuristic film that featured Jane Fonda as a forty-first-century woman who pilots a shag-lined spaceship and does a striptease while floating in space. The parallels were obvious: floating woman, zero gravity. Besides, Bonnie said, "The dome on the other bank looked like a space ship, and the spring looked like the surface of the moon."[97] *Mermaids on the Moon* wasn't as risqué as *Barbarella*. The mermaid's name was Anita Spaceship, and she met a couple of mon-

Beverly Brooks Sutton performs in *Mermaids on the Moon*, 1969. By permission of Photographic Concepts, New Port Richey, Fla. Photo by Sparky Schumacher. Courtesy of Barbara Smith Wynns.

sters in rubber suits and had an adventure in outer space. "The real astronauts went to the moon, and we were flopping around in moon goon costumes," said Dawn Douglas, who swam that show when she first got to Weeki Wachee.[98]

The space-aged bubble dome used in that show is actually an airlock that is still used, although today it's covered by the mermaid's castle. It is a one-of-a-kind piece that was built for Weeki Wachee in the late 1950s. "The dome is a Plexiglas half-sphere," said Allen Scott. "It has bronze rings around the edges to hold it down, because when you put air in something that big, it has tremendous lifting power. It's fastened into the limestone. It's so big the girls can stand up in it, and there's a speaker system in it, and they can talk to someone in the control room."[99]

Later that year, as the mermaids practiced their roles for the show, a young Japanese woman named Shinko Akasofu wrote a letter to Jack Mahon, asking if it would be possible for her to come to Weeki Wachee and become a mermaid. She was a star with the Yomiuri Land Underwater Ballet Troupe, which performed in a giant aquarium in Yomiuri Land, an amusement park in Tokyo. "The legendary Japanese media tycoon Matsutaro Shoriki, the owner of Yomiuri Land, was an avid admirer of Japan's famous pearl divers and dreamed of having his own underwater diving show," said Shinko. "When Shoriki heard about Weeki Wachee, he decided to build a similar attraction in Japan and proceeded to construct a huge aquarium theater and hire the dance choreographer to create the show." Still, Shinko wanted to

Moon Goons, 1969. By permission of Photographic Concepts, New Port Richey, Fla. Photo by Sparky Schumacher. Courtesy of Bonnie Georgiadis.

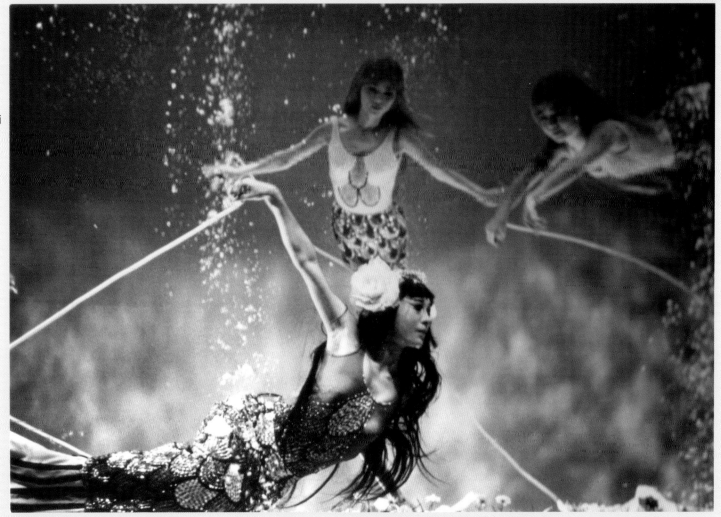

Shinko Akasofu Wheeler performs with the Yomiyuri Land Underwater Ballet troupe. Courtesy of Shinko Akasofu Wheeler.

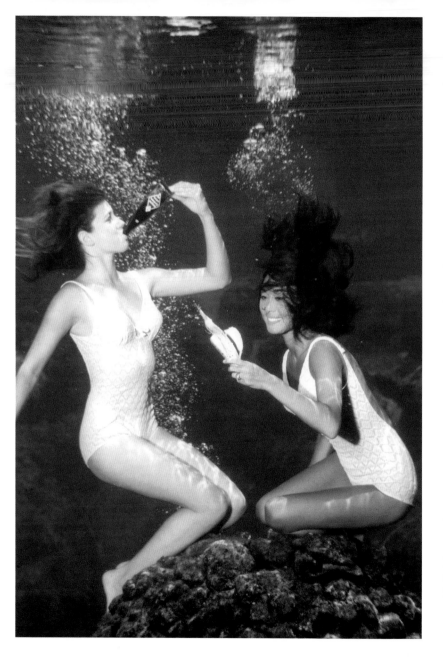

go to the source of underwater entertainment, so she wrote Jack Mahon, told her parents she was going to Hawaii, but instead made a beeline for Weeki Wachee.[100]

Susan was tapped to train her. "When Shinko came to us, she wanted to swim, but they wouldn't hire her sight unseen even though she'd worked in an underwater ballet in Japan. She was the star, but they wouldn't guarantee her a job, so she couldn't get a worker's visa to come to the States. She came on a visitor's visa. Naturally when she got in the water she swam so well they hired her on the spot."

"The only hard part about training her," said Susan, "was that she didn't speak English, so I had to get in the water to show her the routines; I couldn't talk to her over the p.a. system, but she learned really fast. She already knew how to use the air hose; they had the same thing in Japan. She knew the air hose; she knew the ballet—all she had to learn was our routines."[101]

Shinko said she wasn't sure how to tell her parents that she'd become a Weeki Wachee mermaid, so she clipped newspaper articles that had been written about her and sent them to Japan, writing, "I'm sorry but I got the job and I'm staying at Weeki Wachee."

"My mother said, 'I had a feeling you weren't going to Hawaii,'" said Shinko. "She was quite happy." Shinko's first role was that of Anita Spaceship in *Mermaids on the Moon*, but she was only able to swim for four months because of the strike. "I had to go back to Japan," she said, "because I

Susan Sweeney Hopkins and Shinko Akasofu Wheeler eat and drink underwater, ca. 1970. By permission of Photographic Concepts, New Port Richey, Fla. Photo by Sparky Schumacher. Courtesy of Shinko Akasofu Wheeler.

Cheri Lynne Ragland as Cinderella and Pat Crawford Cleveland as the Prince, 1970. By permission of Photographic Concepts, New Port Richey, Fla. Photo by Sparky Schumacher. Courtesy of Barbara Smith Wynns.

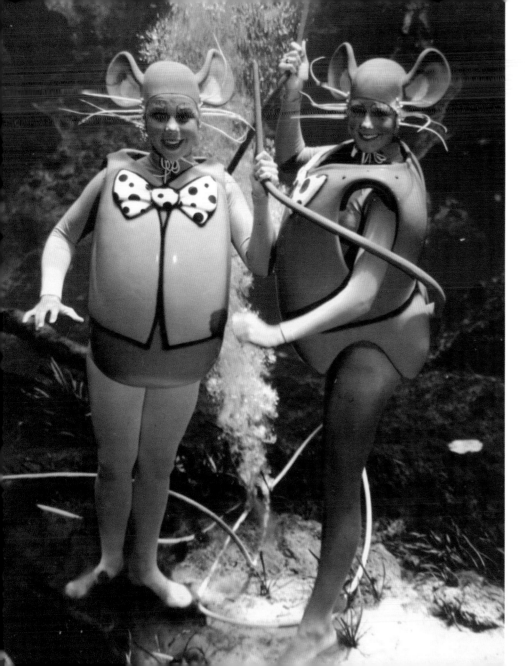

didn't have a worker's visa yet, and they were paying me in cash. I had to wait ten months before I could go back." When she made it back, she swam for three years, making her mark on the mermaids: she introduced a new move, one the mermaids still call "Shinko's Arabesque."[102]

Crystal Robson arrived at Weeki Wachee after the strike ended in 1970, just in time to perform in *Cinderella*. "In *Cinderella* we did 'Belle of the Ball,' and they had four props, these dome bells," she said. "Hoses hung from the bells, and we'd take a breath of air and then do some ballet and then go back to bells. We never had a free hose except for the deep dive; the hoses were on the lifts. In *Cinderella*, we had this big mouse costume with tanks inside so that we were free from the hoses. I had a solo part, and I always have nightmares about that," she said, "about forgetting my part. Those are the dreams you have after you leave—being in the theater and forgetting your fins, your mask, your swimsuit."[103]

Crystal didn't know it then, but her mermaid nightmares were about to get worse than just dreaming that she'd shown up at Weeki Wachee au naturel to do the deep dive. In fact, all the mermaids were about to experience a nightmare, one that still wakes them at night. A mighty mouse was about to move to Florida, and he wasn't wearing rubber ears, and he wasn't toting an air tank in a fiberglass belly. His name was Mickey.

Say "cheese!" Pat Crawford Cleveland and Susan Sweeney Hopkins are mice from *Cinderella*, 1970–71. By permission of Weeki Wachee. Photo by Sparky Schumacher.

The Seventies

The Era of the Mouse

Beverly Dender Sala sits atop Clamity Jane in the Star Garden, ca. 1970s.
By permission of Weeki Wachee. Courtesy of Bonnie Georgiadis.

For the managers of Weeki Wachee, the vision of mermaids walking a picket line was about as appealing as watching a walking catfish propel itself over land, but the strike paled in comparison to what was to come. Elvis and Don Knotts had come and gone and the strike had been resolved, but the 1970s would prove to be cataclysmic for Weeki Wachee in more ways than one.

On a positive note, Weeki Wachee finally opened its doors to African American tourists in the late sixties.[1] Even though integration had been mandated since the 1954 Supreme Court *Brown vs. the Board of Education* ruling, changes were slow to come. The University of Florida didn't admit its first African American student until 1958.[2] Florida State University didn't open its doors to African Americans until 1962.[3] The integration of public spaces outside of schools was even slower and wasn't addressed legally until 1964, with the passage of the Civil Rights Act, which prohibited discrimination in employment, government, and public places.

Ironically, the same day Elvis wowed the crowds at Weeki Wachee in 1961, nearly fifty African Americans staged a couple of wade-ins at Lido Beach and City Island in Sarasota, to protest segregation. Over in Ft. Lauderdale, two hundred African Americans gathered, then waded into the water at the public beach. A short clipping about the protests was buried on page 11B of the *St. Petersburg Times* beneath a photo of Elvis kissing a girl at Weeki Wachee.[4]

This public segregation wasn't the rule in every workplace. Silver Springs employed African Americans like Eddie Leroy Vereen to pilot its famous glass-bottomed boats as early as 1946. Owners Carl Ray and W. M. Davidson also brainstormed with Vereen about creating a park on the Silver River just for African Americans. Named Paradise Park, the exclusively African American attraction opened on Emancipation Day in May 1949 and went on to serve over a 100,000 visitors a year.[5] Wakulla Springs employed African Americans to pilot its glass-bottomed boats and jungle cruises, as did Rainbow Springs. Skipper Locket, who gave tours aboard a submarine boat at Rainbow Springs for twenty-two years, was so well known for his chant that he was asked to perform it at the Florida Folklife Festival in 1957. He put his own colorful spin on looking into the springs:

> Now look through your left side porthole far as your eyes can see. Watch that dreamy sunlit landscape. Look like mountains; look like valleys; look like green pastures. And the fish look like birds winging through the air and the turtles look like cattle roving in the forest. When you look up to the top surface of the water it looks like the skies above. Now the growing of the vegetation looks like the growing of the tree and the sandbar looks like a hill after a snowstorm and Rainbow Spring looks entirely like a world of its own.[6]

Of course, Weeki Wachee had begun employing African Americans as early as 1952 and continued to do so throughout the 1960s and 1970s. Junious Johnson worked with John Hamlet, taking care of the animals along the river, and Joe Ann Bennett began working as a waitress at the attraction's restaurant in '67 or '68. By then the Patio Restaurant had closed, and a new restaurant had opened in the newly built Holiday Inn across the street from the attraction. Joe

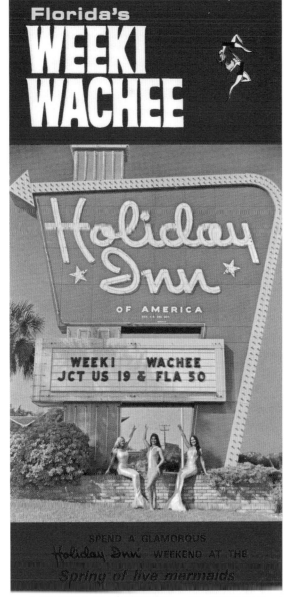

Brochure from the Holiday Inn, ca. 1969. By permission of Weeki Wachee. Courtesy of Bonnie Georgiadis.

Ann said her position was unusual at the time, especially because there weren't many jobs in Hernando County. "You could work in somebody's house," she said. "It was kind of rare for a black lady to have a job as a waitress back then." Asked if she knew of any local African American girls who'd applied to be mermaids, she said, "Hey, it was still the sixties. Even if the local black girls had wanted to try out, they probably wouldn't have hired them." Still, she said, most everyone she encountered at Weeki Wachee was nice. "You ran into some who weren't, but most were."[7]

Up until the 1960s, the only African Americans who saw the mermaid shows were the ones who worked at the park. Joe Ann said that had changed by the time she arrived. "When they started developing Spring Hill, Blacks came down from the North, and on their way to look at houses or land, they would stop by to see the shows," she said. "They seemed to like them."[8]

Martha Delaine, who retired from working in the gift shop in 1974, said African American tourists also stopped in to see the mermaids. But local African Americans reacted differently. Even though they knew they could go to Weeki Wachee, they chose not to. "A lot of them thought, 'Well, I wasn't allowed down there,' so they didn't go," said Martha. "Not many locals went, unless they were bringing the schoolkids over; they'd take a cruise or see a show."[9]

Besides dealing with integration, Weeki Wachee also had to deal with the near-drowning of Susan Sweeney Hopkins and Karen Dutcher and the subsequent strike. Management improved safety conditions at the spring. Not only were staff members trained in lifesaving techniques, but the mermaids were now required to be certified divers. Susan said

they trained in the pool at the Holiday Inn across the street with instructors from Pop's Scuba Diving School.[10]

Performing underwater certainly had its dangers— besides the possibility of suffering from the bends, hypothermia, or an air embolism, there were the props to worry about. One mermaid got knocked out when she hit her head on the oyster shell prop; another time a mermaid got conked on the head by a flower prop,[11] but those mishaps didn't stop Dottie McCullough Stanley from getting married underwater. One day her fiancé, Rick Pelham, was joking around with her and said, "You know, we ought to just get married underwater." She said, "'Sounds good.' So I asked the boss, Mr. Mahon, and he said, 'okay, as long as it's okay with your preacher and the immediate family.' I talked to the preacher, and he said, 'sure,' and I called my parents, and they said, 'yeah, yeah!' So, I went to Rick and told him, 'Well, we're getting married underwater!' And he said, 'I was just teasing you!'"[12]

Of course, the underwater nuptials made the newspapers, and the writers had fun: one headline read "I glub-glub-glub do"; another read "You Are Now Pronounced Man and Mermaid." The bride wore a "white satin swimsuit with a matching satin fishtail," and she "gracefully arched her body back and forth fish fashion" as she joined her fin-footed husband on the platform where he stood with an airhose clenched in his teeth.[13]

"It turned out real nice." Dottie said. "But during the wedding his mother almost had a heart attack because his mask was filling up with water. He couldn't see that well. I didn't have a mask on, so I couldn't see anything but the light. But it was real nice. Holly and Dolly were the bridesmaids."[14]

Dottie may have enjoyed her underwater wedding, but another marriage was about to take place that wouldn't prove to be as lovely. And that was the one precipitated by the arrival of Florida's groom-to-be: the white-gloved, one-button Mickey Mouse who had set up house in Orlando in 1971. In *Team Rodent*, his 1998 collection of essays about Disney, Carl Hiaasen, a novelist and columnist for the *Miami Herald*—but more importantly, a native Floridian— described the takeover of Florida by Disney World in the 1970s:

> Disney is so good at being good that it manifests an evil; so uniformly efficient and courteous, so dependably clean and conscientious, so unfailingly entertaining that it's unreal, and therefore is an agent of pure wickedness. Imagine promoting a universe in which raw Nature doesn't fit in because it doesn't measure up; isn't safe enough, accessible enough, predictable enough, even beautiful enough for company standards. Disney isn't in the business of exploiting Nature so much as striving to improve upon it, constantly fine-tuning God's work.[15]

The management at Weeki Wachee might have filled the spring with mermaids wearing Lycra tails, but they were real women who performed ballet amid schools of fish and curious turtles. If nature got out of hand—if alligators swam into the spring or if a storm blew up, the show would not go on. The mermaids would have to get out of the spring. And Weeki Wachee may have allowed NBC to dump two thousand fish into Weeki Wachee back in the 1950s, but they were struggling mightily with what visitors to Florida springs had been saying for hundreds of years: *Folks, the water is so clear*

it looks like air. NBC used the fish as extras to prove that they were indeed filming underwater in a natural spring. The folks at Weeki Wachee had always focused on the unbelievable beauty of the spring from the very beginning, when Hall Smith dropped a dime into the spring and watched it drift all the way to the bottom.

On the other hand, what attracted Walt Disney to Orlando was not the beauty of the place—the land was mostly swamp—it was the intersection of Interstate 4 and the Florida Turnpike. According to Richard Foglesong, author of *Married to the Mouse*, when Disney did a flyover of the site in 1963—in mermaid aficionado Arthur Godfrey's airplane, no less—he looked down, saw the highways, and said, "That's It." Within a week, the Disney wonks made a decision to enact what they called "Project Winter." They decided to send Bill Lund, a real estate consultant and Walt's future son-in-law, to Florida to evaluate the area in question. Knowing that prices would go up if word got out that Disney was thinking of buying up property for a new theme park, Disney hired William Donovan, the former director of the Office of Strategic Services (predecessor to the CIA) to create a new identity for Lund. Donovan set Lund up with fake business cards, a telephone number at a law firm, and letterhead stationery. Over the next two years, Disney set up five fake corporations to buy up the land. By 1965, they had achieved success, purchasing over 27,000 acres for a little more than $5 million. The most they paid per acre was $350. In October 1965, a thrilled Governor Hayden Burns officially solved the mystery that the local papers had been

Dottie McCullough Stanley weds Rick Pelham underwater, 1970. By permission of Dottie McCullough Stanley

trying to figure out for a year, announcing that Disney was about to build "the greatest attraction in Florida history."[16]

After convincing the state legislature that Disney World should be self-governing, and therefore exempt from laws that apply to everyone else, Disney began construction in the spring of 1969.[17] The first item on the agenda was to figure out how to drain real wetlands so they could build fake ones. But they didn't want the water to go away; they just wanted to move it out of the way. The solution was to build a series of canals and levees to control water levels without losing the water. According to the "Walt Disney World History" Web site, "these canals were the first 'themed' illusion on the property: they curve through the natural landscape much as a stream would, instead of following the straight lines of artificial canals."[18]

Although only about ten thousand people showed up for the opening day of the Magic Kingdom, by the time the 1980s rolled around, Disney World was attracting over 40 million visitors a year, undoing Newt Perry's dream of attracting visitors to the west coast of the state.[19] Toss in the completion of Interstate 75 that routed people over to the Florida Turnpike and from the Turnpike to Disney's doorstep, and it's clear that the funky roadside attractions didn't have to wait that long to feel the effects of having a Small, Small World in their backyard. According to historian Gary Mormimo, "Dog Land in Chiefland, Everglades Tropical Garden in Clewiston, Florida Reptile Land of Lawtey and the Sarasota Reptile Farm failed to survive the 70s."[20] Along with those attractions, a couple of crowd favorites from the 1930s, McKee Jungle Gardens in Vero Beach and Rainbow Springs up in Dunnellon, also failed to hang on.

As Mormimo said, "Americans seem to prefer history with a spoonful of sugar and the synthetic experiences of a theme park."[21]

Bonnie Georgiadis described the effect Disney had on Weeki Wachee: "Our lines used to go out past the parking lot, almost to Highway 19," she said. "People would stand out there waiting to buy tickets. We would have to close our doors at one o'clock to get everyone into the theater. Weeki Wachee was making a lot of money. Then it was *Before Disney* and *After Disney*. Everybody was over in the middle of the state. And I don't understand it because Weeki Wachee is so unique; there's nothing else like it in the world. Why doesn't it continue? Once in a while my phone rings, and the person will say, 'Lucky you—you have won a trip to Disney.' And I'll say, 'That's the last place in the world I want to go.' And they say, 'Whut?'"[22]

Genie Westmoreland Young said the difference Disney made was especially apparent during peak seasons like Christmas: "During that time for several weeks we would have a show an hour, and after Disney it was more like five shows a day. I-75 went in about that time too and pulled all the traffic away. A lot of people didn't bother coming over this far."[23]

However, the dwindling audiences didn't keep Weeki Wachee from putting on elaborate shows or from paddling into Disney territory. Susie Pennoyer swam *Peter Pan* in '71. "The mermaid playing the crocodile wore a rubber suit," she said. "Then there was Captain Hook, and Smee, who came up on a lift and did eating and drinking in the show. And then there were Peter and Wendy, and Michael, and the Indians and the mermaids. Peter and Wendy had a duet,

Ginger Johnson performs in *Peter Pan*, 1962–63. By permission of Weeki Wachee. Photo by Sparky Schumacher.

and the three Indians had a whole number they did. They ended in a totem pole. From there we started doing *The Little Mermaid*."[24]

One person who skipped I-75 and drove over to Weeki Wachee, "where the sky is never blotchy and the air is butterscotchy everyday," was Tony Randall, who filmed the *Wacky Weeki Wachee and Silver Springs Singing and Comedy Thing* at the spring. Comedians Anne Meara and Jerry Stiller (mom and pop of comedian and actor Ben Stiller) play a couple who've gone to Florida to revive their relationship—only to be thwarted by a mermaid. While they are on the glass-bottomed boat at Silver Springs, a mermaid with a shiny gold tail swims beneath the boat, charming Stiller but prompting Meara to complain about the "common, ordinary bleached blonde fish."[25]

When they—along with Randall, country singer Lynn Anderson, and sportscaster Howard Cosell—head to Weeki Wachee, they get a chance to see Weeki Wachee's original *Little Mermaid Show*. Six mermaids perform. One of them is Shinko Akasofu Wheeler. When the mermaids link hands and tails to perform their Ferris wheel, Tony Randall comments dryly on their moves—the "allegre, andante and dead man's float."[26] Weeki Wachee wasn't quite ready to do the dead man's float. Despite the effects of Disney and a gasoline shortage that resulted in rationing, ABC was still trying to pull tourists in. They announced a two-year program to add the *Birds of Prey* show and an exotic bird performance. The *Birds of Prey* show was actually set up under the aegis of a U.S. Wildlife salvage permit to rehabilitate injured

Doreen Durendetto Kurz and Jana Chytka Cofer picnic underwater, 1978. Photo by the Leftwich Brothers. Courtesy of Jana Chytka Cofer.

Left: Three mermaids form a totem pole in *Peter Pan. Top to bottom*, Dawn Douglas, Beverly Brooks Sutton, and Genie Westmoreland Young, 1971–72. By permission of Photographic Concepts, New Port Richey, Fla. Photo by Sparky Schumacher. Courtesy of Barbara Smith Wynns.

Above: Tony Randall visits with Jack Mahon and mermaids, 1973. By permission of Photographic Concepts, New Port Richey, Fla. Photo by Sparky Schumacher. Courtesy of Cathy Mahon Havens.

Shelly Williams with Sierra perform the *Birds of Prey*, 1983. By permission of Weeki Wachee.

birds. Among others, the show included a red-tailed hawk, a Swainson's hawk, a Harlan's hawk, and a great horned owl. Besides entertaining tourists with their dramatic takeoffs and landings, the birds were being rehabilitated so they could return to the wild. Birds that were too injured to be rehabbed were kept on as breeders.[27]

For the Exotic Bird Show, Weeki Wachee followed the tourist-tested lead of dozens of other roadside attractions: Duster the Cockatoo rode a small bicycle when he wasn't sneaking around and letting the other birds out of their cages, Sneezie the green-winged macaw pulled a string that fired a bird-sized cannon, and other birds played cards, roller-skated, and beat the tourists at shell games.[28]

Weeki Wachee's management wasn't putting all their bets on birds either; they also proposed to build "a swamp train ride, Seminole Indian Village, deer exhibit, alligator pond and pony corral" in an attempt to lure the tourists off of I-75.[29] John Hamlet, the nationally known naturalist who had come on board in the 1960s, set up the Seminole Indian Village. Hamlet was part Sioux himself and apparently did such a good job re-creating the Indian village that Chief Billie Osceola of the Seminole Tribe dropped by to check out his work. The chief rode the wagon train through the woods to see the village. In true Florida fashion, Bonnie Georgiadis said, the wagon train was pulled by a Land Rover. Not very 1880s, but Chief Osceola was impressed with Hamlet's work on building chickees, the traditional Seminole dwellings.[30]

Ironically, in the midst of all of Weeki's troubles, in 1975, a former Weeki Wachee mermaid made it to the big screen in a part that did little to entice people into the water. Her name is Susan Backlinie, and the part she landed was the first victim in the movie *Jaws*. Susan now lives on a houseboat her husband built in California, where they spend their time diving and swimming. She left Weeki Wachee in the 1960s, like a lot of other mermaids, to have a baby. "After I had my little one I was hoping to go back," she said, "but by that time they had so many mermaids that they didn't need anybody."

Then, as luck would have it, she met Ricou Browning, Newt Perry's old protégé, who by then was president of Ivan Tors Studios. "They didn't think a girl could work the animals on stage without them getting out of control and away," said Susan. "But Ricou said, 'If you can prove to me that you can do it, you can have the job.'"[31]

Susan Backlinie performs in the *Mermaid Follies*, 1965–66. By permission of Weeki Wachee. Photo by Sparky Schumacher.

Who would've thought that being a mermaid would end up helping a woman break into what was considered "man's work"? But that's just what happened. The truth is, it was the Original Mermaid, Annette Kellerman, who set the stage for women to compete athletically with men, way back in the early 1900s. Unable to compete in the all-male Olympics in 1905, even though she held world records for women's swimming, Kellerman took to Europe's rivers where she outswam men and made a name for herself. When she got arrested in Boston in 1907 for wearing a one-piece body suit instead of the traditional long sleeves, bloomers and skirts, she won the judge's sympathy by telling him that swimming in those clothes was "like swimming in a ball gown." He dismissed the case; women started wearing streamlined swimsuits, and Kellerman was established as a feminist.[32] It wouldn't be long before women were able to swim competitively against men.

Still, not all women athletes see themselves as feminists. Some choose to emphasize their beauty or their femininity over their athleticism, as illustrated by Weeki Wachee's own brochures touting the mermaids as the "Most Beautiful Athletes in the World."[33] Even Newt Perry sought mermaids at beauty contests, telling Ginger Stanley Hallowell he "was looking for swimmers who didn't look like swimmers."[34] What he was really looking for were women who were capable of holding their breath for long periods of time twenty feet underwater in an ice-cold spring full of eels, gators, and catfish, all without panicking. And he had to find these young women during the post–World War II period, the era of the "happy homemaker." Newt was also looking for women who were brave enough and strong enough to dive

a hundred feet down into the deep hole of the spring—no easy feat, said Ginger, who once set a world record at Silver Springs for swimming underwater in the Silver River for seven miles. "I did the deep dive," she said. "Usually I would do it twice; they only wanted you to do it once a day. We went down about 120 feet deep, wayyyy down there, and there was a metal rod they wedged into the gorge, and boy, was the water swift. The water would push you up to the surface if you didn't wrap your legs around the rod. So we'd fight our way in, wrap our legs around the rod, and sit there with our hoses and catch our breath. It was like running. We were winded by the time we got down there. You'd have to take a moment to collect yourself."[35]

All hyperbole about beauty aside, as Ginger points out, the mermaids were and are incredible athletes. Perhaps their athletic ability was what kept them from arousing the ire of feminists like those who tossed bras and girdles and other "instruments of torture" into a trash can at the Miss America pageant in 1968.[36] As Mariah Burton Nelson wrote in her introduction to *Nike Is a Goddess: The History of Women in Sports*:

> the truth is, even when feminism is not an individual's motivating force, it is the result. . . . Athletic training implicitly challenges patriarchal constraints on a woman's behavior. . . . Sport alters the balance of power between the sexes. It changes lives. It empowers women, thereby inexorably changing everything.[37]

Ricou Browning probably knew about that life-changing brand of empowerment from his days of training mermaids back in the 1950s and so did Susan Backlinie. She'd been a

World's Most Beautiful Athletes

Just didn't happen! These glamorous girls from all over the world come to Weeki Wachee to undergo the most rigorous training in precision athletics . . . like the Rockettes, they combine beauty and grace with intense physical stamina.

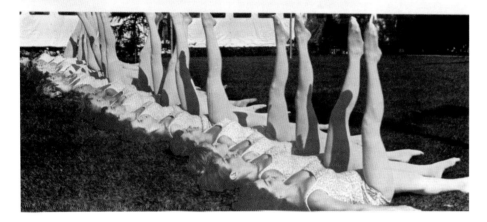

Mermaids in training, ca. 1960s. By permission of Weeki Wachee. Courtesy of Bonnie Georgiadis.

Weeki Wachee mermaid, after all. So of course she proved she could handle "men's work." She got the job and began working with the Ivan Tors studio training lions and tigers, and that work led to a bit part that immortalized her in the minds of moviegoers: the woman who got eaten in *Jaws*.

"I got the role in *Jaws*," she said, "by being in the right place at the right time. I got into the business out here in California doing animal stunts, underwater stunts. Everything I did at Weeki Wachee definitely helped me land *Jaws*, because it taught me how to hold my breath, to do it just right, and not be afraid of what's around me. I learned how to make sure if I got in a spot to get myself out."[38]

For the role, she was dragged back and forth and up and down by divers tugging on straps that were attached to her waist. The straps had special releases attached to them so she could unsnap them if she got into trouble. The studio filmed most of the scene at Martha's Vineyard, but the water was too dark to film underwater so they waited until winter and headed to Catalina Island to film the underwater shots from the shark's point of view.

"It was freezing cold," Susan said, "and one of the special effects guys brought me out in a dinghy to where they were going to film it, and they said, 'We're doing four shots. Go this way, this way, this way and this way.' So I did, and I was gone. You see me do a leg lift and then sink underwater in the film. Well, that was definitely Weeki Wachee, and the idea was to keep everyone on their toes. 'Is she gone?' 'Is she coming back?' 'She's gone.'" It's as though Spielberg had lifted a page from the Mermaid's Manual of Deep Diving: keep the audience in suspense. But Susan credits Spielberg for coming up with the notion of teasing the audience on his own. "That was his idea, but the leg lift was definitely Weeki Wachee."[39]

In 1975, despite the dampening effect on swimming caused by *Jaws*, two hundred girls a year still showed up asking for the chance to get into the water to be mermaids. Even though development was knocking on Weeki Wachee's door, the spring was still in the middle of a metaphorical nowhere. Mermaids could choose to live in one of the cottages on site, but only if they didn't want to be bothered by anyone. "Living in the middle of Hernando County, with Brooksville the nearest town doesn't hold much promise for dates," wrote one reporter. "The girls say they eat out a lot, go to movies, swim, and sunbathe on their days off—which

1970s postcard. By permission of Weeki Wachee. Courtesy of Anna Stephan Cooke.

never fall on weekends or holidays." But even sunbathing had its drawbacks. According to one mermaid, the big-headed catfish, alligators, and eels weren't frightening at all. Being modest, she was mortified by the mermaids' private sundeck, where the more daring of the bunch would tan nude. Unfazed, Genie Westmoreland Young saw the sundeck in practical terms. "It gives them a chance to get rid of bathing suit straps," she told a reporter.[40]

In the late 1960s, development drew closer to the spring. The Mackle Brothers Corporation decided to build Spring

Hill, a retirement community, just three miles south of Weeki Wachee. Because she had an ear infection, mermaid Darlest Clayton Thomas was available to do "dry land work." In what would turn out to be an ironic twist, she posed for the "Welcome from Weeki Wachee to the Spring Hill Development" billboard.

"They probably started out with five to six hundred homes down there," she said of the development. "If you drove in the Spring Hill area now, in 2003, there are probably *twenty thousand homes* in that area. When we drove it one weekend, we got lost. It's just unbelievable what the Mackle Brothers did. Most of their advertising stayed; I left in '67, and in '87 I was still seeing my pictures here and there in their advertisements. So even after you leave Weeki Wachee, you're still a part of it."[41]

What people came to find out was that you didn't have to be anywhere near the spring to be "a part of it," as Darlest said. Weeki Wachee is fed by the Floridan Aquifer, and anything that goes into the groundwater ends up in the spring. Allen Scott explained one of the problems brought on by the extensive development surrounding the spring: the proliferation of brown algae. "With all the houses being built in the area and everyone wanting a nice green lawn, they used a tremendous amount of fertilizer. Plus we were getting it from the farms. We used to have a suction barge, and we'd go in at night and suit up and go underwater and pump the algae out of the spring. The barge had two three-inch suction hoses, and we'd turn on all the lights and go in there and pump the algae into a pipe and send it down the river," he said. "You wouldn't be able to do that today. The last time we did it, we pumped it onto the beach, and they

Mermaids Beverly Bender Sala and Lynn Sacuto Colombo doing dry work at a Miami Dolphins game, 1975. Courtesy of Beverly Bender Sala.

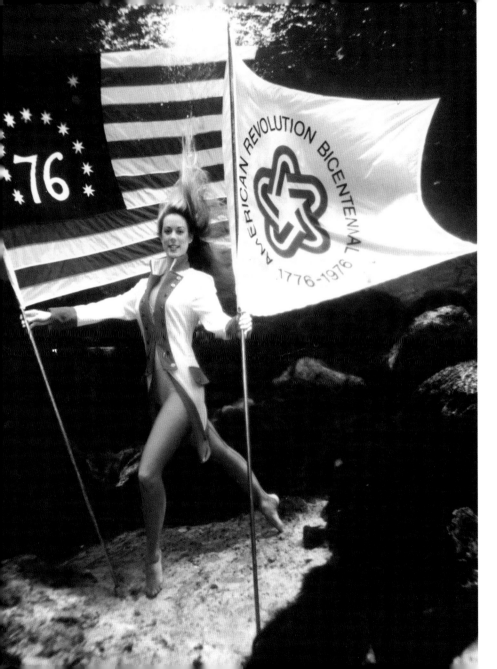

hauled it away in dump trucks. They haven't done it since '97 or '98; it makes a mess."[42]

The brown algae would prove to be a persistent mess that still troubles the spring. One wonders how all those nineteenth- and early twentieth-century visitors to Florida's springs would react these days. What would they think if they looked into Weeki Wachee Spring as James Henshall did back in 1884 and saw not "curious water plants, whose small elliptic leaves exhibit tints of red, purple and blue,"[43] but saw instead great big muckety piles of brown algae?

Even though the development would go on to have long-term effects, it also resulted in a short-term mess that caused big problems in 1976. "When they were developing Spring Hill," said Bonnie Georgiadis, "evidently a clod of clay the size of a train fell into our source, the underground river, and it made the water look white." So white, in fact, that the mermaids couldn't swim their shows for nine months.[44]

The newspapers reported a more scientific explanation. The Mackle Brothers Corporation, renamed Deltona, one of the state's largest developers, dredged two lakes near Weeki Wachee in an effort to meet its eight-year deadline for completing the development of its lakefront property at Spring Hill. When the firm pumped water out of one lake and into another, the second lake's water level declined after initially rising, a characteristic one hydrologist said was typical "of a plugged sinkhole when the pressure has been too great (from added water) and the plug is removed." When the lake drained, he theorized, the silty water entered the aquifer

Linda Sand Zucco in *Perils of Pearls*, 1976. By permission of Weeki Wachee. Photo by Sparky Schumacher. Courtesy of Linda Sand Zucco.

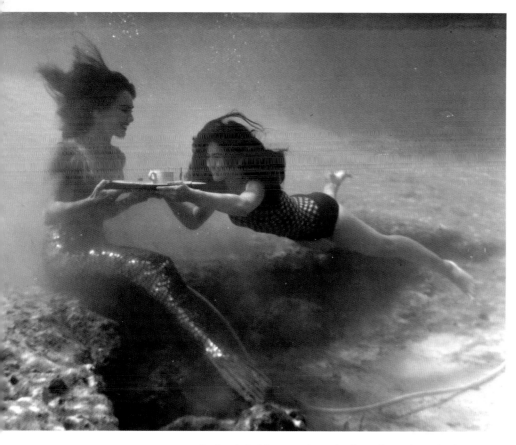

Sue Georgiadis delivers tea to her mother, Bonnie Georgiadis, in a cloudy spring, ca. 1975. By permission of Bonnie Georgiadis.

and traveled to Weeki Wachee, causing the water in Weeki Wachee to cloud up.[45]

"You couldn't see anything," said Bonnie. "It was like looking into a glass of milk, so we put on a show—the *London Fog Mystery with Sherlock Holmes*. The mermaids performed up close to the glass. "What else are you going to do?" asked Bonnie.[46]

After wrestling with that question—what to do about the limited ability of the mermaids to swim—management at Weeki Wachee answered: hire "The Great American High-Diving Team" and construct a 600-seat amphitheater for the audience. They turned a couple of jungle cruise boats into a combination stage and dressing room and built a ninety-foot high dive for Steve Silver, "The Human Torch," to leap off of in a "fire dive." The show also featured the comic dive team the "Aquamaniacs," as well as a couple of world record–holding high divers. The mermaids would get in on the act as well, as one reporter noted, doing some "sexy surfboard paddling . . . sans their fishtails."

According to Silver, the fire diver, the mermaids also made some behind-the-scenes appearances sans their swimsuits. When he climbed up the scaffold to his perch where he'd "flick his Bic," he discovered the mermaids' secret sundeck. "Sometimes I cook up there longer than other times," he told a reporter. "Wind currents, you know?"[47]

In the end, the water did clear up, but not before lawsuits were filed on both sides. Weeki Wachee sued Deltona for $4 million, and Deltona sued Weeki Wachee for slander. Newt Perry and the mermaids were called in to testify on the quality of the water. The case was finally settled out of court.[48]

Melinda Harding Flinn and Susan Cain pose on the sponge dock, ca. 1970s. By permission of Weeki Wachee.

Diane Fry poses with lollipops from the gift shop, ca. 1960s.
By permission of Weeki Wachee. Courtesy of Bonnie Georgiadis.

In 1977, John Campbell, the president of Weeki Wachee Spring, announced plans to upgrade the *Birds of Prey* and Exotic Bird Show facilities as well as to build a new entrance and to add a 5,000-square-foot restaurant and a pearl-diving lagoon. "Our mermaid show has been our mainstay throughout our history, with a new show each year," said Campbell in a press release. "We haven't forgotten what brought the public here in the first place. We're merely providing the public with a more complete entertainment experience."[49]

To complete the entertainment experience, they changed the "look" of Weeki Wachee, adding a cedar bridge, waterfalls, and flower-dripping bougainvillea bushes. They also shingled over the white clamshell roof, aiming for a woodsy look. The promised pearl-diving lagoon turned out to be a Pearl Pavilion "overlooking the Mermaid Pool where a lucky 'fisherman' may come up with the catch of the day—an oyster cradling a real pearl." The lucky fisherman simply handed the oyster over to the shucker/jeweler, who then opened the shell, plucked out the pearl, and cleaned and mounted it right on the spot. They also added a koi pond, a three-acre rain forest complete with rare birds and an orchid house, as well as a Sponge Dock filled with shells and sponges from around the world.[50] And they built not one, but two new gift shops stocked with Florida kitsch, or what one reporter called "water-oriented and hard-to-find Florida tourist merchandise." They pulled in 400,000 tourists that year.[51]

To celebrate the completion of the $3-million renovations, John Campbell, the president of ABC Leisure Attractions, opened the park to local and national news media.

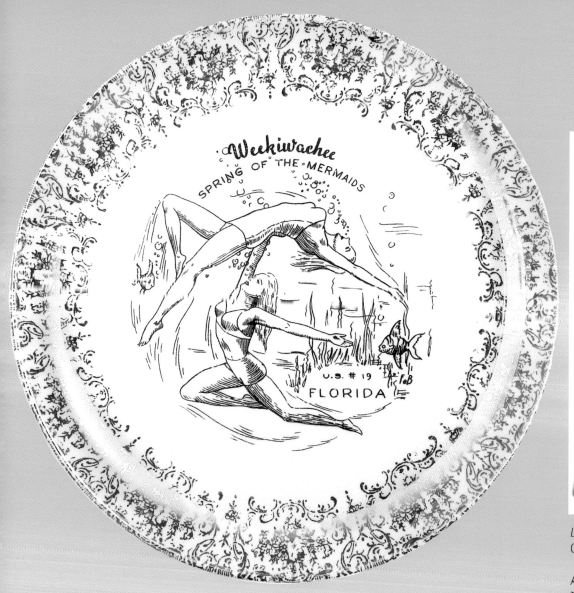

Left: Adagio plate, ca. 1947. By permission of T Photography, Los Angeles, Calif. Photo by T Matsushita.

Above: Mermaid salt and pepper shakers, ca. 1960s. By permission of T Photography, Los Angeles, Calif. Photo by I Matsushita.

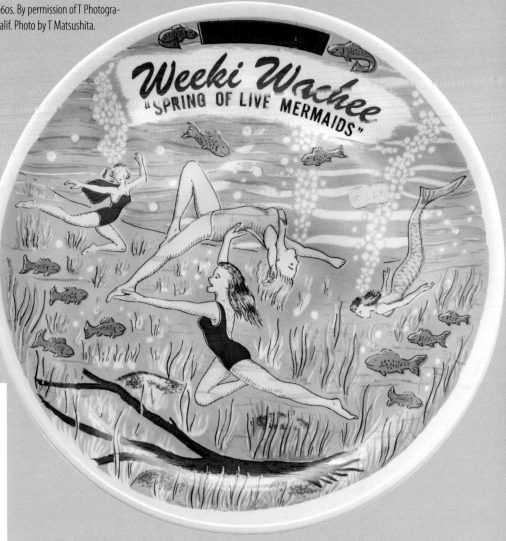

Adagio plate, ca. 1960s. By permission of T Photography, Los Angeles, Calif. Photo by T Matsushita.

Above: Adagio salt and pepper shakers, ca. 1960s. By permission of T Photography, Los Angeles, Calif. Photo by T Matsushita.

Below: Mermaid theater souvenir, ca. 1960s. By permission of T Photography, Los Angeles, Calif. Photo by T Matsushita.

"Spring of Live Mermaids"

Florida's
Weeki Wachee

Left: Weeki Wachee bowl, ca. 1980s. By permission of T Photography, Los Angeles, Calif. Photo by T Matsushita.

Below: Mermaid mugs, ca. 1980s. By permission of T Photography, Los Angeles, Calif. Photo by T Matsushita.

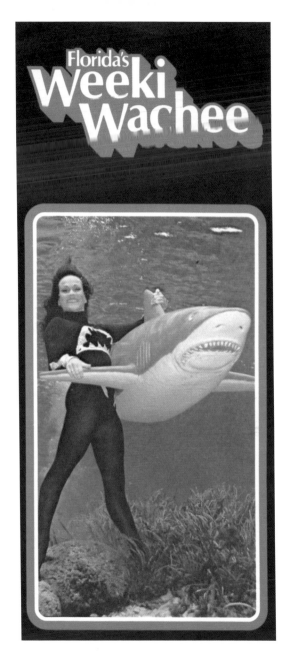

Florida's
Weeki
Wachee

Marti Nosti-Monaldi in *An Aqua(?) Mermaid*, 1977–78. By permission of Weeki Wachee

"This is an ongoing commitment on our part to make this the best natural attraction in Florida," he said. "Whenever we've had to make additions or alterations we've kept the natural elements intact and improved on them when possible." By this time the mermaids were considered a natural element, and most certainly an improvement over the garfish. Still, despite the non-native additions, Weeki Wachee's aim was clear: management wanted to exploit the natural beauty of the spring and the river to keep the tourists coming.[52] To Weeki Wachee's credit, the handlers of the *Birds of Prey* show continued to work closely with wildlife agencies and conservation groups to heal the injured birds that, if left alone, would likely perish in the wild. Bonnie Georgiadis took over as head of the bird department and curator of the "Pelican Hospital."[53]

Campbell took advantage of the news conference to announce other dramatic changes to the upcoming mermaid show with the working title *Mermaids on the Half Shell*. He promised the show would be Broadway in miniature, adding, "The only thing we can't duplicate is the singing and we're working on it."[54] Actually the show ended up being an action adventure called *Operation Mermaid*. Marti Nosti-Monaldi, a sixth-generation Floridian who now lives on top of a mountain in North Carolina, started swimming in 1973. She played Sharkwoman to Linda Sand Zucco's Waterwoman.

"It was a takeoff on Wonder Woman," she said, "and they hired a woman who'd choreographed on Broadway, but who knew nothing about working underwater. She thought you could move at the same speed underwater as you could on land. We had to learn karate, and we had to move

fast." The main prop for the show was a shark that looked so lifelike, Marti said she didn't even like being underwater with it. The shark had a scooter in it, and Sharkwoman drove it around. Unfortunately, because of all the acrobatics the mermaids did, the scooter would fill up with water, causing the shark to sink. "It definitely wasn't my favorite show," said Marti.[55]

Just over a year later, in 1979, during ABC's twentieth anniversary ceremony at Weeki Wachee, Elton Rule, the president of ABC, presented Leonard Goldenson, the chairman of the board and chief executive officer of ABC, with what he called "a 700-year-old burial urn unearthed by archaeologists while studying the history of Weeki Wachee."[56] Ironically, a little over twenty years later, in a report on that dig, those archaeologists Rule referred to speculated on the whereabouts of artifacts missing from the collection. Of special interest was "a ceramic vessel with engraved designs that may be related to the iconography of the Southeastern Ceremonial Complex." The writer noted that former employees of Weeki Wachee were being contacted "to try and locate the missing artifacts."[57] So Elton Rule might have unleashed some bad mojo in handing over that sacred artifact, and not just because it was sacred. But if he did, no one noticed it at that moment. Goldenson himself had already unleashed some bad mojo for Weeki Wachee. When he gave his speech, he noted that back in the 1950s he'd loaned Walt Disney some money to complete Disneyland. "I can tell you

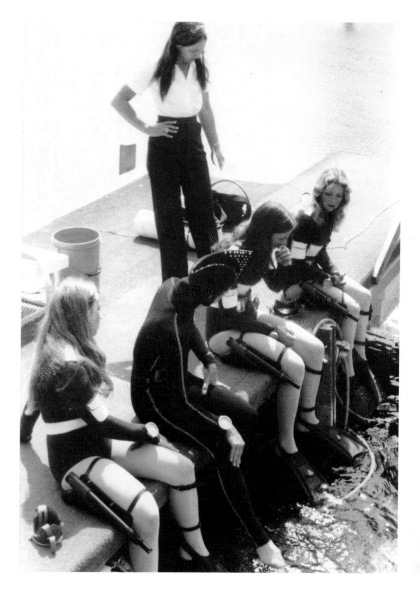

Bonnie Georgiadis oversees mermaids preparing for *The Water Woman Show* (*left to right*), Ginny Farnsworth, Angie Mulzer, Joann Fell, and Anna Stefan Cooke, 1978. Courtesy of Anna Stefan Cooke. Photo by Genie Westmoreland Young.

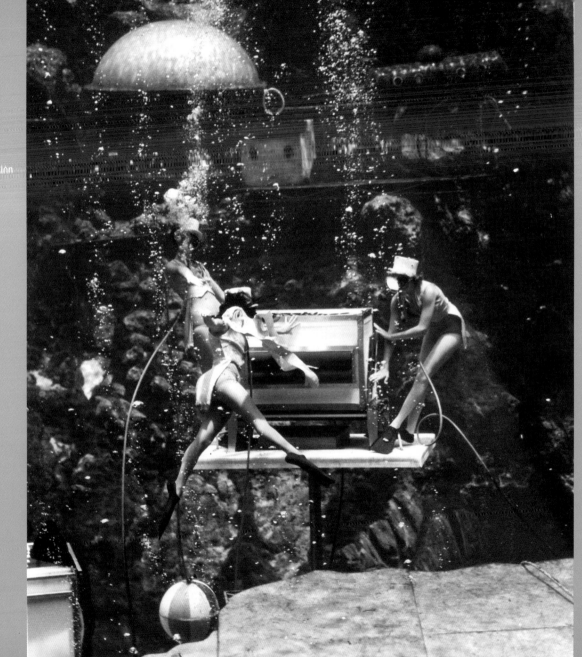

Flattening a mermaid at the first *Magic Show*, ca. 1979. By permission of Weeki Wachee. Courtesy of Barbara Smith Wynns.

that my board regarded that as a much stranger idea than acquiring Weeki Wachee," he said. "But it turned out to be a fine investment, and it was instrumental in bringing Walt Disney to television. And perhaps to Florida."[58]

It was time for the last show of the decade: *The Mermaid Magic Show*. In addition to "The Weeki Wachee Mermaid Flip," an underwater disco dance performed by mermaids wearing high heels, one of the highlights of the show was the moment when "a lovely young Mermaid is flattened into a paper doll . . . and then fed into a second machine [that restores her to] her original curvaceous self."

The show was announced with the usual fanfare: "Not since Houdini has the world seen anything like it. This is the new Weeki Wachee where the world's only underwater magic show will move you to the edge of your seat. There's magic in the air at Weeki Wachee."[59] Unfortunately, the magic in the air was noxious, perhaps intensified by the handing over of that 700-year-old burial urn. It wafted over from Orlando, from Disney's Magic Kingdom, and not only did it seek to flatten the mermaids, it caused the tourists to disappear.

The Eighties

The Age of Acquisition

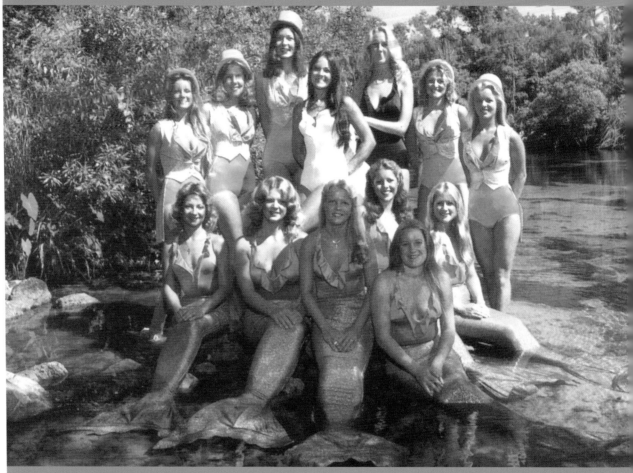

1980s mermaids (*left to right, seated*), Anna Stefan Cooke, Doreen Durandetto Kurz, Melody Harding Hope (*foreground*), Marianne Hope (*background*), Tina Ruggiero, and Rhonda Hope; (*standing*), Susan Cain, Kathy Ecklecamp, Andrea Huber, Marti Nosti-Monaldi, Linda Sand Zucco, Jana Chytka Cofer, and Melinda Harding Flinn. By permission of Weeki Wachee.

In the early 1980s, Kevin Clarke and Horst Wackerbarth decided to haul an eight-foot-long, 200-pound red velvet couch into the theater at Weeki Wachee. They'd already lugged it across most of the country, using it as a prop in photographs, to "disturb the commonplace into something new." The photographers' idea of the "commonplace" was uncommon. They snapped shots of the couch with the Hell's Angels, the Daughters of the American Revolution, and Jimmy Carter. They lowered it into the Grand Canyon and carted it out to a prairie. Then they showed up at Weeki Wachee, where they plunked the couch down in the theater, right in front of the windows overlooking the spring. Mermaid Linda Sand Zucco sat on the back of the couch, while two other mermaids posed in the spring behind her.[1]

Linda, who's from Minnesota, said she'd heard about Weeki Wachee when she flipped through a book she'd found called *1001 Things You Can Get for Free* and saw info on being a mermaid. She wrote to the address provided, and management sent her an application and told her to come down for an interview and a water test. In 1973, right after graduating from high school, she did just that. "It was just one of those freaky things," she said, "almost like it was just meant to be. I found the book with that info, and I thought, I'll go be a mermaid at Weeki Wachee."[2]

Her experience with the red couch was just as providential. She wasn't sure how she was chosen. "These two guys were going around the country, and they wanted to get all sorts of people from different professions, rich people, not so rich people, famous people, photographed on the red couch," she said. "And they came to Weeki, put the couch

in the theater, and sat me down on it. And then the book came out, and I went and got a copy. It was fascinating to see all the different people who had sat on that sofa."[3]

The caption beneath the photograph read:

At Weeki Wachee, one of the old roadside attractions of America, this underwater performer walked to the couch in her body stocking and pulled on the mermaid costume. Once she was in it, she couldn't move off the couch except by falling.[4]

In the introduction to *The Red Couch*, the book that resulted from their work, William Least Heat-Moon commends the photographers for "[leaving] us a strong document that a century from now will still show what we were like in the United States during those first five years of the eighties."[5]

Some of us were mermaids

Although threatened with extinction by Disney, the Weeki Wachee mermaid had made it into our psyches as a piece of Americana, she was definitely not going to fall off the couch. ABC was still committed to the mermaids at this point, even though Goldenson had told stockholders things weren't going so well at Weeki Wachee.[6] In an attempt to draw in more locals and keep the tourists coming back, the company finally opened Buccaneer Bay, a water park that had been in the works since 1979. Like most water parks that were springing up all over the place, this one featured steep slides—the Cannonball, Thunderbolt, and Pirates' Revenge—along with a kiddie pool and bumper boats. Buccaneer Bay was ABC's last big investment. For the first time in the park's history, except for a brief moment in '47 when Newt Perry gave the "Mountain Underwater" top billing,

Mermaids sunning on a rock
(left to right): Melinda Harding
Flinn, Anna Stefan Cooke,
Linda Sand Zucco, and Susan
Cain, ca. 1980s. By permission
of Weeki Wachee. Courtesy of
Bonnie Georgiadis.

Buccaneer Bay brochure (*left to right*), Kim Cox, Jana Chytka Cofer, and Melinda Harding Flinn. By permission of Weeki Wachee.

the mermaids were no longer the main attraction at Weeki Wachee.

But they still considered Weeki Wachee home. In 1983, Weeki Wachee held a mermaid reunion, and 111 mermaids showed up to swim and eat bananas. Newt Perry came, even though he was paralyzed by a stroke he'd had four years earlier. A photograph shows him sitting in a wheelchair surrounded by a group of his original mermaids and mermen.[7] "He was just an absolutely great teacher, and he taught us more than just swimming," said Ed Darlington. "We actually learned how to be young adults and behave ourselves without any temptation to do anything out of the ordinary. That was the last time I got to see him," said Ed. "He remembered Mary and me. He was somewhat paralyzed, but his attentiveness was there, and we just had a great time. He fashioned our early lives, and I can't say enough nice things about Newt Perry."[8]

Like one reporter said, Perry, with his innate talent and enthusiasm, had "created many stars and champions." In the years since he'd left Weeki Wachee, he and his wife, Dot, had built one of the country's largest swim schools and had taught over 120,000 people how to do the breaststroke. One of his students was his nephew Don Schollander, who won four gold medals in the 1964 Olympics, then turned around and won both gold and silver at the 1968 Olympics.[9]

Just one year after the reunion, ABC decided it wanted to get out of the attraction business and concentrate on the communications business. A consortium of "former" ABC execs ponied up $25 million for both Weeki Wachee and Silver Springs and dropped "ABC" from the company's name. By the time Florida Leisure Attractions purchased the park,

Mermaids with Newt Perry at the 1983 reunion. By permission of Weeki Wachee.

Ed Darlington clowns around with Harriet Hope, Genie Westmoreland Young, Barbara Reed, and Bonnie Georgiadis at a reunion, 1983. By permission of Weeki Wachee. Courtesy of Bonnie Georgiadis.

it was being marketed primarily to Suncoast residents since management had decided that the park was not the sort of all-day outing that would attract tourists from more distant places.[10]

Ironically, the new company penalized the locals, changing the way tickets were sold. "When ABC owned it," Bonnie Georgiadis said, "you could go into the gift shop and buy a ticket for a show or you could buy a ticket for a boat ride if that's what you wanted to do, but you were free to go all over the park. The new owners went to tickets you bought up front. A lot of people in the area who'd come over to enjoy the park couldn't get in unless they paid."[11]

Captain Carol Parrish, who pilots Weeki Wachee's tour boat down the river these days, was a mermaid in the late 1960s. She left to get married and then came back in the 1980s right when ABC sold the attraction. "It had changed quite a bit. When I came back, we did our own cleaning; we used to have underwater boys who did that."[12]

Florida Leisure Attractions simply didn't have the deep pockets of an ABC, said Bonnie. Besides losing the underwater boys who helped with maintenance, they stopped changing shows every year. "They hired Shawn O'Malley to do a second magic show, and we had to hold that show for more than one year," said Bonnie. "We stopped having enough time to prepare a new show; they'd hold a show for three years, then all of a sudden they'd want another one in twenty minutes. Previously, we had been doing nine months of preparation and rehearsals before we started a new show. Now all of a sudden we had a month or six weeks to get it together, and I'd say, 'I want to work on this new routine,' and they'd say, 'We don't have time for that. We don't have time for anything new.' They were 'snap your fingers and there It Is,'" she said. "The new company manager was in charge of Holiday Inn hotels; he didn't know anything about putting on productions. When they stopped changing the shows every year, they got a lot of letters. People liked to come every year for the shows."[13]

However, despite the lack of attention to shows at Weeki Wachee, the area itself was attracting attention. The idea of Weeki Wachee as a city populated by six people—mermaids at that—was no longer seen as just a ploy to get the name

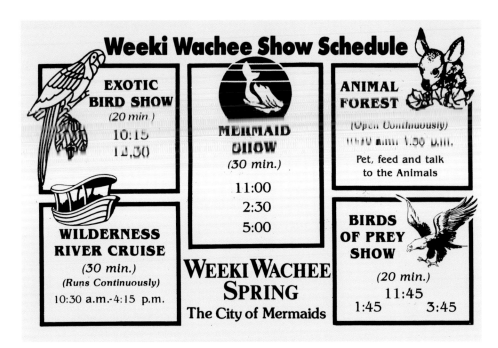

Weeki Wachee Show Schedule

| EXOTIC BIRD SHOW (20 min.) 10:15 11:30 | MERMAID SHOW (30 min.) 11:00 2:30 5:00 | ANIMAL FOREST (Open Continuously) 11:00 a.m.-1:50 p.m. Pet, feed and talk to the Animals |
| WILDERNESS RIVER CRUISE (30 min.) (Runs Continuously) 10:30 a.m.-4:15 p.m. | WEEKI WACHEE SPRING The City of Mermaids | BIRDS OF PREY SHOW (20 min.) 11:45 1:45 3:45 |

1980s Weeki Wachee show schedule. Courtesy of Cathy Mahon Havens.

on the map. "It's as if the city was born and then remained in its infancy all this time," said Sue Vance, mayor and manager of Weeki Wachee. As a reporter for *Florida Trend* noted in 1987: "The helter skelter development that litters U.S. 19 from Pinellas County north is careening straight for the City of Live Mermaids. Weeki Wachee is no longer out in the boonies as it was when the attraction was founded 40 years ago."[14]

And indeed that was true. An Australian firm, Hooker Barnes, was building Weeki Wachee Village, Hernando County's biggest shopping center, right across the highway from the spring. The firm made deals with Winn Dixie and

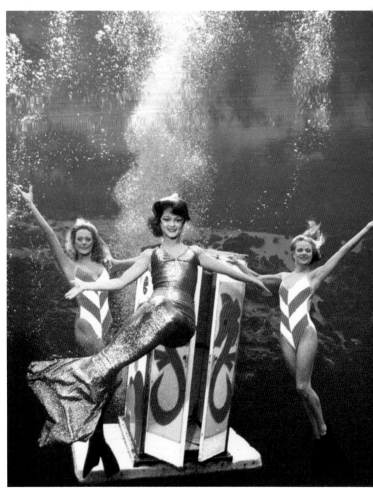

Deja vu, abracadabra—the second *Magic Show* brochure features Kim Burich, Kris Smith, and Jana Chytka Cofer, 1987. By permission of Weeki Wachee.

Eckerd Drugs to lease space. Barnett Bank had already built an office right next to the construction site. Florida Leisure Attractions itself was thinking of developing a golf course community nearby, apparently not having learned the lesson that golf courses and springs aren't compatible.[15]

Newton Perry died at home in Ocala in 1987. He was seventy-nine years old. He'd made it into Ripley's *Believe It or Not* for holding his breath underwater, had doubled for Johnny Weissmuller in *Tarzan*, helped establish Ross Allen at Silver Springs, trained navy frogmen, wrestled pythons and alligators underwater, invented the air hose, invented the airlock, swum more than five thousand miles, died three times in the film *Distant Drums*, and scouted locations for *The Yearling,* as well as tapping his nephew Claude Jarman for the role of Jody. He worked in more than a hundred Grantland Rice shorts, wrote and directed his own films, launched Ricou Browning and Ginger Stanley Hallowell into *Creature* fame—in short, he helped bring the film industry to Florida. And to top it off, he was responsible for luring more than a thousand mermaids to Weeki Wachee. His daughter said he never stopped wanting to get back into the water after his stroke. "Eventually," she said, "we did lower him into the water one last time before he died."[16]

Newt Perry had lived a ferocious life. It was too bad he couldn't return to Weeki Wachee and perform a little resuscitation. The mermaids could've used him. Having to duke it out with Mickey Mouse was bad enough, but things were about to get worse. In 1989, the Florida Leisure Acquisition

A page from a 1980s brochure features the tube room, ca. 1980s. By permission of Weeki Wachee. Courtesy of Anna Stephan Cooke.

"Take a walk down Memory Lane in the Star Garden Hall of Fame," 1970s. By permission of Weeki Wachee. Photos by Claude Long. Courtesy of Larry Warren.

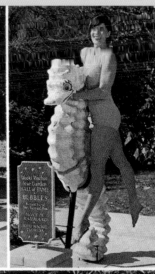

WEEKI WACHEE
STAR GARDEN

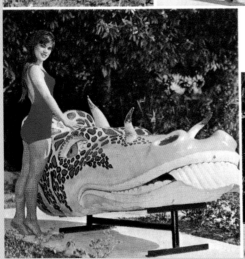
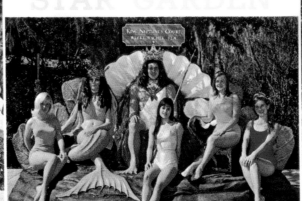
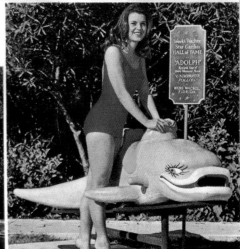

Corporation bought the park. The corporation was made up of a group of investors including a Chicago-based investment company and Merrill Lynch, as well as some of the same people who'd been with Florida Leisure Attractions. The company—like its name, Acquisition—spelled trouble for Weeki Wachee. After the investors bought the property, along with the Weeki Wachee Holiday Inn and Silver Springs, for $40 million, they began making changes many saw as disappointing.[17]

"The manager wanted us to choreograph everything and set it up, but he didn't want us to use any music," said Bonnie. "He said they would do the music later, and we said, 'What can we choreograph if we don't have music?' He didn't get it."[18]

That wasn't all the new company didn't understand.

When ABC still owned Weeki Wachee back in the 1970s, said Allen Scott, they built the Star Garden. "They took all the unused props like the pirate ship and the dolphin that were laying around in the woods and the swamp and the prop shed, and they built what they called the Star Garden. It gave the public a chance to sit on the props, play on them, get pictures of their children sitting on them."[19] Then Florida Leisure Acquisition came along. The company lacked a sense of nostalgia. They bulldozed the Star Garden, smashed the broken bits of dragons, castles, and clams into the ground, and buried them. "The new manager had wanted people from the Bird Department to take axes and chop up all the props," said Bonnie.[20]

"I went back a few years later and almost everything was gone," said Allen. "It was such a powerful sight; everything was just missing. The story is the new management had come in and said all this old stuff has to go; we're going to make new stuff, and they chopped it up and buried it, gave it away. There are some props that are owned by people who live down the Weeki Wachee River; they're in their backyards. The new company sold them for a few dollars just to get them out of the park—like a yard sale. There's no money to build new props the way they built those props; that's why they're still using Bubbles the Seahorse today."[21]

Not only was the Star Garden razed, but box after box of publicity photographs were burned. Allen, Bonnie, and Genie each managed to save some of the photographs that were being tossed into the trash pile.

"I think it's a big-business mind-set that when you're initially put in charge of something, you have to change something," said Genie, "even though it's working. By trial and error we knew what worked."[22]

The company was definitely into change on a large scale. The *St. Petersburg Times* reported a laundry list of contradictory actions on the part of the company. The management revealed plans for an updated *Birds of Prey* show one day, and the next they fired Bonnie, who'd been handling the birds since the inception of the show. They also announced plans to scale back the bird rehabilitation program so employees could devote their time to other jobs. In July 1989, they bragged that the park employed twenty-six mermaids, and then they laid off half of them, including Genie, who had worked for Weeki Wachee for twenty-eight years.

"We felt things could be managed a lot better, more efficiently," explained Eric Studer, the corporation's director of marketing. He then went on to add, crudely, "There was a lot of fat in it, if you will." The employees had to sign releases

Mermaid Bonnie Georgiadis poses on a Queen Conch Shell, ca 1960s. Photo by Burton McNeely. Courtesy of Bonnie Georgiadis.

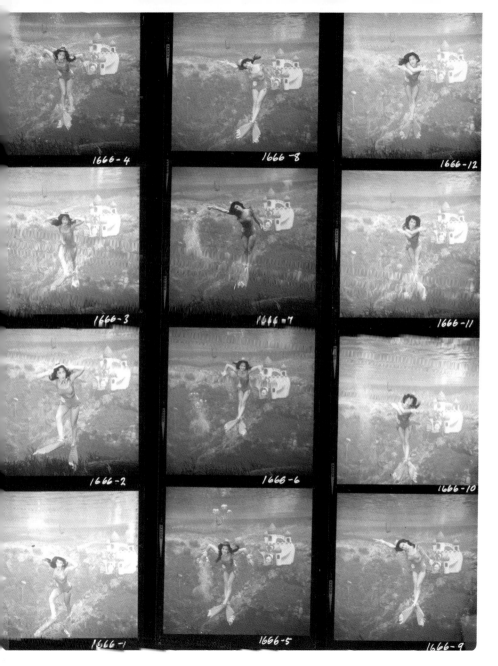

promising not to speak to the media in order to receive severance pay.[23] Bonnie had worked at the park for thirty-seven years, long enough to prompt an outcry on the editorial page of the *St. Petersburg Times*:

> For three and a half decades, Ms. Georgiadis had been a vital part of the Weeki Wachee Spring attraction, first as a mermaid, then in the bird section. . . . Because of management's hasty decision to fire her, Bonnie Georgiadis' voice is silenced and that's a loss for local wildlife and those who care about it. . . . Hoddy [interim director of wildlife activities] said the attraction's commitment to birds remains. But the firing of Bonnie Georgiadis leaves many in this community wondering.[24]

At least one person wasn't wondering about the motivations behind Florida Leisure Acquisition's decisions. Merti Nosti-Monaldi held her breath longer than any other mermaid; she was clocked at an almost unbelievable 6 minutes, 21 seconds. But she wasn't holding her breath for Florida Leisure Acquisition. She said she knew right away that the new owners were not committed to the mermaids. Just talking about the changes is painful, she said. "I was really the only one left who knew how to choreograph a show; Bonnie and Genie both were let go, and they were both very valuable assets to the company. Merrill Lynch had bought it, and I knew what they wanted to do with it. I knew that they had wanted to get rid of the attraction by their behavior: getting rid of all the people that had the most knowledge. In fact,

Bonnie Georgiadis contact sheet from the *Wizard of Oz*, 1966. By permission of Photographic Concepts, New Port Richey, Fla. Photo by Sparky Schumacher. Courtesy of Bonnie Georgiadis.

I was on the list, but they had to keep the show going. They were trying to strike a deal where they could put condos up along the river and the spring. I mean, Merrill Lynch buying it didn't make sense. The whole condo plan didn't go through, but so many valuable people were let go. We had no marketing, no public relations."[25]

Actually the company did have public relations, but they were mostly negative. After angering local residents with its plan to sell eighty acres of unspoiled bear habitat near the head of the river to a developer, the company turned around and sought permission to set up an education center where they would treat injured and endangered manatees.[26] Dan Wilson, a spokesperson for the company, said they wanted to put more focus on "rare and endangered" animals as a way of competing with Disney. They had already ditched the billboards featuring the mermaids, replacing them with images of tropical birds.[27]

The *St. Petersburg Times* questioned the altruism of their request for a manatee habitat in light of the proposed development, noting that "a slick ad campaign mixing mermaids and manatees could attract more tourists to the turnstiles." Ironically, the editorial concluded by questioning whether the corporation "can be trusted with the awesome responsibility of caring for a creature that is in danger of disappearing."[28] It might as well have been referring to the mermaids.

With the staff at Weeki Wachee trimmed to a minimum, the mermaids had to make their own costumes and tails

A manatee at Weeki Wachee Spring, 2005. By permission of Andrew Brusso. Photo by Andrew Brusso.

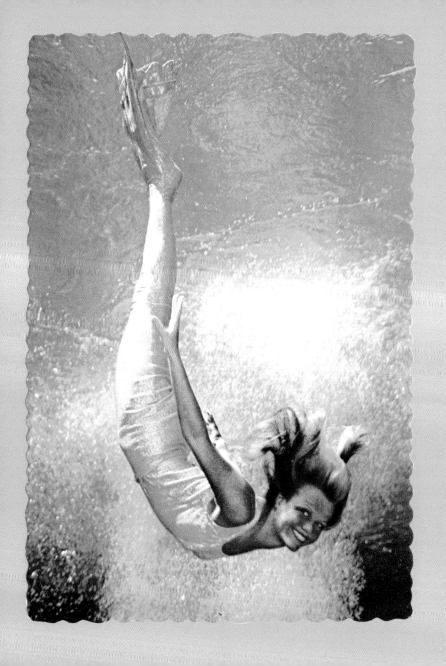

and create their own props. Marti sought out the help of the float makers who were behind the Gasparilla Parade in Tampa. She was also put in charge of choreographing the new show, an updated *Little Mermaid*. It was 1991. "I learned so much from Bonnie," she said. "She used me a lot as a guinea pig to try out new numbers. I had learned how to block numbers before I became a mermaid because I had taken professional dance—ballet and modern jazz. I was inspired by Bonnie's enthusiasm, wit, creativity, and devotion to Weeki Wachee."

Marti's assistant decided she wanted the mermaids to be more realistic. She wanted them to do away with wearing face masks. "I said, 'Listen,'" said Marti, "you've got to have masks or you're not going to be able to have ballet, but she said she wanted it to be more fantasylike, like Disney World. I said you can't make it like Disney—it's a craft, a very specialized craft. You take away the masks and they can't do the ballet or the numbers that really give the show quality. The mermaids still have the air hoses in their hands. You think that people will believe they're real mermaids just because they're not wearing masks? Mythical mermaids don't use air hoses."[29]

What she meant was that the mermaid magic was in the eye of the beholder. The mermaids didn't need to be Disney-fied. The beauty of the mermaids' ballet, the way they floated through the water, their bodies origamied into graceful swans and dolphins, convinced audiences that they were indeed mermaids, despite the masks and hoses, despite the fact that they didn't always wear tails. From its

Melody Harding Hope does the "swan," 1980s. By permission of Weeki Wachee.

Georgia Beattle Underwood uses swim fins, 1968. By permission of Weeki Wachee.

earliest days, Weeki Wachee Spring was a place that had always invited its visitors to suspend their disbelief, to use their imaginations.

It wasn't the first time the mermaids had struggled to keep ballet in the show. The mermaids had always prided themselves on moving like dancers underwater. They critiqued each others' toes and hands. The angle of a leg in an arabesque. The position of an arm. Bonnie said that when the Nagles came on in the early 1960s, they started using lots of hand props. "We had previously worked so hard on ballet hands and the perfection of the hands," she said. "Once you're wearing a prop on your hand, that's lost."[30]

And once you stop performing ballet, you are just "acting underwater," said Linda Sand Zucco. "My favorite show was my first," she said, "*The Best of Everything*. It had a lot of variety and a lot of ballet, which they don't do like they did years ago, which I'm sorry to see. When I was there, it was more dancing underwater and ballet. What I perceive as being a mermaid show would be having a theme behind it, but still performing ballet."[31]

Marti lost her battle over the face masks, and a new era in Weeki Wachee began. *The Little Mermaid* does have a few strategically placed ballet moves in it—but the same show has been running since 1991, except for a break from 1995 to 1997, when the mermaids introduced *Pocahontas Meets the Little Mermaid*. The days of the strenuous Mermaid Ballet course that Lauretta Jefferson instituted were over. There would be no more mermaids bellying up to the barre in the villa to practice their *grand pliés*.

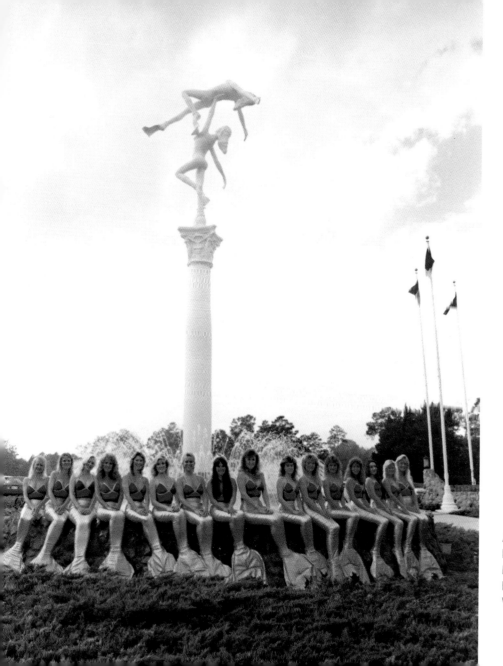

A new era began for Marti as well. After swimming at Weeki Wachee for eighteen years, performing underwater longer than any other mermaid, she decided to move on. "I had applied to nursing school," she said, "and when I was accepted, I left, and I never looked back because it was too painful."[32]

A group photo taken in 1987 (*left to right*), Carol Parrish, Jana Chytka Cofer, Tamar Fraley, Cindy Ledbetter, Rhonda Chancey, Angie Anderson, Mimi Foster, Marti Nosti-Monaldi, Tracey Loman, Julie McLam, Krissy Valentine, Kristin Smith, Trisha, Kim Bleich, Kim Cox, and Kim Vandavoss. Courtesy of Jana Chytka Cofer. Photo by Genie Westmoreland Young.

The Nineteies

From *The Encyclopedia
of Bad Taste* to
the *Tails of Yesteryear*

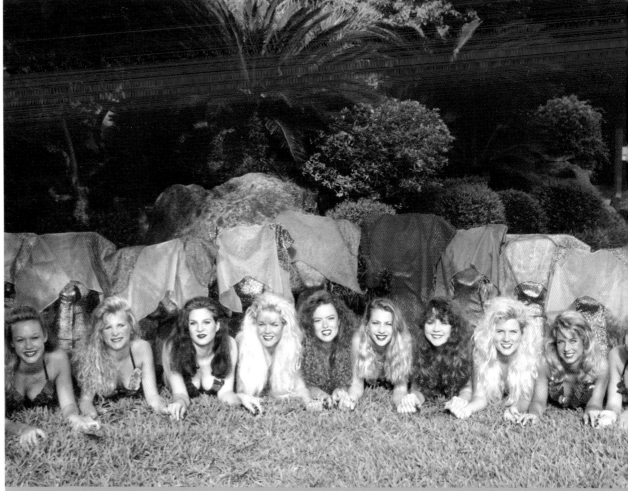

Pretty mermaids all in a row (*left to right*), Janine Maddox, Marcella Elliot, Gina Stremplewski, Beth Thomas, Julie Fouche, Heather Yont, Roni Huber, Amy Crotty, Kim Pippin, and Colleen Grace, 1993. By permission of Weeki Wachee. Photo by Genie Westmoreland Young. Courtesy of Jana Chytka Cofer.

The 1990s got off to a rough start for the mermaids; the emerald-green eel grass that grew out of the sandy white bottom of the spring had all but disappeared, replaced by those billowy clouds of brown algae the mermaids had come to call "scrunge." In the 1940s, it was reported that the spring was so pristine that Brooksville Hospital used the water for its patients,[1] but by the 1990s the water contained twenty-five times the amount of nitrates that it had when Newt Perry and Hall Smith dove in to give it a look.[2] The culprit was the development that mushroomed in Hernando County beginning in the mid-1970s, bringing with it nearly eighty thousand people, numerous golf courses, shopping malls, and manicured lawns.[3]

If the scrunge wasn't bad enough, pop-culture critics Jane and Michael Stern featured the mermaids in their *Encyclopedia of Bad Taste* along with Twinkies, fuzzy dice, and velvet paintings.

> What do the mermaids do when they put on a show?
> . . . They do everyday things. They toss a Frisbee back and
> forth. They drink soda pop from bottles. They eat, actually
> swallowing, apples and bananas . . . If it weren't for the
> long manes of hair hovering weightlessly up and around
> their heads, and a periodic suck on the air hose that each
> mermaid carries (and sometimes wields like a whip) you
> could almost forget they are underwater: they look like
> lovely lunatics dressed in fishtails who happen to have
> been stunned into slow-motion stupor by a heavy dose
> of Thorazine, and for whom these everyday activities are a
> considerable challenge.[4]

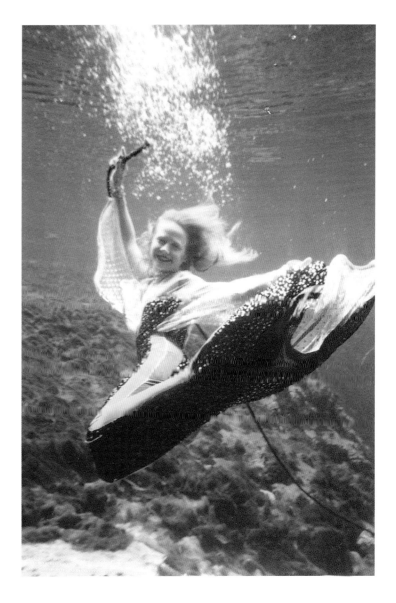

Marcella Elliot, ca. 1990s. By permission of Jo Ann Hausen. Photo by Jo Ann Hausen.

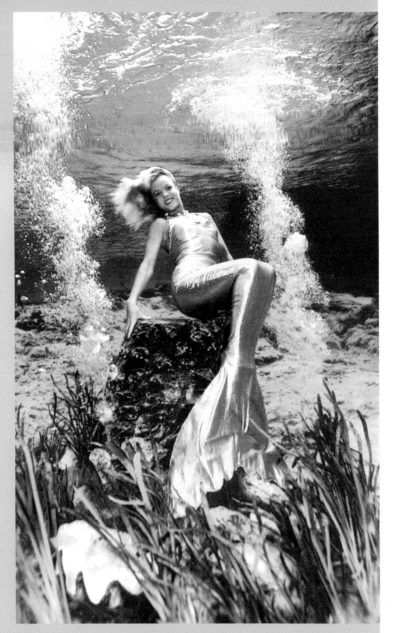

Melinda Huntley Flinn poses for a brochure, ca. 1990s. By permission of Weeki Wachee.

Never mind that Weeki Wachee was once the preeminent Florida attraction, "Disney World before Disney World came along," as one writer put it.[5] Never mind that over 1,500 women had made a splash at Weeki since it opened in 1947, and that the show was still going strong, even if the tourists weren't pouring in. By 1997, when Weeki Wachee celebrated its fiftieth anniversary, most of its fellow roadside attractions had bitten the dust.

The rationale for the Stern's book? A backhanded tribute to "unvarnished awfulness" that has "entered the pantheon of *classic* bad taste," wherein "People start to miss them, crave them, and remember them fondly as signs of devil-may-care exuberance. It has happened to Cadillac tailfins, Elvis Presley, hand-painted neckties, and lava lamps; given time, it might just happen to everything in this encyclopedia."

Actually, even as the mermaids were losing their audience, with every year they continued to perform as "lovely lunatics in fishtails" they were slowly entering the Sterns' "pantheon of classic bad taste."[6] Like Cadillac tailfins, they were becoming iconic. They were becoming kitsch. And kitsch has a life of its own. As the folks at RoadsideAmerica.com noted, "The name 'Weeki Wachee' conjures up as powerful an image as 'Big Sur' or 'Harlem.'"[7]

People may not have visited the park in the numbers they used to, but they never lost interest in Florida's sirens. In July 1992, when *National Geographic* did a piece on how Florida's Gulf coast plays third fiddle to the Atlantic and Pacific coasts, the magazine featured the mermaids prominently in a fold-out color photograph. Just a month earlier, the attraction was used as a backdrop for a swimsuit feature

in *Harper's Bazaar*.[8] There was still the story about Percy, the llama who went berserk in 1995 and attacked his handler at Weeki Wachee's petting zoo, but for the most part people seemed to approach Weeki Wachee with awe.[9]

One of these people was Sally Watts, a reporter over at WUSF, National Public Radio's Tampa station, who unwittingly set in motion a series of events that would lead to a mermaid revival. It was 1997, and Watts wanted to do a piece on the upcoming fiftieth anniversary of Weeki Wachee. "She wanted to get some mermaids together to talk, but she didn't want to get them through Weeki," said Dawn Douglas, a seventh-grade teacher who was one of the first mermaids Watts called. "She wanted to get some unbiased opinions, and it just so happened that one of the men she worked with at NPR as program manager was somebody I knew since I was five years old, so I was on the short list."[10]

"She wanted to meet at USF, and I said if you want to get us emotional at telling stories, we need to meet at Weeki Wachee, at the spring. Get us there, let us smell the water, and the stories will come pouring out," said Dawn. "So we met there one day; in fact, that's the first day I met Mary Darlington Fletcher, and we spent a couple of hours telling stories in a group and alone. We were all from different eras; none of us knew one another, so that was a lot of fun because we got to hear each others' stories. At the end of the day, me and Becky, one of the girls, were standing there looking at the water. We just wanted to jump in so bad. I didn't care if anyone saw me, I just wanted to get in that spring and grab that air hose. Kim Burich, one of the general managers, came walking up; she's a former mermaid too,

and we chatted, and she said, 'What can we do to make the fiftieth anniversary a hit? What would be fun for you girls to do while you're here?' and I said, 'That's easy. Let a group of us former mermaids get together and put on a show.' And she said, 'We'd have no idea how to do that,' and I said, 'Oh, I do.' I'd never done anything like that before in my life, but I knew if we got together it would happen without any great consternation. Kim kind of looked at me funny and said, 'Let me think about that. Give me your phone number.'"[11]

When Dawn left Weeki Wachee that day thinking about what she'd offered to do, she panicked, thinking she'd better come up with a theme and fast, in case Kim Burich called. "I was driving home to Clearwater," she said, "it's about an hour and twenty minute drive, and I wasn't twenty minutes away from Weeki Wachee, and I thought the show has to start with a song that people love and will recognize, but also reflect how we feel about Weeki Wachee—how we loved it and can't forget about it, and I said, 'Unforgettable.' I screamed to myself. It was like a lightning bolt. I had the opening music, the opening lines, and half of the first number choreographed in less than four minutes."[12]

She envisioned the curtain in the theater rising to reveal the famous Weeki Wachee bubble curtain fizzing away to the opening notes of Nat King Cole's song. "First there's some tinkly music," said Dawn, "and over that I laid some words: 'Throughout the years, our hopes, our dreams, our disappointments, the women of Weeki Wachee all agree, swimming in our magical spring has been simply . . .' and Nat King Cole's voice cuts in and goes, 'Unforgettable.'" She had her theme.

Within the week Kim called her back and said, "Go."

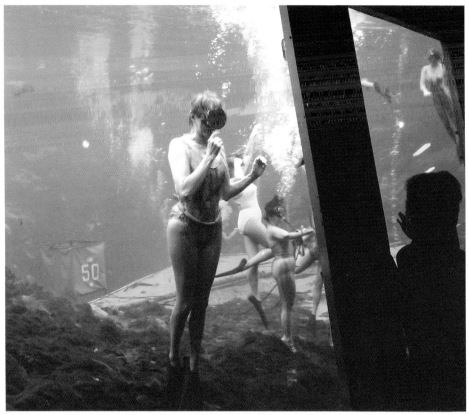

Betty Stoneburner Graves rehearses for the fiftieth anniversary show, 1997.
By permission of Betty Stoneburner Graves. Photo by Gary Graves.

"In my wildest dreams I didn't think they'd say yes," Dawn said. "They'd never really allowed a full-blown production with former mermaids before. At other reunions, mermaids would get in and do a routine, they'd practice a day or two, and that was it."[13]

But Burich was serious. When the park sent out the announcement for the reunion, they let Dawn include a note introducing herself and her idea. "I put my number on it and wrote, 'If anybody's interested, call me,'" said Dawn. Over 125 mermaids called, interested in performing, but the mermaid supervisor cut her off at twelve.

"Then I had a lot of friends," she said. "They changed the rules here—you have to be a certified diver to get into the water to perform, and we actually trained them here."[14] Dawn added just a few lagniappes to the dozen, ending up with twenty-five mermaids, tails on and off. They ranged in age from forty-five to seventy. When they began practicing, the first thing they noticed besides how cold the water was, was how difficult it was to keep their bodies underwater.

"I personally would like to think it's because my bones have more air in them," said Dawn, "but I'm not sure, because there were girls that were thin, like Bonnie Georgiadis; she's still tiny as she ever was, and she popped to the top. She couldn't stay down after thirty-seven years there; she had to wear about three or four pounds of weight. And there were other girls who were overweight who didn't need weights, but most of us needed some kind of ballast. We could still use the air hoses, though."

"In six weeks, twenty-five women put together a forty-minute show that became so popular we had to do it three times the day of the reunion," said Dawn.[15]

Weeki Wachee Spring

WEEKI WACHEE SPRING HOSTS WORLD'S LARGEST MERMAID REUNION . . . Nearly 200 mermaids recently attended a Mermaid Reunion at Weeki Wachee Spring as part of the attraction's 50th Anniversary Celebration. All of the mermaids had performed in underwater productions at the famous Florida attraction, which has staged 35 different mermaid shows for millions of visitors since 1947. The Mermaid Reunion at Weeki Wachee Spring -- The City of Mermaids -- showcased former mermaids performing a special underwater show titled "Unforgettable" and appearing in their "tails" one more time for photographs with the park's guests.

Mermaids of yesteryear on stage at the fiftieth anniversary reunion, 1997. By permission of Betty Stoneburner Graves. Photo by Gary Graves.

Dawn said the interesting part was having so many people in a show when there are only air hoses for six people. Mermaids were everywhere. Some had to wait in the tube room; some had to wait in the tube. Others waited in the airlock in the underwater stage. They just moved forward when it was their turn to perform.[16] And, contrary to mermaid protocol, there was no swimming back to the tube for a seamless exit. The tube wasn't full of catfish this time—it was full of mermaids. "Everybody who wanted to got in the water," said Bonnie. "There was more fish feeding than they'd ever had."[17]

Although the show was initially planned as a private affair for family, friends, and the nearly two hundred mermaids who showed up, at some point, general manager

Curt Parks decided to go public, and the public loved it. The mermaids paid tribute to shows of the past; they walked a tight-rope, played underwater golf, performed balletic moves taught to the original mermaids by Newt Perry: the foot-first dolphin, the flowing knee-back dolphin, the Ferris wheel. They did the "human elevator": arced their bodies, pointed their arms out like movie stars, then drifted slowly upward through the blue water, still as statues. Then they blew out streams of perfect silver bubbles and descended. They guzzled soda and ate bananas, then tossed the yellow peels to the turtles. One mermaid lifted Bonnie arched high above her head, and both ascended, performing Weeki Wachee's trademark adagio, the pose that is immortalized in the statue in front of the park. "I did a lousy adagio," said Bonnie, "but I thought it was so neat to be looking at the surface going up. I got a standing ovation."[18]

Lynn Colombo, who's a sports trainer these days, helped Dawn choreograph the fiftieth anniversary show. Once she got in the water, she performed an underwater strip tease, revealing the magic number "50" on her knickered behind. Crystal Robson, who swam in the 1970s and who now owns B Risque, a swimsuit shop near Weeki Wachee, said, "Everyone who left that place has not stopped dreaming about it."[19]

Crystal supplied the former mermaids with swimsuits for their show. She also got a taste of tail making: "When we came back for the reunion show, I designed a tail that had sort of a plastic in it, thinking it would give us enough kick so we wouldn't have to wear flippers, but it didn't work. And in designing that it was amazing to see how difficult it really is to make a tail."[20]

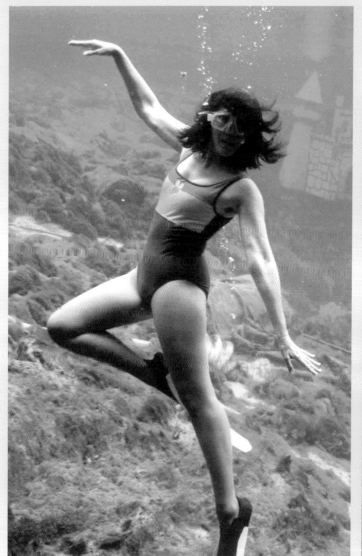

Right: Lydia Dodson rehearses for the fiftieth anniversary reunion, 1997. By permission of Lydia Dodson. Photo by Larry Dodson.

Far right: Crystal Barlow Robson poses with an umbrella, ca. 1970s. By permission of Photographic Concepts, New Port Richey, Fla. Photo by Sparky Schumacher. Courtesy of Crystal Barlow Robson.

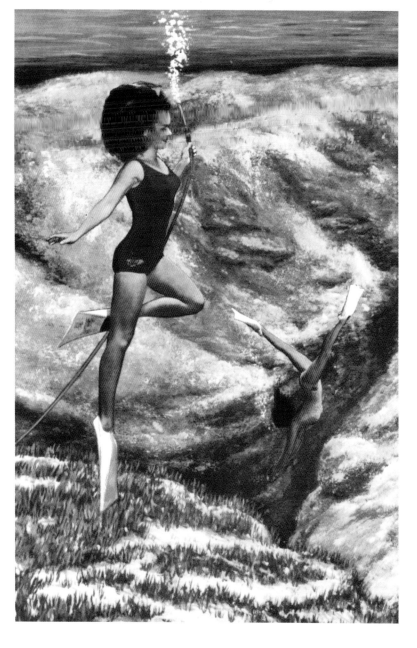

"The fiftieth reunion wasn't too bad of a one to celebrate," said Darlest Thomas, "because I also turned fifty. And out of the 1,500 girls that had gone through the springs at that time, hundreds of us came back. We were all mermaids again, regardless of shape, size, or whatever. Even after a long time, we still felt like friends, like no time has passed at all. And that's very unique. Girls came from as far away as Alaska. We had a couple come from Europe. So it was a weekend of good nostalgia and wonderful memories of being a Weeki Wachee mermaid. Once a mermaid, always a mermaid. Weeki Wachee water is always in our blood, and I have a new little saying to add to postcards I'm writing: 'Mermaids will never die, we'll just drip away.'"[21]

The young mermaids also got in on the fiftieth anniversary celebration. Gina Stremplewski became a mermaid in 1992 when she was working at Scotty's and heard about an opening at Weeki Wachee. She tried out and loved it. "We had the drinking and eating underwater," she said. "I had never done that before—they used to do it a long time ago—so we drank a soda underwater and ate an apple. It was interesting. We also brought back the deep dive."[22]

In keeping with the retro theme, the young mermaids also performed a number that was retro to them. It featured the song "Aquarius." Their prop was a giant peace sign. But they also slipped into high heels and gold jackets with tails for a number choreographed to Madonna's hit "Vogue."[23]

Meanwhile, not one to be left out of festivities, the late Newt Perry was making a splash of his own, up in Tallahassee. Bob McNeil, the senior curator of the Museum

Illustration of the deep dive, ca. 1960. By permission of Weeki Wachee.

Mermaids at fiftieth anniversary reunion (*front row, left to right*), Dena Whipple, Beth Thomas, Gina Stremplewski, and Vicki Monsegur; (*back row*), Tonia Lynn Waldron, Nicole Marino, Jenn Huber, and Amy Pollo. Courtesy of Allen Scott.

of Florida History, had gotten in touch with Delee after seeing her father's name pop up in the credits of film after film—the same way the makers of *Mr. Peabody and the Mermaid* had found him fifty years earlier. The museum decided to honor Newt's memory by dedicating the exhibit Sunshine and the Silver Screen: A Century of Florida Films to him. "A couple of things led me to dedicate the exhibit to him," said McNeil. "I had met his daughter, and she opened a vast archive of material with films and photographs, and she had such high regard for her father; she presented him and his history so well. As I looked at the scripts and photos of people like Johnny Weissmuller walking through her house when she was little—he was a family friend—it was obvious that Newt Perry was a key person in the Florida film industry, more specifically the key person for underwater scenes in Florida. Newt Perry was the person people came to when they needed help filming underwater. He sold people on the clarity and beauty of Florida's springs, and he touched a lot of people, teaching them to perform under-water, like Ricou Browning, who doubled as the Creature from the Black Lagoon. I wanted to dedicate the exhibit to him because he was unheard of and unheralded."[24]

Back in Weeki Wachee, the former mermaids were such a hit that the park decided to stage the shows twice a month. Mary Darlington Fletcher was unable to be a part of that first show because she was recovering from an auto accident, but two years later, with her brother, Ed, pushing her along, she decided she wanted in on the fun too. She was sixty-seven years old at the time. Getting back into the water wasn't as simple as it had been fifty-two years earlier when all she had to do was prove to Newt Perry that she

Mary Darlington Fletcher poses for CBS, 1997. By permission of Richard Fletcher, Gainesville, Fla.

could swim across the spring. The mermaids now had to be certified in scuba.

"What a horrible experience that was," she said. "I finally passed that underwater test where I had to put that tank on my back and go down to the bottom, take off my mask and put it back on, and I want you to know I almost drowned. That was no fun, and I swore I'd never put another tank on my back again. I got real claustrophobic; I wasn't used to that weight on me underwater. I was used to flippers, mask, and an air hose, period."[25]

But Mary was qualified to be a mermaid again, and she liked it. "These girls are twenty years my junior," she said. "There were three of us that were in my age group—my brother, Dottie Meares, and me—and we were kinda like a threesome, like three sore thumbs, but not exactly. They always had a nice spot for us," she said laughing, "kind of in the background, but that's okay. We were part of the team and part of the show, and we had a glorious time."[26]

They had such a glorious time that they kept right on swimming.

Reporters flocked to Weeki Wachee to get a look at the former mermaids. The Mermaids of Yesteryear were featured in newspapers across the state as well as in national venues. Bill Geist of CBS's *Sunday Morning* did a show at Weeki Wachee, referring to Newt Perry as "half Jacques Cousteau, half P. T. Barnum." He interviewed Mary Darlington Fletcher, who obliged his interest in mermaids by perching on a hunk of limestone wearing a white satin fishtail studded with sequins.[27]

Meanwhile, the current mermaids were still in the swim doing their regular shows. "When I started in '91,

THE LITTLE MERMAID
Now Showing Live!

Above: The Little Mermaid brochure (*clockwise from upper left*), Roni Huber and Vicki Monsegur; Jana Chytka Cofer, Matt Driskoll, and Roni Huber; Beth Thomas with treasure chest; Roni Huber and Matt Driscoll, ca. 1991. By permission of Weeki Wachee.

Right: Pocahontas meets the mermaids (*left to right*), Amy Pollo, Melissa Dodd, and Gina Stremplewski, 1995. By permission of Jo Ann Hausen. Photo by Jo Ann Hausen.

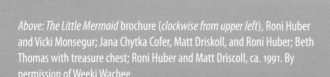

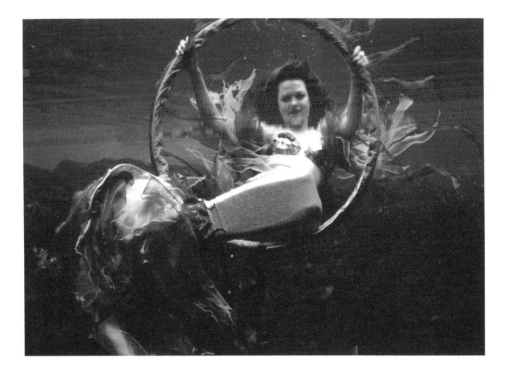

Vicki Monsegur wears a special tail made for trip to Japan, ca. 1990s. By permission of Jo Ann Hausen. Photo by Jo Ann Hausen.

together. After a couple of years, we went back to *The Little Mermaid*."[29]

Jo Ann Hausen made the costumes for both shows. She joined the staff at Weeki Wachee in 1992 after moving to Florida from Chicago and has been making costumes and tails for the mermaids ever since. "You have your posing tails and your swimming tails," she said. "If it's strictly a posing tail—real fancy with sequins and parts that are destructible—the zipper goes in the back. The swimming tail will always have a side zipper for safety reasons so you can get in and out of it fast."[30]

For the fiftieth anniversary, she made Mary Darlington Fletcher's white sequined posing tail. "Our fun is doing the Halloween shows, Christmas, the Fourth of July," she said. "There's a tail for every holiday. For the Fourth, it's red with stars and stripes. Christmas was a red-striped lamé, and it came with a silver cape and a cap with fur around it."[31]

The holiday shows offer the mermaids a break from doing *The Little Mermaid*, and the shows give them a chance to stretch their fins a bit, to put more ballet back into the act. "I got to choreograph a show," said Gina. "We did a lot of ballet and flips. We did 'Shinko's Arabesque,' and leaps, then we'd jackknife into a swan, and reverse up."[32] They also choreographed an underwater *Spiderman*, and a wet *Wild, Wild West*. Then there was the crowd favorite: *Thriller*.

"I played Michael Jackson," said Gina. "I'd go down the tube with no mask, because I didn't want to mess up my Michael Jackson makeup, and I would dart through that thing; it was blurry and pitch-black."[33]

Jo Ann said she sits in on the mermaids' planning sessions and makes sketches of possible costumes. The prob-

we were doing *The Little Mermaid*," said Gina. "Then we did *Pocahontas Meets the Little Mermaid*."[28] Pocahontas meets the little mermaid? That sounds far-fetched, until you remember that Captain John Smith was one of those explorers who reported seeing a mermaid a long, long time ago. "The mermaid was called Felicity," said Gina. "You had Pocahontas; you had Felicity, and Captain Smith. Then you had three sirens; they'd come up and do a little number; you know how they had the sirens singing, and the guys would crash into the water? It was like that. There was a witch in it too. . . . Pocahontas and the Little Mermaid did something

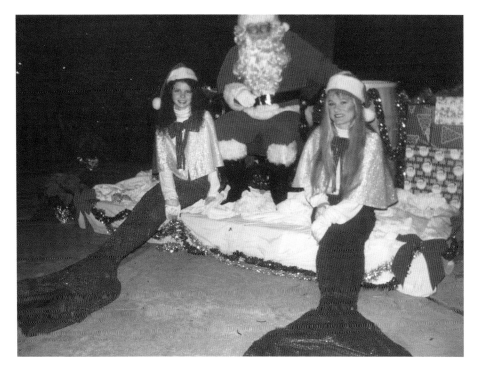

Above: Colleen Grace and Toni
Lynn Waldron are Santa's helpers,
1992. By permission of Jo Ann
Hausen. Photo by Jo Ann Hausen.

Right: Halloween skeleton, 1990s.
By permission of Jo Ann Hausen.
Photo by Jo Ann Hausen.

lems of designing costumes for mermaids haven't changed
at all over the years. "The question is, How do we make it
work underwater?" said Jo Ann. "If you have something you
want flowing, it has to flow at the right level, because water
takes it up. So it has to be weighted. The little skirts they
wear, the men's pants, all have to be weighted. Collars are
sewn down; pockets are sewn down; we want to project to
the audience that this is the real thing."[34]

Projecting "the real thing" to audiences has been a
concern of the mermaids every since the very first day back
in 1947, when a mermaid peeled a banana underwater and

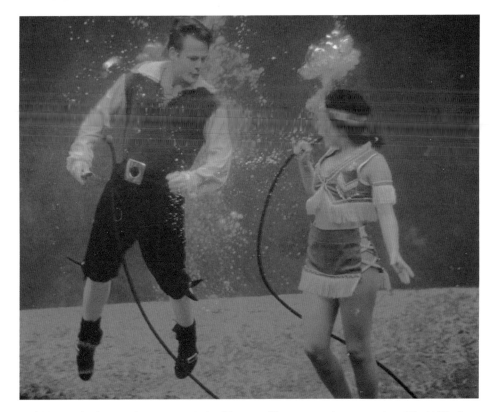

Nicole Marino as Pocahontas and Derrick Burnett as John Smith, ca. 1990s. By permission of Jo Ann Hausen. Photo by Jo Ann Hausen.

The premiere opened with a scene in the theater at Weeki Wachee. The characters in the show press their faces against the glass to see into the spring. Red and orange aquarium fish swim by. Beth Thomas, a real Weeki Wachee mermaid playing the role of a Weeki Wachee mermaid, sucks down a Coke. Then Leanne (Kierstan Warren), the star of the show, swims into the scene and a voice-over announces. "And now she'll make that banana disappear."

However, a huge alligator appears instead, and the next thing the viewer knows, Leanne has dropped the banana, had a near-death experience, acquired a spirit guide, and become a psychic. The question on everyone's mind isn't, What was that near-death experience like? The question people had been dying to ask all those years was, How do you eat a banana underwater?

When asked the question later in the show, Leanne answers slyly, "The secret is in the lips and forming a seal around the fruit."[36] Sexual innuendo aside, experts say she's absolutely right. However, the suggestive nature of bananas may have accounted for a brief period in the late 1950s when the mermaids ate celery instead.[37]

Later that year, in a scene that might well have taken place on the set of *Maximum Bob*, a St. Petersburg city commissioner suggested the city bottle some of the spring water and sell it as "Magic Mermaid Water." Naturally, that idea didn't float.[38] The State of Florida had already come up with a better plan—to purchase the 450-plus acres that made up Weeki Wachee to ensure the land stayed in public hands—although they were mum about it.[39]

In spite of all the attention Weeki Wachee was getting, the park was starting to go downhill. "There were times

ate it. And it was still a concern in 1998, when Weeki Wachee and the famous banana-eating mermaids made it onto prime-time television with the premiere of *Maximum Bob*. The television series was based on a wacky Elmore Leonard novel about a hanging judge named Bob, who happens to be married to a former Weeki Wachee mermaid. Parts of the show were filmed at the spring.

Jo Ann sewed eighteen gold tails for the series. "I guess they thought it was going to be long-lived," she said.[35]

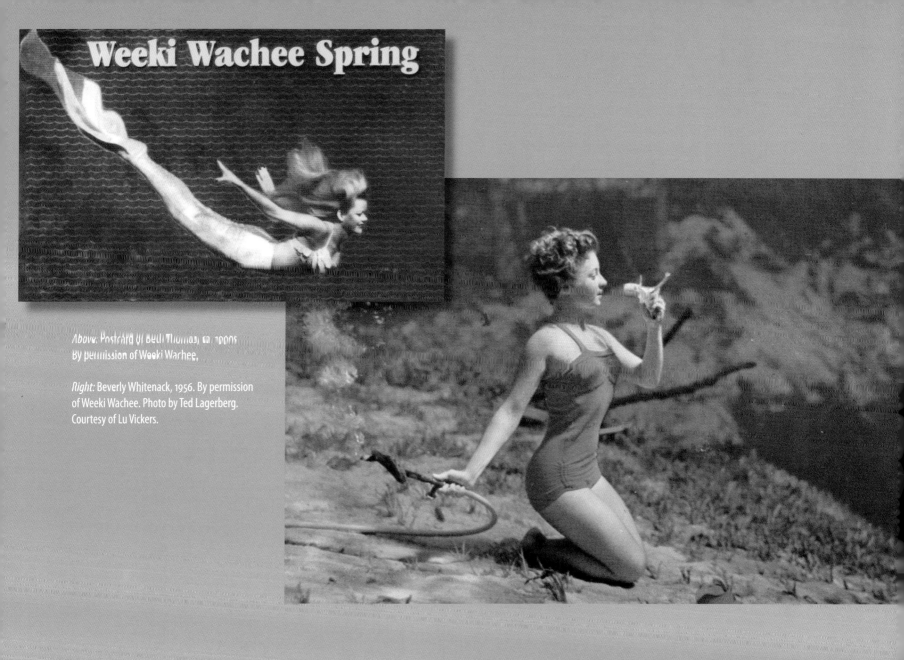

Weeki Wachee Spring

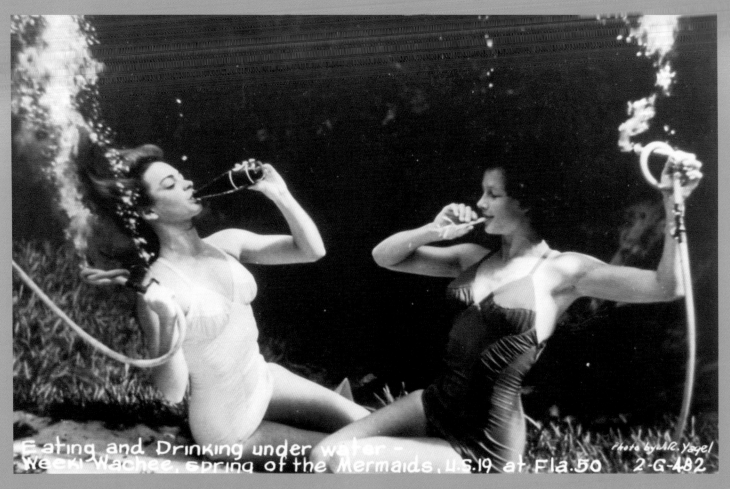

Drinking soda and eating celery, ca. 1950s. Modern Photographers, New Port Richey, Fla. Photo by Ted Lagerberg. Courtesy of Ginger Stanley Hallowell.

Eating and Drinking under water –
Weeki Wachee, Spring of the Mermaids, U.S. 19 at Fla. 50

Photo by W.R. Yagel

2-G-482

when we hardly had anybody," said Gina, "just enough people to do the show. Sometimes we didn't have a guy. Once there was a picture of me in the paper dressed up as a guy, and our general manager at the time says, 'Who's this? Is he new?' And they said, 'No, that's Gina.' When I first started in '92, we had the Exotic Bird Show, we had the *Birds of Prey*, we had the boat ride, we had the mermaid show, and we had the forest you could walk through and Buccaneer Bay. And eventually they took away the *Birds of Prey* show, so we only had the Exotic Bird show and the mermaid show and then Buccaneer Bay. Then we had a reptile show that came in to play, you know, just traveling people that would come in for a little bit. The first couple of years it was real cool, and then it started to slip and slip, a little bit here and there," she said. "About a year or two after the fiftieth anniversary, things really went downhill. It's a shame. Not too long ago a couple of the girls left, and they had to go to short shows. You can't just hire someone and have them come in and swim, it takes time."[40]

Despite being seriously throttled by the Disney empire and years of neglect, the park managed to stay open. In 1999, Florida Leisure Acquisition sold Weeki Wachee to the Weeki Wachee Springs Company, a group of out-of-state and local investors who seemed interested in revitalizing the park. One of the investors was Kim Burich, a former mermaid who'd served as general manager since 1994. She planned to continue in that position.[41]

Once people got past Weeki Wachee's crumbling exterior, they continued to be just as genuinely awed by the mermaids as Elvis had been. The irony, of course, is that some of those mermaids are the same ones who swam

for Elvis. The Elvis-era mermaids had plenty of time on their hands. And, in what was a boon for the park, they performed for free. The audiences loved them. They began performing twice a month as well as on Christmas and Memorial Day Weekend.

One Halloween night, seventy-something Dottie Meares experienced something she probably never dreamed of in 1951, when she was a twenty-one-year-old living in Wauchula, a small town south of Weeki Wachee. "[At that time], I was working at See's Drive-In restaurant, and I saw an ad in the paper for mermaids and applied for the job," she said, as if ads for mermaids appeared in the paper every week. "Bud and Patsie Boyette would drive a station wagon from the springs to Brooksville and go to all our little apartments and pick us up. Afterward they would take us home."[42] One of her favorite things about performing in those days was how quiet the underwater world was. "You could just hear the sound of bubbles and the cool water," she said. "The girls looked angelic underwater."[43] But nearly fifty years later, when the former mermaids gathered to perform their Halloween show, all of that had changed. That night, Dottie drove herself to the spring, where she got decked out in a phosphorescent skeleton suit and danced underwater to the tune of the B-52s' "Rock Lobster."

The 1990s had begun as the era of the mermaid-as-velvet-painting, but the decade disappeared with style, ending on a hopeful note with *Merlinnium, Tails of Yesteryear*, the retro show staged by the former mermaids. Before the show, the Weeki Wachee Mermaids of Yesteryear stand in front of the mirrors in the Mermaid Villa, still in their street clothes, watching themselves walk through the

Tails of Yesteryear group: *(front row, left to right)* Billie Monk Fuller, Susie Bowman Pennoyer, Dottie Meares, Ed Darlington, Mary Darlington Fletcher, Bev Brooks Sutton, Barbara Smith Wynns; *(middle row, left to right)* Dawn Douglas, Becky Stalhut Haldeman, Marianne Hope *(standing)*; *(back row, left to right)* Lynn Sacuto Colombo, Pat Crawford Cleveland, Allen Scott, Crystal Barlow Robson.

dance routines they'll perform later, underwater. On land, the performance doesn't look like much. The mermaids are ordinary women aged forty-five to seventy, lifting their arms, twirling around, kicking their feet out. But something magic will happen when they get into the water. It's that magic-something that drove Newt Perry to build an underwater theater and stock the spring with ballet-dancing, hot dog–cooking teenagers.

After their practice, they walk upstairs into the locker room, where they undress and put on their swimsuits. They lean into the mirrors and cake on their waterproof makeup. Then they carry their tails into the tube room, where they sit on the edge of the portal and put the tails on for the first

show of the day. This isn't easy. The tails are tight and do not slide easily over the special fins they wear. One mermaid lies on her side while another mermaid zips her up. Once their tails are on, the mermaids are ready to drop down into the tube that runs under the auditorium and into the spring. The tube is sixty feet long and dark and scary. There are air hoses along the way, but they are hard to find. The mermaids drop into the water, one by one, and disappear down the tube. Dressed in glittery navy blue tails, they burst into the blue light of the spring one at a time as if birthed.

When the curtain inside the theater rises, the mermaids swim out from behind the bubble curtain, straight toward the windows. Neil Diamond's "Headed for the Future" blares from the speakers, and the mermaids dance, suspended in water, lip-syncing the words. When they finish the song, they disappear behind a spray of bubbles, making way for the rest of the show.

With white clouds of bread crumbs streaming from their fingertips, Mary Darlington Fletcher and Dottie Meares feed the fish and turtles swimming around them, just as they did fifty years ago. Bev Sutton—babysitter for a mermaid before donning a tail herself—and Dawn Douglas guzzle soda and eat bananas, then toss the yellow peels to the turtles. Billie Fuller and Barb Wynns sing Bing Crosby's "My Blue Heaven," and then it's time for the deep dive. Billie is on today. She made up her mind to be a mermaid when she was in the tenth grade, but her mother was terrified of the water and wouldn't let her. She was afraid Billie would hold her breath too long. "You can do it when you turn twenty-one," her mother said, and that's what Billie did.[44]

She's wearing a mask because a bluegill nipped her eye

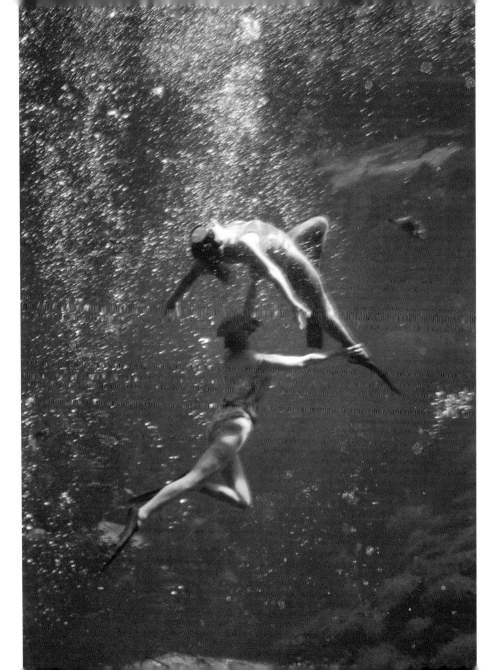

the day before. A voice comes over the speaker: "What you are about to see is extremely dangerous . . ." The audience leans forward to watch as Billie begins her descent. Then we are left watching the empty spring because she has disappeared beneath the stage. "Wait!" The voice says, "Is that her air hose? It is. She has let her hose go. She is now holding her breath. See if you can hold your breath with her."

Just like they did in 1947, the audience gulps air and waits. Billie's husband, Les, clocks her. Two long minutes and fifteen seconds later, Billie floats back into view, her white hair a diaphanous cloud. She gets off a couple of foot-first dolphin moves before picking up her hose and taking a suck of air. The audience lets go of its collective breath, amazed.

The last act of the day is Weeki Wachee's trademark adagio. As Mary's husband, Richard, watches the mermaids ascend through the spring in a pose created over fifty years ago, he quietly jokes, "Adagio. That's French for floating to the top."

Betty Stoneburner Graves and Beverly Brooks Sutton perform the adagio at the 1997 reunion. By permission of Betty Stoneburner Graves. Photo by Gary Graves.

The *Merlinnium*

A Return to the Sublime

Sativa Smith, ca. 2000. By permission of Weeki Wachee.

Sur la veille du millénaire, Weeki Wachee lui-même a été posé dans adagio—avec nullepart aller mais augmenter. That's French for: On the eve of the millennium, Weeki Wachee itself was posed in an adagio—with nowhere to go but up. Mermaid Stayce McConnell unwittingly summed up the park's predicament when she told a reporter, "We can't really see the audience, so we learn to focus on nothing. So when they're out there waving, and we wave back, we're not really waving at them. We're waving at where we think they might be."[1]

Unfortunately, the audience *was* disappearing, and the theater itself had seen better days. The lovely mosaic tile that had graced the front of the theater had been smeared with brown glue and covered with dingy blue carpet. The white clamshell roof the mermaids had once preened on for photographers had been shingled over.

However, the town of Weeki Wachee itself had achieved a pinnacle of sorts. It was no longer just a name printed on a road map to snag tourists. In November 2000, then vice-presidential candidate Dick Cheney planned to stop over at Weeki Wachee for a rally at the former Birds of Prey Amphitheater. "We're expecting a full house," said Tom Barnett, the regional director of George W.'s election campaign. "We're one of the fastest-growing counties in the nation, and it's important that we have this kind of leadership here." Barnett wasn't sure if the mermaids would perform for Cheney or not.[2] They didn't.

However, a year later, when the former mermaids dropped into the spring to lip-sync to "Heartbreak Hotel" and eat bananas underwater, they didn't know it, but they were performing for a less impressive visitor, one the man-agement wasn't too happy about. There was a small disturbance in the back of the theater. Mike Jacobs, the spring manager, was standing in the corner having words with a man who looked like Moe from the Three Stooges. Moe was toting one of those suitcases on wheels.

After the show, Mary and Ed went back to Ed's Winnebago and plopped down in lawn chairs in the parking lot. Everyone was abuzz over Moe. It turns out that he was carrying a bona fide Weeki Wachee mermaid tail in the suitcase. He'd wanted to take a swim in the spring. One of the mermaids remarked that the staff at Weeki Wachee shouldn't just sell the tails to anyone. But Moe hadn't just purchased the tail, he'd worn it into the pool at the Best Western for the past two nights, where he'd sat at the edge of the water, slowly pulling the tail on over hairy legs. He wore a matching yellow swimsuit on top, the empty C cups pooching out over his flabby belly.

"I made it for him," said Jo Ann. "It was a tail I didn't want to make, but I had to because he showed up on my doorstep. You want to keep the image of the beautiful mermaid. But he really wanted that tail. I had to clear him through the front desk, and they made him go through hoops to see if he was really serious, and he was. He followed all the regulations. I'd rather encounter him in the water than an alligator."

Contrary to what the mermaid said about the park selling the tails to just anybody, they don't. They do have standards. "Disney came in one day and wanted us to make a tail for their Little Mermaid," said Jo Ann. "My tongue was hanging out, but we had to say no."[3]

It turns out that Crystal, the mermaid who supplies the

Merman Ed Darlington proves that imitation is the sincerest form of flattery, 1983. Photo by Sparky Schumacher. By permission of Weeki Wachee Spring. Courtesy of Bonnie Georgiadis.

Robert De Niro, Kelly Holloway, and Heather Austin from *Analyze This*, 1999. By permission of Jo Ann Hausen. Photo by Jo Ann Hausen.

former mermaids with their tails, told Moe his swimsuit. "Oh, please," she said when asked if she'd heard about him. "Unfortunately, he came to my shop to buy his bathing suit. He got in the pool with his tail on and his bathing suit that he bought at my shop, and he wanted to do all this under-water stuff. I guess he was performing at the pool. I don't know what happened to him. I think he really thought he was a mermaid. He bought a suit; he had to try them all on. He was there all day. And I realized that he was little off, and I thought, "What do I do with this guy?"[4]

No one quite knew what to do with him that day. They didn't seem to be aware that he was not unusual, that mer-men do exist. Ed was performing that same day with the former mermaids wearing his very own shimmery blue tail.

And in the 1900s, the Three Stooges performed as "diving girls" with Annette Kellerman. Still, mermen simply don't have the seductive power attributed to mermaids, and it's easy to forget that imitation is the sincerest form of flattery. Back at the hotel, as the other guests glared at him, Moe lowered himself into the blue water and backstroked across the pool, flicking his tail up and down.

Moe wasn't the only person who was so enamored with the mermaids at Weeki Wachee. W. Hodding Carter didn't wear a tail, but he swam with the mermaids, then wrote about them for a 2000 issue of the venerable *Smithsonian Magazine*. Clearly smitten by the roadside sirens, he made another jaunt to Weeki Wachee, which he mentioned in an article he wrote for *Outside*. Writers from Jimmy Buffett to Neil Gaiman to Tim Dorsey have made references to the mermaids in their novels. Elizabeth Stuckey-French decided to write her novel *Mermaids on the Moon* after visiting Weeki Wachee and meeting the former mermaids. A Weeki Wachee mermaid was featured on the cover of Alice Hoffman's novel *Aquamarine*. And Weeki Wachee mermaids got a cameo in *Analyze This*, a movie starring Robert De Niro.

In 2002, John Sayles released *Sunshine State*, a swan song of a movie for the old Florida that Weeki Wachee had come to represent. Sayles was no stranger to the real Florida. He told a reporter he'd been coming to the Sunshine State since he was four years old. "My mother's parents lived in Hollywood; my cousins lived in Jacksonville, and my brother lived in Tampa for a while," he said. "So I'm pretty familiar with both the east and west coasts." He'd written about the west coast in a short story titled "Treasure" years earlier, and when he decided to make a film based on the story, he

revisited the area and was shocked by the development as well as the demise of once-familiar roadside attractions.[5]

"What I saw the big difference as being was—there was always tourism, but it was kind of locally owned," Sayles said. "And now it's really corporate tourism. The sons and daughters of people who used to own those places, if they're still there, are pretty much now employees of these multi-national corporations, these chains."[6]

In Sayles's film, *Sopranos* star Edie Falco plays Marly, an ex–Weeki Wachee mermaid. She serves as sort of an aquatic Jacob Marley, the ghost of Florida's Future. Just as Dickens's Marley gives Scrooge a tour of the miserable life he's going to have if he doesn't straighten up, Marly does the same, giving the audience glimpses of a disappearing Florida. *There goes the last of the wetlands; there goes American Beach; there goes the Sea-Vue Motel. There goes Weeki Wachee.* One of the characters, a developer, allows that "Nature is overrated, but we'll miss it when it's gone."[7]

Sayles's crew went to Weeki Wachee, where they filmed Falco standing in the theater, staring out at the spring as a gorgeous mermaid clad in a deep-blue tail glides past the window in front of her. As if remembering the difficulty of eating bananas underwater, Marly sighs, "The important thing is to keep that smile on your face, even if you're drowning."[8] Her comment epitomized two things: the difficulty of eating and drinking underwater, and the mermaids' desire to save the park.

"Who's John Sayles?" asks Gina Stremplewski, when asked if she'd met the director. She's the gorgeous mermaid who swam in blue light past the window. "I met Edie Falco and Timothy Hutton; they were there. They came and did their scene in the theater. I swam across the windows, and then me and Stayce and Sativa swam together. Then we did a Ferris wheel. I spent an hour and a half in the water to do that shot—over and over and holding my breath. It was tiring, but I'm in a movie. At least one."

Asked if she liked it, she replied: "It's an independent film. It was long; you had to really pay attention."[9]

The same could've been said of Weeki Wachee. If you weren't paying attention, you'd think it had disappeared, gone the way of so many other 1950s-era attractions. There were no more "Tails of the Deep" billboards on the highways; there were no more glossy brochures featuring come-hither mermaids in gold lamé tails in the racks lining hotel lobbies. Tourists would ask directions to Weeki Wachee, only to be told it had closed down.

Darlest Thomas, who visited the park in 2001, was shocked by the condition she found the park in. "The magic . . . was still there with the girls," she said. "But it was hard for

me, coming from the era of grand productions, 45-minute shows, fabulous costumes, props that were unbelievable, to see a restaurant filled up with storage unit stuff, walls crumbling, mold creeping up walls, the fabulous *Wild Birds of Prey* Amphitheater down to nothing. Things were literally falling down around our ears."[10]

Because a reunion was coming up that summer, Darlest wrote a letter to her fellow mermaids telling them about the devastation she found. "It took me probably six or eight weeks to even admit to myself that it was falling apart, that it wouldn't be there for very long if we didn't do something. So I let others know. A few didn't agree with the letter, but a majority of the girls did."

Darlest found that even talking about the problems was taboo, akin to pointing out that your dear old friend is losing her looks. "And all of a sudden," she said, "for the first time in my life with the girls, I felt not a part of them."

But then something happened. One of the mermaids who hadn't wanted to talk about the park's problems came around. "She called me a dramatic writer because I'd said the yellow brick road was crumbling and Dorothy and the dream are disappearing, and all of the neat stuff that Newton Perry had started was going," said Darlest. "And now we're working together, stronger than ever to find ways of saving Weeki Wachee and the Weeki Wachee mermaid so we don't become extinct."[11]

Exotic Bird Show employee Shelly Williams, ca. 1980. By permission of Weeki Wachee.

The Springs Need Saving

The problems had begun years earlier when those absentee owners had pocketed the ticket money and failed to maintain the park. In the summer of 2001, using Florida Preservation Trust Funds, the Southwest Florida Water Management District (Swiftmud) bought Weeki Wachee Spring and its surrounding 442 acres for $16.5 million, intending to protect the spring. Under the terms of the purchase, Swiftmud would then lease the 27 acres actually used by the park back to Weeki Wachee Springs LLC, the operator, an arrangement that has led to nothing but quibbling ever since, particularly since the LLC donated the park to the City of Weeki Wachee in 2003.[12]

Although Swiftmud initially had been gung ho about keeping the mermaids in the spring, by June 2003 they were threatening to sue Weeki Wachee and end the lease if the park didn't upgrade the fire exits, repair run-down structures, and fix sewage problems.[13] The owners at that time, the Weeki Wachee Springs LLC, had attempted to save money when they bought the park in 1999 by getting rid of the *Birds of Prey* show and kicking Duster the Cockatoo and his fellow bird performers out. They simply wanted to concentrate on developing the water park.[14] By June 2003, like Swiftmud, they too were at the end of their air hose. At this point, in an attempt to save the park from closing, the owners decided to donate the attraction to the City of Weeki Wachee itself.[15]

By early August 2003, the deal was made and the park belonged to the mermaids who were struggling to satisfy Swiftmud by fixing the rotting beams in the Mermaid Gallery Restaurant and paying $112,500 toward the rent. However, they weren't moving fast enough, and by the middle of the month, Swiftmud's initial deadline had passed. The state agency let it be known that they were seriously considering fishing the mermaids out of the water and turning the spring into a passive public park.[16]

That threat to drive the mermaids to extinction made national and international news. In "Sad Days for Mermaids of the Sequined Sort," an article featured on the front page of the *New York Times*, Robyn Anderson, a former mermaid who is general manager of the park and mayor of the tiny town of nine residents, told reporter Abby Goodnough: "If anybody should have it, it's the city. The people who live and work here actually know this place and would keep an eye on it better than people who are never around."[17]

Anderson also made appearances on *Good Morning America* and the NBC *Nightly News*. Reporters from *People* magazine and CNN called the park trying to set up interviews. Anderson took advantage of her moments on the *Today Show* to announce the slogan for a campaign to save Weeki Wachee: "Save Our Tails."[18] Newspapers across the country picked up the story, and the headline writers had a ball, punning their own tails off: "Alive and Flippin'," "Hope Floats for Mermaid Park," "Mermaids May Get Beached," "Mermaids Thrown a Life Ring," and "Mermaids Saving Tail."

The media storm helped. Not only did the "Save Our Tails" campaign raise $2,000 right off the bat, it also brought forth a number of offers from people eager to help supply the resources needed to make repairs to the park.[19] And, more importantly, at least for the moment, it won the park

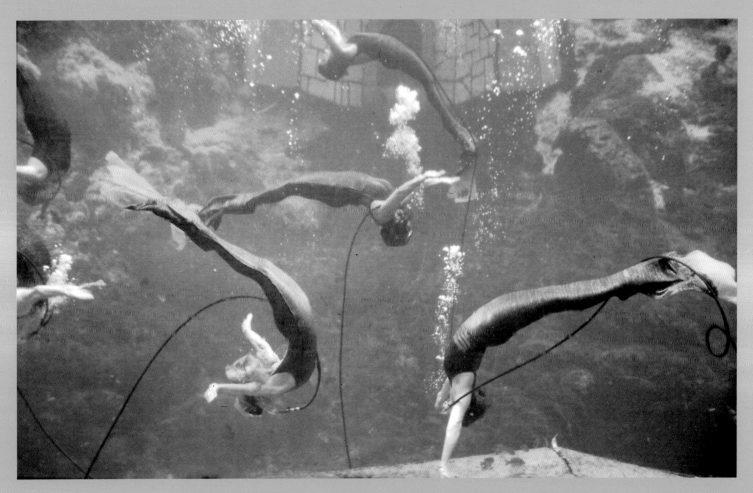

The former mermaids perform at their monthly show, 2002. By permission of Sara Dionne. Photo by Sara Dionne.

a reprieve from Swiftmud, which in late August 2003 announced it would give the managers four more weeks to prove they could get the park in shape.[20]

Chuck Morton was so moved by the mermaids' plight that he wrote the park a check for $1,000. The Hernando County realtor told a reporter that the Weeki Wachee mermaids are an essential part of Hernando County history. "I don't want us to be known as the county with three Wal-Marts," he said.[21]

He didn't have to worry. After amusing viewers with her question "What's a Wal-Mart?" on the first season of her show *The Simple Life*, the tacky Paris Hilton and her foul-mouthed sidekick Nicole Richie took Hernando County by storm in March 2004 to film an episode of *Simple Life 2*. Hernando County was about to get star treatment. Or maybe not. Some of the locals weren't so sure, thinking the two would poke fun at the not-so-simple lives of the natives.

First the two travelers visited the Caliente Nudist Resort in nearby Land O' Lakes, where they attended a "Body Acceptance" class, then they headed to Brooksville, where they effortlessly convinced Jimmy Batten, a candidate for the Hernando County Commission, to moon them while wearing chaps. Without anything on underneath. On film. All that was left was for them to head over to Weeki Wachee, where they babysat a manager's child, taught her curse words, and swam in the spring.[22] Mermaid Nikki sort of met them. "We didn't really talk to them a lot because there were so many people around. They were nice, nothing like they are on TV." Some of the mermaids accompanied the two celebrities to Ybor City in Tampa, where Paris obliged the crowd by dancing on top of a table.[23]

One of the mermen says he didn't make it to Tampa, but he had his own close encounter with Hilton. She mooned him, but with a couple of exceptions—she was wearing tights and he couldn't see her. "I didn't see it because I was in the water and she pressed that moon against the glass."[24] Clearly, this was not the same Weeki Wachee Arthur Godfrey had visited numerous times.

Not only did Hilton make an impression on Weeki Wachee, Weeki Wachee made an impression on Hilton as well. Remembering the springs in her autobiography, *Confessions of an Heiress: A Tongue-in-Chic Peek behind the Pose*, she wrote:

> We had to get jobs to make a hundred dollars, which would pay for our gas and food. My first job was at Weeki Wachee, a kid's place with an underwater show. I got to play a mermaid, and Nicole was a turtle. It was kind of stupid, but Elvis has been there so that made it kind of cool.[25]

At least she knew Elvis had been there.

Strangely enough, on March 18, 2004, the same day that Hilton and Richie made their appearance at Weeki Wachee, the bidding for a four-inch lock of twenty-five strands of Elvis's hair ended. Lynn Chako, the St. Petersburg high school student who had written about Elvis's visit to Weeki Wachee back in 1961, had put the King's hair up for auction on the Internet. Apparently, Elvis dated Chako while finishing work on the film *Follow That Dream* over in Crystal River. Although the romance lasted only one month, they remained friends for years, close enough so that at some point Chako clipped the hair from his head. Elvis's hair sold

Shirley Walls welcomes Elvis Presley, 1961. By permission of Photographic Concepts, New Port Richey, Fla. Photo by Sparky Schumacher.

Former mermaids greet the audience prior to a performance (*left to right*), Dottie Meares, Billy Monk Fuller, Beverly Brooks Sutton, Pat Crawford Cleveland, Becky Stahlhut Haldeman, and Lynn Sacuto Colombo on the microphone, 2002. By permission of Sara Dionne. Photo by Sara Dionne.

for $3,425 and came with a copy of Chako's *St. Petersburg Times* article about his visit to Weeki Wachee.[26]

March was a busy month for Weeki Wachee. *National Geographic* heard about the threat to the mermaids and sent a crew from their show *On Assignment* to Weeki Wachee to film them in action. "The mermaids are highly endangered," intoned an article on the magazine's Web site, noting that fewer than twenty people in the United States perform jobs that require them to wear fishtails. For the uninitiated, Krista Lewis, one of the trainee mermaids, clarified a couple of points. "We breathe underwater. That's what mermaids do. We're half-fish, half-human."[27]

It's clear that the magazine took the mermaids seriously, particularly the older mermaids and their fight to save the park: "Some former mermaids, rather than soaking in a hot tub in a retirement home, have squeezed back into their sequins to breathe life back into the park."[28] The former mermaids had hit on a formula that seemed to be working, drawing press from around the country. They were also featured in a less exalted venue—the tabloid *National Examiner.*

"The *National Examiner* photo shoot was really very unobtrusive—like every other person that has come and photographed," said Susie Pennoyer, who slipped into a beautiful blue tail and posed in the grass with her fellow former mermaids. "Half the time—no, I would say 90 percent of the time—we never see photos; we never see print, we never see anything of all these people who come and talk to us. When the *Examiner* came, that was just another time that somebody was there for a few hours, talked to everybody, took a few pictures and left."[29]

The mermaids may have had to buy their own copies of the tabloid off the rack at the Winn-Dixie, but still, the *Examiner* treated the mermaids with just as much respect as *National Geographic* had. "Retired Mermaids Still in the Swim," shouted the purple headline of the two-page spread beneath a yellow banner that read "Amazing but True."

The aquatic ladies, who range in age from 49 to 73, hop into the 117-foot-deep spring-fed pool and, in their bulky leg-shackling costumes, manage to fight the current, sneak breaths through air tubes, lip-sync songs and dance in unison—all while keeping effortless smiles plastered on their glowing faces during their 30-minute show, "Tails of Yesteryear."[30]

Susie Bowman Pennoyer and Liz Franke pose for a New Year's publicity photo, 1972. By permission of Photographic Concepts, New Port Richey, Fla. Photo by Sparky Schumacher Courtesy of Barbara Smith Wynns.

"I can't imagine why they'd want to see fat old floppy women in the water," said Rev Sutton. "But we like it, and we're glad they do. They do like it. I guess it's our age. They just can't believe we can get in there and still lift our legs over our heads and do that kind of stuff. Dottie's goal is to swim 'til she's eighty; she's seventy-four now, and I want to make that goal and longer if I can."[31]

What the *Examiner* and all the other magazines and television shows are responding to is not "fat old floppy women," but athletes in complete possession of their bodies. These mermaids have overcome worrying about the American obsession with youth and beauty:

> Female athletes repossess their bodies. Told they're weak, they develop strength. . . . Told that their bodies are too dark, big, old, flabby or wrinkly to be attractive to men, they look at naked women in locker rooms and discover for themselves the beauty of actual women's bodies in all their colors, shapes and sizes.[32]

The older mermaids are "actual women." Their willingness to dive into the spring and perform with their "actual bodies" is an inspiration to everyone.

Clearly, the mermaids are crossover muses; they bridge the high-culture, low-culture divide. In 2004, a couple of the mermaids were featured in "Blood, Sea," a video/photo/drawing exhibition by German-Brazilian artist Janaina Tschäpe at the Contemporary Art Museum at the University of South Florida in Tampa. Tschäpe, who has exhibited her art in museums from Sao Paulo to Tokyo, was inspired by

Billy Monk Fuller swims with a manatee, 2005. By permission of Andrew Brusso. Photo by Andrew Brusso.

Janaina Tschäpe photo from "Blood, Sea," USFCAM exhibition, 2004. By permission of Janaina Tschäpe. Courtesy of the University of South Florida Graphics Studio.

the wacky beauty of Weeki Wachee. In the catalog accompanying the exhibit, critic Gean Moreno wrote:

> Value is certainly redistributed when Tschäpe introduces a beautiful image of a maiden doing her sublime aquatic ballet conjuring up timeless metaphors and narratives of the sea, and we then learn that the video was filmed in the Americana world of Weeki Wachee Springs, Florida. It's almost as if the most refined part of the culture meets its opposite—Homer in kitsch crackerland. . . . All of a sudden, our maiden, so Nijinsky-like in her grace when we first saw her, is sublime in the way that a lava-lamp is sublime in the thick incense fog and Marlboro smoke of a trailer.[33]

Internationally known photographers Diane Cook and Len Jenshel featured a shot of the Little Mermaid and her prince in their book *Aquarium*. In an interview with former *New Yorker* writer Lawrence Weschler, Cook commented on aquariums in general:

> I guess it's ironic that we humans, who think of ourselves as being separate from nature are the ones who try to create these artificial and perfect worlds. I'm sure some would like to think that aquariums are perfected universes, but when you look at some of these pictures, you see peeling paint and crumbling tanks.[34]

With those words, Cook summed up the world that is Weeki Wachee. Natural and yet artificial. Artificial and yet perfect. Perfect and yet crumbling. Appealing, nonetheless.

It's a rainy day in March 2005 when I show up to watch Hans Christian Andersen's *The Little Mermaid* at Weeki Wachee.

Mermaid Heather is sitting in a lawn chair by the ticket office, wearing a pink Lycra mermaid tail. She's doing what mermaids do when they aren't swimming; smiling and posing. If she's uncomfortable in the cold, she's not letting on. When I ask her how she came to Weeki Wachee, she tells me her grandmother worked in the gift shop for nearly thirty years. "When I told her I was going to be a mermaid she wasn't too happy about it. She can't swim," said Heather. "I think she kind of felt helpless. If something happened there was nothing she could do, but she's all right with it now, she just gets a little nervous."[35]

Heather plays the role of one of the Little Mermaid's sisters. During the show, she swims close to the glass and gives a knowing wink to the audience. In between shows, the mermaids huddle on couches in the Mermaid Villa and eat and discuss everything from Disney World to Paris Hilton to their place in Florida history. "Disney doesn't compare to us," says Mermaid Nikki. "They might have their rides and stuff, but they don't have the springs." She tosses out a few more reasons why Weeki Wachee is superior to the Magic Kingdom. "Weeki Wachee is the Fountain of Youth. We're more authentic. We're family; they're not. They just do it for the job."[36]

For these young mermaids, swimming at Weeki Wachee clearly isn't just a job. It's a love affair, just like it's always been. Merman John has worked at Weeki Wachee for almost eight years. "I said this was my last year, but I've said that for the past five years. Me and the other merman are starting a business doing Web design," he said, "but I'll still keep my foot in the door. No one wants to leave completely."

Left: Mermaid Nikki at Weeki Wachee, 2005. Photo by John Athanason. By permission of Weeki Wachee Spring.

Above: Mermaid Angela rehearses *The Little Mermaid*, 2005. Photo by John Athanason. By permission of Weeki Wachee Spring.

Merman Justen prepares for an underwater show, 2004. Photo by John Athanason. By permission of Weeki Wachee Spring.

Asked how he felt about being part of Florida history in his role as a merman in one of Florida's longest-lived roadside attractions, he shrugged: "I don't really think I'm part of history; the guys don't really get too much recognition. It's a mermaid thing. People come to see the mermaids, which I understand. We don't wear the tails. The traditional ideal of a mermaid is a woman; you don't hear too much about mermen."

John expressed hope that his life as a merman would improve now that the tiny city owned the park. "There are people here who actually care about the park," he said. "We used to have a lot more shows, and there was a lot more to do. I can see already we're making some positive changes; I hope they can save the park. Disney has a monopoly, and it shouldn't be like that. History is important. I think we should preserve nature and history."[37]

Merman Justen became a merman at the suggestion of a friend who was a mermaid. "She called me when I was living in Indiana and said, 'You should come do this.' So I did." He said he feels inspired by the park's longevity. "You're part of something that goes deeper than you," he said, adding that even though the park has been in existence for nearly fifty-eight years, people still have trouble believing the performances take place underwater, just like they always have from the beginning.

"Some people come up to me and say, 'Where are the strings?' 'Where're the ropes?' Especially the older people. They'll say, 'That's not really water in there; that's a sheet of water and you're just manipulated by some string.' And some people think [the spring] is just a huge aquatic fish

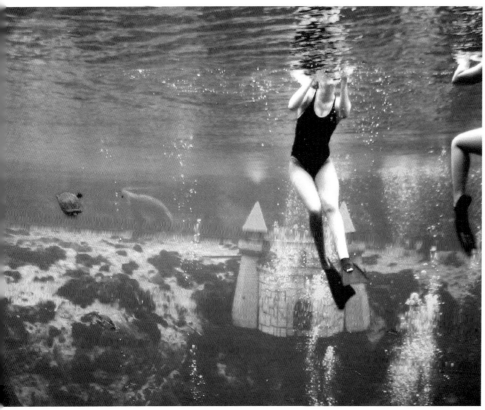

Mermaid Erin swims to the surface for air while in training, 2005. Photo by Lu Vickers. By permission of Lu Vickers.

tank. And they have to realize it's not a fish tank; it's an upside down waterfall; I mean the amount of water that flows out of it is equivalent to a giant waterfall—190 million gallons a day. If you go right up to the boil [where the water gushes out], it's pretty fun."

Fun or not, he agrees with Merman John: the mermaids are the stars. "I put 'merman' on job applications and people look at me like I'm weird," he said. "Who really wants to hire a merman? Now I put 'professional diver.' There's a huge bias against mermen."[38]

Weeki Wachee's last show of the day is over, and the mermaids have made their bow and disappeared behind the bubble curtain. Thirty or so audience members have walked away. In a few moments, the spring will hold both the newest of the new mermaids, and a couple of the oldest Mermaid Erin has been swimming for nearly three weeks along with her fellow trainee Mermaid Angela. Erin's great-aunts, Margaret and Bunny Eppele, were among the original mermaids who swam at Weeki Wachee back in the 1940s. Like several of her mermaid sisters, Margaret doubled for actress Ann Blyth in some of her long shots for *Mr. Peabody and the Mermaid*.[39]

Angela and Erin are practicing moves like the bent-leg dolphin underwater, while inside the theater Mermaid Nikki and Mermaid Cassie, swaddled in thick white bathrobes, shout out directions over the underwater speaker system. "Your back leg is funny," "Hold your chest up." Erin and Angela aren't allowed to use the air hoses yet, so they have to keep swimming to the surface for gulps of air.

Meanwhile, Vicki Smith and Bev Sutton, two former mer-

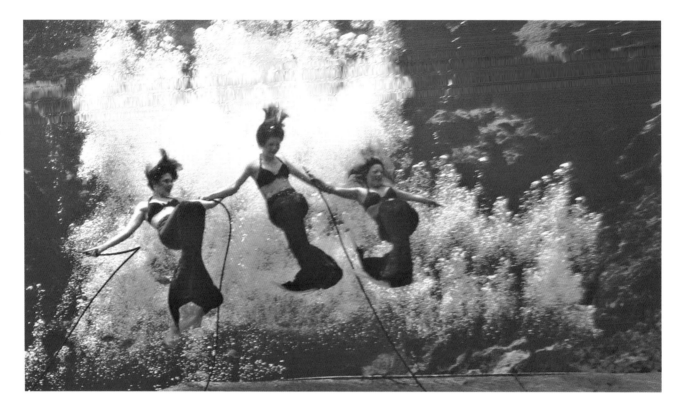

Current mermaids, 2005. By permission of the *Tampa Tribune*. Photo by Scott Iskowitz.

maids, share the spring with the trainees. They are working out for an upcoming show. Every once in a while, they take a suck from one of the air hoses snaking across the underwater stage, then somersault away, rolling weightlessly through the clear blue water as easily as the algae-covered turtles who sail past them. At the very back of the spring, behind the mermaid's castle, a manatee lounges on a bed of algae. "Is he dead?" shouts Nikki into the mike. "He's not moving."

"He's asleep," says Cassie, the Little Mermaid. "The algae is warm."

Erin and Angela swim over to the manatee, then head back to the window of the theater, where they practice foot-first dolphins, then shoot to the surface for air. The constant swimming to the surface for air and then back down again is exhausting.

Except for the algae blanketing the bottom of the spring, the scene hasn't changed for nearly sixty years. Local girls

become mermaids. Erin says her great aunts' exploits are the stuff of legend in her family. Mermaiding, it seems, is NOT taken for granted in Hernando County. Nikki says she wants to be a mermaid forever. "One day we'll be formers." She says the word *formers* as if it has a certain cachet, and it does—for a mermaid, it's like calling yourself a "Supreme."

The mermaids might have a chance to swim forever. In spite of its acrimonious relationship with the City of Weeki Wachee, Swiftmud has said it wants to keep the mermaids. The agency's attorney, Bill Bilenky, said, "The one thing they don't want to do is shut this facility down."[40]

Part of the problem seems to be that there is no clear distinction between Weeki Wachee the attraction and Weeki Wachee the city. "Put Weeki Wachee out of Its Suffering," suggested the headline for a March 2005 editorial in the *St. Petersburg Times*, calling for a revocation of the city's charter. The editorial went on to argue that if the attraction is going to succeed, it can do so without being incorporated as a city, adding that the whole "city" thing was a gimmick from the get-go.[41] If getting spanked in public wasn't enough, just one month later the *St. Petersburg Times* reported that Weeki Wachee Spring had been identified as a "potential terror target" by the United States Department of Homeland Security. The management at Weeki Wachee was working closely with the Hernando County sheriff's department to "harden the target."

"I can't imagine (Osama) bin Laden trying to blow up the mermaids," marketing director John Athanason told a reporter, "but with terrorists, who knows what they're thinking?"[42]

You'd think that swimming through all of this political flotsam and jetsam would be like staying underwater for too long without an air hose, but at least one person didn't feel that way. In May 2005, Athanason announced that Hank Capshaw of the California-based Size 12 Productions had been at Weeki Wachee filming this "modern-day David and Goliath" story. Capshaw, whose reality-TV company has worked on shows such as *Unsolved Mysteries*, told a reporter he was fascinated by the roadside attraction's battles with state and local government. He told Athanason he was impressed by the struggles of "a bunch of young people" to keep Weeki Wachee afloat. The plan is to sell the pilot to a network and then follow with a thirteen-show series. "The pilot has been very well received," said Capshaw.[43]

High-profile folks aren't the only people interested in helping Weeki Wachee. John Athanason said that since the spring had been threatened with closure, locals have stepped up to help the park, particularly local businesses. "Home Depot donated thousands of dollars in supplies," he said.[44] Many of the local businesses that offered help are headed by people who have fond memories of the park. In April 2005, the *St. Petersburg Times* reported that workers peeked behind a bit of loose carpeting down in front of the theater and discovered that the original 1950s mosaic installed when ABC built the new theater was still intact, although it was covered with brown glue. Bryan Banfill, who owns ADSB, Inc., a flooring business, donated his family's services to the park. Banfill, who'd visited the park as an eight-year-old, vowed to do whatever he could to help save the mermaids. He and his brothers didn't waste any time ripping the carpet from the wall to reveal the aqua, pink,

Rendition of Weeki Wachee's
corporate seal from 1966.

City of Live Mermaids

and burgundy mosaic of funky fish featured in so many postcards from the 1960s. Even the mermaids got in on the act, scraping away at the crusts of glue to reveal the shiny tile.

Shane Banfill will soon find out just how much time it takes to create a mosaic like that. He's been given the job of retiling the pillars in the theater, part of a whole retro-restoration project envisioned by Athanason. "Because the park is one of the original roadside attractions, we want to focus on the nostalgia of old Florida," Athanason told a reporter.[45]

It turns out the concrete clamshell roof was also there all the time, and the park hopes to uncover it. It's as though Weeki Wachee is excavating its original self from the rot-

ting timbers, the piles of stained blue carpet, the layers of weathered shingles. The building isn't the only part of Weeki Wachee that Athanason envisions resurrecting. The crystalline waters of the spring itself are also endangered. John Karcher Enterprises and All Coast Enterprises recently donated over $13,000 worth of services and supplies to fortify a seawall that will, hopefully, prevent runoff from the surrounding area from pushing sand into the spring. "We've got to save the spring," said Athanason. John Karcher, whose company headed the project, agreed. He signed on to help out of nostalgia for the spring, having grown up going to the park. "You got to get in there and help, any way you can," he told a reporter. "We need [the spring], and we've been fighting to save it."[46]

And he's right. If they don't, there's more at stake than the mermaid show. There will be an extinction, not unlike the loss of the night sky to light pollution. If Florida's springs aren't looked after, the next generation will never know the giddy feeling of floating over that deep, clear water; they'll never know the feelings of "being suspended between two atmospheres," of losing one's "hold on the earth."

The impulse to move toward a retro theme isn't just evident in the theater—the mermaids themselves have been paddling steadily backward, ever since the fiftieth reunion. The mayor, Robyn Anderson, wants new shows from both the former and current mermaids. "We're coming up with a show," said Nikki, "that's kind of like a history. We'll have a couple of numbers, and we'll demonstrate eating and drinking. Eating's not hard at all; the drinking is. You blow into the bottle and gulp it down. Right now we eat and drink underwater on Thursdays and Fridays."[47]

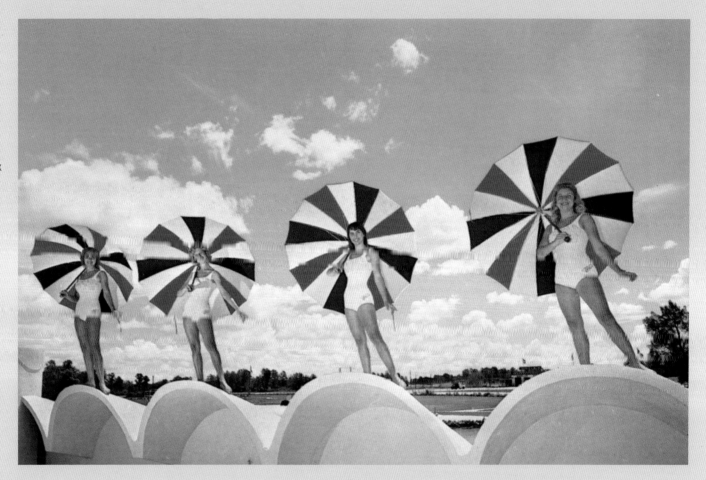

Mermaids on the clamshell roof (*left to right*), Joan Gately, Penny Briggs, Bonnie Georgiadis, and Sharon Cihak Elliot, 1960. By permission of Weeki Wachee. Photo by Sparky Schumacher.

The former mermaids plan a new show to cover the entire history of the park as well, beginning with a nod to the very first show, when the girls performed ballet in the silent spring. Then they'll move into the 1960s and 1970s, when the mermaids began performing sculpted shows with music. They plan to end the show with *Unforgettable*, the show Dawn Douglas originated back in 1997. They are also bringing back another oldie but goodie, and that's Bonnie Georgiadis. The former mermaid/choreographer/film-maker/bird curator is going to write the script for their new show, proving again what mermaid after mermaid has said of their days at Weeki Wachee.[48] Marti Nosti-Monaldi said it best: "We were family."

"When I think of Weeki Wachee," Marti said, "the first thing that comes to mind is, 'those were the best years of my life.' Above the job, the P.R., or anything else involving Weeki, were the unbreakable bonds of our mermaid sister-hood. We worked day after day with each other, always watching each other's backs. We knew each other inside and out. We shared laughter, tears, and really supported one another. If I could pick one thing in my career that was my most favorite, it would have to be the mermaid sister-hood."[49]

Weeki Wachee Spring is the friend these women can't forget, the love of a mermaid's life. And it's not just the former mermaids who feel this way about that cold, clear wa-ter. Gina Stremplewski left the park in 2003 after ten years. She got a chance to get back in the spring and breathe underwater only once since she left. "I just cried in there," she said. "It's hard to explain, but you'll never feel anything like that anywhere else."[50]

It's odd to think of a mermaid crying in the spring, especially a Weeki Wachee mermaid with her pancake makeup and love of bananas. Add those tears to the bones of mastodons, the pottery of ancient Indians, the blood of Spanish conquistadors, and soapsuds of the locals that have filled the spring for years. Yet, something else besides mermaid tears has gotten into the water at the kitschy roadside attraction that will celebrate its sixtieth anniver-sary in October 2007. Mermaid lore—at least as professed by the grandmother of the little mermaid in Hans Christian Andersen's tale—has it that mermaids have mortal souls, unlike humans, whose souls are immortal. A mermaid will live for three centuries, and then that's it; when her time is up, she dissolves into sea foam. Unless she can earn the undying love of a human.[51]

It seems the mermaids of Weeki Wachee have done just that. As the late pop-culture critic Jerome Stern put it:

> At home now, having traveled through much of the state, I think about what gives Florida character. The image that stays with me is State Highway 50, a mostly two-lane road running like a belt across our waist, from the rocket wizardry of the Kennedy Space Center . . . to the ancient green lagoons of Gator Jungle . . . to Weeki Wachee where the mermaids still sing that they have the world by the tail. . . . The tourist attractions remain, still weird, still loved. They deserve celebration, and may need our help, too, to survive.[52]

It's too bad Newt Perry isn't around to see all the waves that've been made at Weeki Wachee since he and Hall Smith dove into Weeki Wachee over fifty years ago. But maybe he

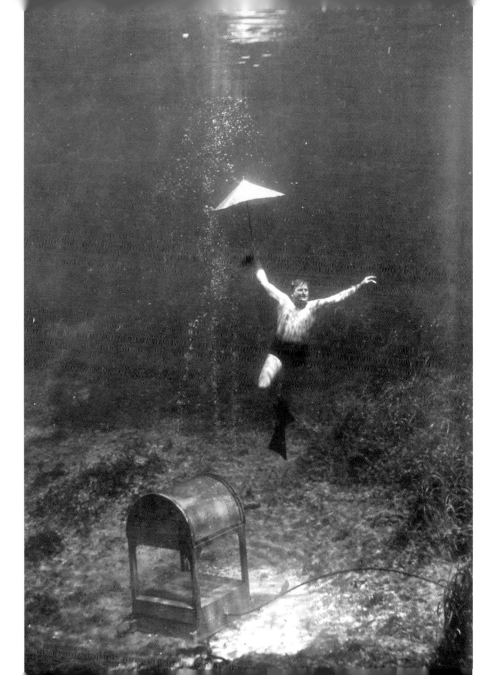

is. Delee Perry says she still sees her dad, the Human Fish, swimming past her sometimes. "I was flipping channels and saw Don Ameche and Betty Grable in *Moon over Miami*. And all of sudden they decided to drive to Silver Springs . . . and then they were on the photo sub, and there was my dad swimming by." One night she was sitting in her family room watching Johnny Carson. "He used to show these pictures of unusual things, and then there was my dad carving a turkey underwater. I'll be watching television, and then there'll a picture of my dad doing something underwater fifty years ago."[53]

Dot Fitzgerald Smith, who left mermaiding over fifty years ago, still envisions herself underwater, performing as a mermaid at Weeki Wachee. "Something I do when I'm tired and can't sleep is go back to the spring," she said. "I put my bathing suit on, get my flippers, and I do a routine, and that calms me down. Underwater, it's so beautiful over there. On a good sunny day the sun's shining and sparkling, and the fish are swimming all around, and you're in your own little world. I was taught to do everything slow. Now I'm in an exercise class in the pool, and they do everything fast, but I do it slow—and when they're done, I'm still going."[54]

Some of us want the show at Weeki Wachee to go on forever. We never want the show to end. But it does. At the end of the last show of the day, all of the mermaids swim close to the glass, blowing kisses that turn into fine sprays of silver bubbles, their skin waxy-looking in the blue light of the spring, their hair waving upward in strands sleek as silk, their eyes wide open, unseeing, like women trapped in

Newt Perry floats above the airlock at Wakulla Springs, ca. 1944.
Courtesy of Delee Perry.

A child watches Crystal Barlow Robson perform, 2005. By permission of Crystal Barlow Robson.

blue amber. Children kneel on the stage in front of the glass staring at the mermaids; they are always more than willing to suspend their disbelief. They are like Hernando de Soto's soldiers; they would climb the cypress trees downriver to get a glimpse of a mermaid. But at Weeki Wachee Spring, something happens to everyone's perception. Ponce de León looked deep into a Florida spring and saw a Fountain of Youth; Newton Perry looked deep into his spring and saw mermaids, maypoles, and swing sets. He knew that the ordinary could be transformed into the extraordinary, if you just do it underwater. And it is extraordinary.

When the mermaids have made their last farewells to an audience they can't even see, they swim back into the tube, back through the darkness, back to the portal where they climb out, take off their tails, sling them across a rack to dry, then slosh across the wet tile floor to the showers, where they stand beneath blasts of hot water to get warm. Their skin has started to turn blue from the cold, cold water. Their blue lips tremble. Their wet hair hangs limp as weeds against their cheeks. They dry off, get their clothes back on, and go home. They are grandmothers, mothers, wives, sisters, daughters. They are Weeki Wachee mermaids.

Shinko Akasofu Wheeler and Genie Westmoreland Young head back to the Mermaid Villa after a show, ca. 1970. By permission of Shinko Akasofu Wheeler.

Notes

Chapter 1. Florida: A Watery Dreamscape

1. "Plant Management in Florida's Waters: Fascinating Fossils," Institute of Food and Agricultural Studies, University of Florida. http://aquat1.ifas.ufl.edu/guide/fossils.html.

2. Stephen Trumbull, "Weekiwachee Easy to Say — In Chinese," *Miami Herald*, February 6, 1948.

3. Marilyn Reed Webb, interview by Lu Vickers, October 15, 2004.

4. Mitchem et al., "Early Spanish Contact on the Florida Gulf Coast," 181.

5. Bonnie Georgiadis, e-mail message to Lu Vickers, September 29, 2005.

6. Mitchem, "Spanish Contact Sites in Florida," 26.

7. Belleville, "Florida's Deep Blue Destiny," 10.

8. Bartram, *The Travels of William Bartram*, 151.

9. Ashton Nichols, "William Bartram," *A Romantic Natural History*, Dickinson College. http://www.dickinson.edu/~nicholsa/Romnat/.

10. Stamm, *The Springs of Florida*, 64.

11. Proby and Audubon, *Audubon in Florida*, 127.

12. "A Suwannee Spring Revival?" *Research in Review*, Florida State University Office of Research, Fall 2003, http://www.research.fsu.edu/researchr/fall2003/revival.html.

13. "Subterranean Rivers and Mineral Springs of Florida," *Floridian and Journal*, July 22, 1854, 1.

14. Long, *Florida Breezes or Florida New and Old*, 287.

15. William Drysdale, "It Gushes from the Rock," *New York Times*, May 26, 1889, ProQuest Historical Newspapers, http://proquest.umi.com/login.

16. Stanaback, *A History of Hernando County, 1840–1976*, 13–17.

17. Covington, "An Episode in the Third Seminole War," 48.

18. Stanaback, *A History of Hernando County, 1840–1976*, 26–27.

19. *The WPA Guide to Florida*, 5.

20. Stanaback, *A History of Hernando County, 1840–1976*, 30, 43.

21. Barbour, *Florida for Tourists, Invalids and Settlers*, 59.

22. Stanaback, *A History of Hernando County, 1840–1976*, 231.

23. Henshall, *Camping and Cruising in Florida*, 219–20.

24. Stanaback, *A History of Hernando County, 1840–1976*, 204–8.

25. Ibid., 221.

26. "Homosassa," advertisement, *Brooksville Herald*, February 11, 1926, collection of Lu Vickers.

27. "Homosassa Destined to be among Great Developments of Nation When Complete," *Brooksville Herald*, February 11, 1926.

28. Stanaback, *A History of Hernando County, 1840–1976*, 221.

29. Ibid., 222.

30. "Rex Beach Gathers Material for Book on Florida Growth," *Tampa Sunday Tribune*, August 9, 1925.

31. Ibid.

32. Hartzell, *St. Petersburg, Florida: An Oral History*, 55–56.

33. Stanaback, *A History of Hernando County, 1840–1976*, 231.

34. Dot Fitzgerald Smith, interview by Lu Vickers, October 14, 2004.

35. "$100,000 Playground Development Planned at Weekiwachee Springs," *St. Petersburg Times*, June 28, 1946.

36. Dot Fitzgerald Smith interview.

37. Mary Darlington Fletcher, interview by Lu Vickers, February 13, 2000.

38. "Tour 6," in *The WPA Guide to Florida*, 413.

39. John Reese, "Florida's Boomlet," *New York Times*, December 7, 1947, ProQuest Historical Newspapers, http://proquest.umi.com/login.

40. "Tour 6," in *The WPA Guide to Florida*, 420.

41. Penny Smith Vrooman, interview by Lu Vickers, April 30, 2005.

42. David Cook, "Visionary Developed Silver Springs," *Ocala Star Banner*, March 30, 1997, Newsbank Newsfile Collection, http://in-foweb.newsbank.com.

43. John Reese Jr., "At Weekiwachee Springs It's All Done Underwater," *St. Petersburg Independent*, November 21, 1947.

44. Penny Smith Vrooman interview.

45. John Reese Jr., "At Weekiwachee Springs It's All Done Underwater," *St. Petersburg Independent*, November 21, 1947.

46. Howard Turtle, "Kansas Citians Stage Show in Deep Water in Florida," *Kansas City Star*, undated clipping, collection of Penny Smith Vrooman.

47. Delee Perry, interview by Lu Vickers, November 15, 2004.

48. Ricou Browning, interview by Lu Vickers, September 24, 2004.

49. "Group Asks for 30-Year Lease on City-Owned Beauty Spot," *St. Petersburg Times*, June 30, 1946.

50. "$100,000 Playground Development Planned at Weekiwachee Springs." *St. Petersburg Times*, June 28, 1946.

51. Ibid.

52. "Weekiwachee Springs Will Be Developed," *Brooksville Journal*, July 4, 1946.

53. "Over $300,000 to Be Spent in Developing Weekiwachee Springs," *Brooksville Journal*, May 29, 1947.

54. Ricou Browning interview.

55. "Development of Springs Begins," *Brooksville Journal*, April 3, 1947.

56. Mary Darlington Fletcher, interview by Lu Vickers, February 13, 2000.

57. Delee Perry interview.

58. Penny Smith Vrooman interview.

59. Scotty Campbell, "Aqua Kids, Sea Nymphs, Aqua Belles of Spa Pool," *St. Petersburg Times Magazine*, March 28, 1948, 2–3.

60. Dianne Wyatt McDonald, interview by Sara Dionne and Frederick Olsen Jr., January 18, 2003.

61. Judy Ginty Cholomitis, interview by Sara Dionne and Frederick Olsen Jr., January 18, 2003.

62. Ed Darlington, interview by Lu Vickers, February 13, 2000.

63. Nancy Tribble Benda, e-mail message to Lu Vickers, September 13, 2005.

64. Ibid.

65. Ibid.

66. Gerry Hurlbut Dougherty, interview by Sara Dionne and Frederick Olsen Jr., January 19, 2003.

67. Dot Fitzgerald Smith interview.

68. Nancy Tribble Benda, e-mail message to Lu Vickers, September 13, 2005.

69. Ibid.

70. Penny Smith Vrooman interview.

71. "Underwater Theaters State's Latest Promotion to Lure Visitors' Dollars," *St. Petersburg Times*, October 19, 1947.

72. "Weekiwachee Formal Opening Set Sunday," *Brooksville Sun*, October 10, 1947.

73. "Weekewachee," advertisement, *St. Petersburg Independent*, October 11, 1947.

74. "Over $300,000 to Be Spent in Developing Weekiwachee Springs," *Brooksville Journal*, May 29, 1947.

75. "Weekiwachee, The Mountain Underwater," undated press release, collection of Delee Perry.

76. Bob Thomas, "Disney Celebrates, Mickey Mouse Now Twenty Years Old," *St. Petersburg Independent*, October 4, 1947.

77. Delee Perry interview.

78. Dianne Wyatt McDonald interview.

79. Mary Darlington Fletcher, interview by Sara Dionne and Frederick Olsen Jr., February 22, 2003.

80. Dot Fitzgerald Smith interview.

81. "Underwater Theaters State's Latest Promotion to Lure Visitors' Dollars," *St. Petersburg Times*, October 19, 1947.

82. "Group Asks for 30-Year Lease on City-Owned Beauty Spot," *St. Petersburg Times*, June 30, 1946.

83. Judy Ginty Cholomitis interview.

84. Weeki Wachee Spring brochure, collection of Delee Perry.

85. John Reese Jr., "At Weekiwachee Springs It's All Done Underwater," *St. Petersburg Independent*, November 21, 1947.

86. Dot Fitzgerald Smith interview.

87. Ibid.

88. "Welcome to YMCA Scuba," YMCA, September 3, 2005, http://www.ymcascuba.org.

89. Dot Fitzgerald Smith interview.

90. Nancy Tribble Benda, interview by Lu Vickers, October 10, 2004.

91. "Newt Perry's Mermaids Provoke Wirephoto Battle," *St. Petersburg Evening Independent*, April 28, 1948.

92. Ed Darlington interview.

Chapter 2. The Human Fish

1. Corse, *Shrine of the Water Gods*, 5–6.

2. Brinton, *Notes on the Floridian Peninsula*, 185.

3. Richard Martin, *Eternal Spring*, 153.

4. Constance Fenimore Cooper Woolson, quoted in King, "Through the Looking Glass of Silver Springs," 5.

5. John Audubon, quoted in Blanton, "Myth and Reality," 12.

6. Braden, *The Architecture of Leisure*, 1, 25

7. Field & Gipe, "Florida Expects a Big Winter," *New York Times*, October 22, 1925, ProQuest Historical Newspapers, http://proquest.umi.com/login.

8. "My Florida Home," Lester Levy Collection of Sheet Music, box 58, item 79, Johns Hopkins University Eisenhower Online Catalogue, http://levysheetmusic.mse.jhu.edu/.

9. Ricci, "Boasters, Boosters and Boom."

10. Delee Perry interview.

11. Ibid.

12. Ibid.

13. Ibid.

14. "Young People Get Thrill from Hunting Alligators," *Ocala Morning Banner*, March 26, 1931, collection of Delee Perry.

15. Delee Perry interview.

16. John Reese Jr., "At Weekiwachee Springs It's All Done Underwater," *St. Petersburg Independent*, November 21, 1947.

17. Katherine Hansard, "Movie Making in This Area on Increase: Shorty Davidson Was in First Underwater Shoot," *Ocala Morning Banner*, April 9, 1940, collection of Delee Perry.

18. Richard A. Martin, *Eternal Spring*, 1, 59–60.

19. Delee Perry interview; Katherine Hansard, "Movie Making in This Area on Increase: Shorty Davidson Was in First Underwater Shoot," *Ocala Morning Banner*, April 9, 1940, collection of Delee Perry.

20. Delee Perry interview.

21. Ibid.

22. Ibid.

23. Richard A. Martin, *Eternal Spring*, 160.

24. Brinton, *Notes on the Floridian Peninsula*.

25. Delee Perry interview.

26. Katherine Hansard, "Movie Making in this Area on Increase: Shorty Davidson Was in First Underwater Shoot," *Ocala Morning Banner*, April 9, 1940, collection of Delee Perry.

27. Ibid.

28. Ibid.

29. "'Sprinting' Under Water," *Washington, D.C., Sunday Star*, March 19, 1939.

30. "Speaking of Pictures . . . This Is an Underwater Movie," *Life*, April 26, 1937, 6.

31. Delee Perry interview.

32. Bruce Mozert, interview by Lu Vickers, August 13, 2004.

33. Delee Perry interview.

34. Bruce Mozert interview.

35. Delee Perry interview.

36. Billy Grady to Newton Perry, February 9, 1939, collection of Delee Perry.

37. Wakulla Springs Lodge brochure, ca. 1940s, collection of Delee Perry.

38. Harriet Carson, "Down the Old Sand Road," script of radio program broadcast from WTAL, Tallahassee, in 1946, collection of Delee Perry.

Chapter 3. Wakulla: Fit Palace for Neptune

1. Rich, "Wakulla Spring," 351.

2. Mary Bates, quoted in Rich, "Wakulla Spring," 357.

3. "Weismuller Guest of Wakulla Lodge," *Wakulla County News*, June 13, 1941, Wakulla Springs Archive.

4. Revels, *Watery Eden*, 44.

5. Gerald Ensley, "Dislodging the 'Grime of the Ages,'" *Tallahassee Democrat*, February 5, 2002, Newsbank Newsfile Collection, http://infoweb.newsbank.com.

6. Hettie Cobb, "Everything Ball Touches Turns to Gold," *Tallahassee Democrat*, undated clipping, Wakulla Springs Archive.

7. Jack Eaton to Newton Perry, February 28, 1941, collection of Delee Perry.

8. Jack Eaton to Newton Perry, May 20, 1941, collection of Delee Perry.

9. "Movie Tryout Is Set for Saturday," Tallahassee Daily Democrat, May 22, 1941.

10. Ricou Browning interview.

11. Delee Perry interview.

12. "Tarzan Movie Goes to Wakulla? Movie Men Leave," Ocala Morning Banner, June 4, 1941, Wakulla Springs Archive.

13. "Weissmuller Guest of Wakulla Lodge," Wakulla County News, June 13, 1941, Wakulla Springs Archive.

14. Allen Skaggs, "Tarzan Johnny Weissmuller Disports Self at Wakulla," Tallahassee Daily Democrat, June 12, 1941.

15. "Weissmuller Will Be Guest of Hollands at Dinner," Tallahassee Democrat, June 13, 1941.

16. Andy Lindstrom, "A 35-Cents an Hour Job Provided the Adventures of a Lifetime," Tallahassee Democrat, April 29, 1990.

17. Ibid.

18. Stephen Trumbull, "Kilroy de Leon Was Here: Hollywood Touch Fails to Injure Wakulla Springs," Miami Herald, November 17, 1946.

19. "The Wondrous Fountain of a Romantic Land," Florida Archives, State Library of Florida.

20. Ricou Browning interview.

21. Delee Perry interview.

22. Newton Perry to Ed Ball, June 11, 1945, Wakulla Springs Archive.

23. Minutes from staff meeting at Wakulla Springs Lodge, December 10, 1946, Wakulla Springs Archive.

24. Nancy Tribble Benda interview.

25. Ibid.

26. Ricou Browning interview.

27. Becky Watson, "Merman Perry," Ocala Star Banner, June 5, 1983.

28. Delee Perry interview.

29. Nancy Tribble Benda interview.

30. Ibid.

31. Ricou Browning interview.

32. Bradley and Blair, A General's Life, 112.

33. "Wakulla Springs Is Best GI Weekend," Camp Gordon Johnston Amphibian, April 24, 1943.

34. Becky Watson, "Merman Perry," Ocala Star Banner, June 5, 1983; Harriet Carson "Down the Old Sand Road," script of radio program broadcast from WTAL, Tallahassee, in 1946, collection of Delee Perry.

35. Delee Perry interview.

36. "New Grantland Rice Sportlight Features Water War at Wakulla," Camp Gordon Johnston Amphibian, April 24, 1943, 3.

37. Revels, Watery Eden, 46.

38. Ricou Browning interview.

39. Nancy Tribble Benda interview.

40. "Wakulla Manager Newton Perry Holds 185 Foot Depth Record," Camp Gordon Johnston Amphibian, April 24, 1943, 3.

41. Newton Perry to Ed Ball, March 5, 1945, and May 21, 1945, Wakulla Springs Archive.

42. Ed Ball to Newton Perry, March 8, 1945, Wakulla Springs Archive.

43. Stephen Trumbull, "Kilroy de Leon Was Here: Hollywood Touch Fails to Injure Wakulla Springs," Miami Herald, November 17, 1946.

44. "Perry Resigns Wakulla Post," Tallahassee Daily Democrat, June 12, 1947.

45. Harriet Carson, "Down the Old Sand Road," script of radio program broadcast from WTAL, Tallahassee, in 1946, collection of Delee Perry.

46. Nancy Tribble Benda interview.

47. "Wakulla Springs to Crown Queen 10 Feet Underwater," Tallahassee Democrat, May 16, 1947.

48. "Underwater Queen Named," Tallahassee Democrat, May 19, 1947.

49. Newton Perry to Ed Ball, June 1, 1947, collection of Delee Perry.

Chapter 4. Transforming Myth into Kitsch

1. Joel Achenbach, "Three Floridas; The Authentic, the Fake, the Authentically Fake," Chicago Sun-Times, December 15, 1991, Newsbank Newsfile Collection, http://infoweb.newsbank.com.

2. Ibid.

3. Walton, "From Sirens to Splash," 28.

4. Ibid., 29–30.

5. Holland, The Historie of the World.

6. Murphy, *Pliny the Elder's Natural History*, 210.

7. Walton, "From Sirens to Splash," 30.

8. Piccolo, "Women of the Deep."

9. Dunn and Kelley, *The "Diario" of Christopher Columbus's First Voyage to America*, 210.

10. Floyd, *Great Southern Mysteries*, 118.

11. Anson, *Fisher Folklore*, 125.

12. Ibid., 125.

13. Bondeson, "The Feejee Mermaid," in *The Feejee Mermaid and Other Essays in Natural and Unnatural History*, 38–40.

14. Ibid., 41–48.

15. Ibid., 51–53.

16. Lucas, "Making a Statement," 25.

17. Greg Hartung, quoted in Lucas, "Making a Statement," 27.

18. "Moe Howard," Official Web Site of the Three Stooges, http://www.threestooges.com.

19. *The Original Mermaid*, VHS, Michael Cordell and Ana Kokkinos (2002; Ronin Films, 2003).

20. Lucas, "Making a Statement," 28.

21. Ibid., 29.

22. Gallic, *The Guitar Players*, 84.

23. Louvich, *Man on the Flying Trapeze*, 47.

24. Lucas, "Making a Statement," 32, 35.

25. "History of Synchronized Swimming in the U.S.," United States Synchronized Swimming, August 5, 2004, http://www.usasynchro.org/about/history.htm.

26. Wood, *New York's 1939–1940 World's Fair*, 111–12.

27. Weeki Wachee brochure, 1940s, collection of Lu Vickers.

28. Weeki Wachee brochure, 1960s, collection of Sara Dionne.

29. Bonnie Georgiadis, interview by Lu Vickers, March 7, 2005.

Chapter 5. The Forties and Fifties: Weeki Wachee's Glamour Shot

1. Ricou Browning interview.

2. "Mermaids Soon Apt to Be Part of Florida's Scenery," *Tampa Sunday Tribune*, January 11, 1948.

3. Russell Kay, quoted in Wing, "Weekiwachee's Underwater Ballet," undated clipping from the *Brooksville Sun,* collection of Delee Perry.

4. Ed Darlington interview.

5. Nancy Tribble Benda interview.

6. Ibid.

7. Ibid.

8. Mary Darlington Fletcher, interview by Lu Vickers, February 13, 2000.

9. "Movie Group Gets Permit to Trap Fish," *Tampa Morning Tribune*, January 2, 1948.

10. "Mermaid Tails Attract Bear at Movie Lot," *Tampa Morning Tribune*, January 6, 1948.

11. Nancy Tribble Benda interview.

12. Blyth, "or would you rather be a fish?" 110.

13. Ruth Prince, "Star Likes Making Underwater Movie," *St. Petersburg Independent*, January 8, 1948.

14. Ed Darlington interview.

15. Blyth, "or would you rather be a fish?" 110.

16. "'Mermaid' Location Crew Weary of Grits on Menu," Universal-International newsletter, 1948, collection of Nancy Tribble Benda.

17. Nancy Tribble Benda interview.

18. Undated, untitled clipping from *St. Petersburg Independent*, collection of Diane Wyatt McDonald.

19. Diane Wyatt McDonald interview.

20. Nancy Tribble Benda interview.

21. "Amazes Citizenry. Mermaid Splashes In Pool to Herald Movie Debut," *Tampa Daily Times*, August 3, 1948.

22. Nancy Tribble Benda interview.

23. "Beauty Contest Highlights Park Theater Premiere Tomorrow of 'Mr. Peabody and Mermaid,'" *Tampa Daily Times*, August 4, 1948.

24. Mary Dwight Rose, interview by Lu Vickers, October 13, 2004.

25. "The Mayor and the Mermaid," *Tampa Daily Times*, August 6, 1948.

26. Penny Smith Vrooman interview.

27. Snyder, "Monkey Tycoon," 3.

28. Nancy Tribble Benda interview.

29. Penny Smith Vrooman interview.

30. "Gator Forgets Rules: Alligator Attacks Woman near Weekiwachee Spring," *Tampa Daily News*, August 5, 1948.

31. Carle, "Alligators DO Attack!" 10–11.

32. "Woman Escapes 'Gator Attack by Skill in Water," *Brooksville Sun*, August 6, 1948, 10–11.

33. Penny Smith Vrooman interview.

34. Fran Dwight Gioe and Mary Dwight Rose, interview by Lu Vickers, October 12, 2004.

35. Ibid.

36. *Underwater Mermaid Ballet Show*, VHS, directed and produced by Newton Perry (1949), collection of Delee Perry.

37. Russell Kay, quoted in Wing, "Weekiwachee's Underwater Ballet," undated clipping from *Brooksville Sun*, collection of Delee Perry.

38. Ibid.

39. Interview with Nancy Tribble Benda.

40. Fran Dwight Gioe interview.

41. Dot Fitzgerald Smith interview.

42. Ibid.

43. Fran Dwight Gioe and Mary Dwight Rose interview.

44. Ginger Stanley Hallowell, interview by Lu Vickers, November 15, 2004.

45. Ibid.

46. Elsie Jean Bell, interview by Sara Dionne and Frederick Olsen Jr., May 29, 2003.

47. Mary Dwight Rose interview.

48. Gerry Hatcher Dougherty interview.

49. Newt Perry to Bob Gilham, August 15, 1950, collection of Delee Perry.

50. Ibid.

51. Grantland Rice to Newt Perry, October 1, 1951, collection of Delee Perry.

52. Harrigan, *A Natural State*, 50.

53. Jackson, "Mermaid Theater," 71–73.

54. "Crosley Aqua-Kitchen Is Underwater Show All Will Want to See," *Tampa Daily Times*, February 2, 1953.

55. Penny Smith Vrooman interview.

56. Mary Dwight Rose interview.

57. Fran Dwight Gioe and Mary Dwight Rose interview.

58. Ginger Stanley Hallowell interview.

59. Ricou Browning interview.

60. Martha Delaine, interview by Lu Vickers, September 9, 2005.

61. Gussie Washington, interview by Lu Vickers, October 12, 2005.

62. Martha Delaine interview.

63. Gussie Washington interview.

64. Martha Delaine interview.

65. Gussie Washington interview.

66. David McNabb, interview by Lu Vickers, May 11, 2005.

67. Gussie Washington interview.

68. Martha Delaine interview.

69. Bonnie Georgiadis, interview by Lu Vickers, December 1, 2004.

70. Ibid.

71. Ibid.

72. Ginger Stanley Hallowell interview.

73. Ibid.

74. "Movies Are Wetter Than Ever," 67–68.

75. Dan Guido, "Jayne Mansfield Was Discovered at Attraction," *Ocala Star Banner*, July 25, 1983.

76. Ruthann Skinner Manuel, interview by Sara Dionne and Frederick Olsen Jr., May 22, 2003.

77. "NBC 'Spectacular' Sunday to Feature Weekiwachee," *Tampa Morning Tribune*, October 15, 1955.

78. Paul Wilder, "2000 Fish Cause Headache in Florida's TV Show Today," *Tampa Tribune*, October 15, 1955.

79. Bonnie Georgiadis interview, March 7, 2005.

80. Genie Westmoreland Young interview.

81. Ruthann Skinner Manuel interview.

82. *Wide Wide World*, Dave Garroway, ABC, WFLA-TV, Tampa, Fla., October 16, 1955.

83. Bonnie Georgiadis interview, March 7, 2005.

84. Elsie Jean Bell, interview by Sara Dionne and Frederick Olsen Jr., May 29, 2003.

85. Lorna Carroll, "Pleasant—Under Glass," *St. Petersburg Times*, September 25, 1955.

86. Schmetterer, *Leap*, 21.

87. Gary Mormino, "Vanishing Florida," *Tampa Tribune*, May 25, 2003, Newsbank Newsfile Collection, http://infoweb.newsbank.com.

1. "Elvis Meets the Suncoast Public—And It's Love," *St. Petersburg Times*, July 31, 1961.

2. Lynn Chako, "Elvis Kissed Her Four (Sigh) Times," *St. Petersburg Times*, July 31, 1961.

3. Marilyn Reed Webb interview.

4. Michael Bates, "Elvis Memory Springs to Mind," *Tampa Tribune*, August 14, 1991.

5. Ibid.

6. Naomi McClary, e-mail message to Lu Vickers, May 21, 2005.

7. Martha Delaine interview.

8. Michael Bates, "Elvis Memory Springs to Mind," *Tampa Tribune*, August 14, 1991.

9. "Weeki Wachee Maidens Get Enlarged Theater," *St. Petersburg Times*, February 1, 1960.

10. Frank Madden, "Sarasotan Shapes up Underwater Show," *Sarasota News*, August 7, 1960.

11. Paul Wilder, "Manager of the Mermaids," *Tampa Tribune*, October 9, 1960.

12. Pfening, "Spec-ology of the Circus, Part Two."

13. Sally Washington, "Sarasotan Teaches Dancing Mermaids!" *Sarasota News*, April 16, 1960.

14. Ibid.

15. "Weeki Wachee Maidens Get Enlarged Theater," *St. Petersburg Times*, February 1, 1960.

16. Bonnie Georgiadis interview, March 7, 2005.

17. Ibid.

18. "Florida's Weeki Wachee Fact Sheet—Underwater Theater," ca. 1960s, collection of Sharon Cihak Elliot.

19. "Refurbished Theater Lures Throngs to Weeki Wachee," *St. Petersburg Times*, November 13, 1960.

20. Bonnie Georgiadis interview, March 7, 2005.

21. Paul Wilder, "Manager of the Mermaids," *Tampa Tribune*, Oct. 9, 1960.

22. Bonnie Georgiadis interview, March 7, 2005.

23. Paul Davis, "Attraction Opens at Weeki Wachee," *St. Petersburg Times*, October 14, 1960.

24. "Refurbished Theater Lures Throngs to Weeki Wachee," *St. Petersburg Times*, November 13, 1960.

25. Marilyn Reed Webb interview.

26. Weeki Wachee brochure, ca. 1960s, collection of Sara Dionne.

27. Bonnie Georgiadis interview, March 7, 2005.

28. "Famous Naturalist at Weeki Wachee Springs," *Brooksville Sun-Journal*, June 2, 1960.

29. C. E. Wright, "Florida Taps Spring as Tourist Attraction," *New York Times*, May 15, 1960, ProQuest Historical Newspapers, http://proquest.umi.com/login.

30. "One Dozen Mermaids," *St. Petersburg Times*, July 7, 1963.

31. Bonnie Georgiadis interview, March 7, 2005.

32. Marilyn Nagle Cloutier interview.

33. Ibid.

34. Ibid.

35. Bonnie Georgiadis interview, March 7, 2005.

36. Carol Parrish, interview by Lu Vickers, March 20, 2005.

37. Marilyn Nagle Cloutier interview.

38. Bonnie Georgiadis interview, March 7, 2005.

39. Genie Westmoreland Young interview.

40. Bonnie Georgiadis interview, March 7, 2005.

41. Genie Westmoreland Young interview.

42. Bonnie Georgiadis interview, March 7, 2005.

43. Marilyn Nagle Cloutier interview.

44. Ibid.

45. Thomas Rawlins, "Alice Falls into Waterland," *St. Petersburg Times*, October 4, 1964.

46. Genie Westmoreland Young interview.

47. Bonnie Georgiadis interview, March 7, 2005.

48. Allen Scott, interview by Lu Vickers, April 24, 2005.

49. Bonnie Georgiadis interview, March 7, 2005.

50. Marilyn Nagle Cloutier interview.

51. Ibid.

52. Genie Westmoreland Young interview.

53. Ibid.

54. Ibid.

55. Bonnie Georgiadis interview, March 7, 2005.

56. Ibid.

57. "Weekend at Weeki Wachee" (supplementary documentary), *The Incredible Mr. Limpet*, DVD (Warner Home Video, 2002).

58. Bernie McGovern, "Stars, Press See Film in Underwater Premier," *Tampa Tribune*, January 18, 1964.

59. Bonnie Georgiadis interview, March 7, 2005.

60. Genie Westmoreland Young interview.

61. Bonnie Georgiadis interview, March 7, 2005.

62. Ibid.

63. Genie Westmoreland Young interview.

64. Bonnie Georgiadis interview, March 7, 2005.

65. Genie Westmoreland Young interview.

66. Bonnie Georgiadis interview, March 7, 2005.

67. Genie Westmoreland Young interview.

68. Delee Perry interview.

69. Weeki Wachee brochure, ca. 1960s, collection of Bonnie Georgiadis.

70. Bonnie Georgiadis interview, December 1, 2004.

71. Marilyn Nagle Cloutier, interview by Lu Vickers, September 17, 2005.

72. Allen Scott interview.

73. Bonnie Georgiadis interview, March 7, 2005.

74. Marilyn Nagle Cloutier interview.

75. Bonnie Georgiadis interview, March 7, 2005.

76. Ibid.

77. Genie Westmoreland Young interview.

78. Bonnie Georgiadis interview, March 7, 2005.

79. Sparky Schumacher, interview by Sara Dionne and Frederick Olsen Jr., October 27, 2002.

80. Ibid.

81. Genie Westmoreland Young interview.

82. Vera Benson Huckaby, interview by Lu Vickers, March 8, 2006.

83. Dolly Heltsley and Holly Hall, interview by Lu Vickers, October 13, 2004.

84. Ibid.

85. Ibid.

86. Ibid.

87. Susan Sweeney Hopkins, interview by Lu Vickers, April 23, 2005.

88. Dottie McCullough Stanley, interview by Sara Dionne and Frederick Olsen Jr., May 2, 2003.

89. Ibid.

90. Susan Sweeney Hopkins interview.

91. Ibid.

92. Ibid.

93. Lucy Ware Morgan, "Mermaids, Others on Strike at Weeki Wachee," *St. Petersburg Times*, July 5, 1970.

94. Dolly Heltsley and Holly Hall interview.

95. Susan Sweeney Hopkins interview.

96. Dolly Heltsley and Holly Hall interview.

97. Bonnie Georgiadis interview, March 7, 2005.

98. Dawn Douglas, interview by Lu Vickers, April 24, 2005.

99. Allen Scott interview.

100. Shinko Akasofu Wheeler, interview by Sara Dionne, May 10, 2005.

101. Susan Sweeney Hopkins interview.

102. Shinko Akasofu Wheeler interview.

103. Crystal Robson, interview by Lu Vickers, April 23, 2005.

Chapter 7. The Seventies: The Era of the Mouse

1. Joe Ann Bennett, interview by Lu Vickers, October 5, 2005.

2. "University of Florida History: 1948–1974, Post-war Expansion," University of Florida, August 18, 2005, http://www.ufl.edu/history/1948.html.

3. "Florida State University Celebrates Its Integration in a Monumental Way," Florida State University, January 30, 2004, http://www.fsu.edu/~unicomm/Newfiles/release_2004_01_30a.html.

4. "Negroes Stage a 'Wade In' at Sarasota," *St. Petersburg Times*, July 31, 1961.

5. Monte Martin, "Paradise Lost."

6. Skipper Lockett, "Welcome to Rainbow Springs," *Music from the Florida Folklife Collection*, Tallahassee, Bureau of Florida Folklife Programs, Florida Folklife Archive, 2005.

7. Joe Ann Bennett interview.

8. Ibid.

9. Martha Delaine interview.

10. Susan Sweeney Hopkins interview.

11. Bonnie Georgiadis interview, March 7, 2005.

12. Dottie McCullough Stanley interview.

13. Connie Standish, "Things Went Wrong, but Wet Wedding Beautiful," *Tampa Tribune*, March 9, 1970.

14. Dottie McCullough Stanley interview.

15. Hiaasen, *Team Rodent*, 17–18.

16. Foglesong, *Married to the Mouse*, 17, 34, 35, 44, 49.

17. Hiaasen, *Team Rodent*, 26–27.

18. "Walt Disney World History 101—'How to Buy 27,000 acres of land and no one notice,'" Disney World Trivia.com, http://www.disney-worldtrivia.com.

19. Ibid.

20. Mormino, "Eden to Empire," 10.

21. Mormino, "Trouble in Tourist Heaven," 13.

22. Bonnie Georgiadis interview, December 1, 2004.

23. Genie Westmoreland Young interview.

24. Susie Pennoyer, interview by Lu Vickers, April 29, 2005.

25. *Wacky Weeki Wachee and Silver Springs Singing and Comedy Thing*, perf. Tony Randall, Lynn Anderson, Anne Meara, and Jerry Stiller. Howard Cosell, ABC (New York: Museum of Television and Radio, 1975).

26. Ibid.

27. Diane Stallings, "As They Mend, They Entertain," *St. Petersburg Times*, July 25, 1976.

28. "Exotic Macaw Stolen from Weeki Wachee," *St. Petersburg Times*, July 23, 1977.

29. "Weeki Wachee Preening," *St. Petersburg Times*, September 4, 1974, business section, Pasco-Times.

30. Bonnie Georgiadis interview, March 7, 2005.

31. Susan Backlinie, interview with Sara Dionne and Frederick Olsen Jr., June 6, 2003.

32. Cochrane, "'Too Much Boldness and Rudeness.'"

33. Weeki Wachee brochure, 1970s, collection of Lu Vickers.

34. Ginger Stanley Hallowell interview.

35. Ibid.

36. Terry Anderson, *The Movement and the Sixties*, 228.

37. Nelson, introduction to Smith, *Nike Is a Goddess*, xii.

38. Susan Backlinie interview.

39. Ibid.

40. Carolyn Nolte-Watts, "Mermaiding: Below the Glamorous Surface It's a Chilling Experience," *St. Petersburg Times*, July 3, 1975.

41. Darlest Thomas, interview by Sara Dionne and Frederick Olsen Jr., April 24, 2003.

42. Allen Scott interview.

43. Henshall, *Camping and Cruising in Florida*, 219.

44. Bonnie Georgiadis interview, December 1, 2004.

45. Diane Stalling, "Dirty Water Closes Weeki Wachee Show," *St. Petersburg Times*, March 26, 1976.

46. Bonnie Georgiadis interview, December 1, 2004.

47. Peter Gallagher, "Singe Benefits." *St. Petersburg Times*, July 25, 1976.

48. Bonnie Georgiadis interview, March 7, 2005.

49. "Weeki Wachee Spring Expansion Announced," *St. Petersburg Times*, March 15, 1977, Pasco-Times.

50. Charla Wasel, "Weeki Wachee—New and Traditional," *St. Petersburg Times*, December 15, 1978.

51. Ibid.

52. Gayle Guthman, "Weeki Wachee Marks Completion of Renovation," *St. Petersburg Times*, December 5, 1978, Citrus-Hernando section.

53. Diane Stallings, "Pelican Hospital Has the Comforts, Service of a Boarding House," *St. Petersburg Times*, February 15, 1987.

54. Gayle Guthman, "Weeki Wachee Marks Completion of Renovation," *St. Petersburg Times*. December 5, 1978, Citrus-Hernando section.

55. Marti Norti-Monaldi, interview by Lu Vickers, May 8, 2005.

56. Press release from Weeki Wachee, October 2, 1979, collection of Cathy Mahon Havens.

57. Mitchem, "Spanish Contact Sites in Florida," 23.

58. Press release from Weeki Wachee, October 8, 1979, collection of Cathy Mahon Havens.

59. Press release from Weeki Wachee, 1979, collection of Cathy Mahon Havens.

Chapter 8. The Eighties: The Age of Acquisition

1. William Least Heat-Moon, introduction to Clarke and Wackerbarth, *The Red Couch*, 10.

2. Linda Sand Zucco, interview by Lu Vickers, April 24, 2005.

3. Ibid.

4. Clarke and Wackerbarth, *The Red Couch*, 21.

5. William Least Heat-Moon, introduction to Clarke and Wacker-barth, *The Red Couch*, 14.

6. Diane Stallings, "Weeki Wachee Announces Expansion and New Attraction," *St. Petersburg Times*, October 9, 1979.

7. Becky Watson, "Merman Perry," *Ocala Star Banner*, June 5, 1983.

8. Ed Darlington interview.

9. Becky Watson, "Merman Perry," *Ocala Star Banner*, June 5, 1983.

10. Collins Conner and Diane Stallings, "Weeki Wachee Is Sold," *St. Petersburg Times*, March 25, 1984.

11. Bonnie Georgiadis interview, March 7, 2005.

12. Carol Parrish interview.

13. Bonnie Georgiadis interview, March 7, 2005.

14. Wilson, "Growth Gushes at Weeki Wachee," 58.

15. Ibid.

16. Delee Perry interview.

17. Alicia Caldwell, "Theme Parks' Owners Say Operations Won't Change," *St. Petersburg Times*, January 4, 1989, Newsbank Newsfile Collection, http://infoweb.newsbank.com.

18. Bonnie Georgiadis interview, March 7, 2005.

19. Allen Scott interview.

20. Bonnie Georgiadis interview, March 7, 2005.

21. Allen Scott interview.

22. Genie Westmoreland Young interview.

23. Ken Zapinski, "Weeki Wachee Lays Off Nine Workers," *St. Petersburg Times*, October 14, 1989.

24. "Firing at Weeki Wachee Raises Questions," *St. Petersburg Times*, August 18, 1989.

25. Marti Nosti-Monaldi interview.

26. "Motives for Manatee Plan at Weeki Wachee Murky," *St. Petersburg Times*, June 20, 1990, Newsbank Newsfile Collection, http://infoweb.newsbank.com.

27. Judy Holland, "Weeki Wachee Changes Focus, Targets Floridians," *Tampa Tribune*, September 4, 1990, Newsbank Newsfile Collection, http://infoweb.newsbank.com.

28. "Motives for Manatee Plan at Weeki Wachee Murky," *St. Petersburg Times*, June 20, 1990, Newsbank Newsfile Collection, http://infoweb.newsbank.com.

29. Marti Nosti-Monaldi interview.

30. Bonnie Georgiadis interview, March 7, 2005.

31. Linda Sand Zucco interview.

32. Marti Nosti-Monaldi interview.

Chapter 5. The Nineties: From *The Encyclopedia of Bad Taste* to the *Tails of Yesteryear*

1. John Reese, "At Weekiwachee Springs It's All Done Underwater," *St. Petersburg Independent*, November 21, 1947.

2. Neil Johnson, "Trouble May Bubble from Springs," *Tampa Tribune*, March 16, 1997, Newsbank Newsfile Collection, http://infoweb.newsbank.com.

3. "Welcome to Hernando County," Hernando County Board of Commissioners, August 27, 2004, http://www.co.hernando.fl.us/visit/about.htm.

4. Stern and Stern, "Weeki Wachee Mermaids," 320.

5. Michael Dunn, "They're Making a Splash: Thirty to 40 Former Mermaids Will Suit up Once Again for an Underwater Ballet as Part of Weeki Wachee Spring's 50th Anniversary Celebration," *Tampa Tribune*, October 4, 1997, Newsbank Newsfile Collection, http://infoweb.newsbank.com.

6. Stern and Stern, "Weeki Wachee Mermaids," 12.

7. "Weeki Wachee, City of Mermaids," RoadsideAmerica.com: Your Guide to Offbeat Tourist Attractions, http://roadsideamerica.com/attract/FLWEEmer.html.

8. Brian Chichester, "Weeki Wachee's Famous 'Fins' Gain Exposure," *St. Petersburg Times*, July 7, 1992, Newsbank Newsfile Collection, http://infoweb.newsbank.com.

9. Justin Blum, "Llama Attacks Park Attendant," *St. Petersburg Times*, July 9, 1995, Newsbank Newsfile Collection, http://infoweb.newsbank.com.

10. Dawn Douglas interview.

11. Ibid.

12. Ibid.

13. Ibid.

14. Ibid.

15. Ibid.

16. Ibid.

17. Bonnie Georgiadis interview, March 7, 2005.

18. Ibid.

19. Crystal Robson interview.

20. Ibid.

21. Darlest Thomas interview.

22. Gina Stremplewski, interview by Lu Vickers, April 23, 2005.

23. Ibid.

24. Bob McNeil, interview by Lu Vickers, February 3, 2006.

25. Mary Darlington Fletcher, interview by Sara Dionne and Frederick Olsen Jr., February 22, 2003.

26. Ibid.

27. "The Diving Belles," *CBS Sunday Morning*, Bill Geist, September 6, 1998.

28. Gina Stremplewski interview.

29. Ibid.

30. Jo Ann Hausen, interview by Lu Vickers, May 1, 2005.

31. Ibid.

32. Gina Stremplewski interview.

33. Ibid.

34. Jo Ann Hausen interview.

35. Ibid.

36. Pilot show for *Maximum Bob*, August 4, 1998 (New York: Museum of Television and Radio).

37. Script of Weeki Wachee Show, Series D-WW-July 7, 1958, collection of Sharon Cihak Elliot.

38. Kelly Ryan, "Weeki Wachee Spring Water: For Sale?" *St. Petersburg Times*, October 21, 1998, Newsbank Newsfile Collection, http://infoweb.newsbank.com.

39. Kelly Ryan, "State May Buy Weeki Wachee Land," *St. Petersburg Times*, April 30, 1998, Newsbank Newsfile Collection, http://infoweb.newsbank.com.

40. Gina Stremplewski interview.

41. Robert Farley, "Weeki Wachee Park Is Sold," *St. Petersburg Times*, March 12, 1999, Newsbank Newsfile Collection, http://infoweb.newsbank.com.

42. Dottie Meares, interview by Lu Vickers, February 13, 2000.

43. Dottie Meares, interview by Sara Dionne and Frederick Olsen Jr., November 23, 2002.

44. Billie Fuller, interview by Lu Vickers, February 13, 2000.

Chapter 10. The *Merlinnium*: A Return to the Sublime

1. Lane DeGregory, "Even Mermaids Reach a Boiling Point," *St. Petersburg Times*, November 9, 2001, Newsbank Newsfile Collection, http://infoweb.newsbank.com.

2. Jennifer Farrell, "Cheney to Make Stop in Hernando," *St. Petersburg Times*, October, 31, 2000, Newsbank Newsfile Collection, http://infoweb.newsbank.com.

3. Jo Ann Hausen interview.

4. Crystal Robson interview.

5. Bill DeYoung, "Writer/Director John Sayles Explores the Development of Florida in His New Movie 'Sunshine State,'" *Gainesville Sun*, July 24, 2002, http://www.billdeyoung.com.

6. Ibid.

7. *Sunshine State*, directed by John Sayles, perf. Timothy Hutton, Edie Falco (Sony Pictures Classics, 2002).

8. Ibid.

9. Gina Stremplewski interview.

10. Darlest Thomas interview.

11. Ibid.

12. Brad Smith, "Swiftmud to buy Weeki Wachee," *Tampa Tribune*, June 27, 2001, Newsbank Newsfile Collection, http://infoweb.newsbank.com.

13. Dan DeWitt, "Weeki Wachee Avoids Lawsuit for Now," June 26, 2003, Newsbank Newsfile Collection, http://infoweb.newsbank.com.

14. Robert Farley, "Weeki Wachee: Bye-Bye Birdies," *St. Petersburg Times*, March 26, 1999, Newsbank Newsfile Collection, http://infoweb.newsbank.com.

15. Dan DeWitt, "Weeki Wachee Avoids Lawsuit for Now," June 26, 2003, Newsbank Newsfile Collection, http://infoweb.newsbank.com.

16. Robert King, "Springs Misses Deadline for Repairs," *St. Petersburg Times*, August 13, 2003, Newsbank Newsfile Collection, http://infoweb.newsbank.com.

17. Abby Goodnough, "Sad Days for Mermaids of the Sequined Sort," *New York Times*, August 12, 2003.

18. Robert King, "Paradise in Peril," *St. Petersburg Times*, September 21, 2003, Newsbank Newsfile Collection, http://infoweb.newsbank.com.

19. Robert King, "Last Rites for the Springs," *St. Petersburg Times*, August 24, 2003, Newsbank Newsfile Collection, http://infoweb.newsbank.com.

20. "Water District Gives Weeki Wachee More Time to Fix Aging Park," *Naples Daily News*, August 28, 2003, http://www.marcodailynews.com.

21. Robert King, "Last Rites for the Springs," *St. Petersburg Times*, August 24, 2003, Newsbank Newsfile Collection, http://infoweb.newsbank.com.

22. Eric Deggans, "'Simple' Humiliation, Part 2," *St. Petersburg Times*, June 15, 2004, Newsbank Newsfile Collection, http://infoweb.newsbank.com.

23. Mermaid Nikki, interview by Lu Vickers, March 26, 2005.

24. Mermaid Justen, interview by Lu Vickers, March 26, 2005.

25. Hilton, *Confessions of an Heiress*, 120.

26. "Lot 334: Elvis Presley's Hair," AmericanMemorabilia.com, March 18, 2004, http://www.americanmemorabilia.com.

27. "Mermaids Fight to Save Roadside Attraction," *National Geographic News*, March 22, 2004, http://news.nationalgeographic.com.

28. Ibid.

29. Susie Pennoyer interview.

30. Linda Makel, "Retired Mermaids Still in the Swim," *National Examiner*, May 17, 2004.

31. Bev Sutton, interview by Lu Vickers, March 26, 2005.

32. Nelson, introduction to Smith, *Nike Is a Goddess*, x.

33. Gean Moreno, *Janaina Tschäpe: 'Blood, Sea'* (Tampa, Fla.: Contemporary Art Museum/Institute for Research in Art, 2004), http://www.usfcam.usf.edu/Janaina/Tschape.html.

34. Cook and Jenshel, *Aquarium*, 109.

35. Mermaid Heather, interview by Lu Vickers, March 26, 2005.

36. Mermaid Nikki interview.

37. Merman John, interview by Lu Vickers, March 26, 2005.

38. Merman Justen interview.

39. Mermaid Erin, interview by Lu Vickers, March 26, 2005.

40. Angeline Taylor, "Is Weeki Wachee a City in Peril?" *Tampa Tribune*, May 16, 2005, Newsbank Newsfile Collection, http://infoweb.newsbank.com.

41. "Put Weeki Wachee out of Its Suffering," *St. Petersburg Times*, March 9, 2005, Newsbank Newsfile Collection, http://infoweb.newsbank.com.

42. Mary Spicuzza, "Are Mermaids in the Crosshairs?" *St. Petersburg Times*, April 22, 2005, *Newsbank Newsfile Collection*, http://infoweb.newsbank.com.

43. Angeline Taylor, "Weeki Wachee's Struggle May Come to Television," *Tampa Tribune*, April 30, 2005, Newsbank Newsfile Collection, http://infoweb.newsbank.com.

44. John Athanason, interview by Lu Vickers, October 13, 2005.

45. Mary Spicuzza, "Weeki Wachee Finds Wall-to-Wall History," *St. Petersburg Times*, April 16, 2005, Newsbank Newsfile Collection, http://infoweb.newsbank.com.

46. Mary Spicuzza, "Restoration of Sea Wall Under Way," *St. Petersburg Times*, September 24, 2005, Newsbank Newsfile Collection, http://infoweb.newsbank.com.

47. Mermaid Nikki interview.

48. Bonnie Georgiadis interview, March 7, 2005.

49. Marti Nosti-Monaldi interview.

50. Gina Stremplewski interview.

51. Hans Christian Andersen, *The Little Mermaid and Other Fairy Tales*.

52. Stern, "At Home in the Snake-A-Torium," 21.

53. Delee Perry interview.

54. Dot Fitzgerald Smith interview.

Bibliography

Andersen, Hans Christian. *The Little Mermaid and Other Fairy Tales*. Mineola, N.Y.: Dover Evergreen Classics, 2003.

Anderson, Terry. *The Movement and the Sixties*. New York: Oxford University Press, 1996.

Anson, Peter. *Fisher Folklore: Old Customs, Taboos and Superstitions among Fisher Folk, Especially in Brittany and Normandy, and on the East Coast of Scotland*. Leighton Buzzard: Faith Press, 1965.

Barbour, George. *Florida for Tourists, Invalids and Settlers*. Gainesville: University of Florida Press, 1964.

Bartram, William. *The Travels of William Bartram*. Edited by Mark van Doren. New York: Dover, 1928.

Belleville, Bill. "Florida's Deep Blue Destiny." *Forum*, Summer 2002, 8–13.

Blanton, Casey. "Myth and Reality." *Forum*, Spring 2001, 12–15.

Blyth, Ann. "or would you rather be a fish?" *Modern Screen*, June 1948, 64–65, 110.

Bondeson, Jan. *The Feejee Mermaid and Other Essays in Natural and Unnatural History*. Ithaca: Cornell University Press, 1999.

Braden, Susan R. *The Architecture of Leisure: The Florida Resort Hotels of Henry Flagler and Henry Plant*. Gainesville: University Press of Florida, 2002.

Bradley, Omar, and Clay Blair. *A General's Life*. New York: Simon and Schuster, 1983.

Brinton, Daniel. *Notes on the Floridian Peninsula, Its Literary History, Indian Tribes and Antiquities*. Philadelphia: J. Sabin, 1859. http://diglib.lib.fsu.edu.

Carle, William. "Alligators DO Attack!" *Florida Wildlife*, September 1948, 10–11.

Clarke, Kevin, and Horst Wackerbarth. *The Red Couch*. New York: A. van der Marck Editions, 1985.

Cochrane, Peter. "'Too Much Boldness and Rudeness,' Australia's First 'Olympic Ladies Swimming Team.'" *National Centre for History Education*. http://www.hyperhistory.org.

Cook, Diane, and Len Jenshel. *Aquarium*. New York: Aperture Foundation, 2003.

Corse, Carita Doggett. *Shrine of the Water Gods: Historical Account of Silver Springs, Florida*. St. Paul, Minn.: Brown & Bigelow, ca. 1935–38. Florida Collection, Florida State University.

Covington, James W. "An Episode in the Third Seminole War." *Florida Historical Quarterly* 45, no. 1 (July 1966): 45–59.

Dunn, Oliver, and James E. Kelley Jr. *The "Diario" of Christopher Columbus's First Voyage to America 1492–1493*. Norman and London: University of Oklahoma Press, 1988.

Floyd, E. Randall. *Great Southern Mysteries*. New York: Barnes and Noble, 2000.

Foglesong, Richard. *Married to the Mouse*. New Haven: Yale University Press, 2001.

Harrigan, Stephen. *A Natural State: Essays on Texas*. Austin: University of Texas Press, 1994.

Hartzell, Scott Taylor. *St. Petersburg, Florida: An Oral History*. Charleston: Arcadia, 2002.

Henshall, James. *Camping and Cruising in Florida*. Cincinnati: Clarke, 1884. FSU Digital Library, http://diglib.lib.fsu.edu.

Hiaasen, Carl. *Team Rodent: How Disney Devours the World*. New York: Ballantine, 1998.

Hilton, Paris. *Confessions of an Heiress: A Tongue-in-Chic Peek behind the Pose*. New York: Fireside, 2004.

Holland, Philemon, trans. Plinius Secundus. *The Historie of the World. Commonly called, The Natural Historie of Plinius Secundus*. http://penelope.uchicago.edu/holland/index.html.

Jackson, Norris. "Mermaid Theater." *Popular Mechanics*, June 1952, 71–73.

King, Wendy Adams. "Through the Looking Glass of Silver Springs: Tourism and the Politics of Vision." *Americana: The Journal of American Popular Culture, 1900 to Present* 3, no. 1 (Spring 2004): 5. http://www.americanpopularculture.com/journal/articles/spring_2004/king.htm.

Long, Ellen Call. *Florida Breezes or Florida New and Old*. Gainesville: University of Florida Press, 1961.

Louvish, Simon. *Man on the Flying Trapeze: The Life and Times of W. C. Field*. New York: Norton, 1999.

Lucas, John. "Making a Statement: Annette Kellerman Advances the Worlds of Swimming, Diving and Entertainment." *Sporting Traditions* 14, no. 2 (May 1998): 25–35.

Makel, Linda. "Retired Mermaids Still in the Swim." *National Examiner*, May 17, 2004, 4–5.

Martin, Monte. "Paradise Lost." *Ocala Magazine*, February 2, 2005. http://www.ocalamagazine.com.

Martin, Richard A. *Eternal Spring: Man's 10,000 Years of History at Florida's Silver Springs*. St. Petersburg, Fla.: Great Outdoors Publishing, 1966.

"Mermaids Fight to Save Roadside Attraction." *National Geographic News*, March 22, 2004. http://news.nationalgeographic.com.

Mitchem, Jeffrey. "Spanish Contact Sites in Florida." In *The Complete Lamar Briefs*, edited by Mark Williams. LAMAR Institute, University of Georgia, Publication 48, 2000. http://www.shapiro.anthro.uga.edu/Lamar/PDFfiles/Publication%2048.pdf.

Mitchem, Jeffrey, Marvin T. Smith, Albert Goodyear, and Robert Allen. "Early Spanish Contact on the Florida Gulf Coast: The Weeki Wachee and Ruth Smith Mounds." In "Indians, Colonists and Slaves," Special Publication no. 4, *Florida Journal of Anthropology* (1985): 179–215. Special Collections, Florida State University.

Mormino, Gary. "Eden to Empire." *Forum*, Spring 2001, 7–11.

———. "Trouble in Tourist Heaven," *Forum*, Summer 1994, 11–13.

"Movies are Wetter Than Ever, Underwater Premiere Is Rehearsed in a Dive-in." *Life*, January 1955, 67–68.

Murphy, Trevor. *Pliny the Elder's Natural History: The Empire in the Encyclopedia*. Oxford: Oxford University Press, 2004.

Pfening, Fred D., Jr. "Spec-ology of the Circus, Part Two." *Bandwagon*, 48, no. 1 (January-February 2004): 3–21. http://www.circushistory.org.

Piccolo, Anthony. "Women of the Deep: A Light History of the Mermaid." *Sea History* 68 (Winter 1993–94). http://members.cox.net/mermaid31/merhist.htm.

Proby, Katherine Hall, and John Audubon. *Audubon in Florida*. Coral Gables: University of Miami Press, 1971.

Revels, Tracy. *Watery Eden: A History of Wakulla Springs*. Tallahassee: Sentry Press, 2002.

Ricci, James M. "Boasters, Boosters and Boom: Popular Images of Florida in the 1920s." *Tampa Bay History* (Fall/Winter 1984). http://www.lib.usf.edu/ldsu/digitalcollections/T06/journal/v06n2_84/v06n2_84_31.pdf.

Rich, Lou. "Wakulla Spring: Its Setting and Literary Visitors." *Florida Historical Quarterly* vol. 4, issue 42 (1964): 351–62.

Sallis, James. *The Guitar Players: One Instrument and Its Masters in American Music*. Lincoln: University of Nebraska Press, 1994.

Schmetterer, Bob. *Leap: A Revolution in Creative Business Strategy*. Hoboken, N.J.: Wiley, 2003.

Smith, Lissa, ed. *Nike Is a Goddess: The History of Women in Sports*. New York: Atlantic Monthly Press, 1998.

Snyder, Bill. "Monkey Tycoon." *Florida Wildlife*, October 1947, 3–9.

Stamm, Doug. *The Springs of Florida*. Sarasota, Fla.: Pineapple Press, 1994.

Stanaback, Richard. *A History of Hernando County, 1840–1976*. Orlando: Daniels, 1976.

Stern, Jane, and Michael Stern. "Weeki Wachee Mermaids." In *The Encyclopedia of Bad Taste*. New York: HarperPerennial, 1990.

Stern, Jerome. "At Home in the Snake-A-Torium." *Forum*, Summer 1994, 14–21.

Walton, Chelle Koster. "From Sirens to Splash." *Oceans* 18 (November/December 1985): 28–31.

Wilson, Elizabeth. "Growth Gushes at Weeki Wachee." *Florida Trend*, August 1987, 58–62.

Wood, Andrew. *New York's 1939–1940 World's Fair*. Charleston, S.C.: Arcadia, 2004.

The WPA Guide to Florida: The Federal Writers' Project Guide to 1930s Florida. New York: Pantheon, 1984.

Index

Lu Vickers is a former Kingsbury Fellow from Florida State University and a three-time recipient of the Florida Individual Artist Grant for fiction, most recently (2007) for an exerpt from her novel-in-progress *The Natural History of a Mermaid*. She also received the 2002–03 Astraea Award for emerging writers. Her work has appeared in the *Apalachee Review* and in *Salon.com*. Her first novel, *Breathing Underwater* (2007) is not about mermaids, but Weeki Wachee does make an appearance.

Sara Dionne is a fashion designer in New York City, who became interested in Weeki Wachee after seeing its deteriorated state. She is currently working on *Once in a Mermaid*, a documentary exploring the history of the attraction. See her Web site: www.daughtersofneptune.com.